NEW BARS & RESTAURANTS

NEW BARS & RESTAURANTS

Cristina del Valle

HARPER
DESIGN

An Imprint of HarperCollins*Publishers*

NEW BARS & RESTAURANTS
Copyright © 2004 by HARPER DESIGN and LOFT Publications

First published in 2004 by:
Harper Design,
An imprint of HarperCollinsPublishers
10 East 53rd Street
New York, NY 10022
Tel.: (212) 207-7000
Fax: (212) 207-7654
HarperDesign@harpercollins.com
www.harpercollins.com

Distributed throughout the world by:
HarperCollins International
10 East 53rd Street
New York, NY 10022
Fax: (212) 207-7654

HarperCollins books may be purchased for educational, business, or sales promotional
use. For information, please write: Special Markets Department HarperCollins
Publishers Inc. 10 East 53rd Street, New York, NY 10022

Editor
Nacho Asensio

Coordination and texts
Cristina del Valle

Translation
William Bain

Graphic design and layout
Núria Sordé

Editorial project:
Bookslab, S.L.
editorial@bookslab.net

Library of Congress Cataloging-in-Publication Data

Valle, Cristina del, 1979-
 New bars & restaurants / by Cristina del Valle.
 p. cm.
 ISBN 0-06-074795-1 (hardcover)
 1. Bars (Drinking establishments). 2. Restaurants. I. Title.
 TX950.7.V35 2004
 647.95—dc22

 2004016244

Printed by:
Indústrias Gráficas Mármol, Sant Andreu de la Barca, Spain

D.L: B-47.318-2004

First Printing, 2004

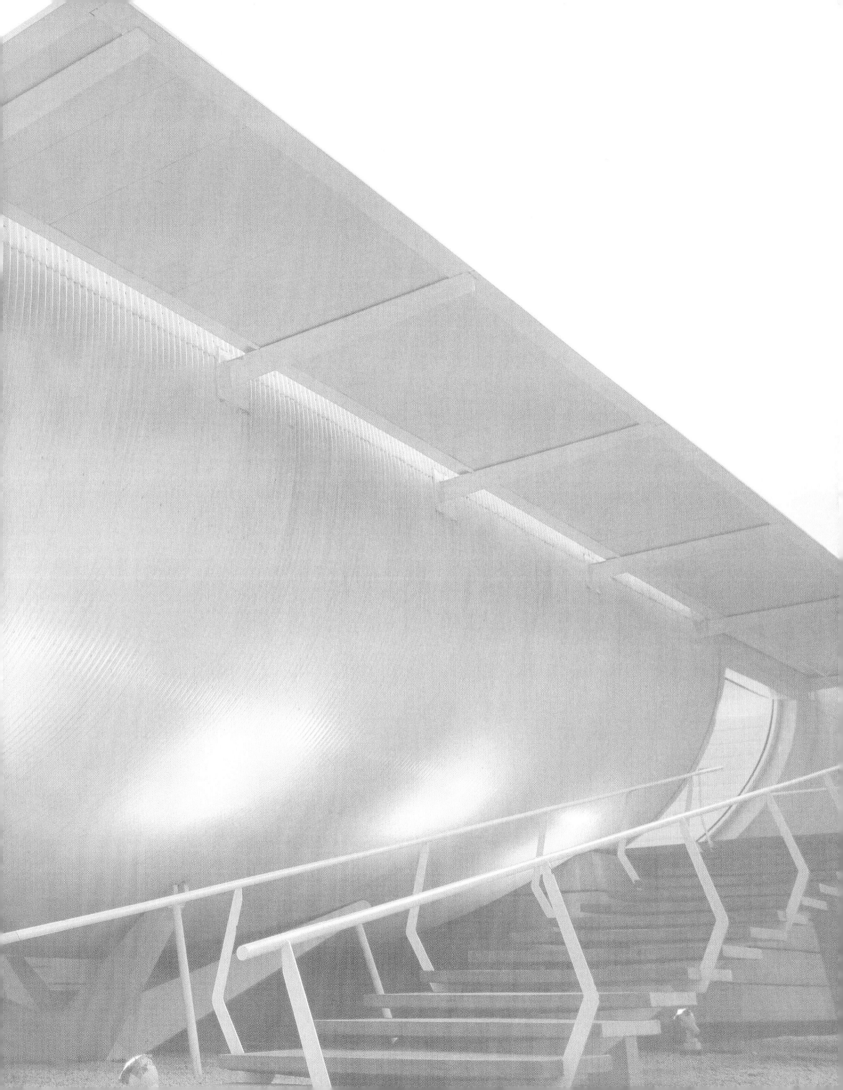

Contents

Introduction

The current workings of consumerism are generating a clear tendency to convert natural, daily activities into authentic rituals, a phenomenon echoed by the interior design of bars and restaurants. Using an imaginative lighting system as the central element and exploiting the symbolic use of color—intrinsically linked to the spectrum of the emotions—are some of the solutions that unfold veritable universes of fantasy in a spectacle where the main role is assigned to the kitchen. Formerly relegated to a merely functional position, today the kitchen's central, open arrangement and its treatment as an element of the interior design reflect a voracious desire for entertainment on the part of a public that has never before had such a great variety within its reach.

Classical or modern, plain or ornamental, vanguardist or traditional, the projects shown in these pages make up part of a selection that seeks to be global in scope and aspires to elucidate the path the interior design of bars and restaurants has taken in recent years. At the heart of a global culture that serves as an experimental laboratory for radically different identities and ways of life, interior design tends to opt for the eclectic. The concept of innovation is thus redefined as the sum of values, aesthetics, and opposed cultures in spaces that substitute disjunctions for conjunctions, in a fusion of styles that makes choosing a restaurant or a cocktail bar an enjoyable activity.

Sant Celoni Madrid Barcelona Oslo Helsinki Paris

Florence Rome Syracuse London Oslo Helsinki

Zürich Grund bei Gstaad Pamplona Seville London

Barcelona Oslo Helsinki Paris Nice Amsterdam

Sant Celoni Madrid Barcelona Oslo Helsinki Paris

Florence Rome Syracuse Nice Pamplona Seville London

Zürich Syracuse Nice Pamplona Seville London

Barcelona Oslo Helsinki Paris Nice Amsterdam

Sant Celoni Madrid Barcelona Oslo Helsinki Paris

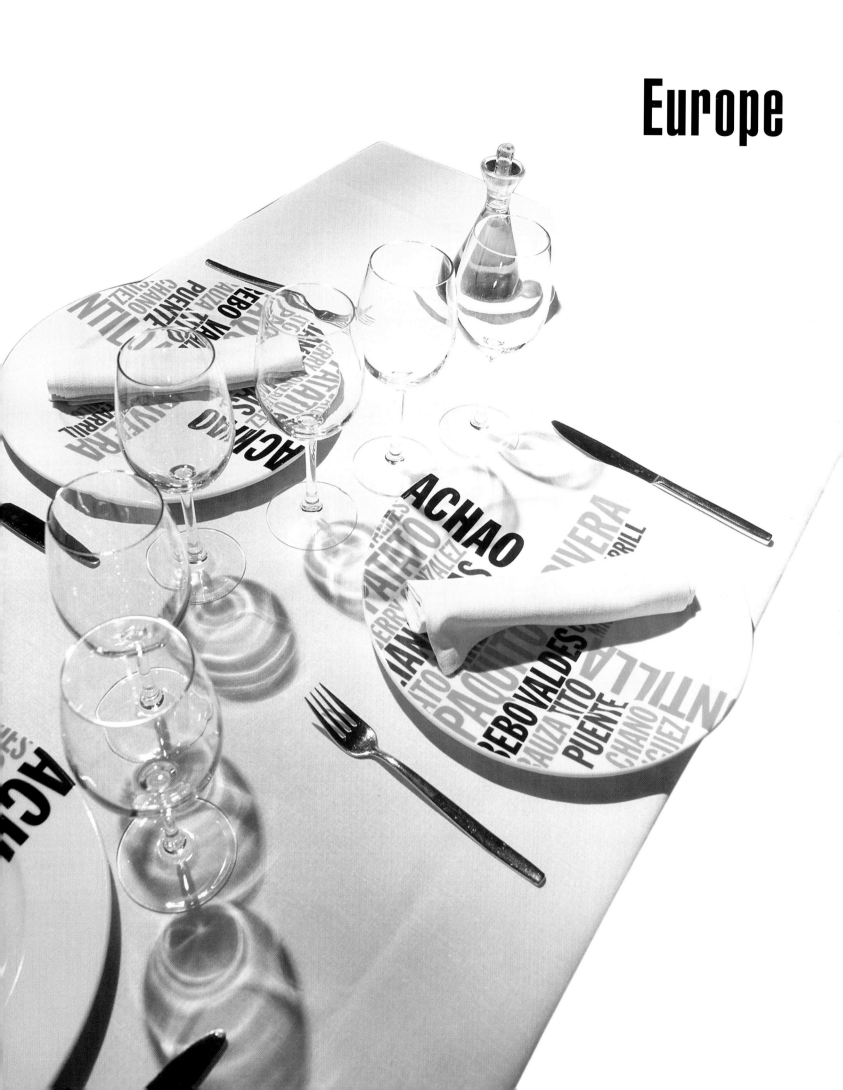

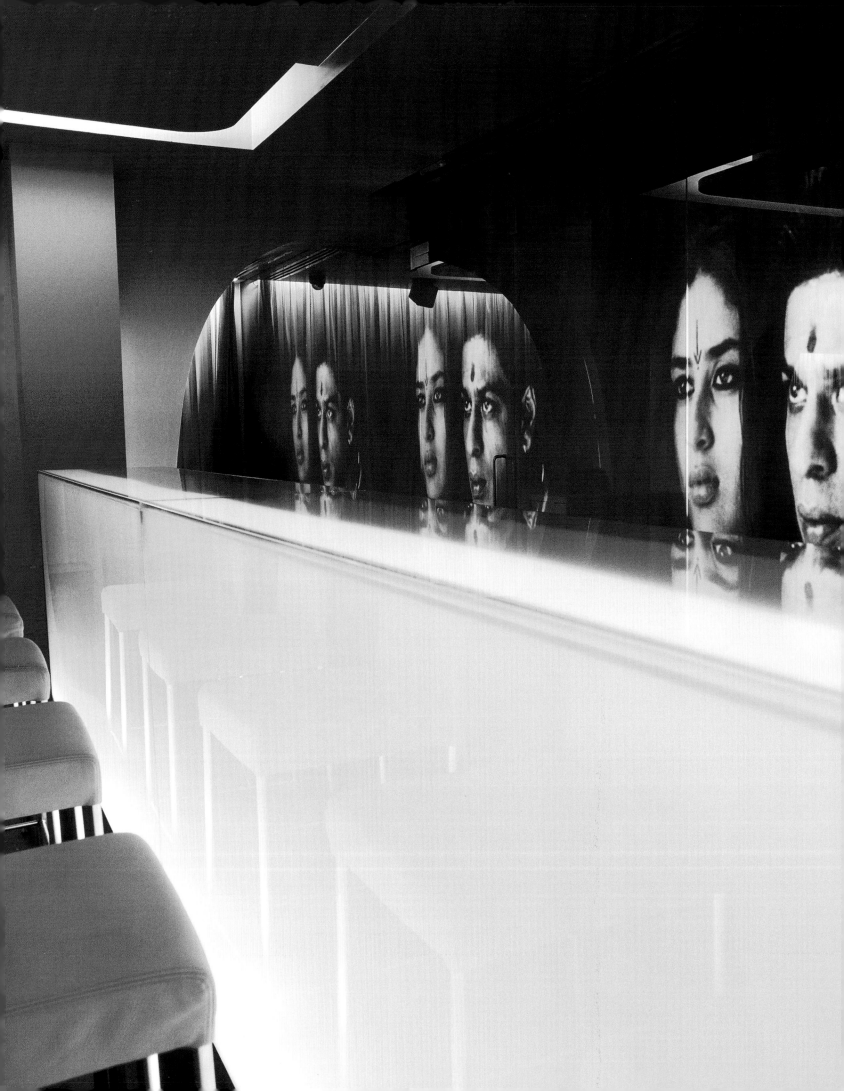

Cinnamon Club · London · United Kingdom

The former Westminster Library Building, near the abbey and the Houses of Parliament, is now the site of an exclusive dining experience—the Cinnamon Club. The trendy new bar is distributed over four main spaces: the bar, the restaurant (with a capacity for 200 guests), an art gallery, and a private zone. The décor has been conceived as deluxe and opulent, with a leitmotif that incorporates contemporary aesthetic trends such as Art Nouveau and attention to the traditions of India.

The choice of materials centers on a gentle illumination effect: dark shiny leather contrasts with bright white walls and curtains. The softness and elegance permeating the whole place is achieved largely due to the inclusion of arches. The curtains configure a swank gauzy perimeter and—with the assistance of direct overhead lighting—extend into a soft embrace. The bar resembles a large block of illuminated ice, in contrast to the large dark glass screen behind the bar that successively shows different portraits of Indian personages, not altogether unlike the animated curtain in a theater, thus producing a focal point at which all gazes meet.

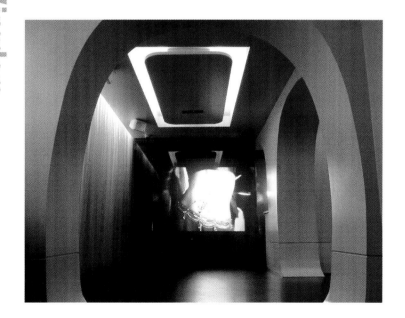

Designer **MUELLER KNEER ASSOCIATES**
Photographer **ROLANT DAFIS**
Location **LONDON. UNITED KINGDOM**
Opening date **MAY 2002**

The indirect lighting enhances the brilliance of the materials and the white of the curtains. It also creates an effect of plasticity in the walls. The absence of elaborate decoration thus achieves its end: the creation of an exclusive space that plays with the sensation of being inside a living cell.

Imported from Rajasthan, the tables were made with seesham, a variety of wood that is not often used and that changes color at different times of the year.

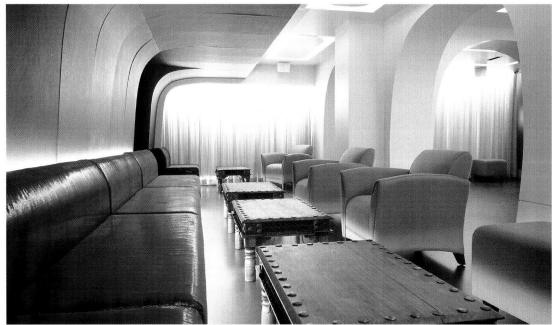

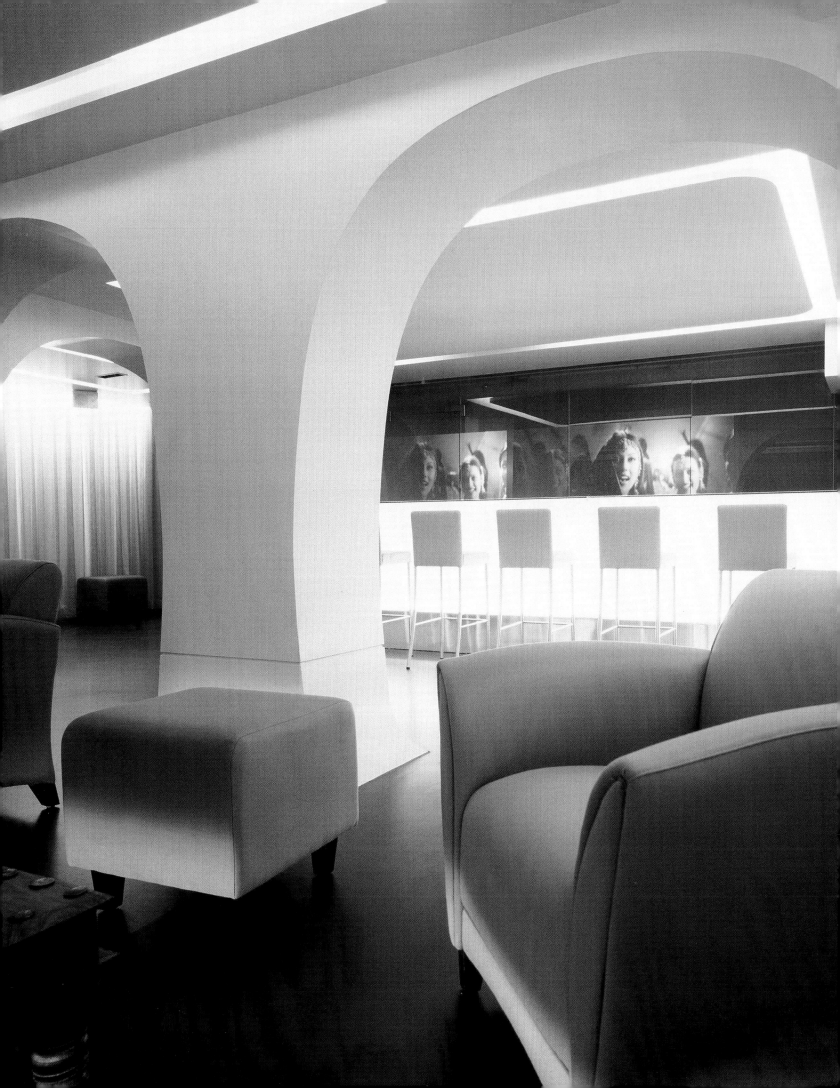

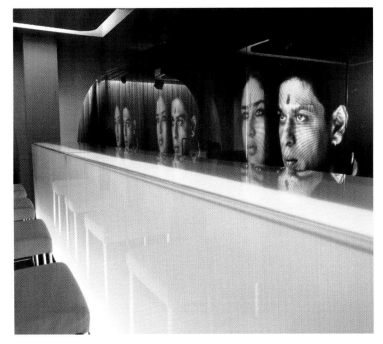

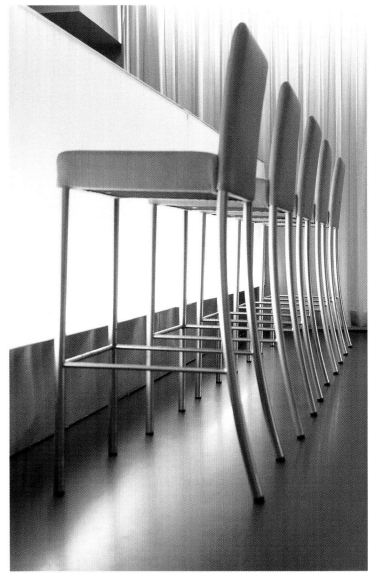

Phosphorescent lighting at the bar counter creates a hypnotic effect that attracts the gaze as soon as one enters the space.

Ground-floor plan

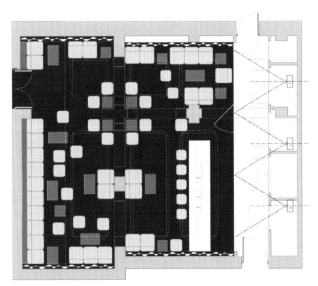

Entirely finished in white, the bar plays intelligently with different tones of this shade and its symbolic connotations of purity, mysticism, and elegance.

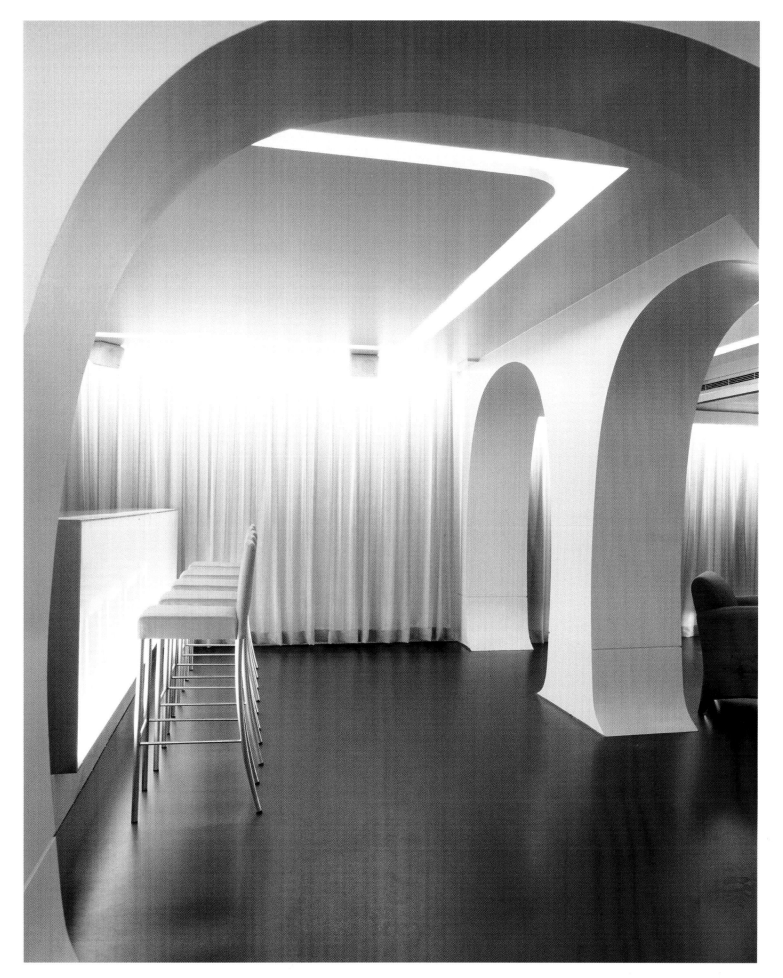

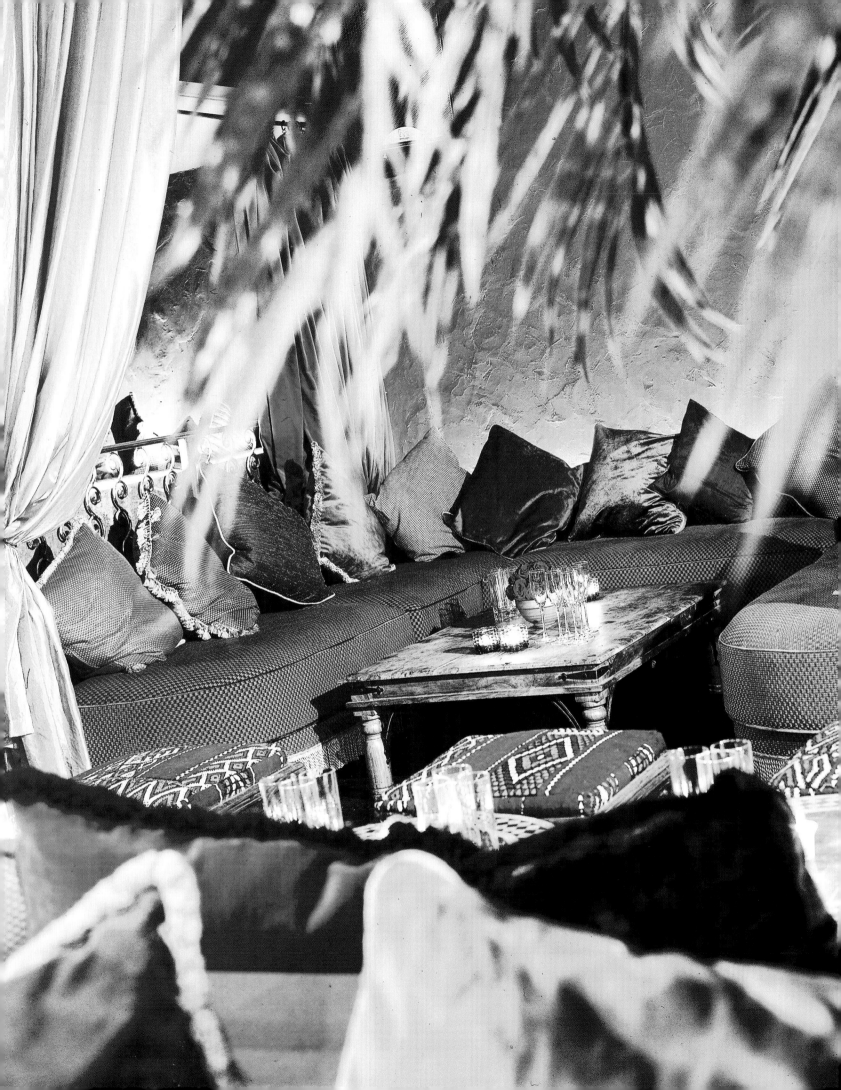

Elysium · London · United Kingdom

In a place previously occupied by a Masonic temple, Elysium occupies an immense space that includes a lounge, a restaurant, a bar, and a discothèque. The four zones are laid out according to the same aesthetic, after the fashion of a temple, and the sumptuousness and the somewhat kitsch luxury of the zones contribute to the visitor's visual enjoyment. The dominant note is set by the use of long silk curtains, the agglomeration of cushions scattered on the sofas, the preference for red and ocher, and an extraordinary penchant for decorative detail. The combination of candles and candelabra in very different forms and colors, mixed with a mosaic tile floor and murals with hand-drawn floral motifs, creates a wild eclectic style whose entry point is Eastern sensuality.

The first image one gets of Elysium is the Amber Bar—with its impressive candelabrum and the figure of a lion's head coming out of the wall—which serves as the restaurant's anteroom, separated by curtains. From that point, the swankiness grows as you proceed from room to room. The room that flanks the restaurant is the VIP Room, done in even greater style. The high point of this room is a hand-carved double door that leads to the main club area where, on both sides of the floor, there are VIP areas featuring cushioned sofas, Indonesian tables (also hand-carved), and a small room just below the DJ hut.

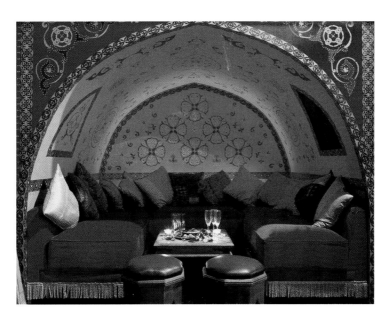

Designer **TIBBATS DESIGN**
Photographer **JAMES BALSTON/ARCBLUE.COM**
Location **LONDON. UNITED KINGDOM**
Opening date **APRIL 2002**

The luxury of detail is the mayor asset of this project. The gaze of the curious visitor takes in the space and is constantly attracted by a newly perceived detail in a seemingly endless set.

The VIP room flanks the restaurant. The sofas covered with cushions, the low tables, and the carefully crafted artisan objects create a relaxed ambience.

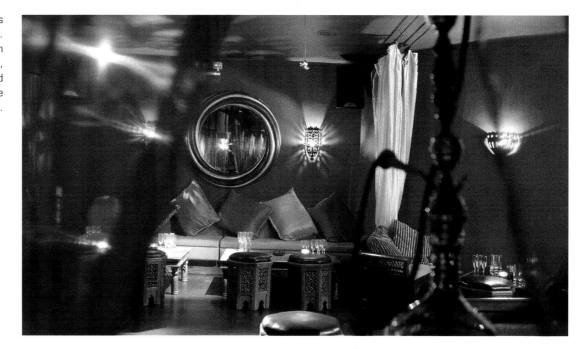

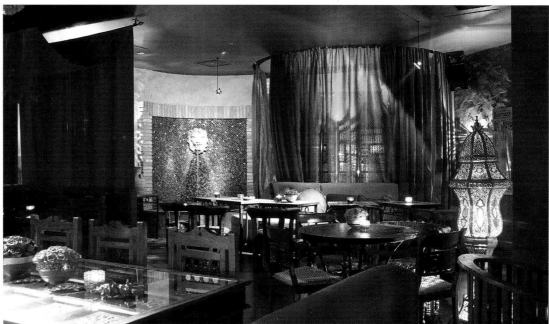

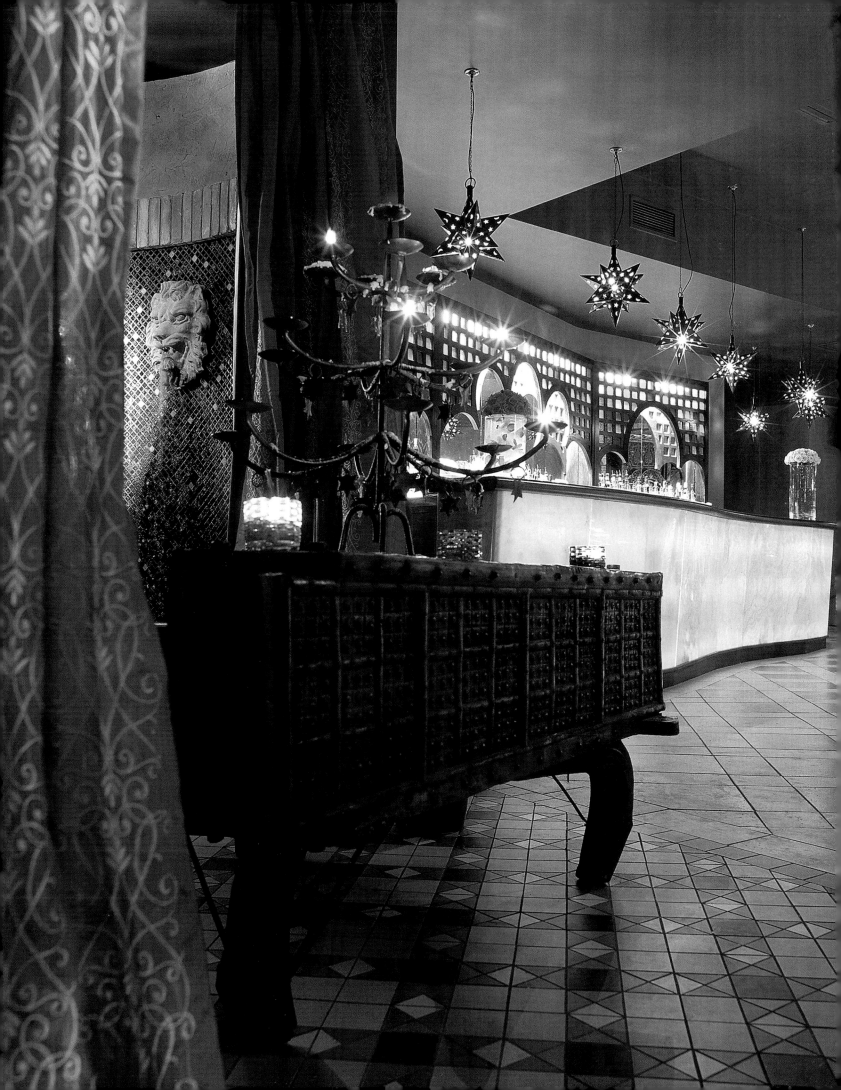

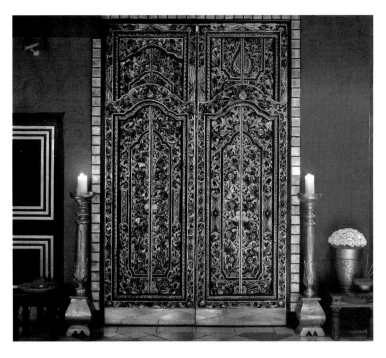

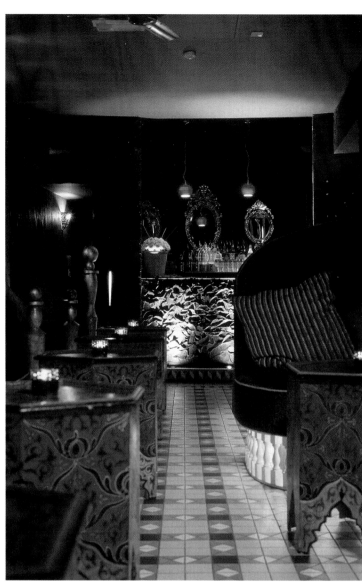

The large, hand-carved, gilt door is the stylistic high point of the locale. It is flanked by two candelabra like proud guards protecting the treasures enclosed behind the door.

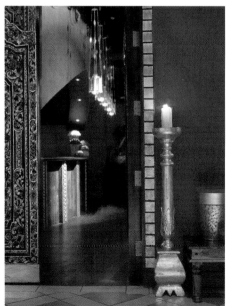

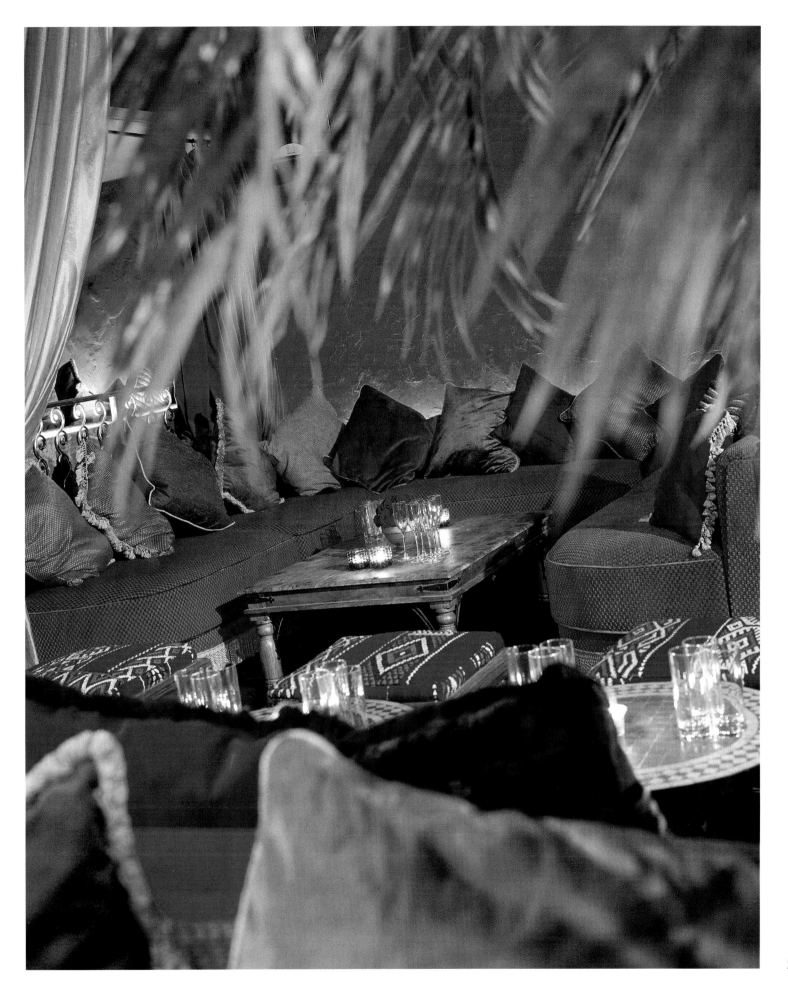

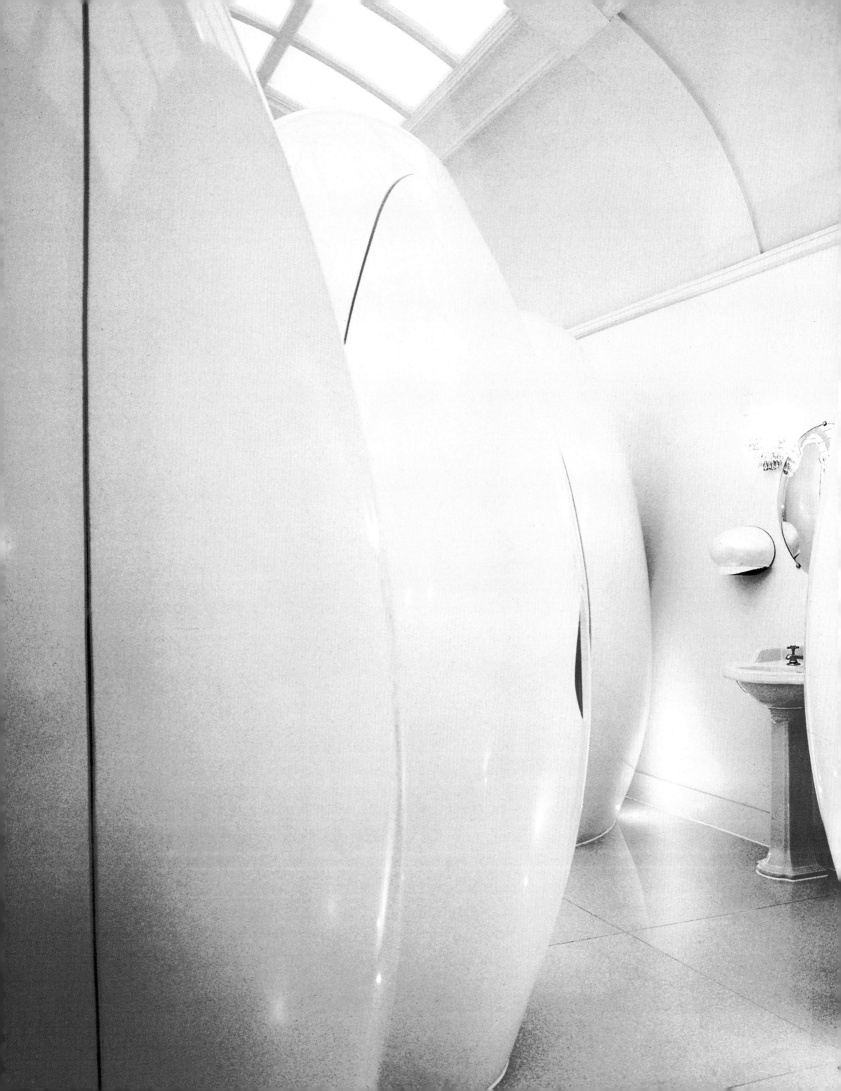

Sketch · London · United Kingdom

The latest jewel in the British crown is the eclectic Sketch, the new business venture of the multitalented Mourad Mazouz. Conceived by a group of design geniuses, Sketch shows the will to get away from the crowd, and the singularity and individuality that have gone into the making of a radically different design proposal. Admirably refurbished, with original wood floors and plasterwork, Sketch boasts a large space where designer Jurgen Bey has put his usual magic to work to impress new meaning on once familiar objects through the use of unexpected materials in the finishes. In the front, a large counter displays pastries that are more like priceless jewelry pieces. In the foyer, kinetic sculptures in niches preside over the sculptural steel counter and a spectacular chair. From the foyer, a white staircase leads to different spaces. Upstairs, the Lecture Room is the last word in elegance and excellence. In the adjacent bookshop, wholly finished in white leather with a scattering of convex mirrors that multiply reflections, Gabhan O'Keeffe proposes a personal interpretation of luxury and an interesting mix of historic styles whose result is, in and of itself, a new style. The downstairs floor contains the West Bar, the Gallery, and the East Bar. By day an exhibition and video projection space, by night the Gallery becomes a brasserie with an exquisite mix of the London elite. Sketch is a tripartite dream: a mecca for food lovers, art lovers, and music lovers.

Designer MOURAD MAZOUZ
Photographer JAMES BALSTON/ARCBLUE.COM
Location LONDON. UNITED KINGDOM
Opening date DECEMBER 2002

Each room bears the stamp of the designer who created it. Marc Newson, Rod Arad, and Jurgen Bey head the list of designer celebrities who have given free rein to their imagination in the different Sketch spaces.

The hand of Gabhan O'Keeffe was present in the creation of a comfortable, creative, luxurious space—one that sates desires for opulence with more than a pinch of intimacy.

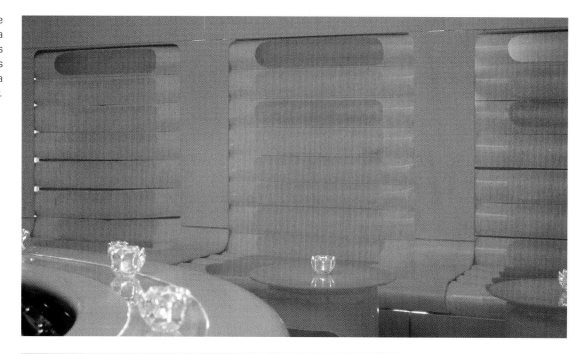

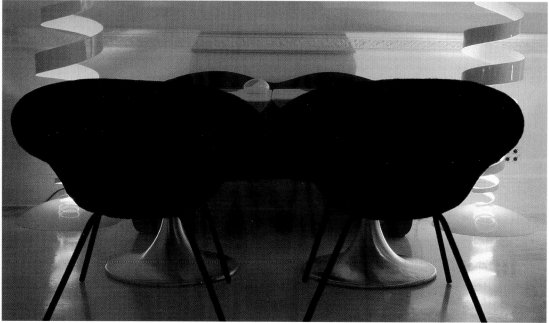

Doubtless one of the most surprising elements in Sketch is the originality of its bathrooms—12 suggestive, sculptural cubicles based on the design of jewelry boxes.

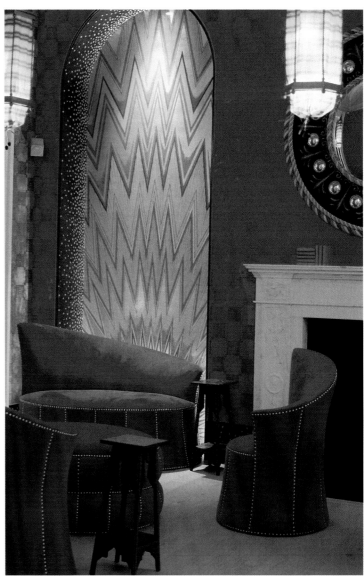

Floor plan

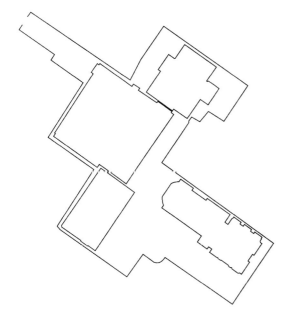

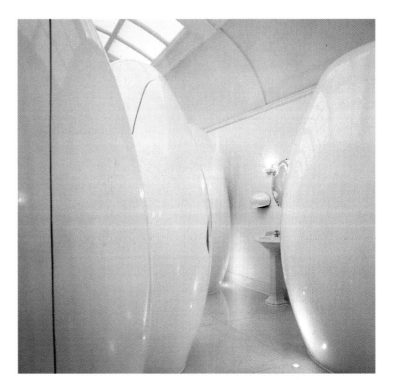

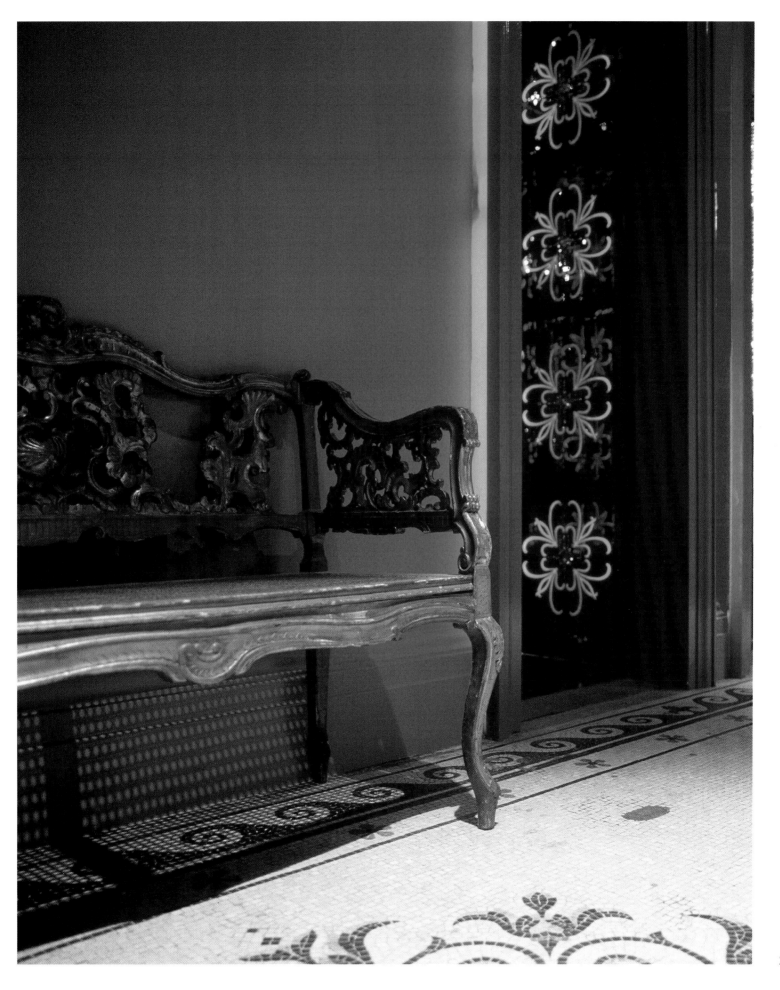

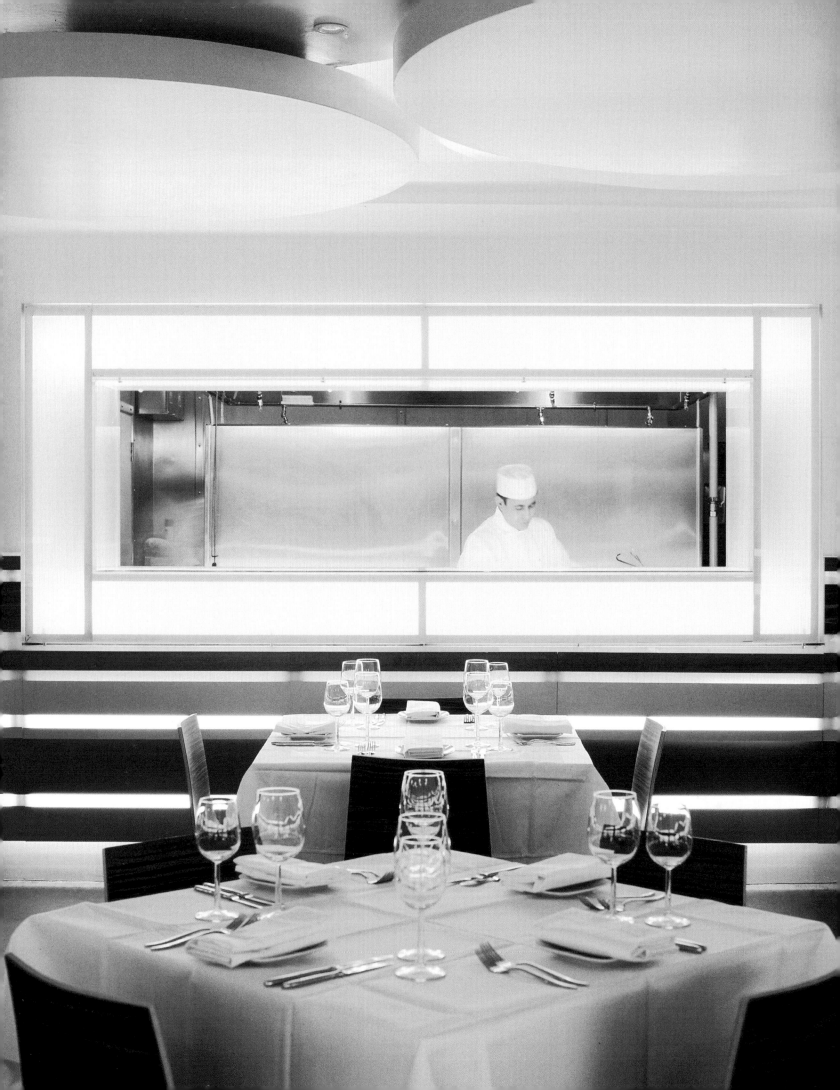

Silka · London · United Kingdom

Silka is located next to the front entrance of London's Borough Market (between London Bridge and Tate Modern). The restaurant's interior design reflects a new concept in Indian restaurants that avoids the clichés of traditional Oriental style. Silka offers an authentic, "energetic" cuisine traditional with older generations, a concept integrating the health (both mental and physical, and comprising fields like yoga and breathing techniques) and the culinary aspect. The interior design of the restaurant echoes this philosophy (our old friend "*mens sana in corpore sano*") to evoke a landscape of horizontal sections, culminating in cloudy metaphors that hover over the landscape of the main room. The effect seems to owe something to the large spherical volumes suspended from the ceiling.

Silka's lighting takes on special importance in a space created to serve its guests' mental welfare. Thanks to a balanced combination of cream and chestnut tones, the natural effect achieved generates a restful ambience backed up by the lighting, which is generally indirect and soft. The light filters in from behind the ornamentation of the walls, the ceiling of clouds, and the two windows that frame the bar and the restaurant. The classic style of the tables and the cutlery is set off by this original lighting system, which generates a contemporary and elegant aesthetic. The project transmits an immediate sensation of balance that bathes diners in a serene setting.

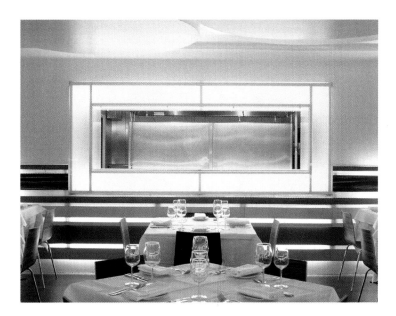

Designer **MUELLER KNEER ASSOCIATES**
Photographer **ROLANT DAFIS**
Location **LONDON. UNITED KINGDOM**
Opening date **SEPTEMBER 2002**

In Silka, modernity and classicism find a fragile balance. The correspondence between the two endows the interior with a welcome balm that contrasts with the commotion of the big city scene outside.

The walls are decorated by a series of horizontal wooden strips in alternating green, chestnut, and white tones. Backlighting takes advantage of this resource to create the illusion of three dimensions.

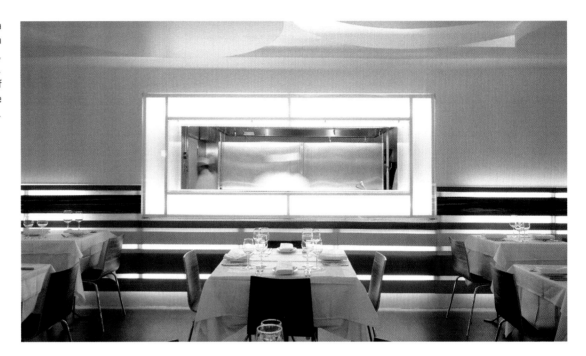

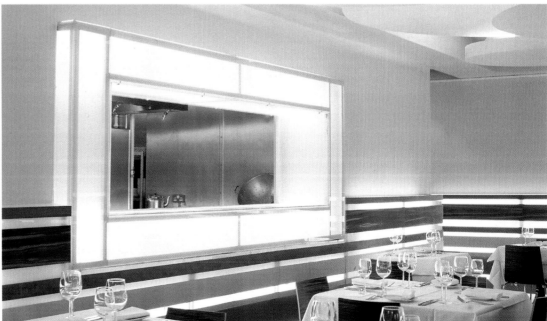

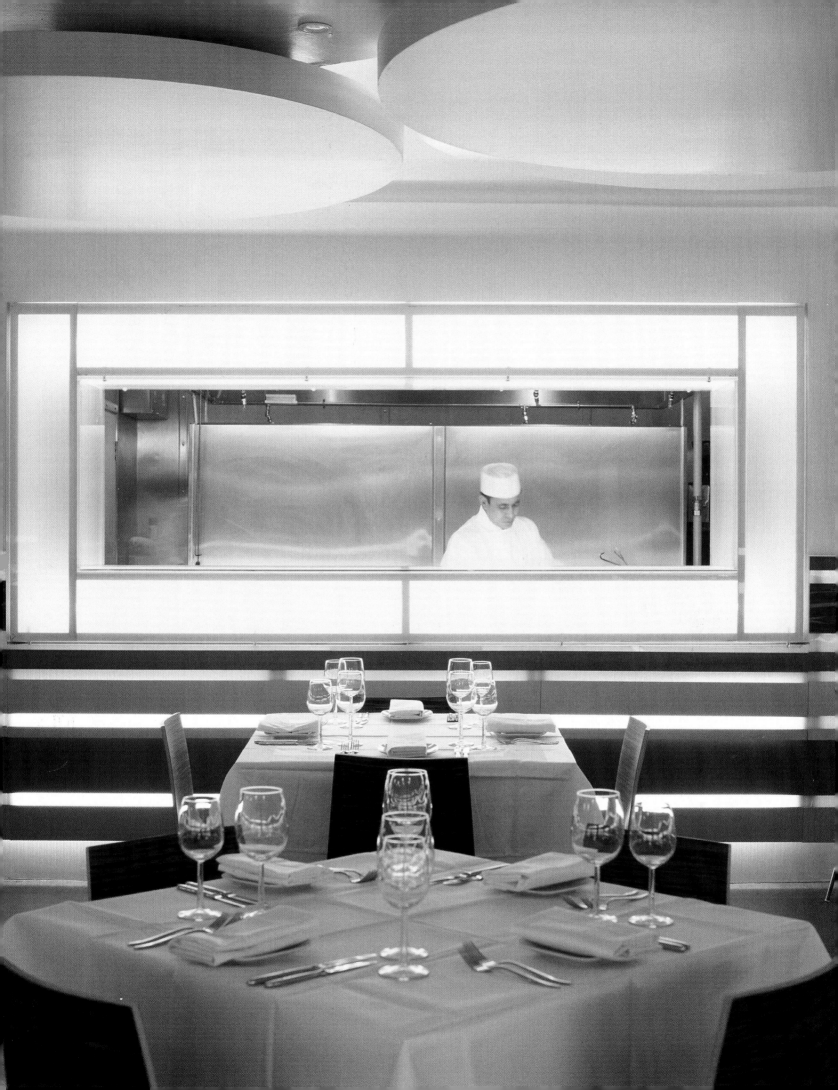

The visual attraction of the two luminous, oversize windows contrasts with the plain treatment and the elegance of the horizontal strips used on the walls. The exotic woods used in the strips include ebony, makore, and rosewood.

Floor plan

Elevation

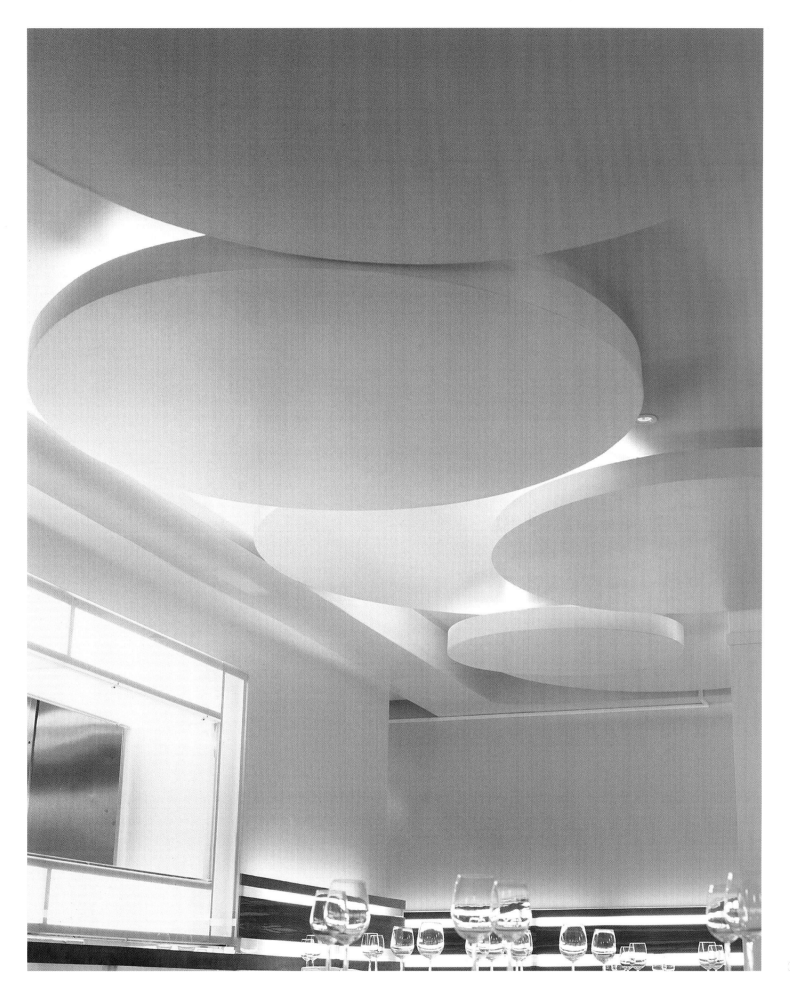

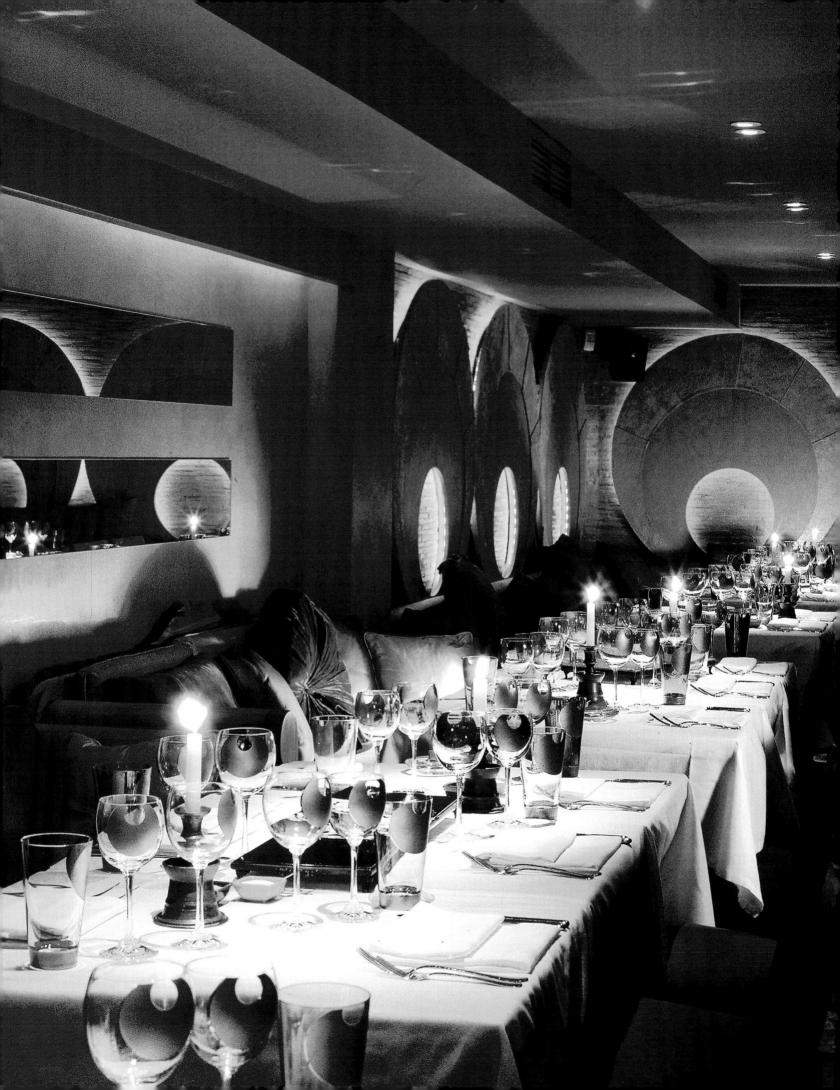

Chintamani · London · United Kingdom

Chintamani is establishing itself as one of the most original eateries in London's West End, thanks to a timeless proposal that blends the 1,000-year-old Ottoman tradition with modern work by contemporary Turkish artists. Owned by Turkish restaurateur Metin Fadillioglu, and entirely designed by his wife, Zeynep, Chintamani is a hybrid between a Bedouin tent and a deluxe Western restaurant. Silky fabrics cover the ceiling and are complemented by the thick cushions of the comfortable sofas that invite guests to repose after a copious dinner. From the extensive filigree work on the windows (making for an intimate space half hidden from the outside), and passing through the wall tapestries and the stained-glass tumblers, everything in the restaurant echoes the Ottoman days. The soft, seductive lighting of candelabra and indirect spotlights sets the stage for a warm, welcoming space with the brightness of the fabrics thrown into low relief. The prevailing red and warm brown tones work in subtle counterpoint against the white tablecloths to create a delicate chromatic balance that submerges the visitor in a state of true relaxation. Chintamani's cuisine embraces a highly varied list of recipes ranging from Western European to the far shores of the Bosporus in a clear attempt to follow the lead of Istanbul in this mélange of East and West.

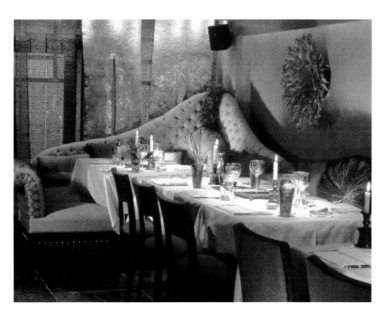

Designer ZF DESIGN
Photographer FRITZ VAN DER SCHULENBURG
Location LONDON. UNITED KINGDOM
Opening date OCTOBER 2002

The predominance of warm tones more than matches the intimate lighting scheme that brings out the texture of the tapestries. The décor shows a clear preference for earthen colors—browns and ocher—with occasional dashes of red to spice up the exuberant play of light and shadow.

The work of contemporary Turkish artists impresses a particular vision on the ornamentation of the lamps and walls.

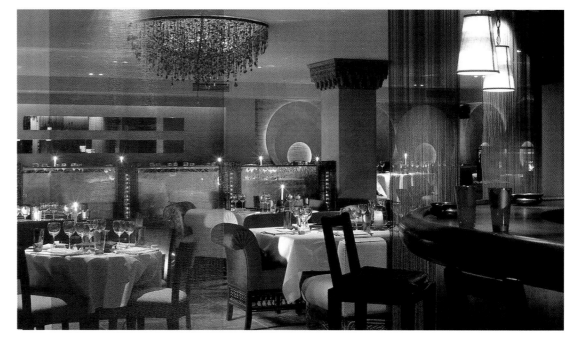

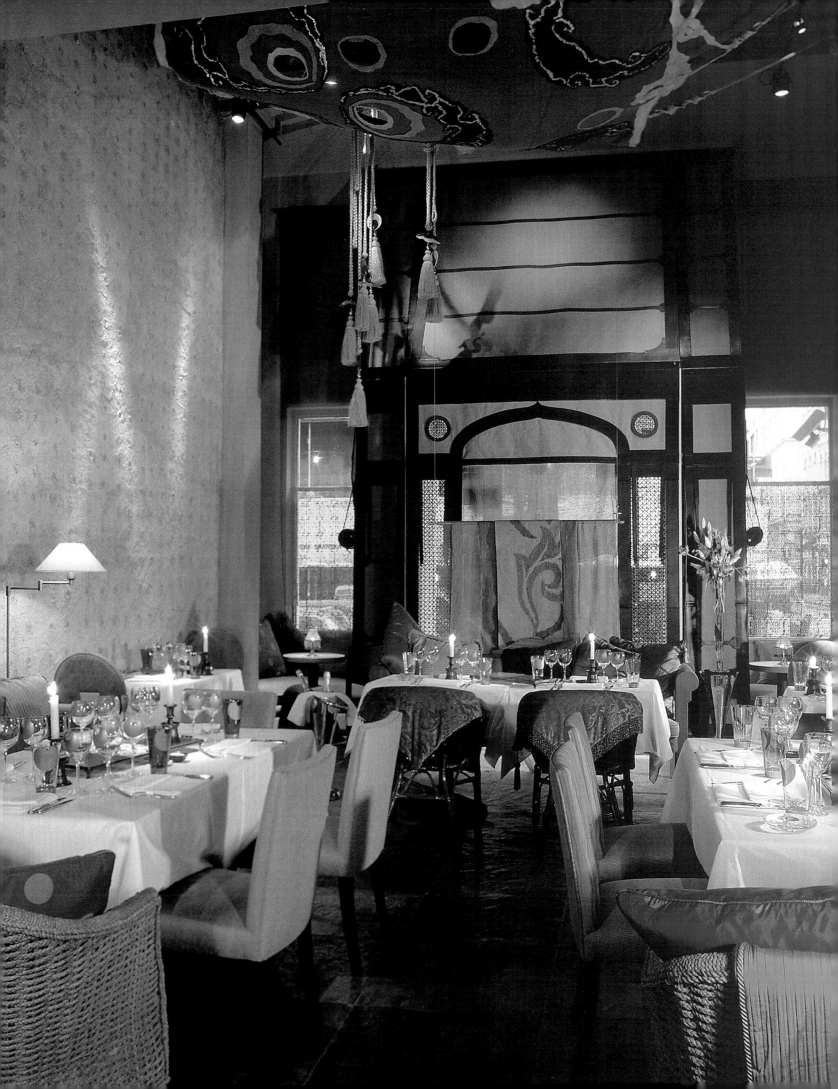

Chintamani's aesthetic blends
the contemporary with the
purest Ottoman tradition.

Floor plan

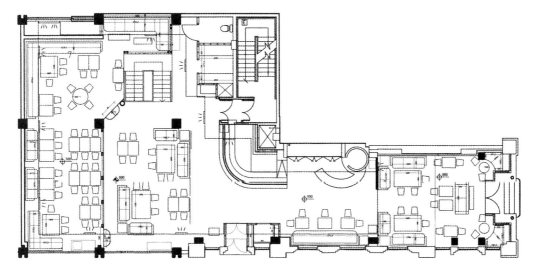

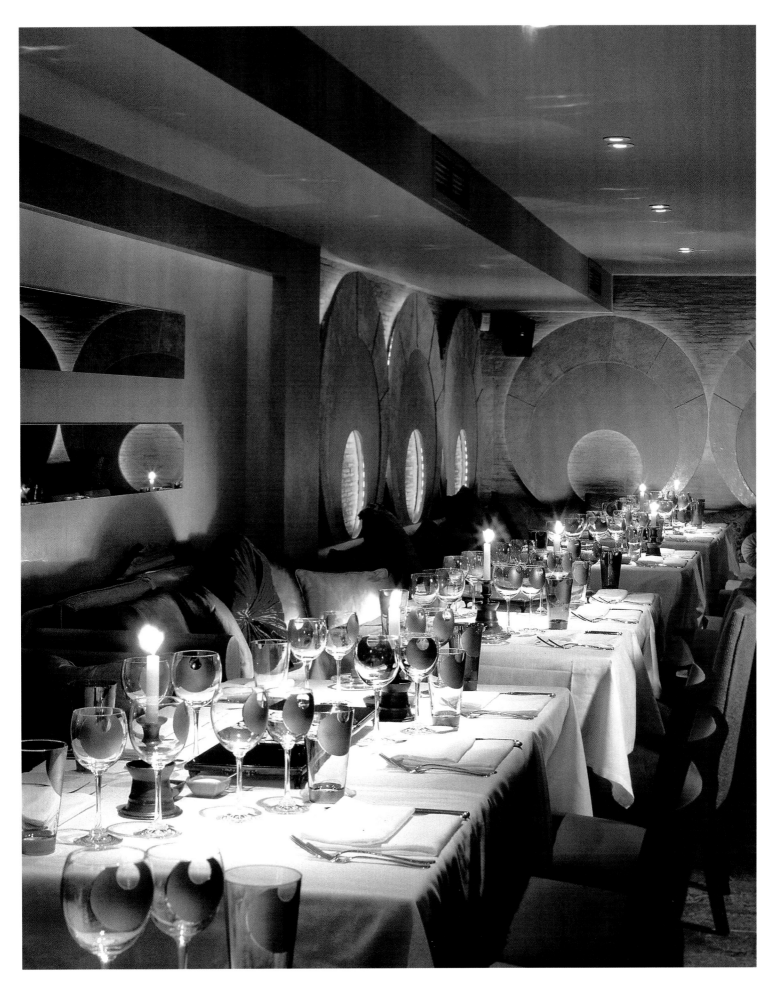

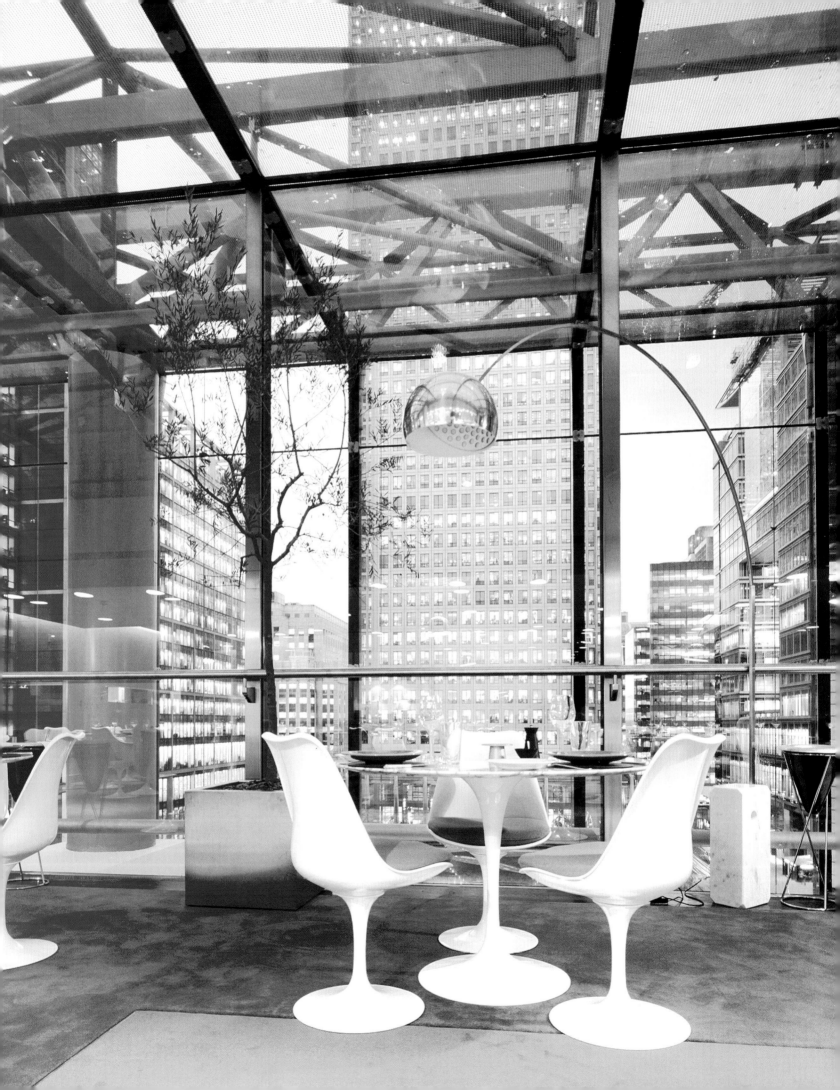

Plateau · London · United Kingdom

The success of Plateau, designed by Conran and Partners and located on Floor 4 of the Canada Place building opposite the tower in London's Canary Wharf, is due in part to the excellent views diners may enjoy from the restaurant's privileged position. Seated at one of its round tables, designed by Eero Saarinen, diners get the agreeable but somewhat dizzy feeling of floating above the frenetic urban landscape of the city as it carries on many, many feet below. The space—the very feeling of space—created by the oversized windows surrounding the diners integrates them after a fashion and makes for better communication with the concrete horizon of the Wharf. The interior design is diaphanous and marked by small round tables with actual breathing space between them. The union between restaurant interior and skyline exterior is also motivated by a subtle color scheme based on different tones of green, gray, chestnut, and light bluish shadows, reflecting a contemporary aesthetic in the key of modern metropolitan. The contrast of straight and curved lines, creating a counterpoint between the rectangular architectural structure, the rounded design of the tables, and the feet of the chairs, breaks the monotony and generates a pleasant, dynamic, and fresh space. Plateau is a calm oasis amid the frenetic sprawl of Canary Wharf.

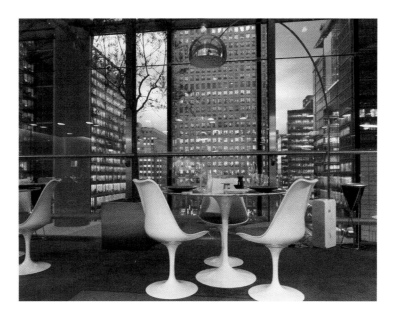

Designer **CONRAN & PARTNERS**
Photographer **JONATHAN PILE**
Location **LONDON. UNITED KINGDOM**
Opening date **OCTOBER 2003**

The modernity of the external structure acts as a counterpoint against the classic designs of the tulip chairs, the Italian marble of the tables, and the colorful upholstery. The furnishings take on something of the glamour of 1950s Manhattan and filter it into this wonderful London scene.

Plateau is divided by a central kitchen into two differentiated spaces: a bar-grill and the main restaurant, each with its own exterior terrace and olive tree border.

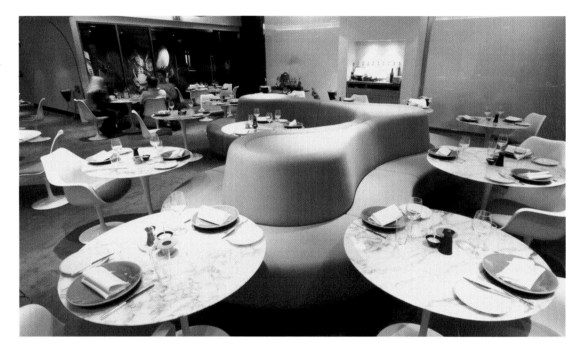

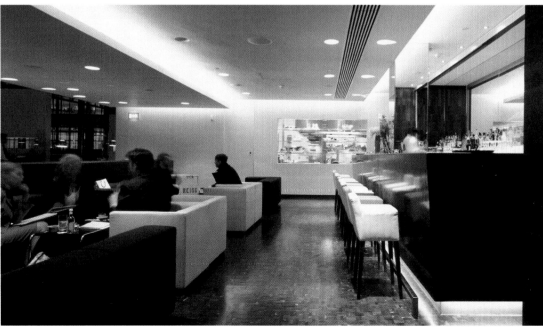

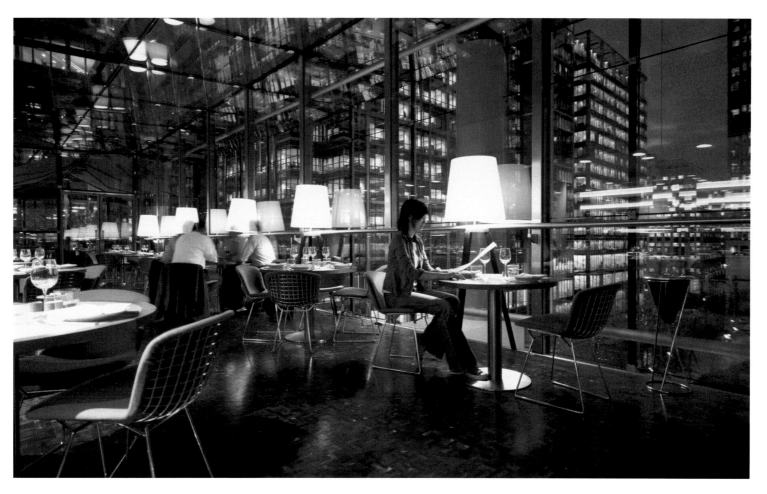

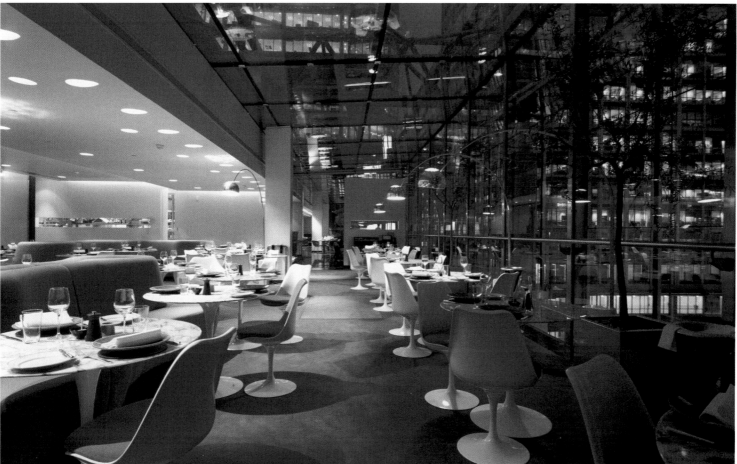

New Café in the National Gallery · Oslo · Norway

Closed to the public and transformed into administrative offices in 1960, the French room of the National Gallery of Oslo, considered one of the most impressive in the museum, now houses a café. The stucco work in the walls—a mixture of marble and plaster that was a gift from France dating from the 1920s—was preserved to provide a sumptuous setting for this café, which, done entirely in glass, is the very paradigm of modernity.

The project is comprised of a square cabin in the center of the room. The multiple plies of glass in the shelving include a refrigeration and lighting system programmed for different color variations. Configuration around such a small module and the location of the kitchen in an adjacent room make it possible to free space for the tables. Extending the length of the room, which has the capacity for 60 people, these relatively plain seats were designed to go almost unnoticed in the midst of the luxury that surrounds them.

With this project, Kristin Jarmund proposes an elegant and minimalist solution that scarcely interferes with the space of a rigid framing that admits no changes. At the same time, what is being proposed is an original creation not only because of the structure of the central module, but also due to the extreme contrast this module creates with the environment. The cabin's luminosity exercises a hypnotizing effect that invariably draws the visitor's gaze and holds it, as if spoiling for a fight in this highly sumptuous décor.

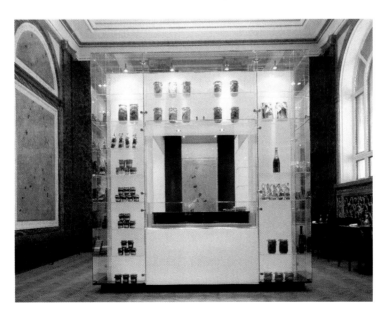

Designer **KRISTIN JARMUND ARKITEKTER AS**
Photographer **JIRI HAVRAN**
Location **OSLO. NORWAY**
Opening date **OCTOBER 2002**

Never have classicism and modernity been more at odds . . . and never have they gotten on so well together. Marble and glass, mattes and fluorescents, extension and concentration—each and all of these are maintained in their place without getting in the way of the other.

Pascal Dupuy's products decorate shelves that seem like the show window of an elegant jewelry shop whose finery is only for viewing.

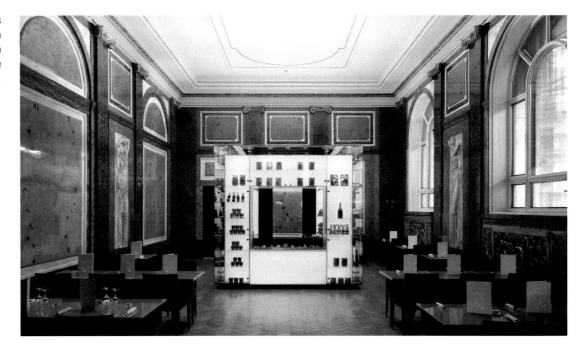

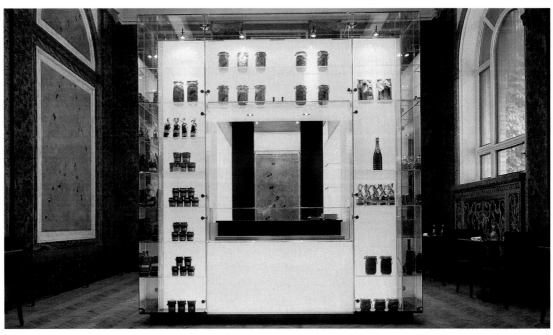

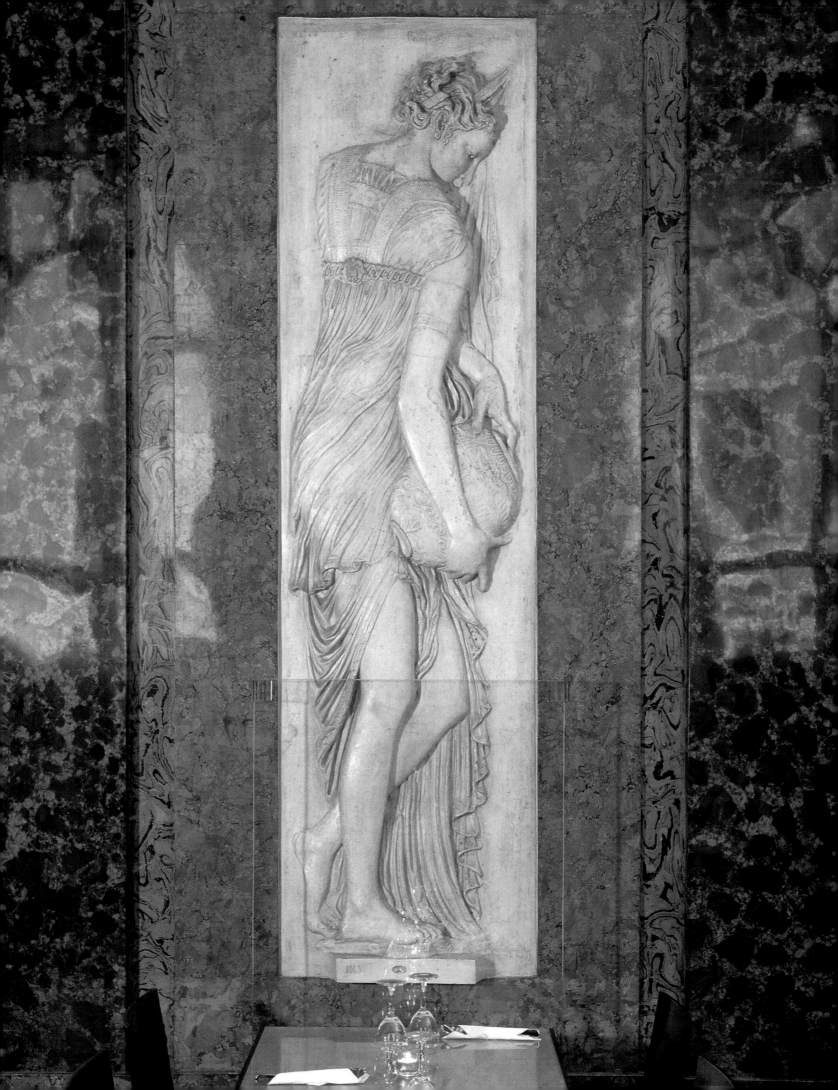

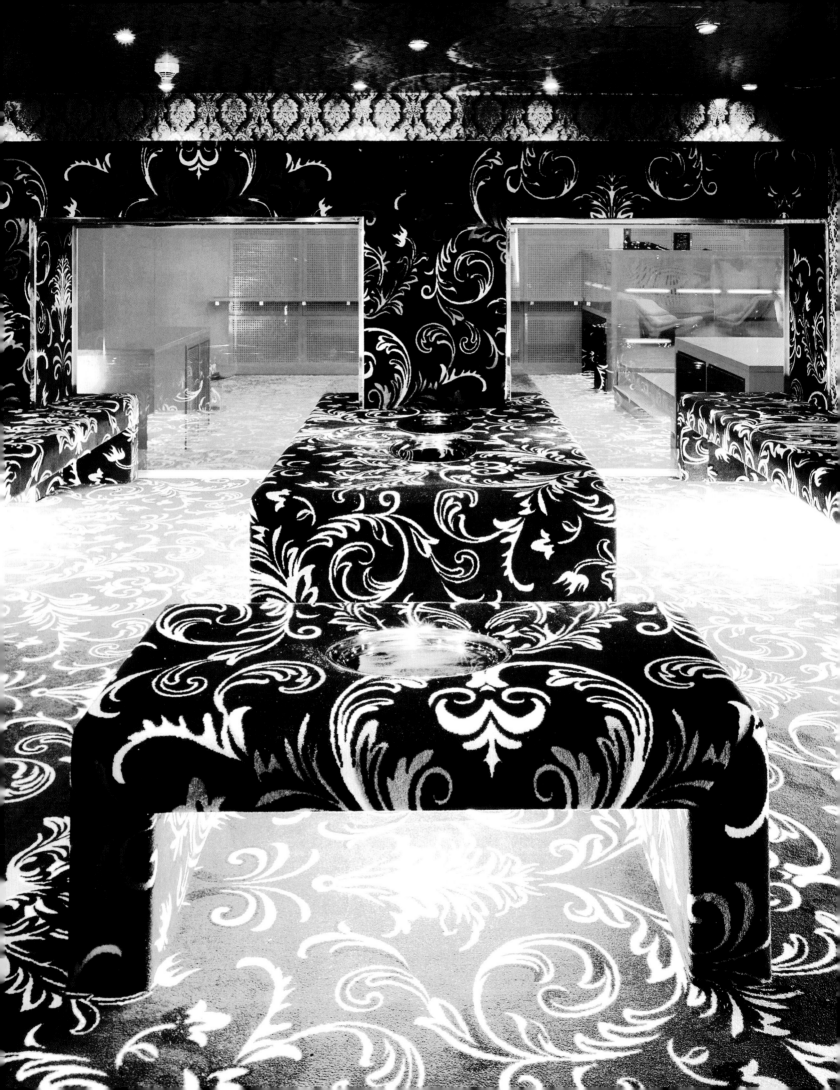

Helsinki Club · Helsinki · Finland

When the M41LH2 group received the brief to redecorate the Helsinki Club, a night-club and casino in the Finnish capital, the quartet of designers rejected the idea of a single dominant style in favor of a collective approach. Other designers were then called in, with the idea of having each room or space the object of a different design.

The challenge of the project lay in the putting together of a locale whose multivalency in terms of function would lend itself whenever necessary to an innovative and unconventional design, while at the same time satisfying the requisites of elegance and harmony appropriate to the Helsinki Club's antiquity and reputation.

The collective aesthetic thus takes visitors past the entrance foyer and submerges them into a sea of blue shining under a luminous dome. From there, the central atrium is reached, a piece of baroque extravagance where absolutely everything, from the floor to the furniture to the vertical planes, is covered in a carpet of gold designs on a black background. This is the representation of a golden opulence from which we devise, at the back, two openings—the very image of two immense red panels in contest with the central dance floor. This is the pulsing artery of the club, entirely decorated in glossy red, which sporadically incorporates white and orange accents. A white bar counter at the back contrasts vividly with a nearby red staircase that extends to a chill-out zone and the VIP room.

Designer M41LH2
Photographer MATTI PYYKKÖ
Location HELSINKI. FINLAND
Opening date MARCH 2003

The Helsinki Club is a conglomerate of different materials, forms, and colors that stamp their own character onto each zone and act as dividers among the different spaces.

Each zone has its own personality and plays a different role. In a room adjacent to the dance floor, a completely distinct layout evokes what could be the landscape of an enchanted forest.

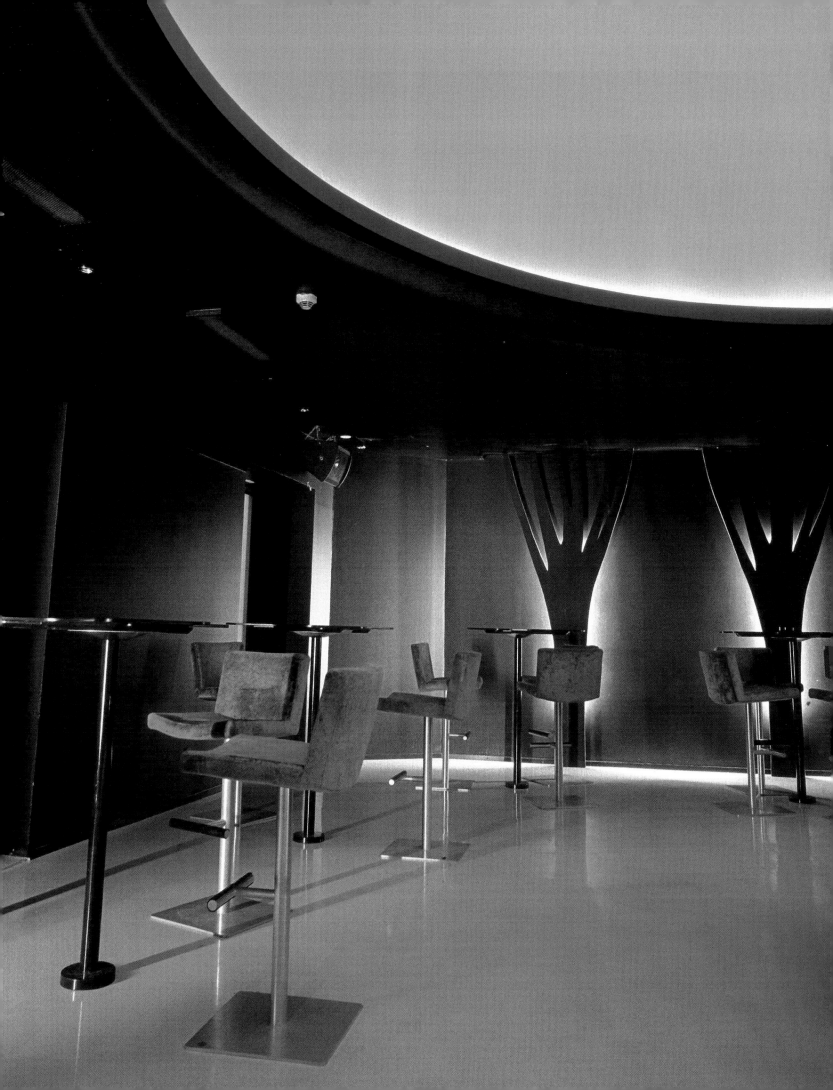

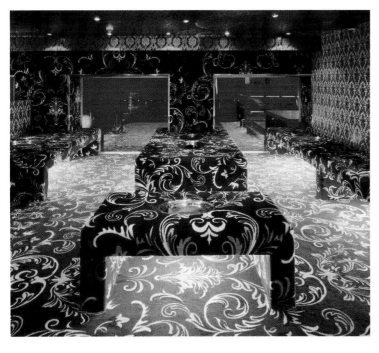

Red is one of the main
protagonists of this project,
due both to its inclusion in the
lighting and to its presence in
the furniture.

First-floor plan

Section

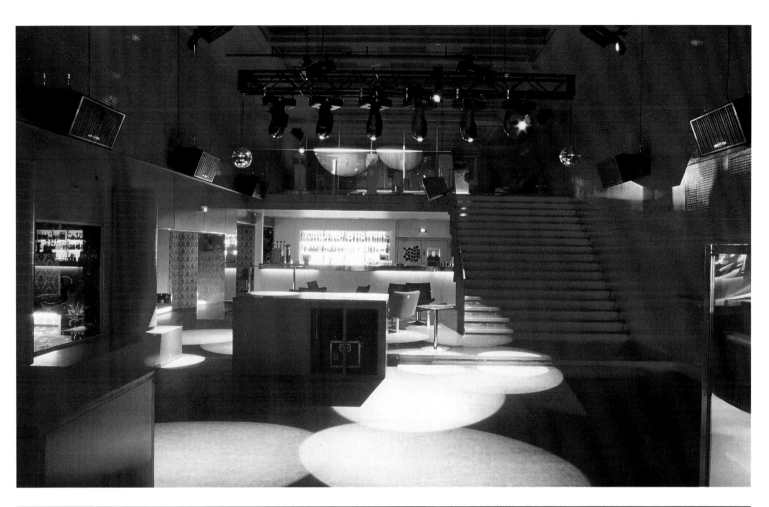

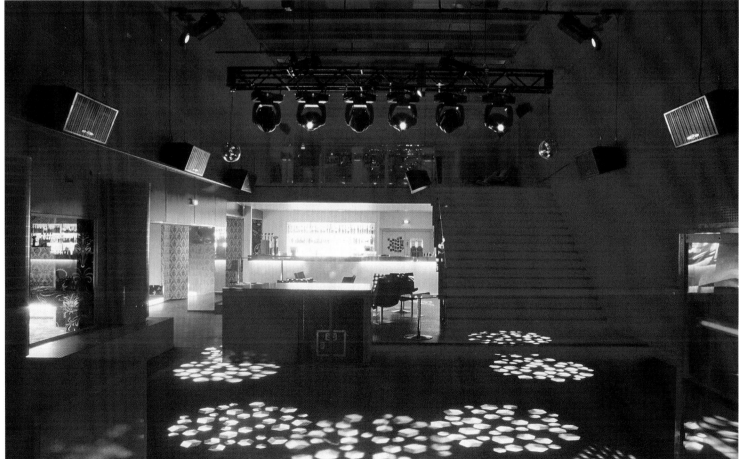

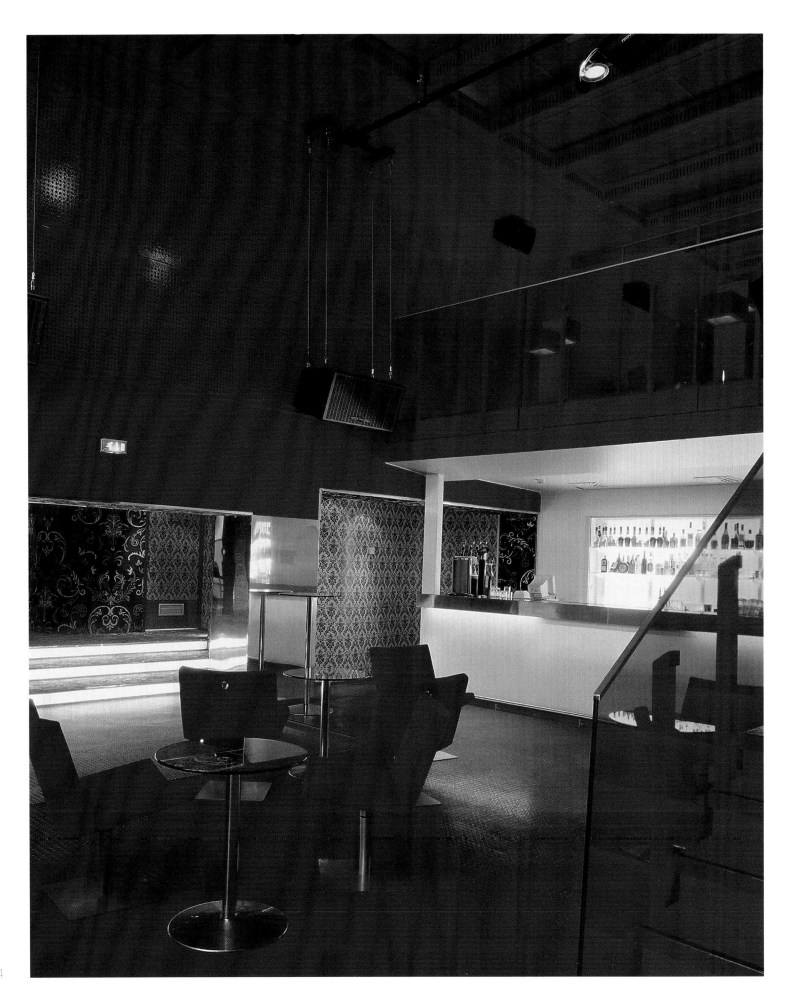

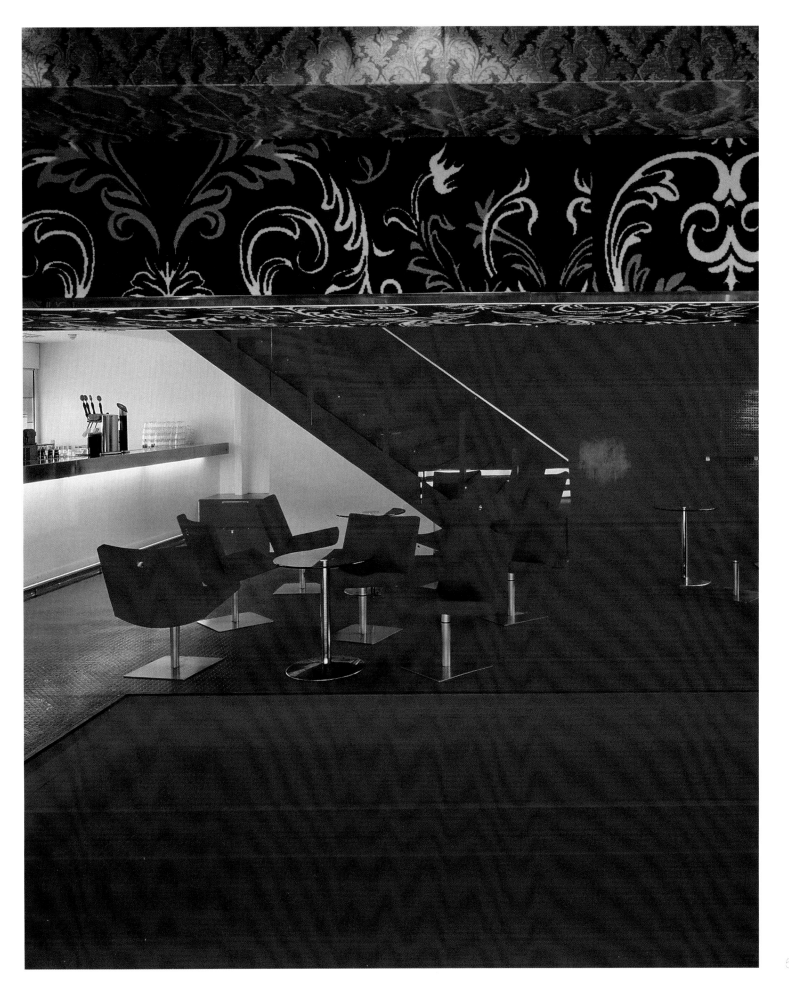

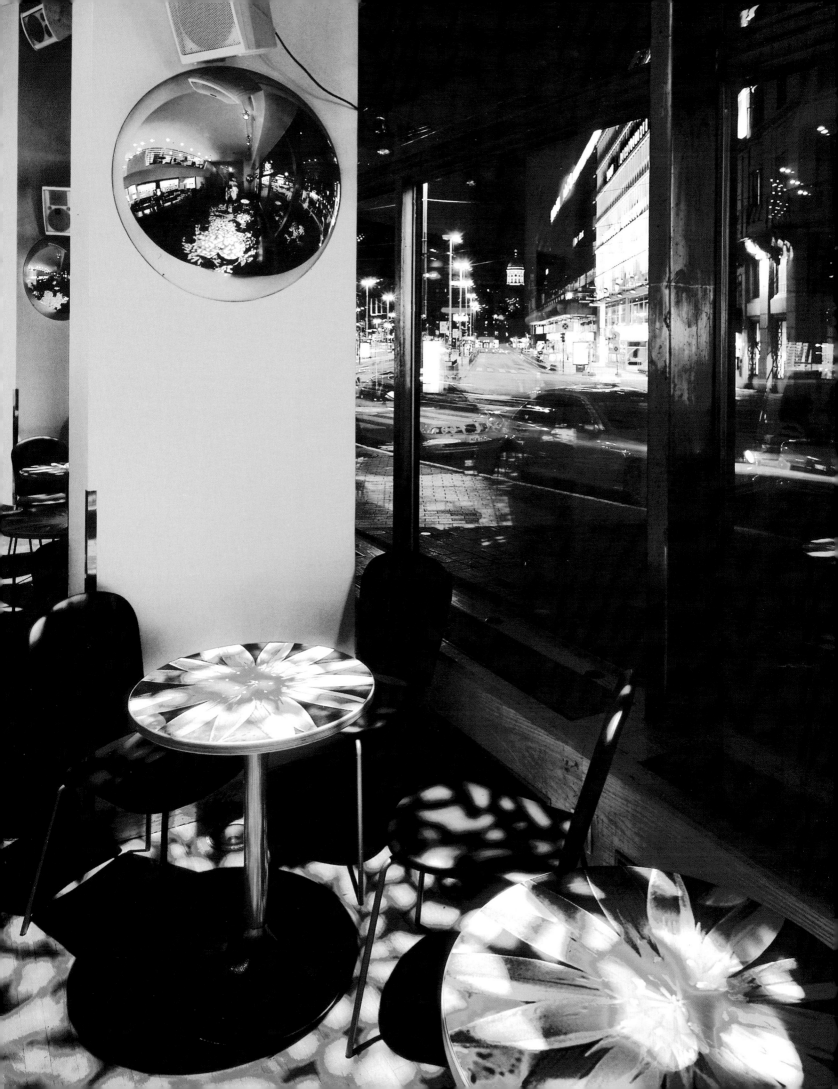

Memphis Vaakuna · Helsinki · Finland

Going inside the Memphis Vaakuna means submerging oneself in a world of saturated colors, materials that are to all appearances opposites, and original textures that build up a universe of fantasy. This vision of the urban world, with color and freshness in leading roles, serves as the main focus in this interior created by the Finnish group of designers M41LH2. Memphis is a restaurant chain, with a total of seven locales distributed throughout the country; and although the individual restaurants belong to different proprietors, they are defined by the chain's general aesthetic.

In keeping with the image of modernity it aims to transmit, the whole project is dominated by orange, a surrounding color that evokes freshness, youth, and freedom—definitively the essence of new urbanism. In a zone immediately adjacent to the entrance, a series of tables form a space dedicated to a cafeteria. The blue chairs contrast with the white walls and the red upholstery that provides the setting with color—a subtle introduction to the explosion of oranges and reds that tint the space of the bar lounge. The stream of natural light that inundates the cafeteria by day, due to its proximity to the exterior, gives way at night to phosphorescent lighting, glimmers, and other artificial light sources that glint off the upholstery, bounce off the polished concrete floor, and continue unimpeded to irradiate indirect lighting that hypnotizes the viewer.

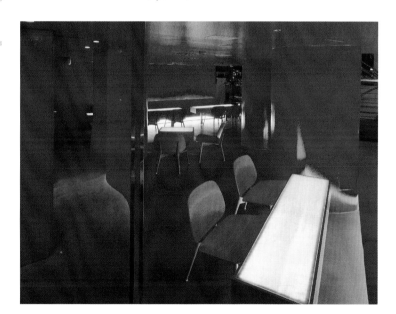

Designer M41LH2
Photographer MATTI PYYKKÖ
Location HELSINKI. FINLAND
Opening date NOVEMBER 2002

Memphis Vaakuna re-creates a flirtation of materials and colors that, like the modernity it serves to promote, justifies itself by its transgression.

The frontiers are crossed when night enters the space and the furniture becomes a source of light following the tradition of combining functions that characterizes modernity.

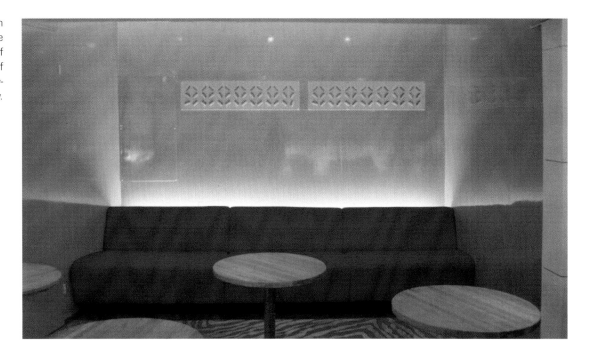

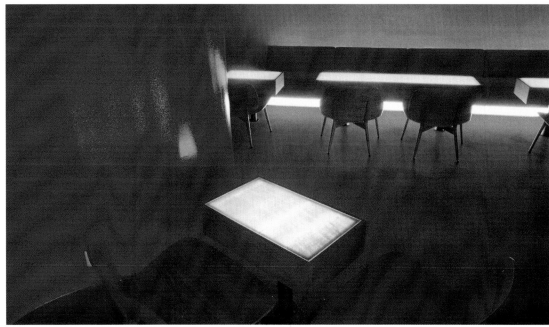

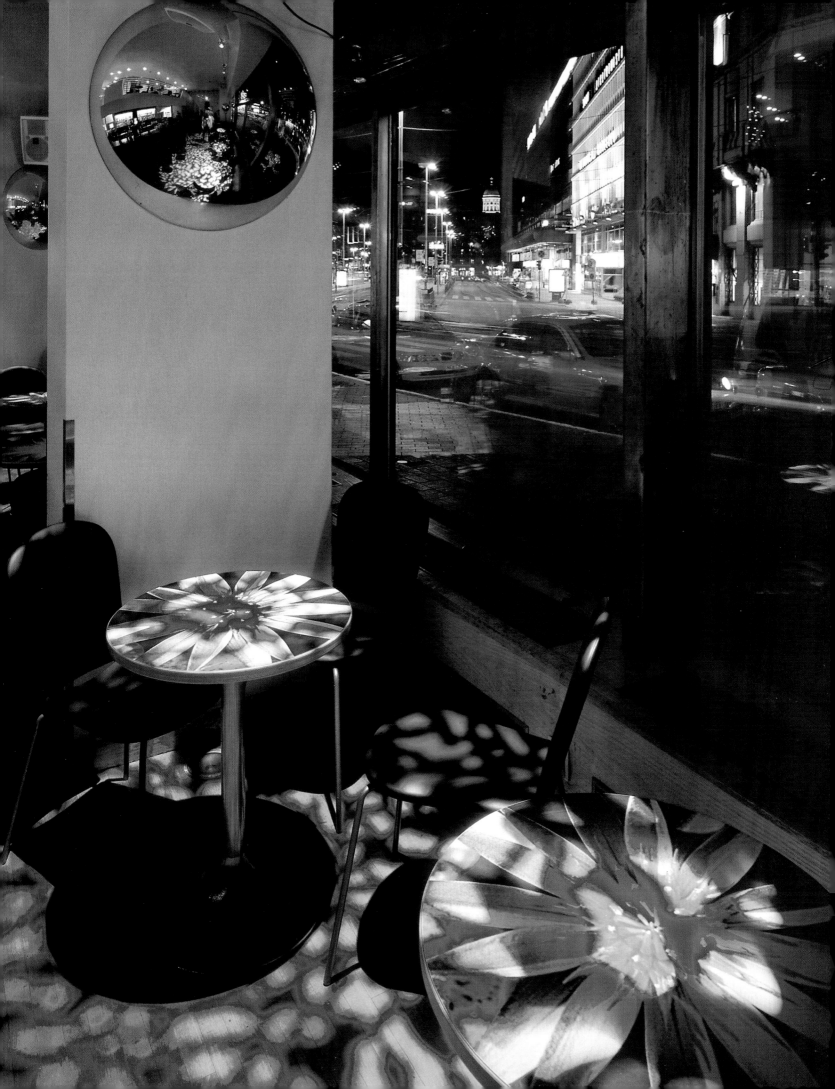

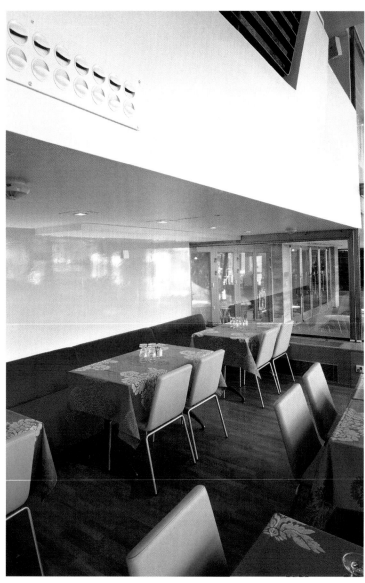

In the daytime, the vividness of the oranges combines with the blue upholstery chairs and the white walls to create a space submerged in natural light. This light gives way to phosphorescence at night.

Ground-floor plan

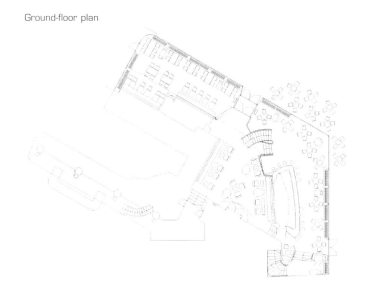

First-floor plan

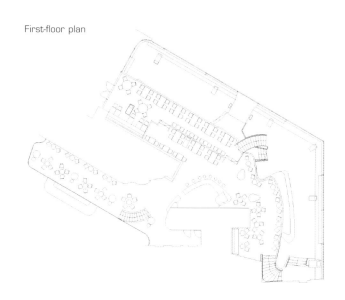

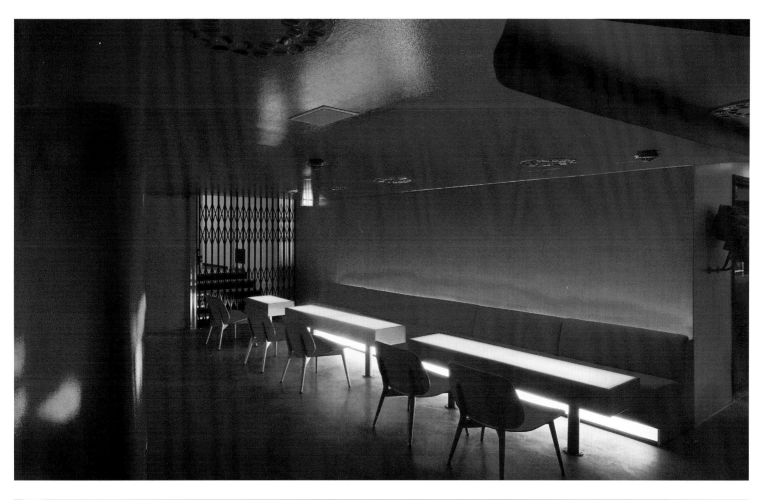

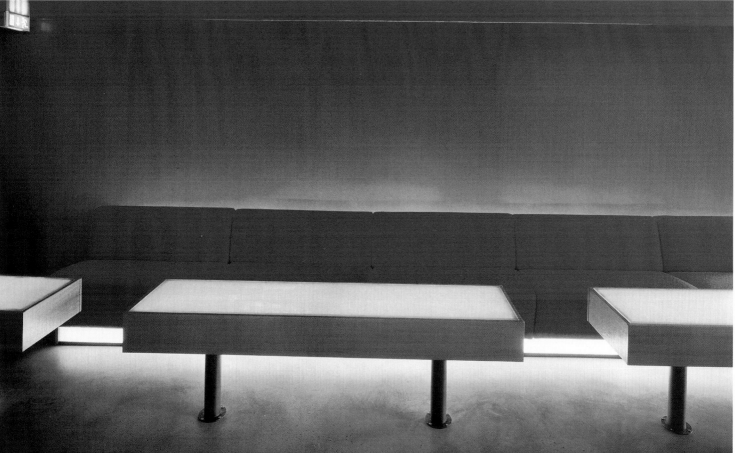

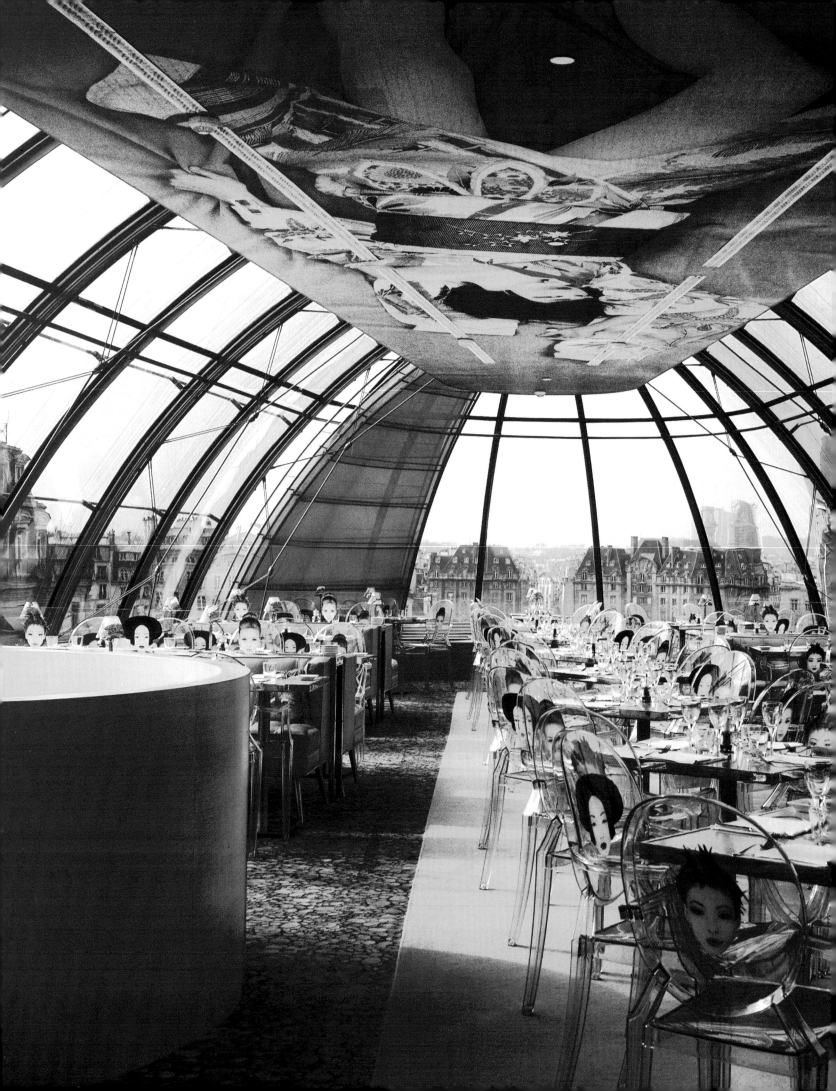

Kong · Paris · France

The top two floors of the new Kenzo building in Paris are the creation of Philippe Starck, the enfant terrible of French design who, shortly after designing the restaurants Bon and Bon 2 for Laurent Taïeb, associated himself again with the famous French restaurateur. Kong personifies the desire to shape the spirit of the Kenzo building into a metaphor for the old Japan's presence in the new. And voilà: a very Parisian style with direct allusions to Japan, the true protagonist of the project, rather than the imposing views over the mythical Parisian rooftops offered from the large glass dome, designed by the building's architect, Jean-Jacques Ory.

Upon entering Kong, visitors are suddenly confronted with dozens of female faces, most of them Asian. These faces are printed on the transparent backs of the chairs and the dividers separating the tables, and they appear to observe the visitor's every move. A geisha reigns supreme among them from the highest point, a mural on the ceiling of the dome and, as if this weren't enough, the figure of a teenage sumo wrestler is repeated throughout the bathrooms.

The transparency is certainly a constant. The glass dome and the metacrylate chairs on the top floor, where the restaurant is located, restate the theme of the female face, along with the inclusion of holograms in the cafeteria. Beneath the surface of the bar counter, a vast explosion of poppies, also transparent, seems to float on a red background, a clear homage to the spirit of Kenzo.

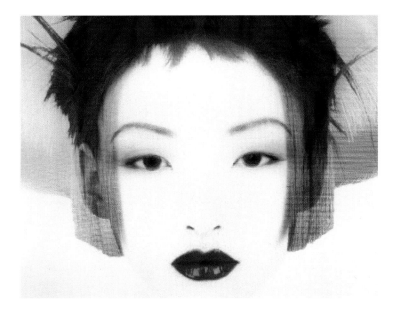

Designer **PHILIPPE STARCK**
Photographer **PATRICIA BAILER/MIHAIL MOLDOVEANU**
Location **PARIS. FRANCE**
Opening date **MAY 2003**

Shocking pinks, acid greens, intense reds,
and saturated oranges bounce around with
the gray of the sofas and aluminum objects
in a color welter seemingly derived from a Japanese
comic strip.

The female faces printed on the backs
of the metacrylate chairs are the most
characteristic feature of Kong.

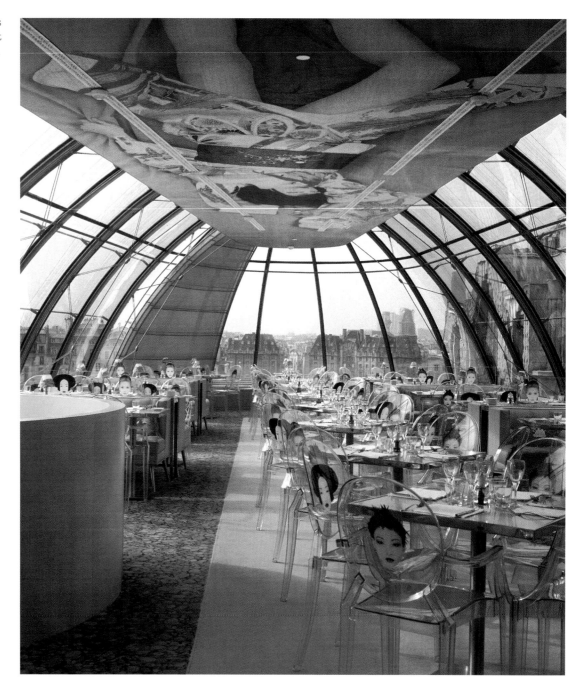

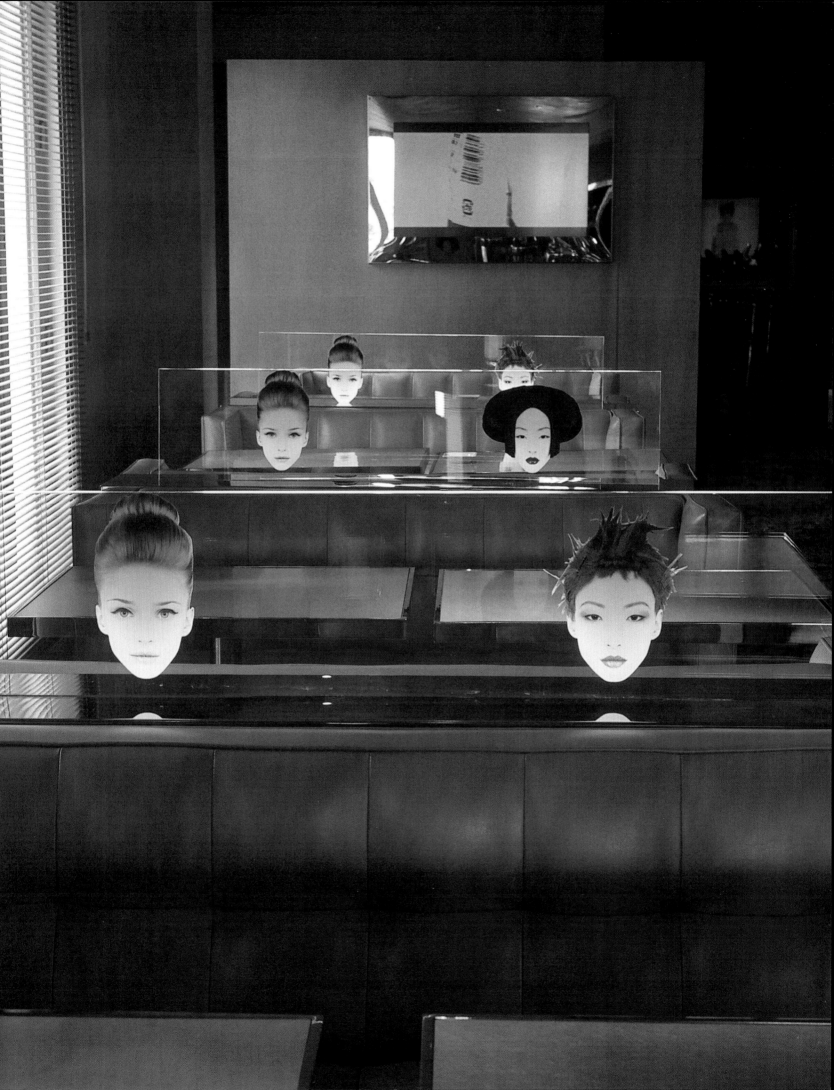

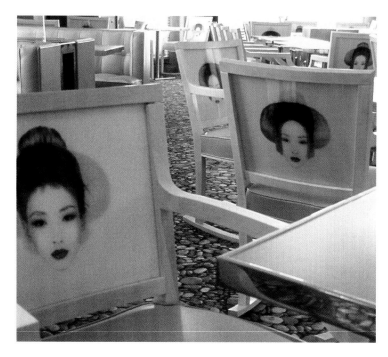

A free-for-all of motifs, materials, colors, and furniture styles make for a peaceful coexistence among the eighteenth-century-inspired chairs, 1960s leather sofas, and maple rockers bearing holograms on their backs.

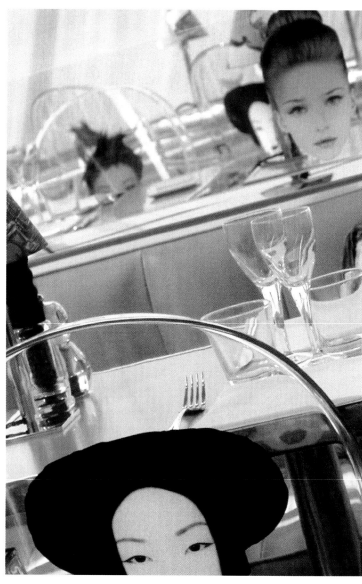

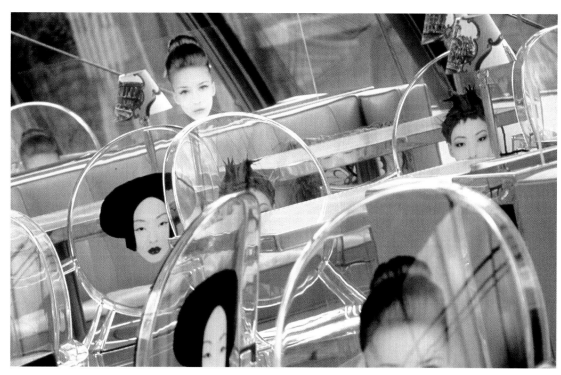

A sea of red poppies that float under a transparent surface form a unique bar counter that extends across the space.

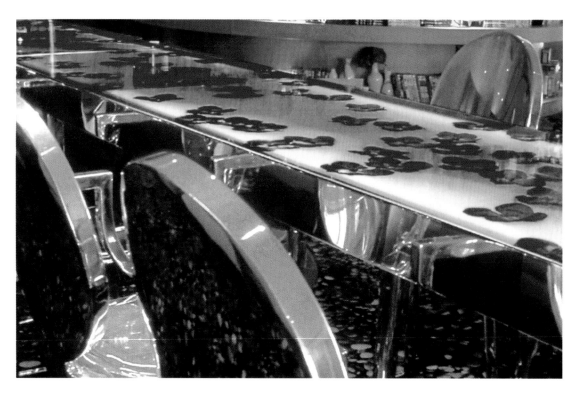

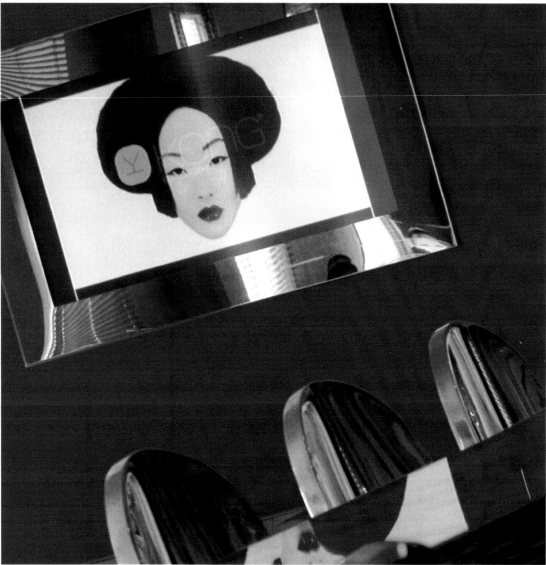

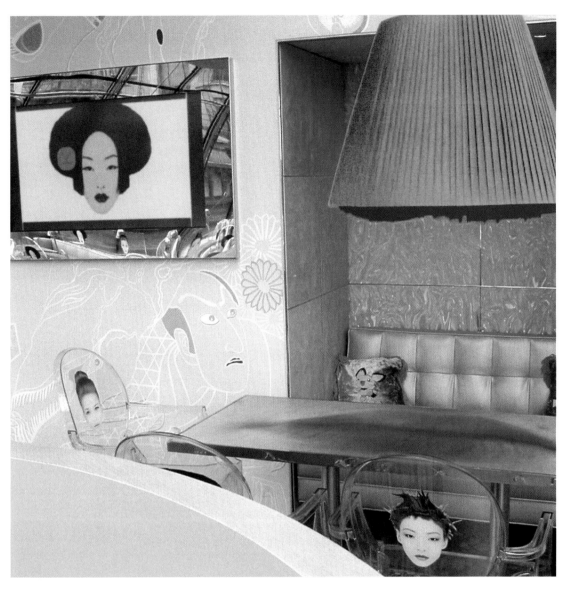

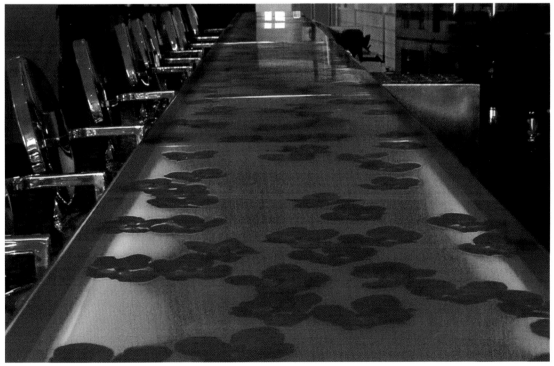

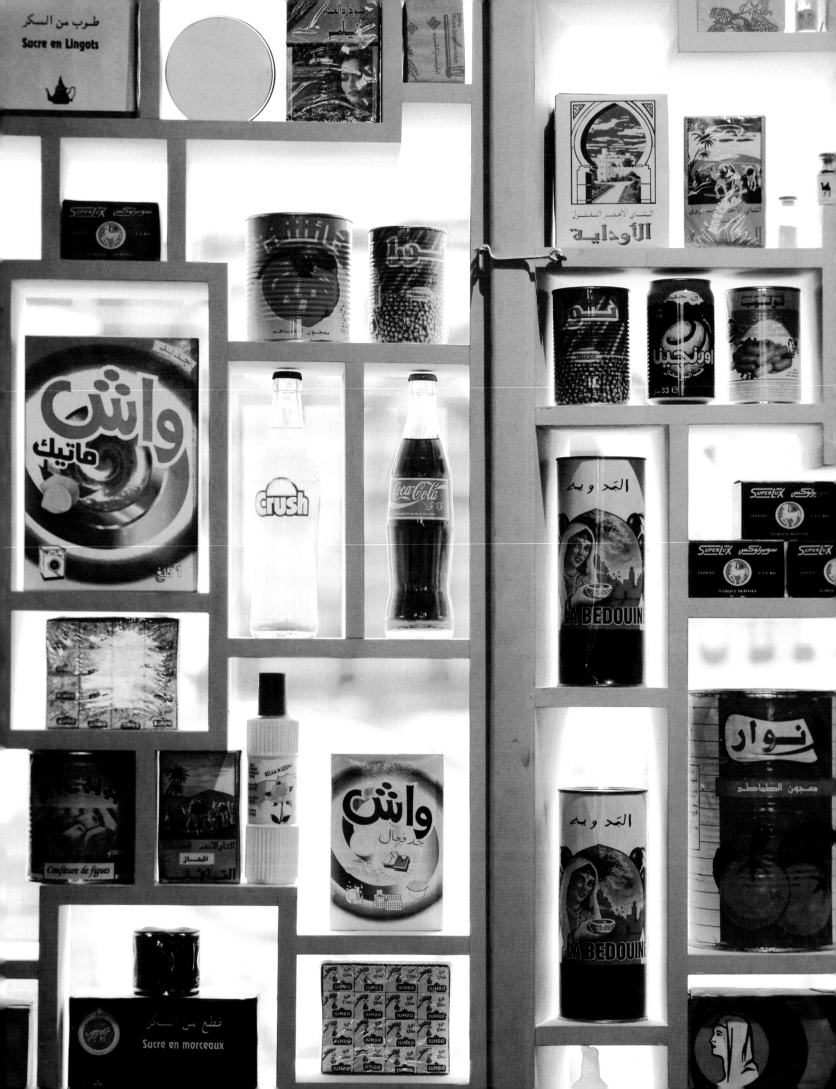

Andy Wahloo · Paris · France

Reaching a new phase in current interior design, Moroccan artist Hassan Hajjaj is giving the phenomenon of recycling a new artistic dimension in his recent work, a tapas bar in an anonymous Paris street. Andy Wahloo pays homage to Andy Warhol with Eastern flair: the combination is strange, and the end result is original. The space is crammed full of an eclectic mix of objects whose originality resides not so much in their own interest as in their combination with other objects of diametrically opposed character, color, or aesthetic.

Containers of food from the 1960s, Moroccan ads and packages, Coca-Cola crates reused as stools, and traffic lights that serve as table settings are demonstrations of the love Hajjaj has for Pop Art. The end result is an animated, colorful, kitsch setting that reflects the cultural values of a Morocco where nothing is thrown away and everything has a possible function in addition to that for which it was originally designed.

In an age when Eastern things are invariably associated with the lavish, Andy Wahloo represents a valuable show of humility when it comes to creating a fusion of Western and Eastern styles, something which has grown hackneyed in recent times. The bar's lack of pretensions makes it possible to take advantage of a space whose kitsch composition welcomes the eyes of a public that has grown unaccustomed to standing before a work of Pop Art.

Designer **BRUNO CARON, HASSAN HAJJAJ**
Photographer **DANIEL NICOLAS**
Location **PARIS. FRANCE**
Opening date **DECEMBER 2002**

The concept behind this project is not merely a reaction to much-too-common interior design style, but neither is it an echo of hippie dregs from the 1970s. Developed under Hassan Hajjaj's artistic criterion, this opening of spirit reflects a creative freedom that is rarely seen in the interior design of commercial spaces.

Architect Bruno Caron collaborated with Hajjaj in the design of this project that, from the outside, might be considered a neighborhood drugstore.

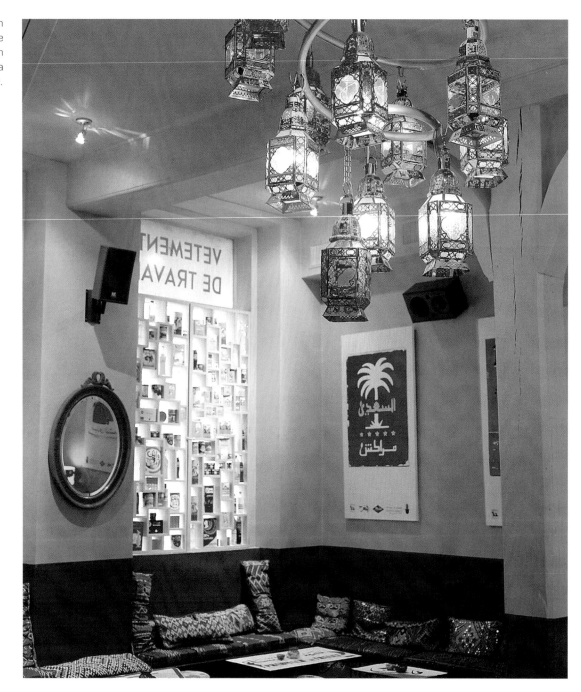

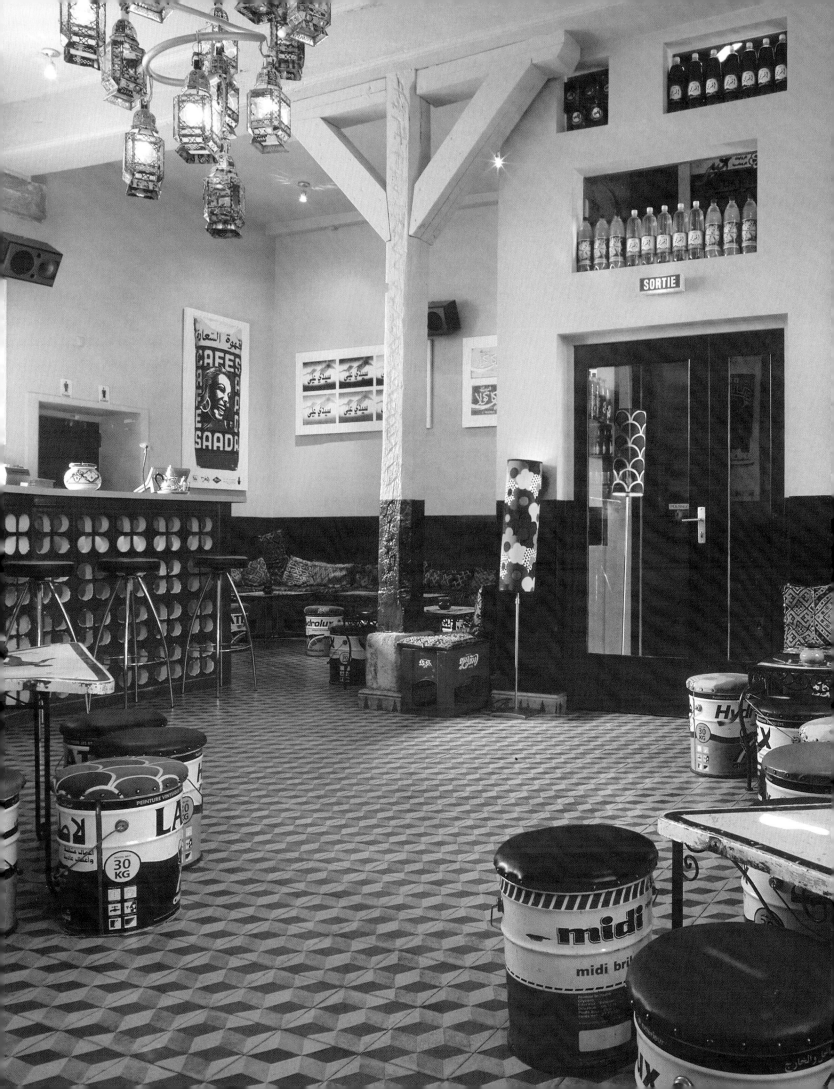

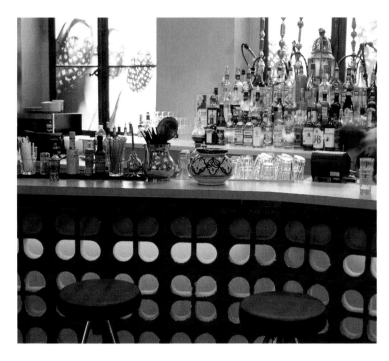

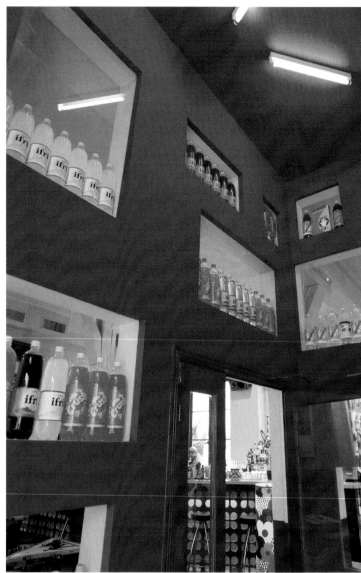

Bright and contrasting colors
generate an animated atmosphere
and, at the same time, highlight
the space's inventive decoration.

Floor plan

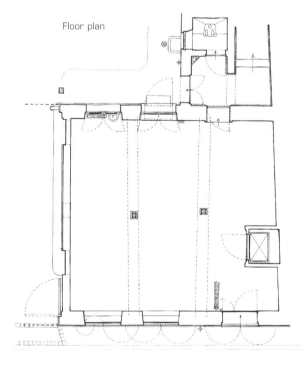

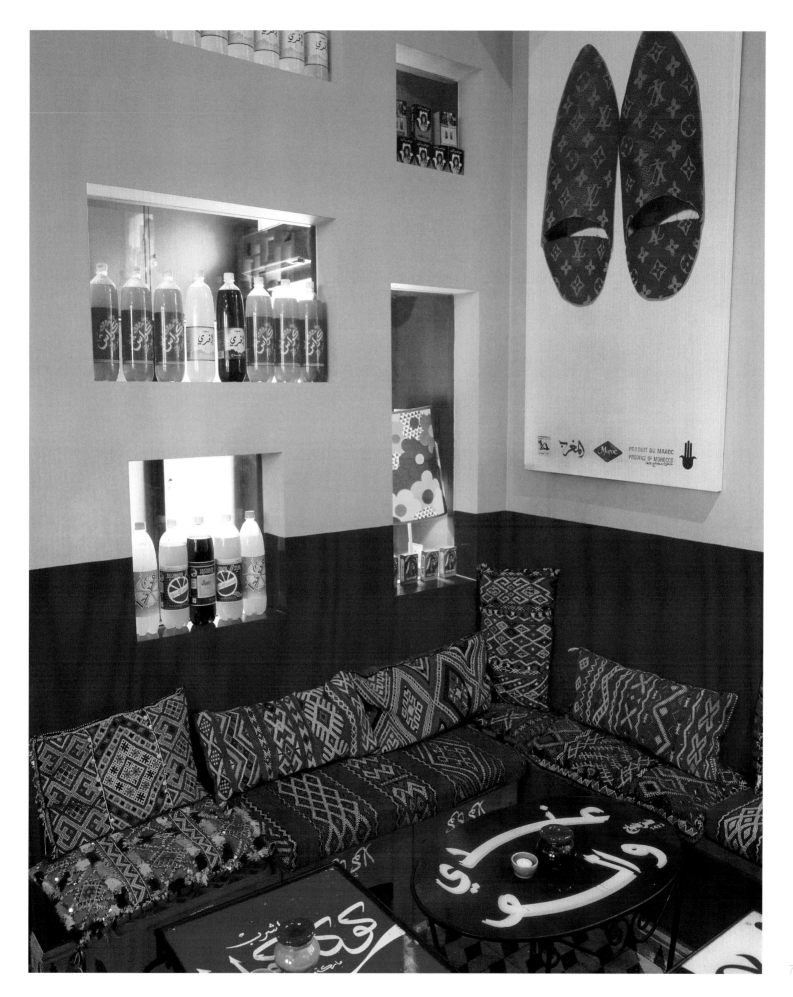

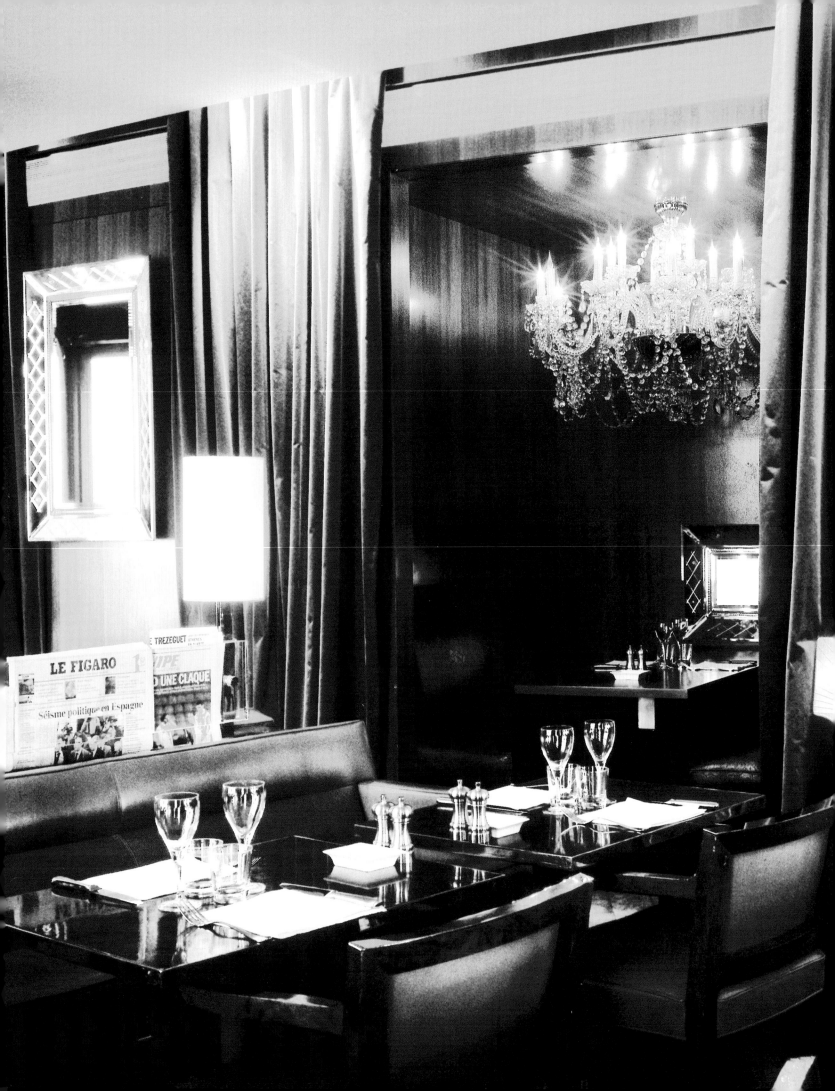

How do you define modernity? For Laurent Taïeb, owner of Lo Sushi, Kong, and Bon restaurants, modernity is "the opposite of fashion." For Philippe Starck, by now a regular associate of Taïeb's, it signifies "incorporating the best of classicism." Bon 2 scrunches both visions into a high-tech space that pays its dues to classicism and that in no way duplicates the first Bon, but opts for a declination of the philosophy that the latter has adapted as its setting. Close to the Place de la Bourse and the offices of France Press, Bon 2 offers its clientele a luxurious and welcoming ambience. The dark makore wood that permeates the whole locale, combined with armchairs in dark leather and thick moquette and several plasma display panels, testifies to all of this luxury. Smaller than its predecessor, this mixed-media project encompasses a main space that sweeps the bar and restaurant into a single embrace. Available in the restaurant are newspapers and magazines that cater to the type of clientele characteristic of this Parisian business zone. At the end of the corridor, shelves with a choice of books invite diners to have a relaxed read.

In a country where food is raised to the category of a major art form, the cuisine in Bon 2 has become a veritable experimental lab under the baton of Jean-Marie Amat.

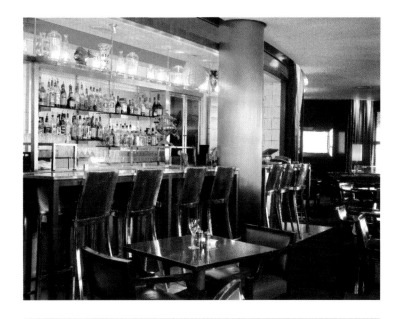

Designer PHILIPPE STARCK
Photographer PATRICIA BAILER; MIHAIL MOLDOVEANU
Location PARIS. FRANCE
Opening date APRIL 2002

Plasma display panels (PDPs) show messages addressed to everyone, while stock market figures flow uninterruptedly on an outsize PDP stretched above the bar.

An adjacent room, lighted by a gigantic glass lamp, provides space for private dining.

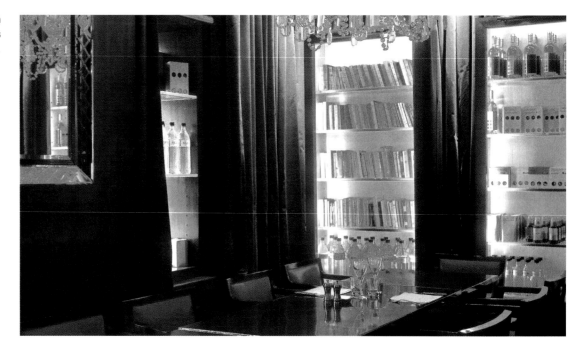

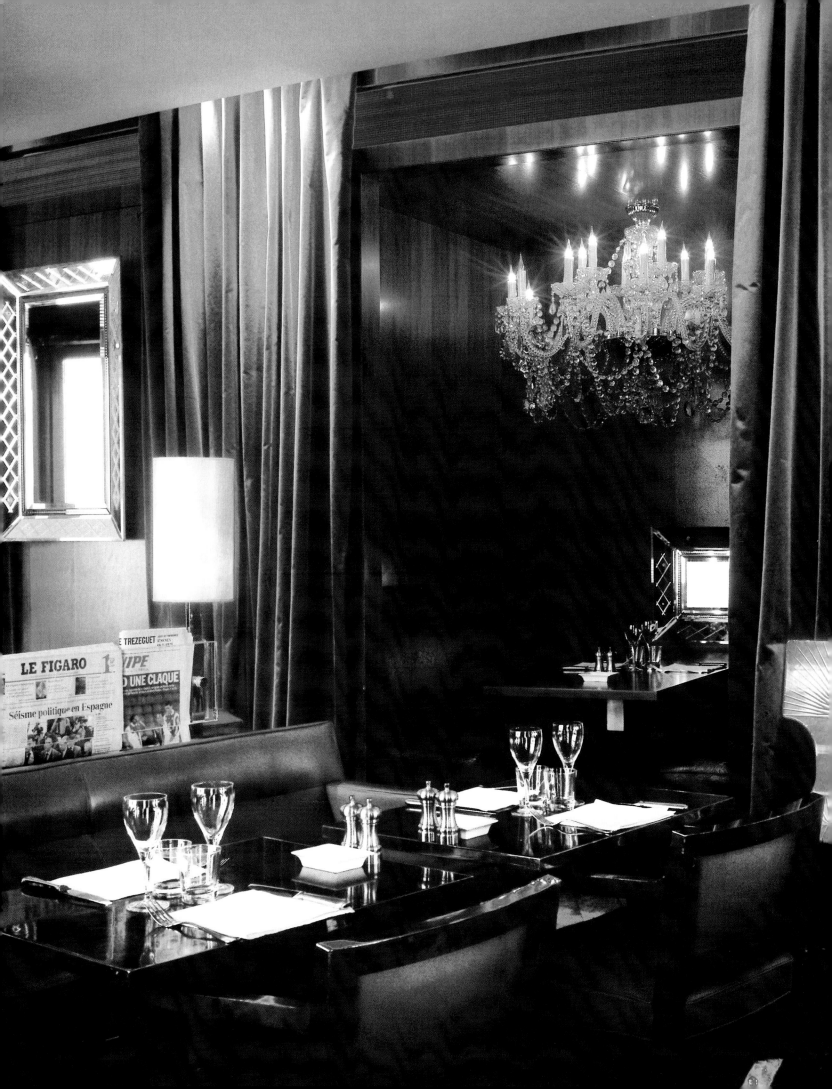

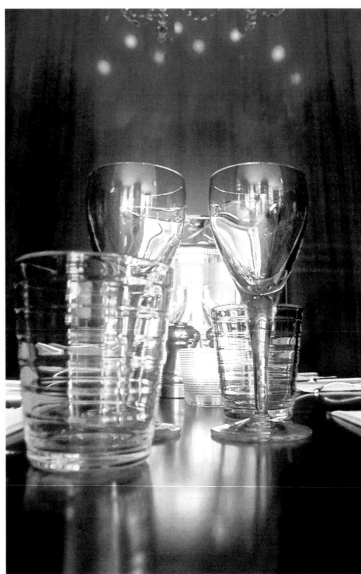

The restaurant's mixed-media approach to classically inspired furnishings is the work of Philippe Starck.

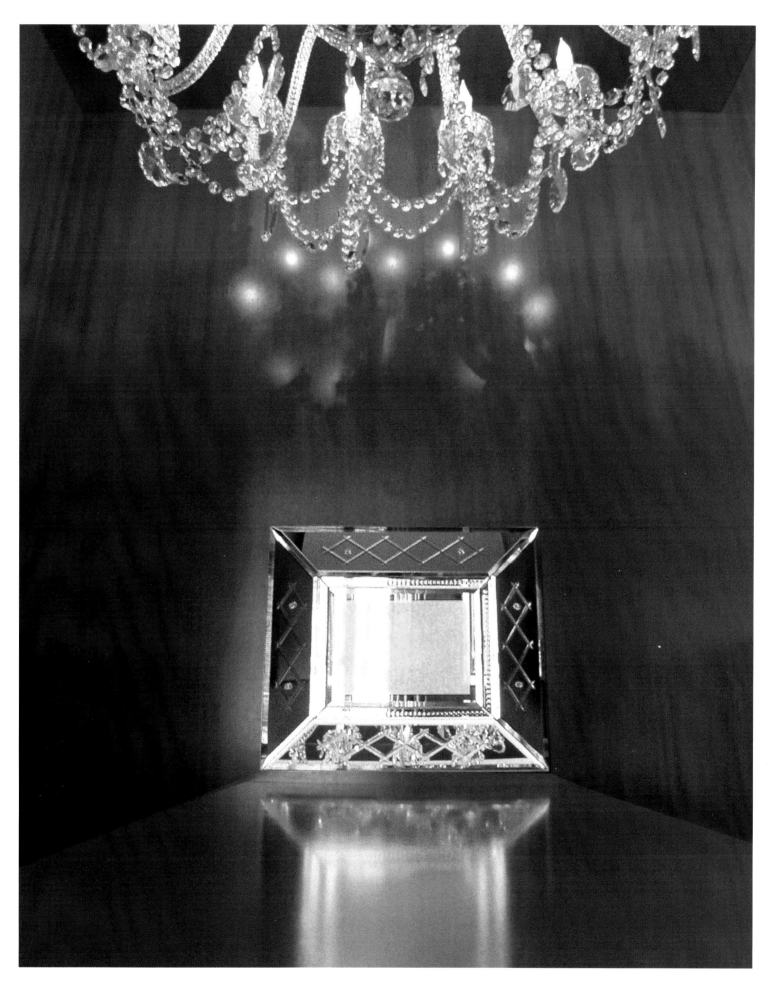

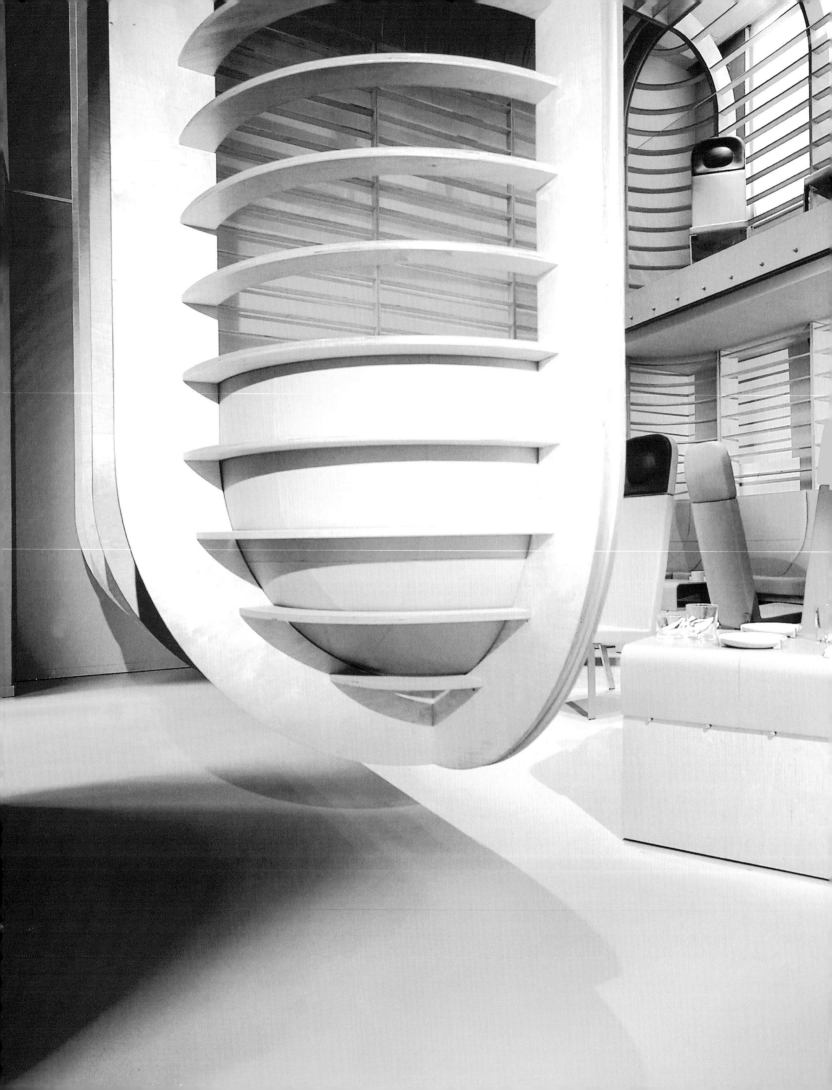

Happy Bar · Nice · France

Interacting in a medium different from the one we're used to brings with it an opening of the spirit that encourages a sense of experimentation. The bar of the Hi Hotel in Nice accompanies visitors as they discover a space that—far removed from the ornament-covered surfaces of yore, where each element is limited to a place and a function—has yet to be defined. With this project, Matali Crasset proposes a different decorative setting, centered on experimentation and mobility, as an alternative (or alternatives) to traditional hotel luxury.

The moldable structure of the Happy Bar clearly incites us to give in to our curiosity. It makes the customer the actor who invents his or her own subjective space—a call to reinvention. In the heart of the hotel, the bar is framed around a sort of basket pretending to belong to a rising balloon. Both impressive and light, the bar has an elongated semicircular bench, as well as an area of squarish low tables and chairs (also low) with elongated backs. Opposite, from a long board, brightly colored "trays" project to serve as tables. The predominant color is an acid avocado green that connotes happiness, hope, and the modern. Hi is, above all, urban, new, young, and contemporary—inserted, there is no denying, in a 1930s building that makes the brutal shock between interior and exterior one of its main virtues.

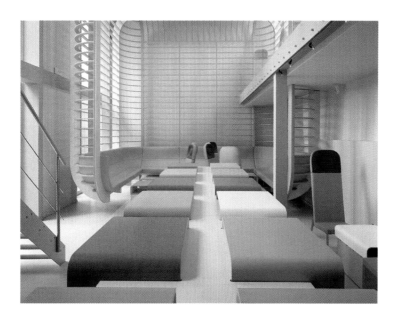

Designer **MATALI CRASSET**
Photographer **UWE SPOERING**
Location **NICE. FRANCE**
Opening date **MARCH 2003**

The rules of the game change in a space free of decoration. Comfort is no longer reduced to a single service dimension based on setting but to the freedom of feeling autonomous.

Beside the large central table inviting one to socialize, small individual tables offer greater intimacy.

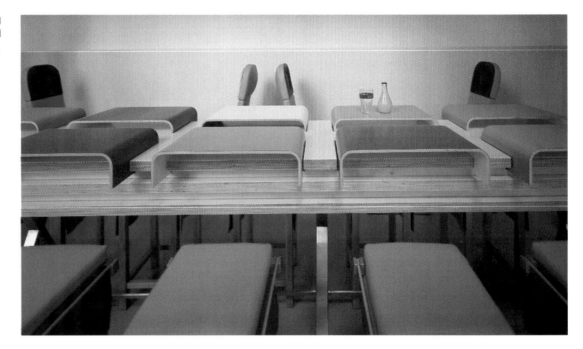

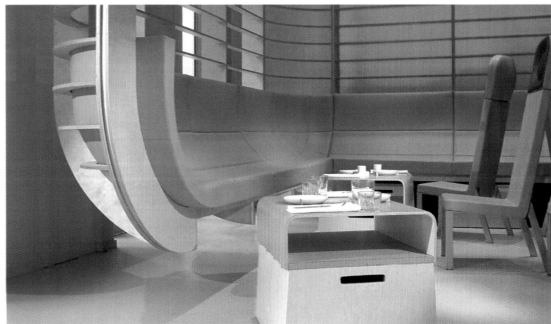

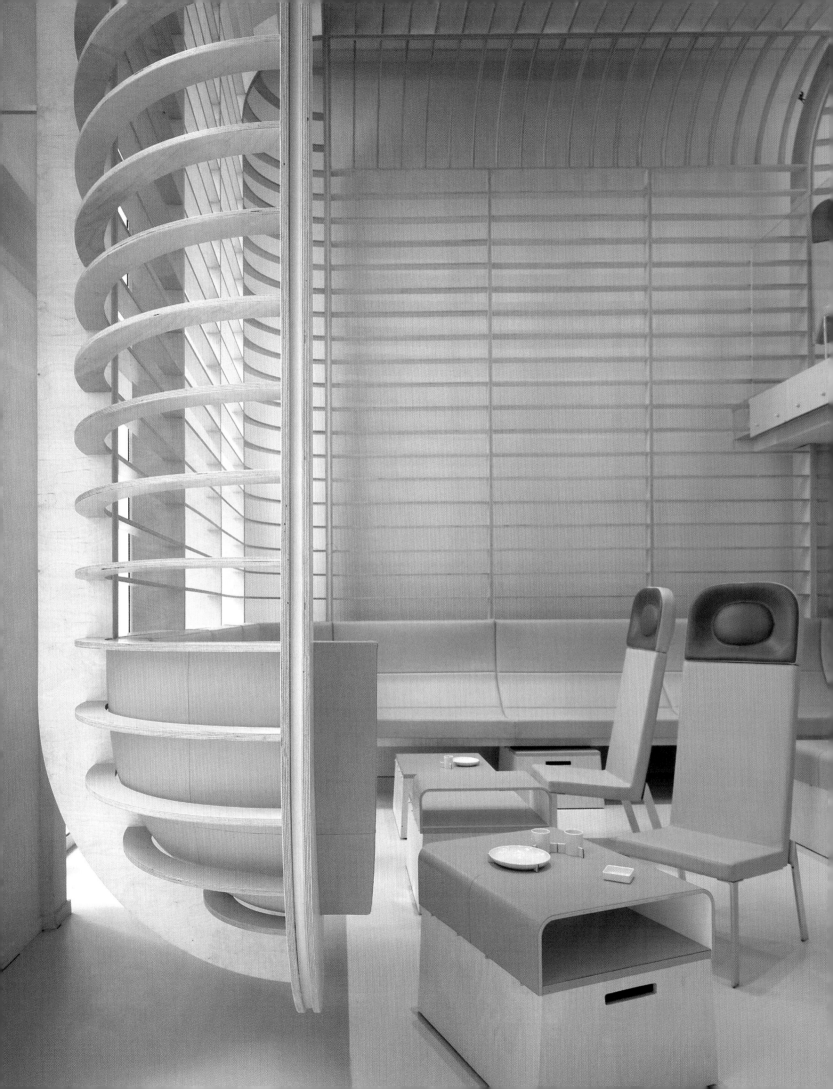

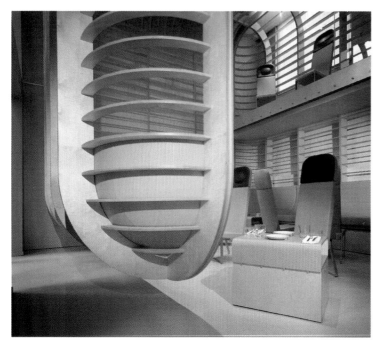

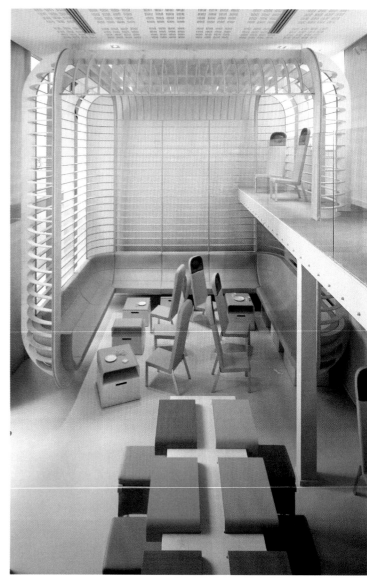

A second floor, created by a narrow catwalk with seats, offers the visitor an observation point for the whole bar.

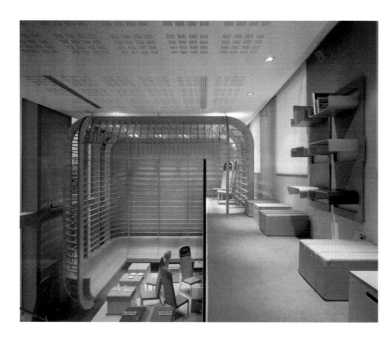

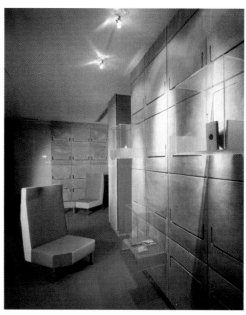

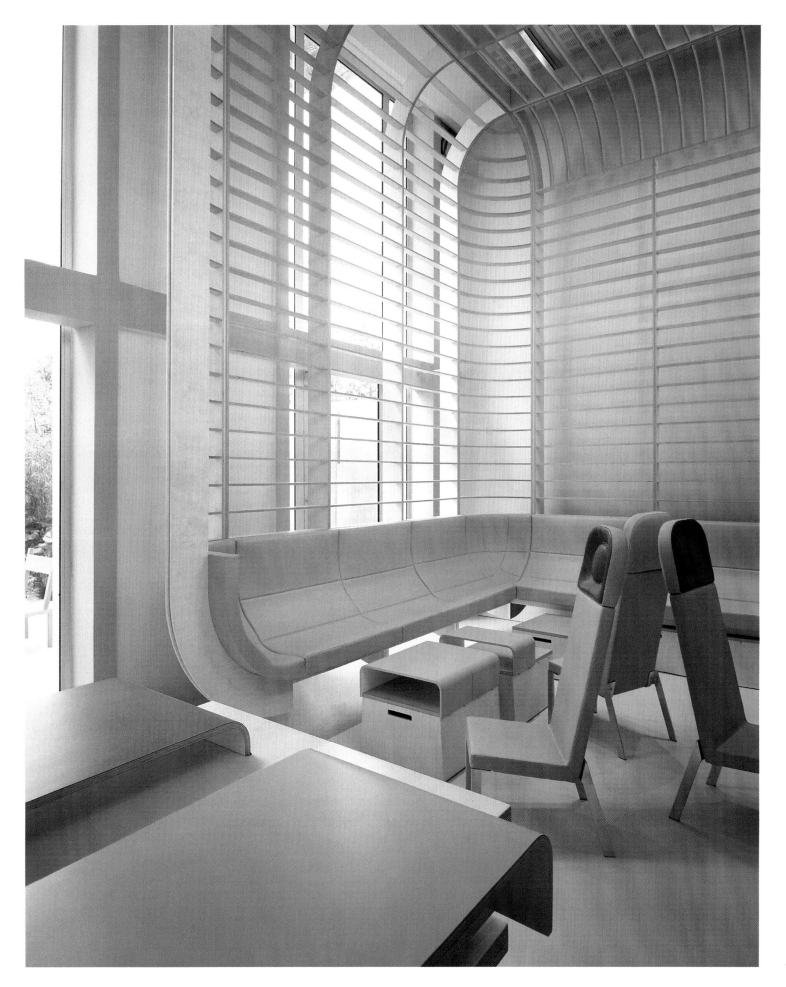

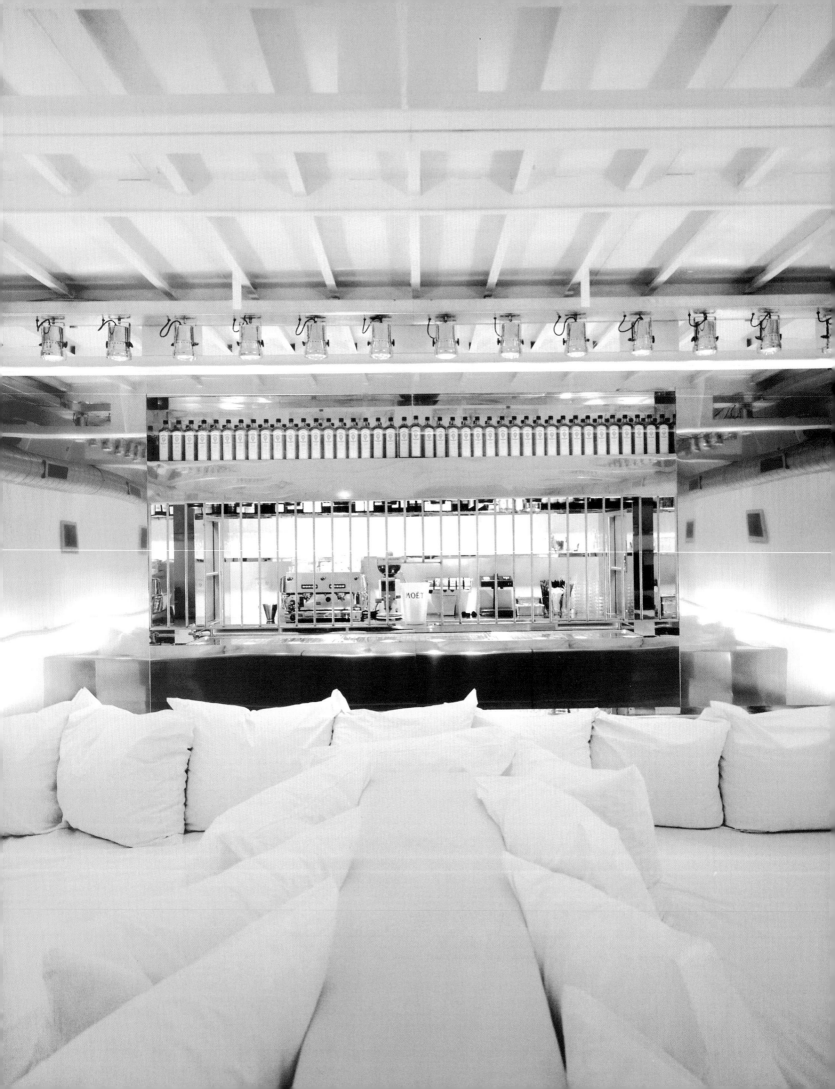

Supperclubcruise · Amsterdam · Netherlands

Supperclubcruise, as the name indicates, was born of a desire to integrate a bar-club-restaurant into the interior of a boat that taxis its customers to different geographical points during its nighttime parties. It thus combines clubbing entertainment with the adventure of a cruise boat.

The interior design was clearly influenced by the vessel's architecture. The tripartite division of the space has one part comprising the entranceway and the toilets, another the Neige Room and the Noir Bar, and the last the upper deck. The Neige Room is a guest's paradise of large cushions that stage an original setting for the restaurant. The room is long, free of any dividers or other planar impediments, with a central space occupied by an enormous chromed steel bed: two mattresses topped with mountains of pillows amenable to Roman-banquet-style dining. It is a pristine white bed, "seating" 75 diners with a bar counter in the same material and iron bars that separate customers from the personnel.

The original ceiling in the room has been replaced by a new one, painted white and fitted with 120 spots in a circumference around the bed. These create thin threads of light with scintillating reflections off the chrome. Resin flooring runs throughout the three rooms. The three spaces, demarcated by highlighted chromatic effects, generate the name as well as a feeling that clearly alters the perceptions in the rest of the boat.

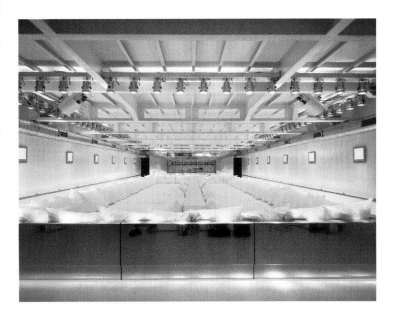

Designer **CONCRETE ARCHITECTURAL ASSOCIATES**
Photographer **CONCRETE ARCHITECTURAL ASSOCIATES**
Location **AMSTERDAM. NETHERLANDS**
Opening date **OCTOBER 2003**

In contrast with the purity of the main room, red reigns in the entranceway and on the bathroom walls, which are partially carpeted and partially painted in the same color. High-gloss black dominates the Noir Bar, complementing the gray of the chairs.

The Noir Bar's seating elegantly insinuates itself from point to point in the room, converging on the red neon sign.

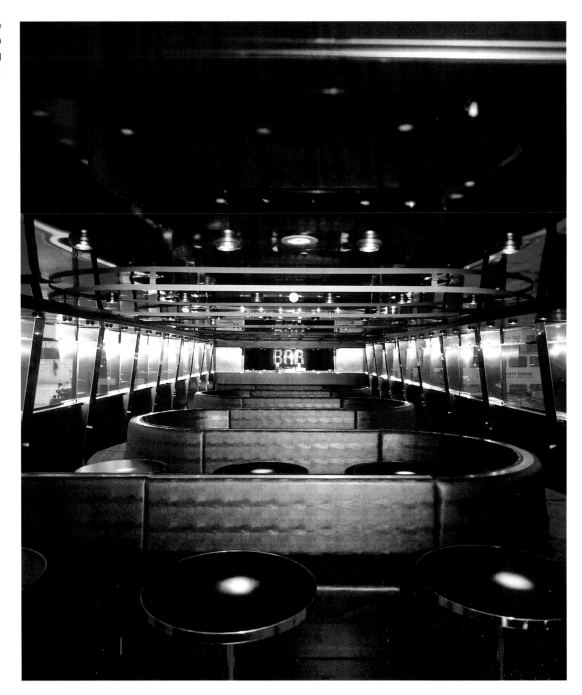

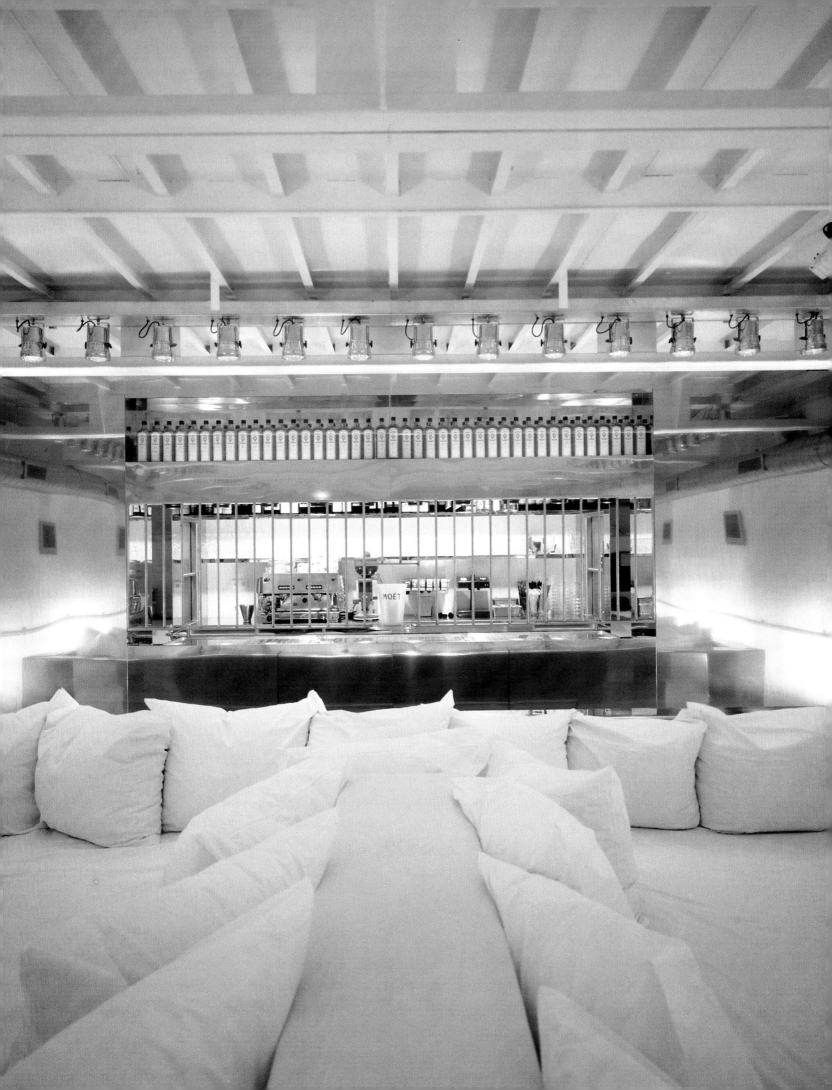

Colored steel in the bathrooms contrasts with the intense color in the walls.

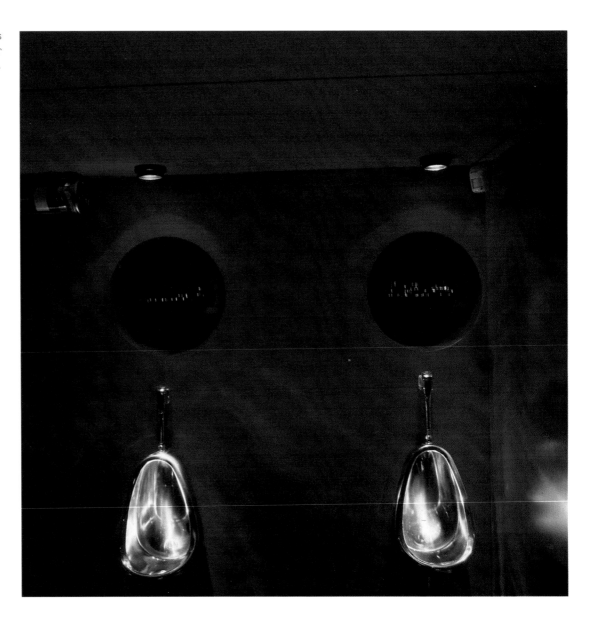

Side view

Section

Floor plan

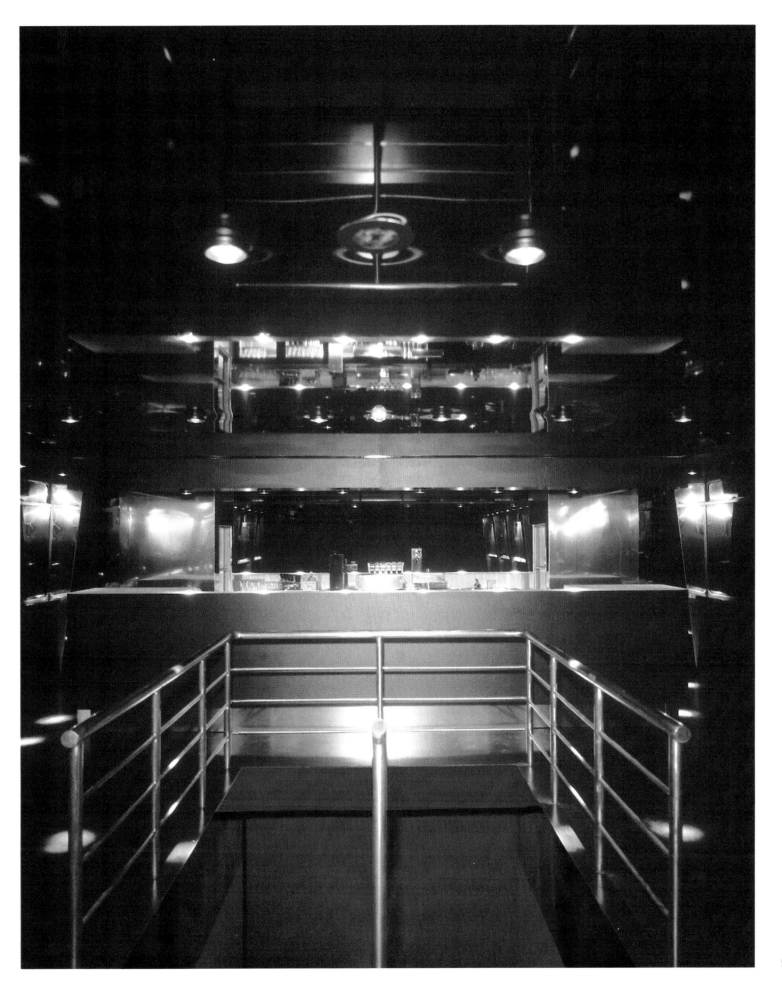

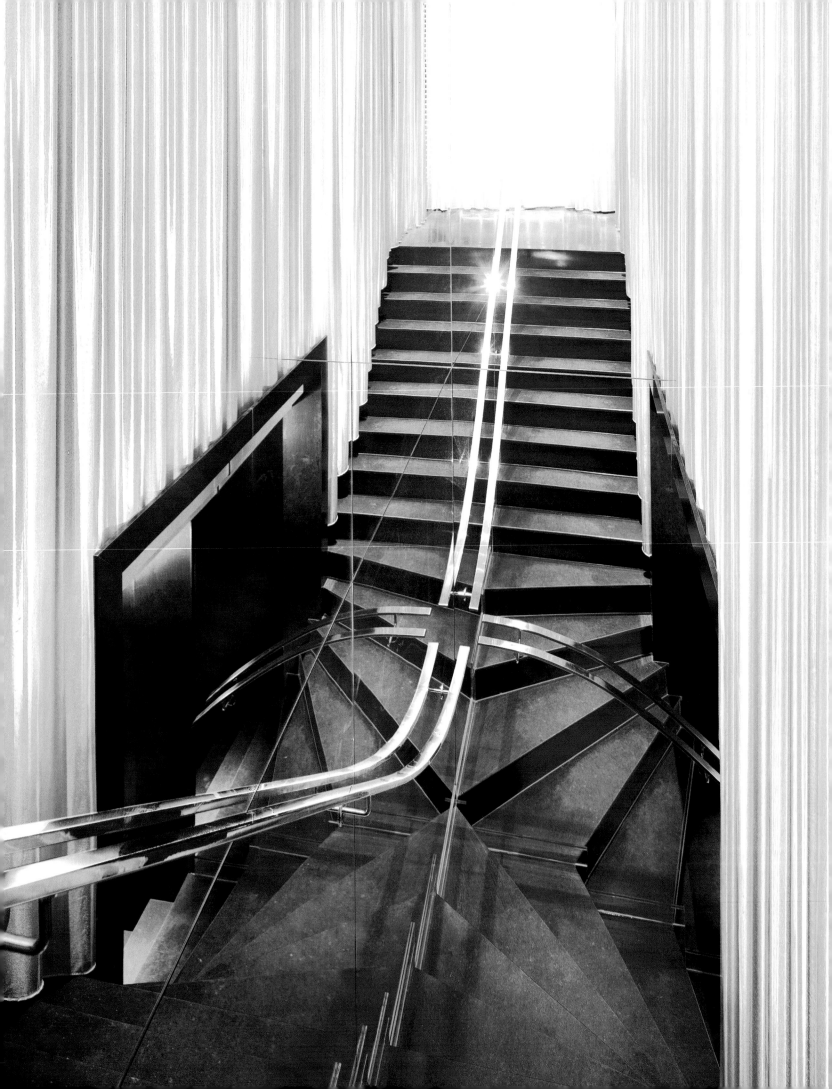

Strozzi's Piu · Zürich · Switzerland

Zürich has always been a traditional city, rarely given to innovation in terms of the design of its dining establishments. In a pedestrian area in the city center, where Armani, Bulgari, and Ermenegildo Zegna boutiques rub shoulders with large banking centers, Jasmin Grego and Josef Smolenicky have created a locale that keeps the highest-level consumers on their feet with the concept of fresher, younger exclusiveness. Strozzi's Piu—part cafeteria, part bar, part lounge, and part restaurant—is housed in a banking building once the home of the financial giant Credit Suisse.

Conceived as an open, glazed interior, Strozzi's Piu is a promenade that begins as an interior patio, continues on through the different rooms, and ends in the street. The passage through the different spaces is effected almost imperceptibly along an axis made up of the bar counter, a continuous chaise longue, and a long curtain that flows along the whole length of the wall. The design of this interior centers on a few key elements that are interrelated and that generate a glamorous, elegant setting—cheerful and light. Even the pearl gray curtains contribute to this, as does the unexpected backdrop of little stones in the middle of the space. But it is above all the strange asymmetrical form of lilac-colored seats that injects the project with its novel take on earlier traditions.

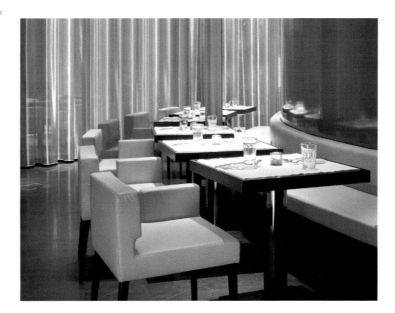

Designer **GREGO & SMOLENICKY ARCHITEKTUR**
Photographer **WALTER MAIR**
Location **ZÜRICH. SWITZERLAND**
Opening date **OCTOBER 2002**

The reversed situation in the gallery interior carries with it a special lighting situation. On the one hand, the lack of direct sunlight makes some places dark; on the other, the light pouring in from adjacent interior patios is carefully exploited.

The asymmetric form of the seats, halfway between a side chair and an armchair, enables their pairing into little two-person sofas—an interesting example of aesthetic functionalism.

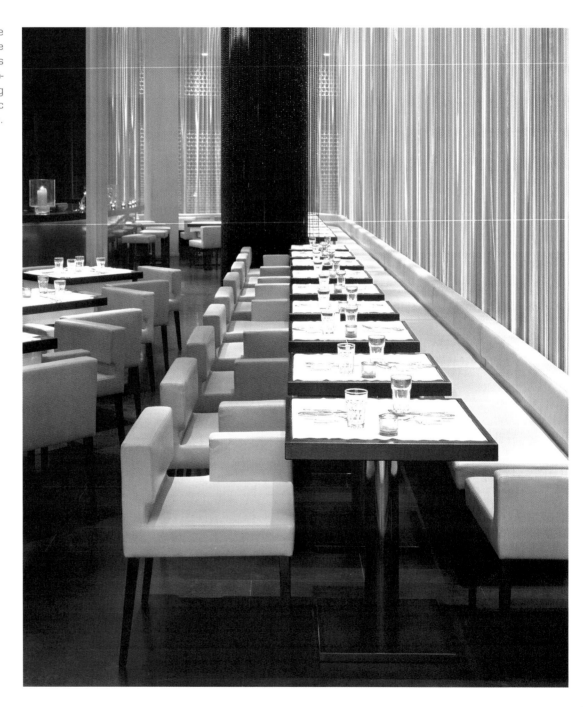

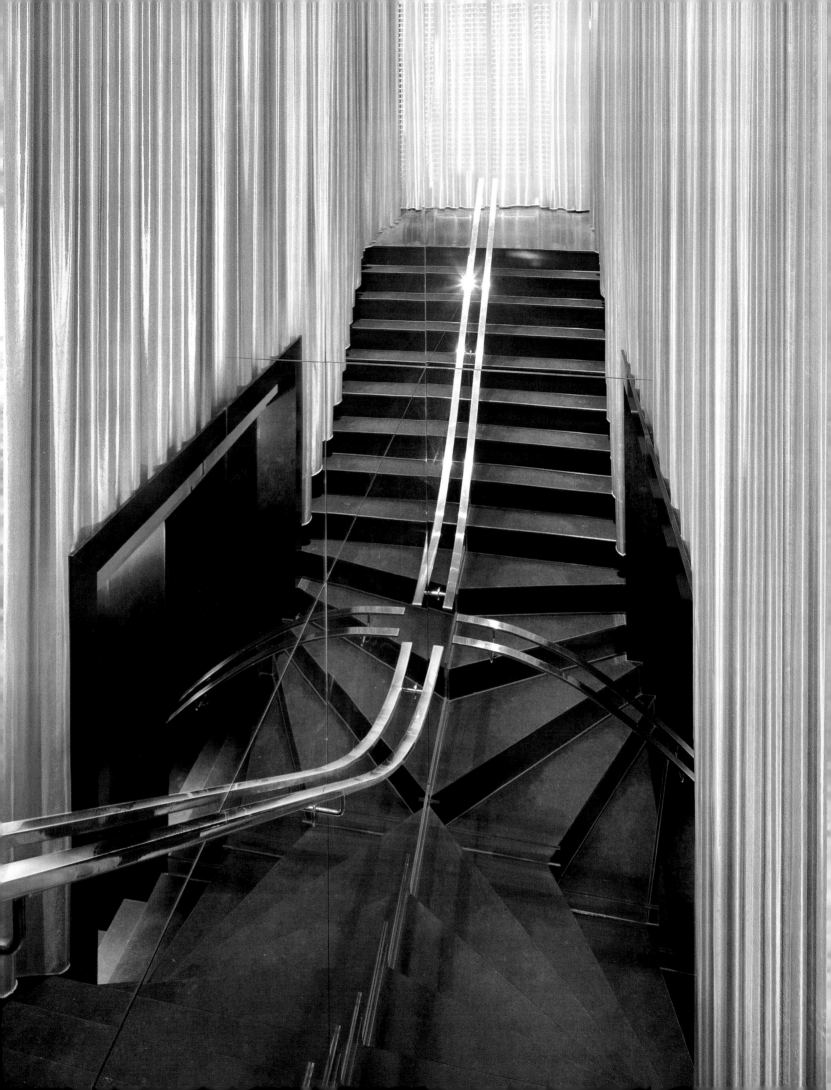

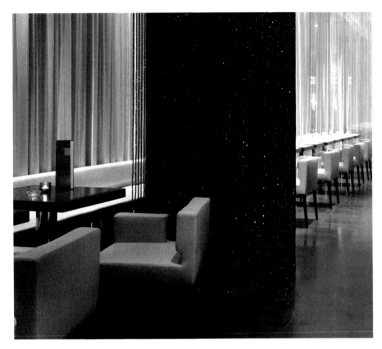

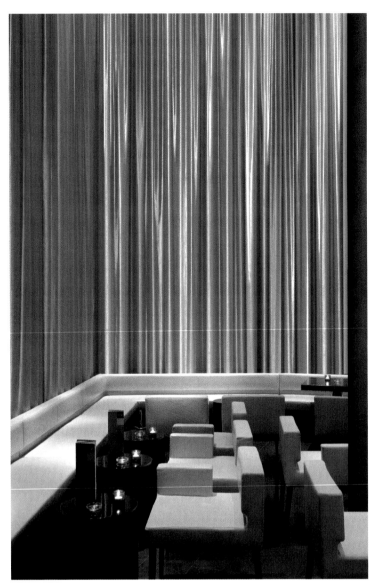

The low backs of the sofas
reinforce verticality in this
space, whose planes are
entirely covered by curtains to
counteract the transparency of
the glazed cladding.

Basement plan

Ground-floor plan

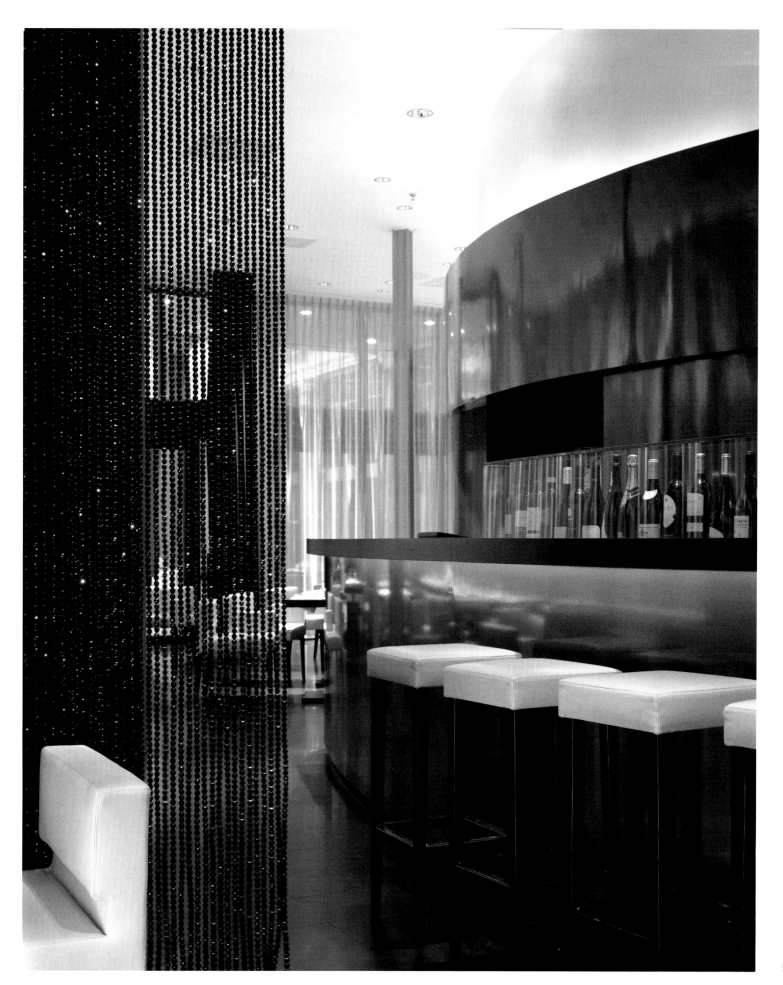

Le Chlösterli · Grund bei Gstaad · Switzerland

Following the highway in the direction of Gstaad, Switzerland, one comes suddenly upon Le Chlösterli, an old mountain chalet built around 1700 by the monks of the Abbey of Rougemont. Patrick Jouin has now reinvented it, preserving the intimate character of its architecture and converting its interior into a fantasy world that fuses the past and the future. Inserted into a picturesque mountain landscape and surrounded by wood-frame chalets, the building uses an aesthetic that respects the 300-year-old history of the original. Jouin has recycled already existing elements, but given them new meaning. Thus, a round wooden container, once used as a watering trough, becomes a table; a milk container is made into an original refrigerator for bottles of champagne; and a series of monitors shows images of flames—an allusion, perhaps, to the site's old fireplace. The most radical intervention in this space consists of a gigantic glass wall that, standing nearly 20 feet tall, is in complete opposition to the style that surrounds it, both in terms of dimensions and materials. This structure separates the kitchen from the remainder of the space, which includes two restaurants, a bar, and a disco. Outside, the creation of terraces brings the landscape closer, while the walls, constructed of wooden beams, generate a feeling of protection in the face of a panorama of almost frightening beauty.

Designer PATRICK JOUIN
Photographer THOMAS DUVAL
Location GRUND BEI GSTAAD. SWITZERLAND
Opening date DECEMBER 2003

A warm illumination system bathes the areas formed by the bar and the restaurants, empowers the rich tone of the wood, and creates a sense of retrospection that contrasts with the more modern aesthetic of the dancing area.

The architecture of the terrace is inspired by the wood-frame buildings of the zone.

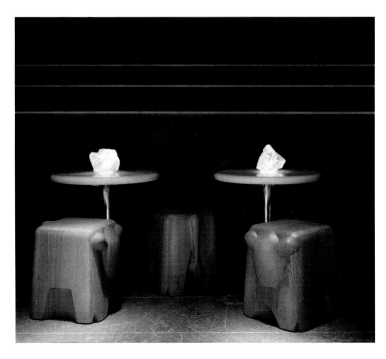

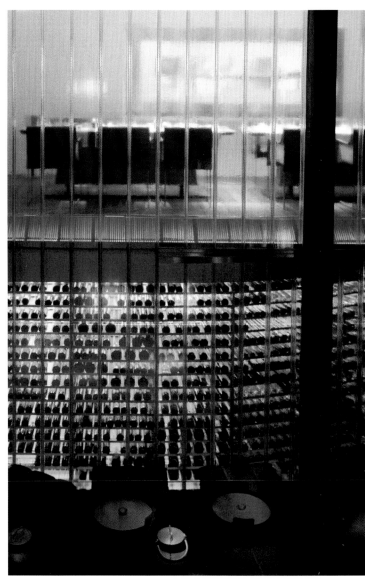

Tradition and modernity fuse in an interior that re-creates a whole fantastic world where the real and the virtual unite.

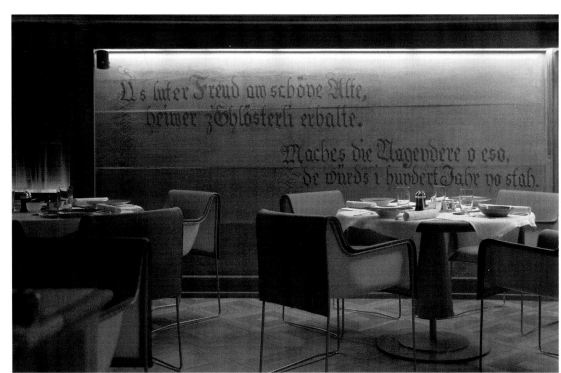

Le Chlosterli

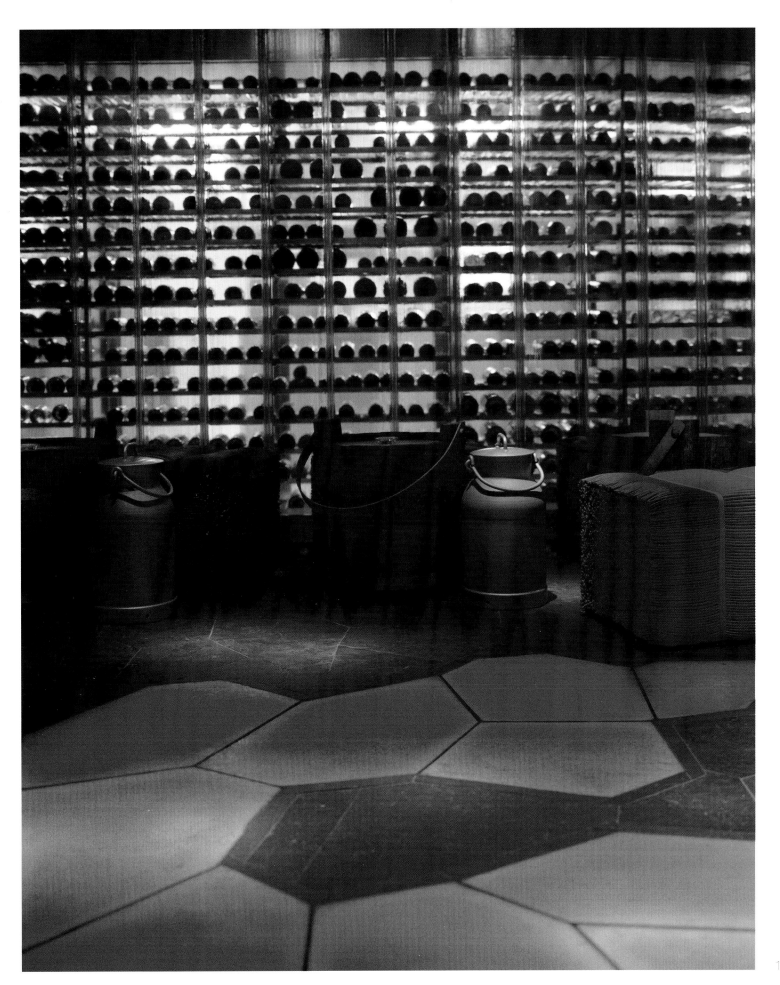

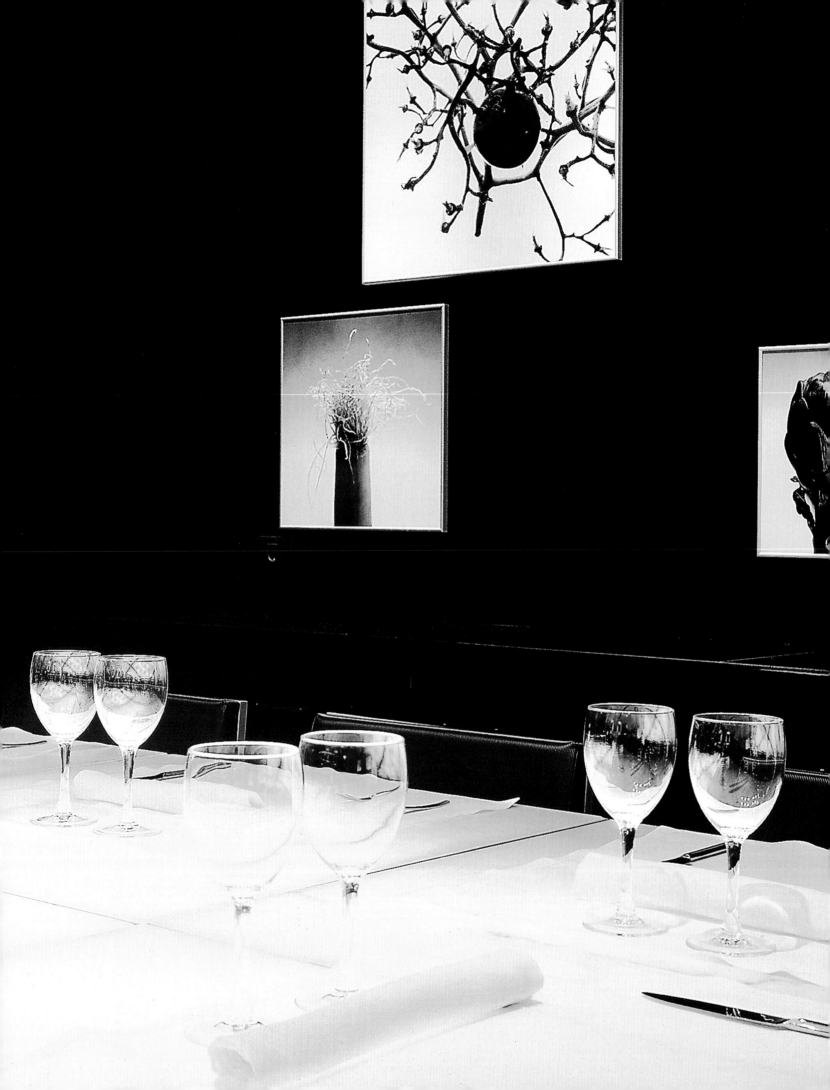

Hotel AC Pamplona · Pamplona · Spain

The refurbishment project in the restaurant of the Hotel AC in Pamplona, carried out by GCA Arquitectes Associats, was focused on two major tasks. The first was to make it easier to circulate inside the restaurant and to create independent access to the hotel proper. In the second place, an attempt had to be made to "hygienize" the space visually, with the substitution of heavy materials, such as woods or chrome-plated pieces with lighter components so that the relations established between them would be prioritized.

The project generates an abstract interrelationship where superimpositions, alternations, and contrasts are the ruling forces. The predominance of cubes is patent via the selection of a furniture scheme based on rectangular forms, but also at work here is the incorporation of stoneware (also rectangular) that, from the vantage point of the central counter, gives the appearance of overlooking the whole scene. Continuing the rectangular motif, the black-and-white photographs at one end of a multi-use table represent a true ode to abstract art. Thus, resolved by way of contrasts in whites and blacks, lights and shadows, the space is an elegant connection of presence and absence. In a large black panel projecting from the wall, a series of niches has been "excavated" to reveal the white of the wall. An absence thus becomes a presence when the missing part appears in an adjacent wall, a solution conferring it with tridimensionality.

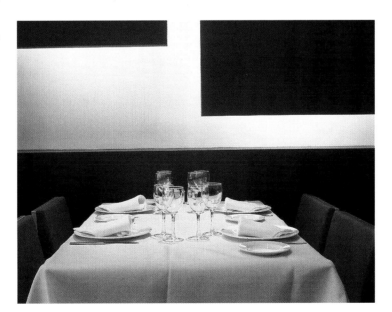

Designer **GCA ARQUITECTES ASSOCIATS**
Photographer **JORDI MIRALLES**
Location **PAMPLONA. SPAIN**
Opening date **MARCH 2002**

The lighting alternates the direct illumination of the tables with indirect sources. Lighting the panels from behind creates a three-dimensional effect that makes the project's walls its principal feature.

Red, orange, and yellow jars—displayed on a long central counter—provide striking notes of color that contrast with the project's black and white decorative motifs.

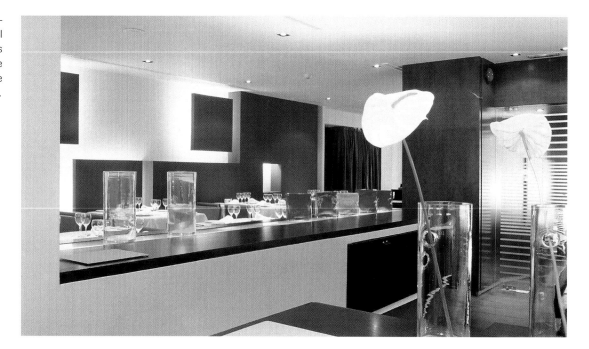

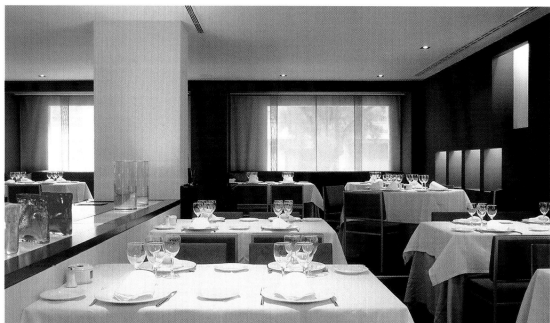

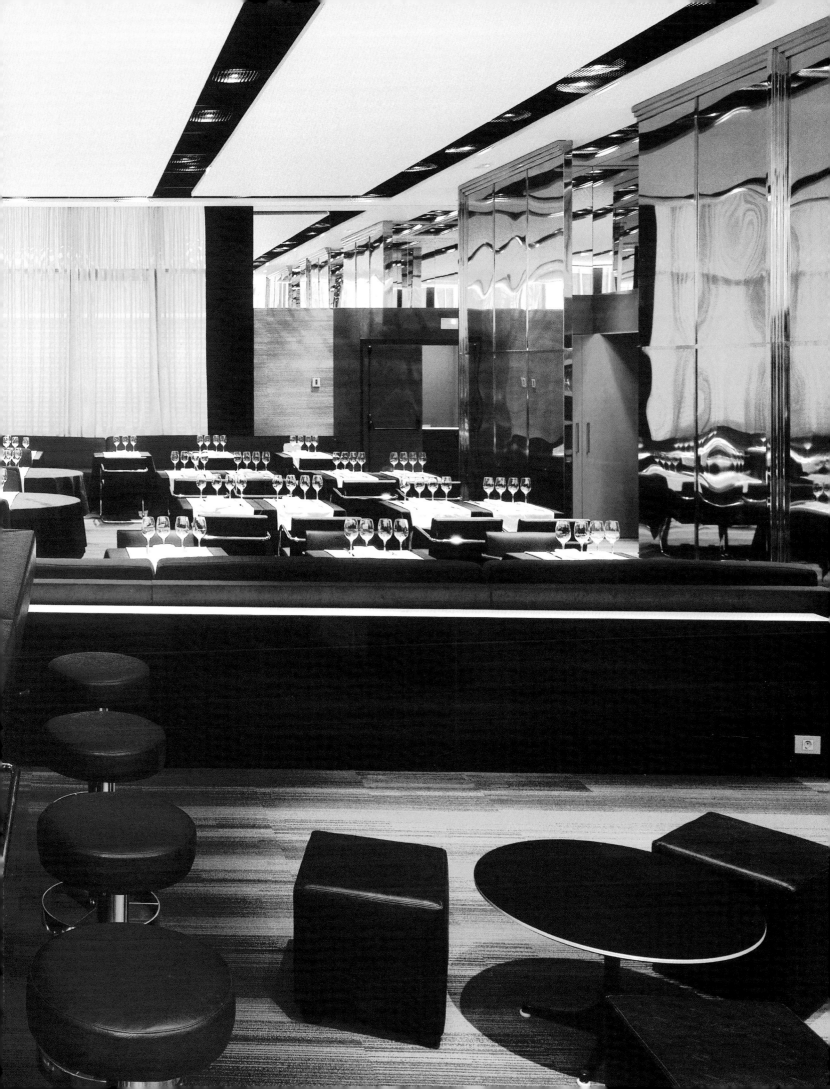

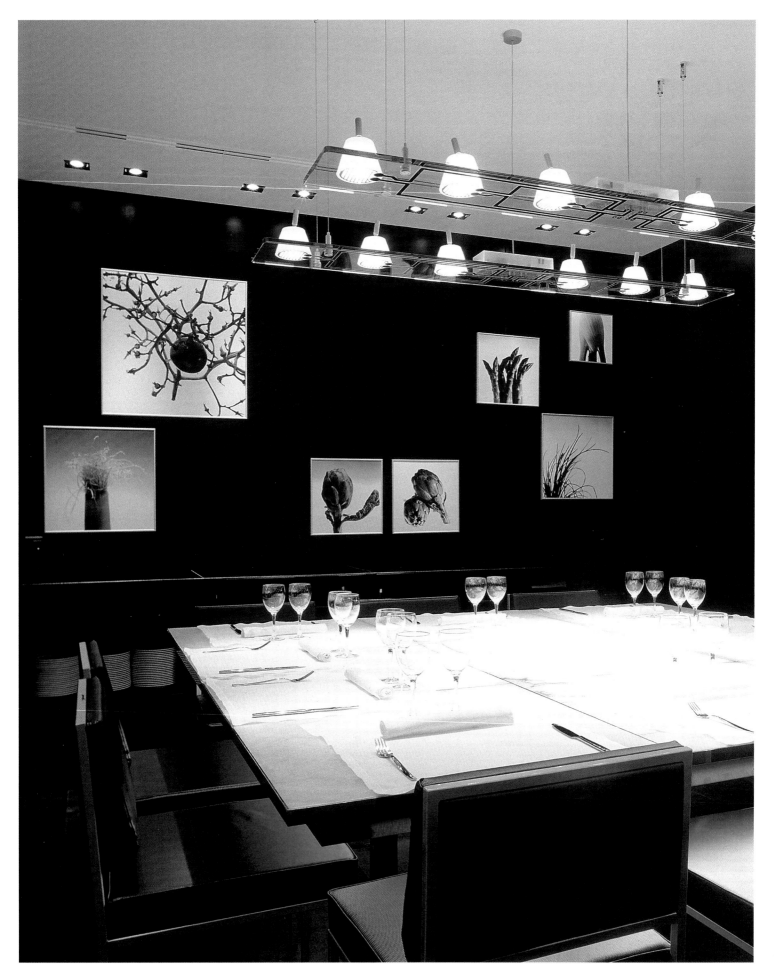

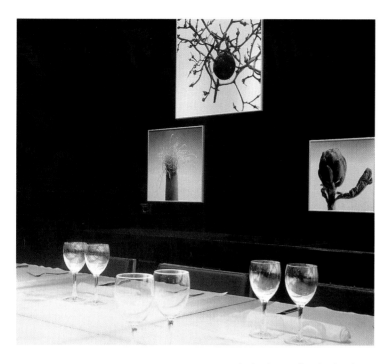

As in the walls, the furniture plays with the contrast created by alternating whites and blacks.

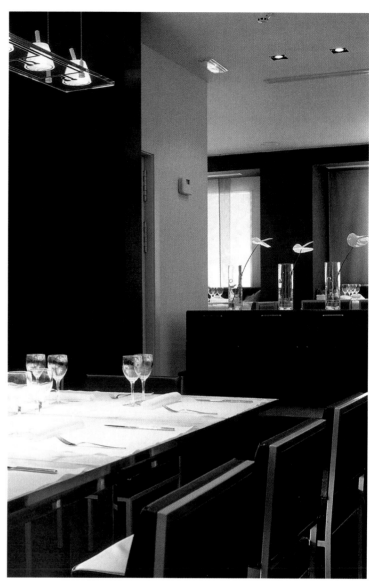

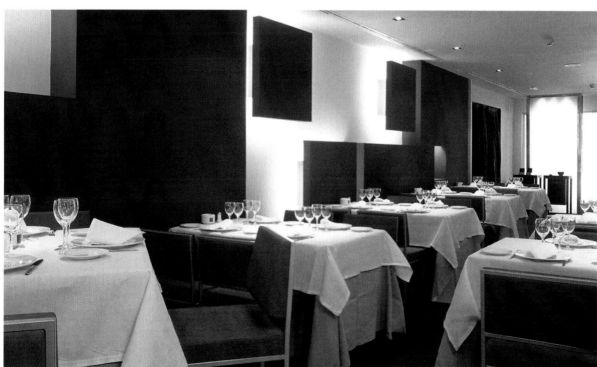

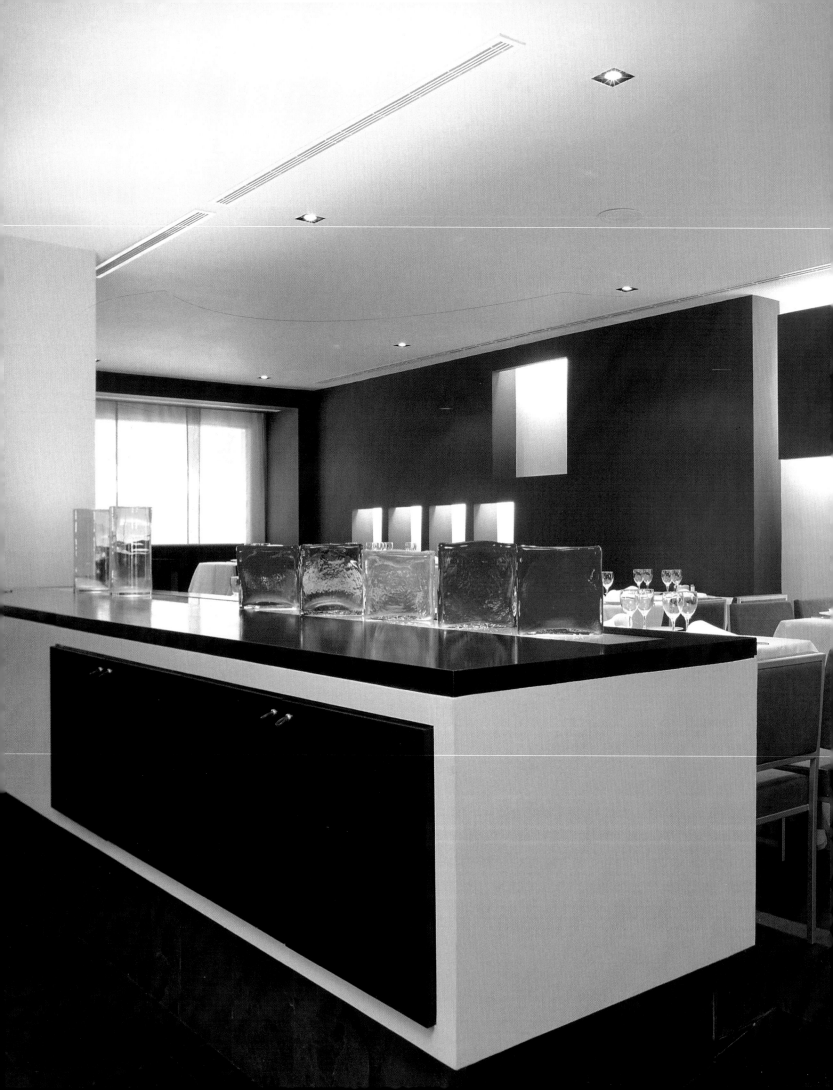

With this project, Barcelona recovers one of its most emblematic buildings. Francesc Pons converted the old headquarters of El Noticiero Universal, a newspaper where several generations of journalists worked, into a vanguardist restaurant that is both elegant and functional in design. The building in the Eixample neighborhood was originally conceived as a free-plan container linked to other spaces of the building next door. In its day, the construction was at the center of a debate hinging on whether or not buildings of contemporary cut should be incorporated into the historic centers of cities. And it is in this dialectic between the traditional and the modern that this project finds its historical justification. Pons opted for a certain plainness that would keep modernity on the far side of the evolution of fads and unify the eternal tradition/renovation antagonism.

In a juxtaposition of colors that translates into an image of modernity, panels of brass open the space and show the distorted reflection of the main lobby, offering glimpses of the red walls located just behind. In perfect harmony, the selection of black-and-white furnishings, combined with the opulent red velvet upholstery of the sofas, warms up the minimalist aesthetic. The interior of the El Noti building is reminiscent of the stage of a theater built from a collage of sumptuous materials such as red velvet, Japanese silk, brass, and Formica—a parade of traditional materials inspired by the past and used by Pons to re-create his particular vision of glamour.

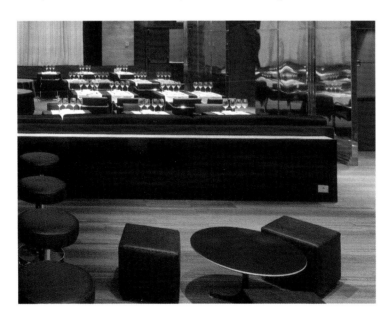

Designer **ESTUDI FRANCESC PONS**
Photographer **RAIMON SOLÀ**
Location **BARCELONA. SPAIN**
Opening date **NOVEMBER 2002**

The cuisine, in the hands of Christian Crespin, follows the same line of thought as the restaurant's interior design: traditional and sophisticated at the same time. A visit to El Noti turns into a multisensory experience that combines aromas, taste, and staging.

Attention to detail and an absolute passion for elegant materials comprise the personal stamp of Francesc Pons' designs, replete with references to a sumptuous and romantic past.

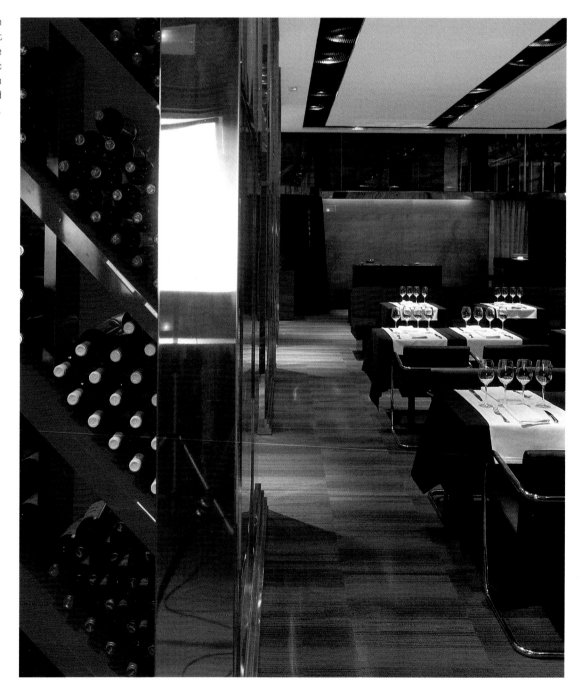

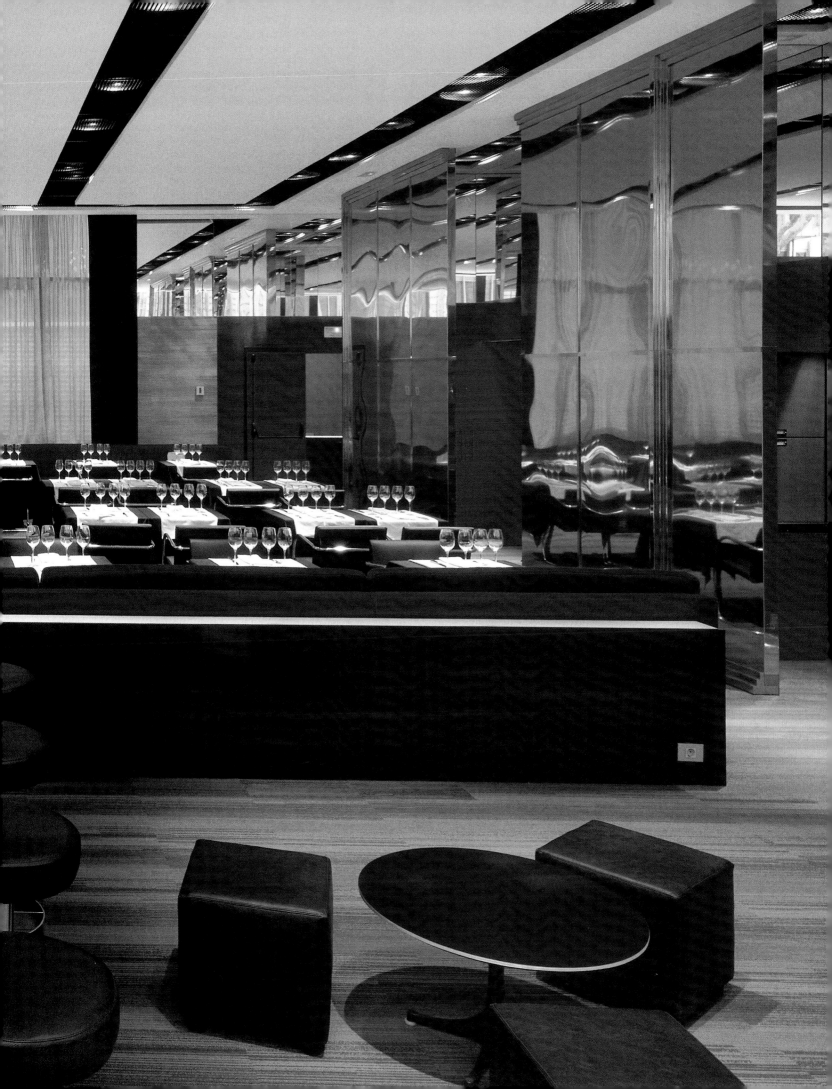

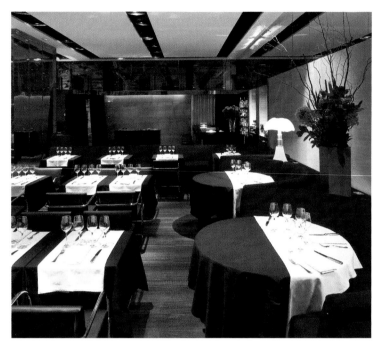

Trichromatic furniture bestows a classical plainness on this interior that is compensated by the brass panels, which are, in their turn, central images of modernity.

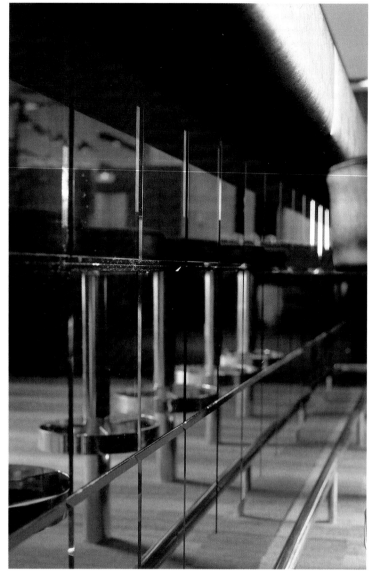

Basement plan

First-floor plan

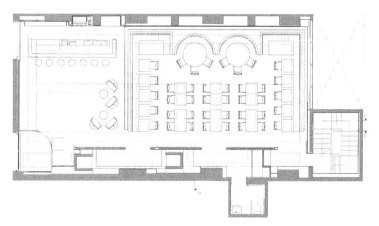

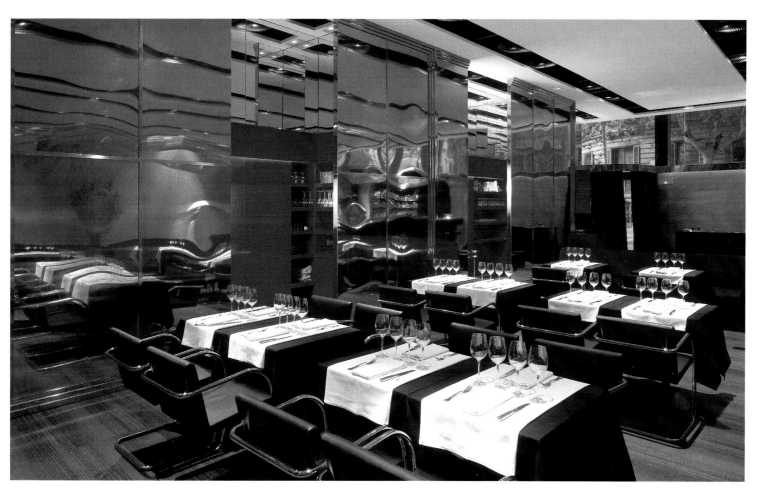

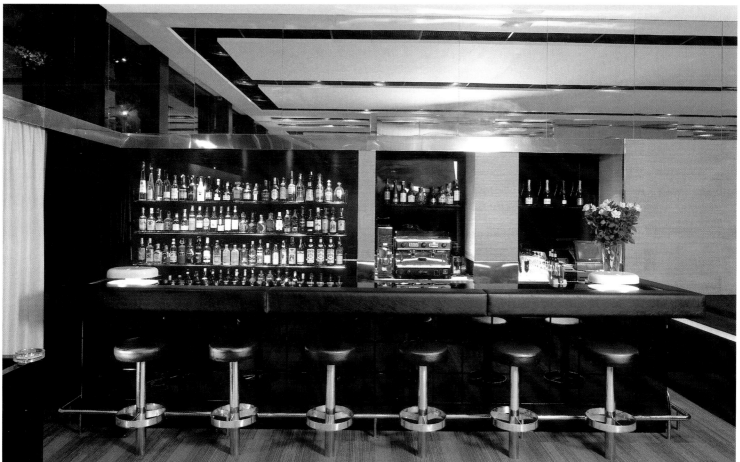

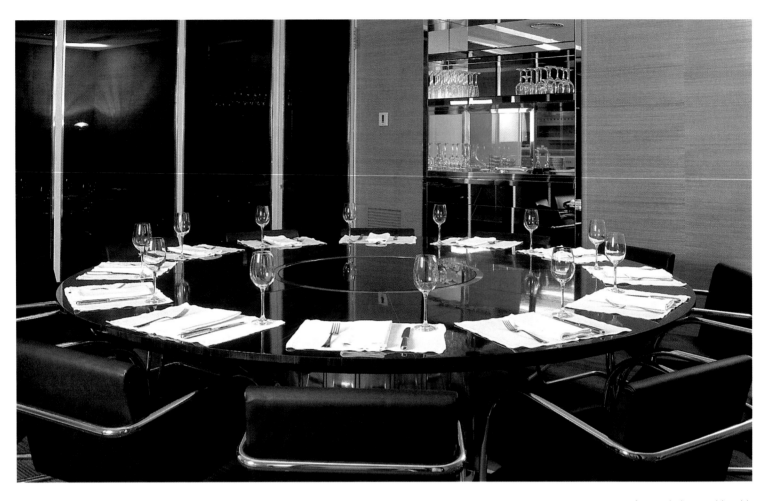

A round ebony table with
a seating capacity of 12 people
occupies the center of a private
dining space that opens onto
the kitchen via a mirror-lined
buffet room.

Section

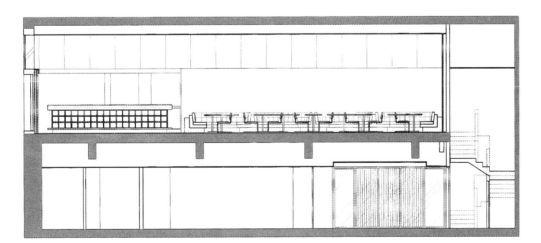

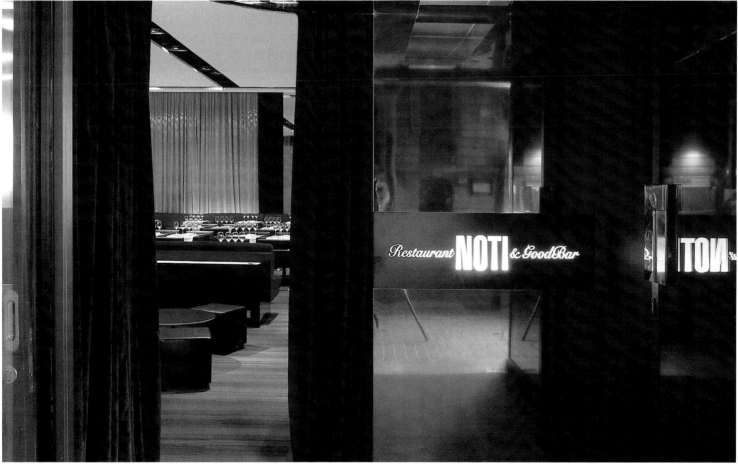

Neri · Barcelona · Spain

The 2,000-year history of Barcelona is brought to life in this new project created by Damià Ribas and Juli Pérez-Català in an 18th-century mansion in the heart of the city's Gothic Quarter, very close to the old Jewish Quarter.

Finding a way to connect the many historical and artistic references concentrated in the environs of Neri was one of the challenges faced by the creators of this project from the very start. Rehabilitated in a way that respects the peculiarities of its architecture, Neri boasts an atemporal aesthetic that conflates the original 18th-century materials with vanguardist, decorative elements. In the entranceway, an enormous contemporary lamp of circular design has been placed right beside the centenary stones. The interior decoration of the restaurant, which looks onto and actually accesses the picturesque Plaça Sant Felip Neri, stands out because of the two 17th-century arches preserved from the original edifice. The arches now provide an impressive entryway to the main room, at the far end of which an oversize steel mirror attracts the viewer's eye. The walls are covered with thick dark velvet curtains matching the original asymmetric chairs, which are upholstered in the same material. The dining room, with a seating capacity of 35 guests, also includes a private room for celebrations. Both spaces have the advantage of indirect lighting and thus reap the benefits of a certain intimacy.

Designer DAMIÀ RIBAS, JULI PÉREZ-CATALÀ
Photographer ANA MARIA LÓPEZ SOTOMAYOR
Location BARCELONA. SPAIN
Opening date JULY 2003

The Roman, medieval, and contemporary ages meet in this eclectic space that pays homage to the building's historical development.

A medieval flair is perceptible in this space, but is sporadically interrupted by contemporary decorative motifs.

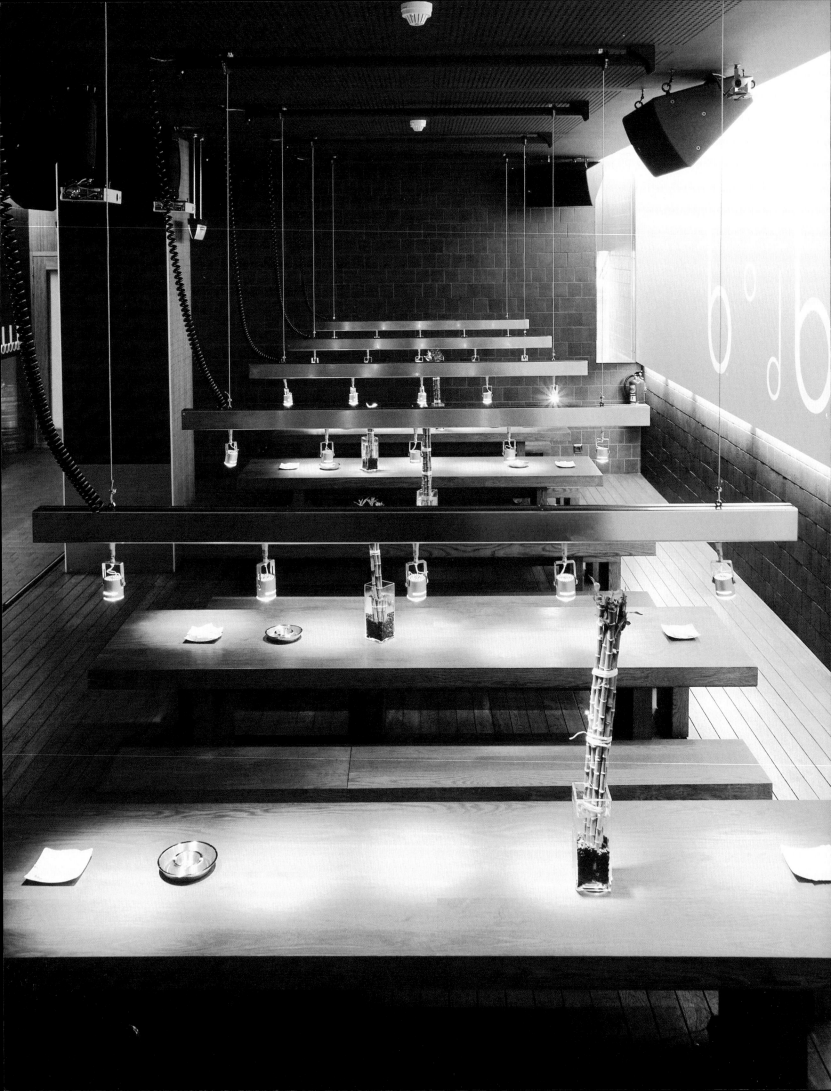

Dodoclub · Pamplona · Spain

The mechanics of consumerism today tend to turn natural, everyday activities into genuine rituals, whose purposes are to immerse us in a kind of spectacle for the senses. This is precisely the aim of Dodoclub's interior design: to focus attention on the spectacle of the activities that take place in a restaurant, from the kitchen to the wine cellar. In terms of form, the designers sought to create a neutral space that would focus on these activities. Geometric shapes, pure strokes, and straight lines converge on the work area, the authentic epicenter the architecture of the space is designed to serve. Public and service areas run parallel to one another throughout the length of the restaurant, with the service area as the thematic background, and thus spectacle, for the diners.

In the first space, where the bar is the focal point, long tables with lamps hung lengthwise over them form a dining area for groups by day and a bar area by night. To facilitate this change in function, both furniture and lighting have been designed to "disappear." At night, the lights are raised all the way up to the ceiling and the movable tables are stored under the stage. A dark stone tunnel leads to the second space, this time thematically connected to the kitchen, and like the first zone, plays a double role: private dining room by day and lounge bar by night.

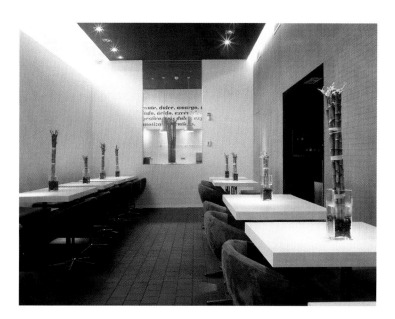

Designer **ENRIQUE KAHLE, ANA GONZÁLEZ**
Photographer **ALFONSO PERKAZ**
Location **PAMPLONA. SPAIN**
Opening date **FEBRUARY 2003**

The graphics on the walls and the vases adorning the tables are the only decorative features of this interior, which is both subdued and warm. At the Dodoclub, the service areas play the leading roles.

Lamps are hung lengthwise at eye level, creating a sensation of intimacy that counteracts the feeling of empty space.

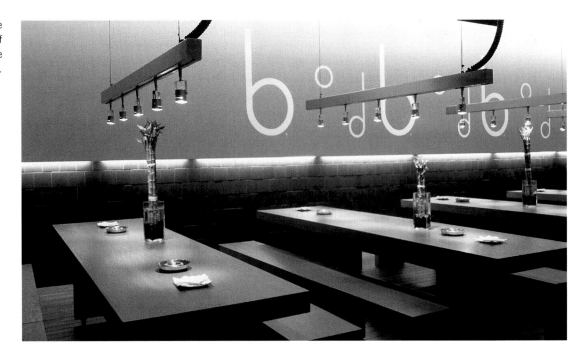

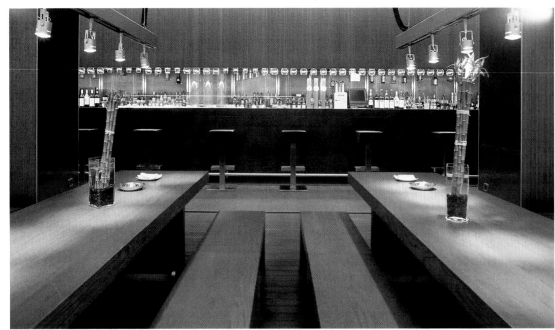

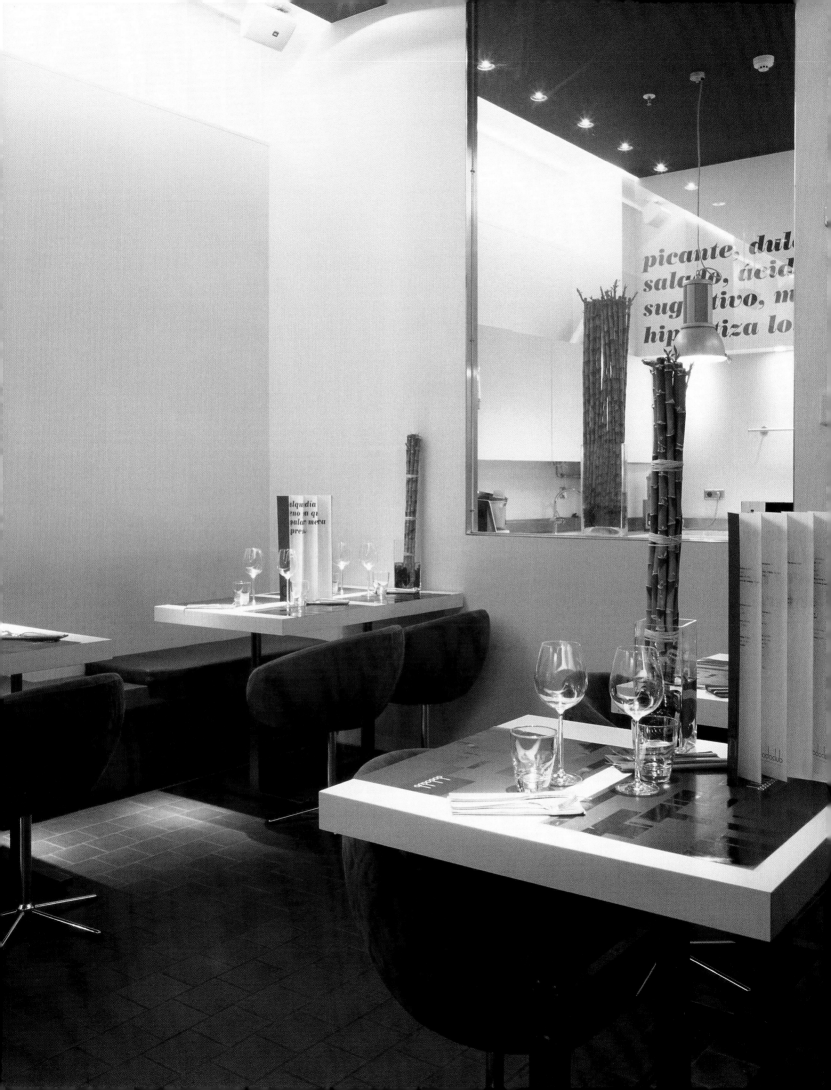

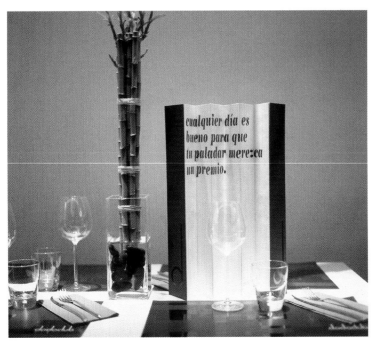

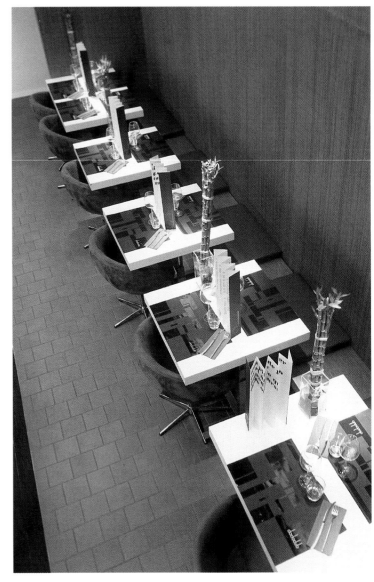

The vases on the tables provide the only touch of color in an interior that favors grays and browns.

Floor plan

Elevations

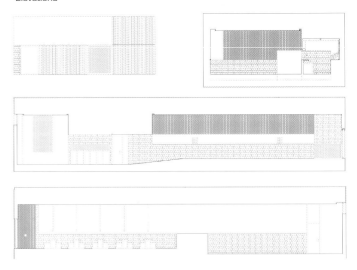

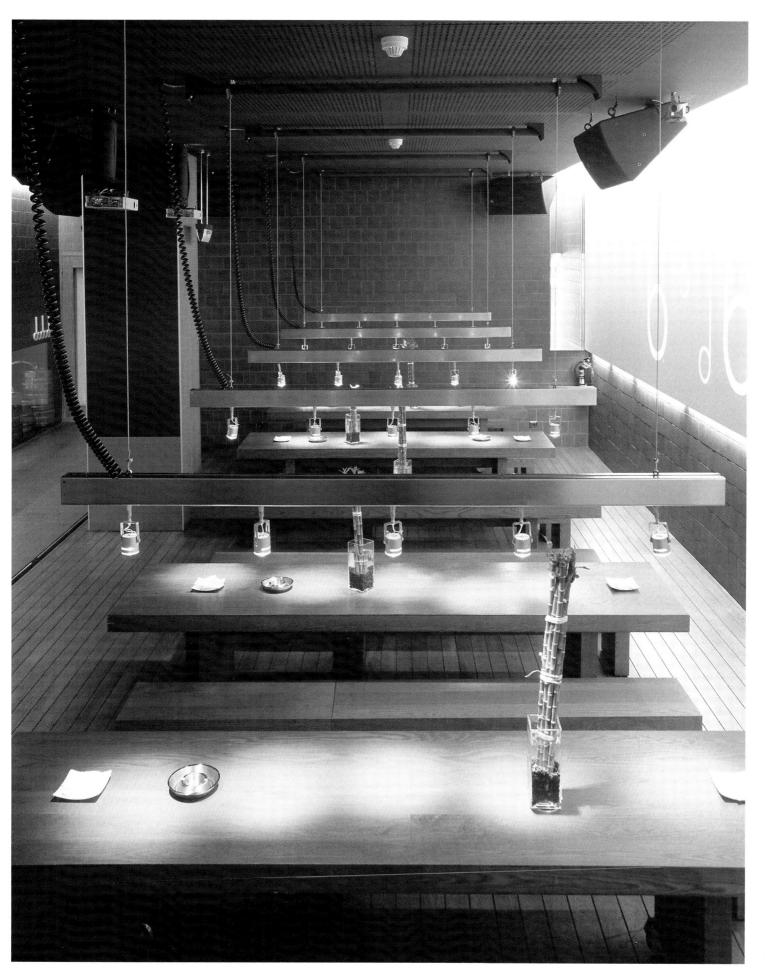

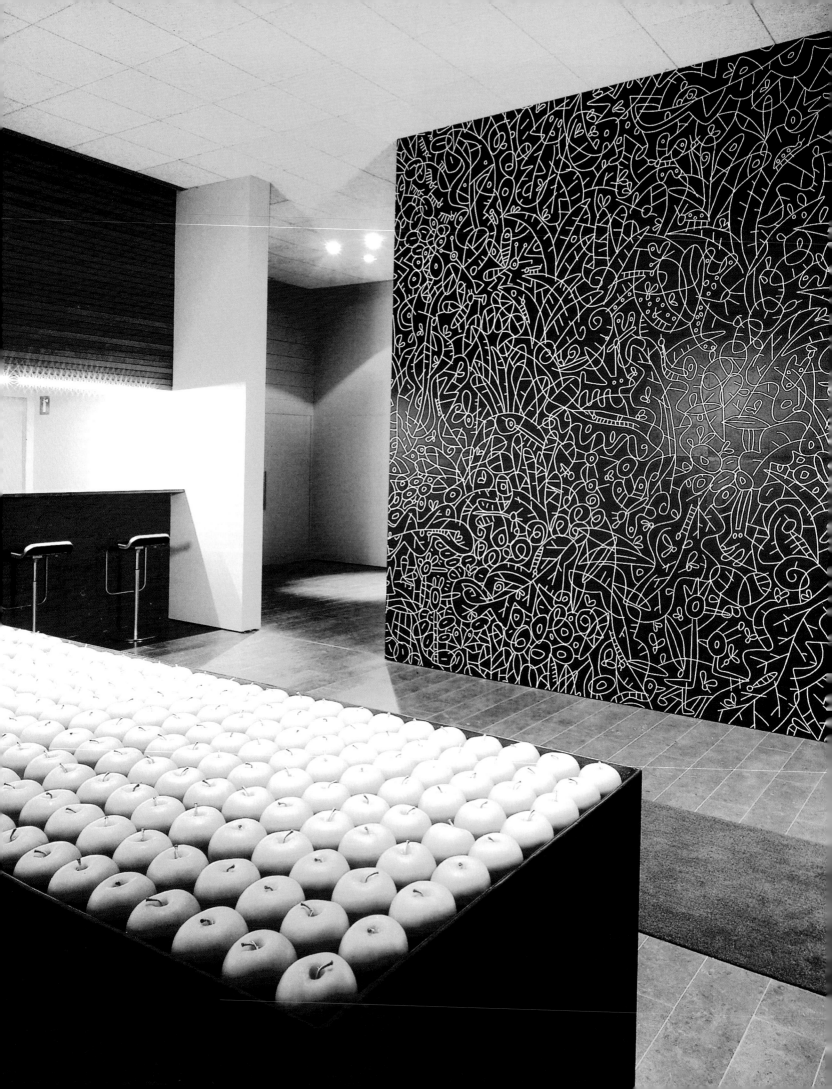

Naturalment.e · Barcelona · Spain

We are, among other things, what we eat. Bringing about a balance between mind and body is the main proposal of this new project, as can be seen in the pun involved in its name. Naturalment.e is the culture medium of a natural mind, reading natural as the basic, the absence of any ornamentation. But natural can also mean adaptation to the environment and, thus, the incorporation of technology. The design of this project presents a space where technological advances are not at odds with the natural. Traditional materials such as wood contrast with the use of metallic structures, in juxtaposition with earth colors and acid greens. The configuration of the main room is based on the subdivision of a large space via wood lath dividers. These separate the tables to bring about a sense of intimacy among the diners. The bar counter, also metal, flows along one side and ends at an immense 13- by 26-foot mural by Javier Mariscal. The mural is a work of black lines on a white background, and it finds its negative in a mural of white lines on a black wall, a sort of joining of opposites that sums up the philosophy of this project.

Fernando Salas chose a space of pure geometric forms. The main color content is provided by a long container filled with apples as acid green in color as Naturalment.e's logo.

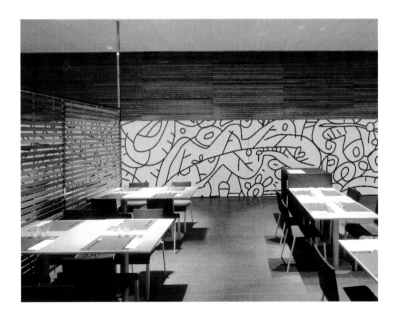

Designer **ESTUDIO FERNANDO SALAS**
Photographer **EUGENI PONS**
Location **BARCELONA. SPAIN**
Opening date **SEPTEMBER 2003**

Subtlety is the greatest virtue of this project, which elevates the plain both in its décor and in the contrasts it incorporates. The abstract lines of the murals join the bright colors of the logo and the tray of apples as the only decorative elements, immersed in a universe of calm.

The room dividers, made of wood, find their corresponding elements in the strips on the upper part of the bar counter.

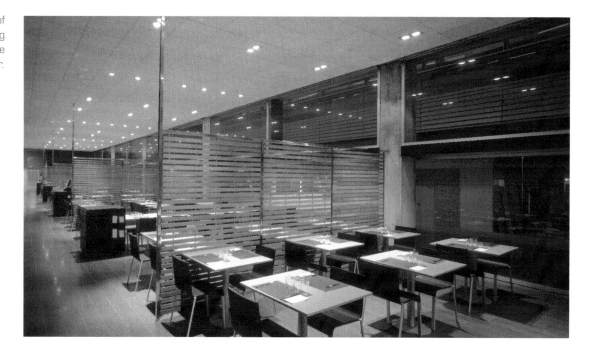

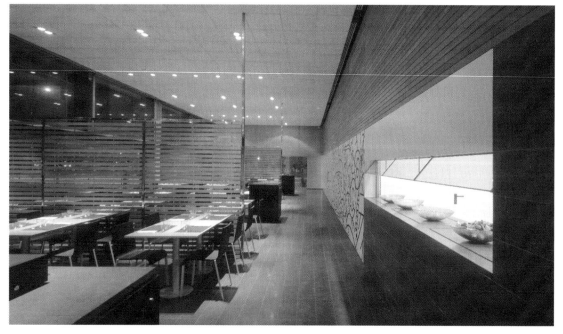

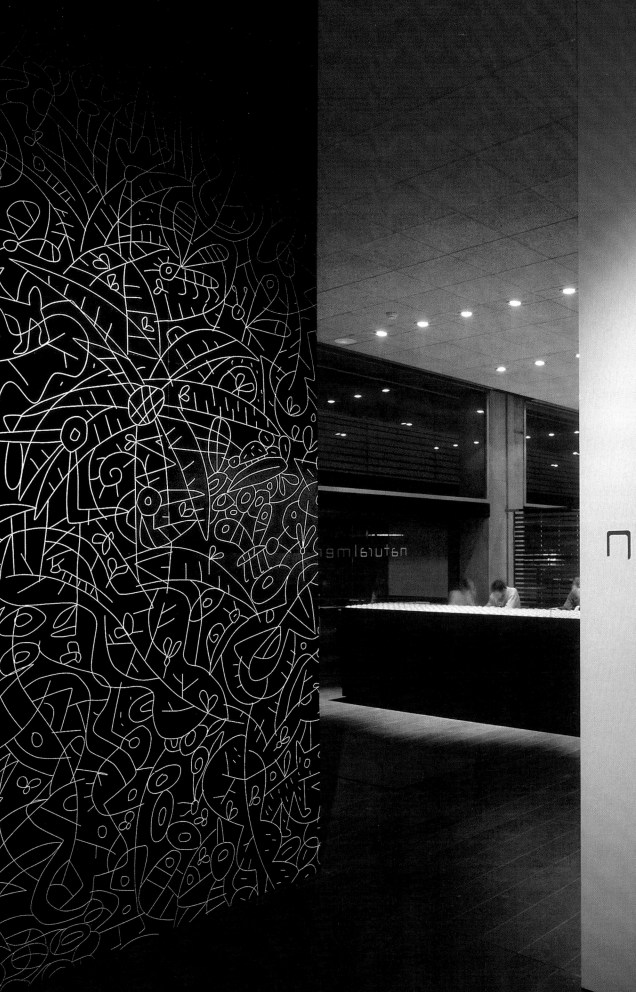

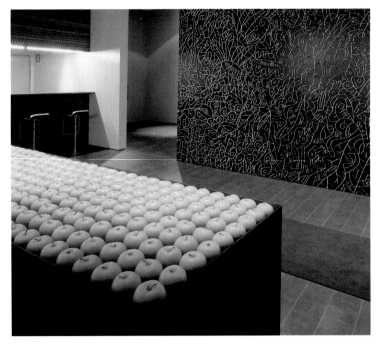

The enchantment of subtlety resides in the intelligent combination of colors and forms, reflected in the project's alternation of wood with the black and white of newer materials.

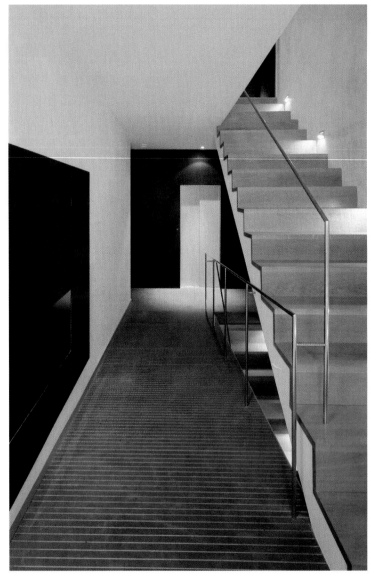

Floor plan

Elevation

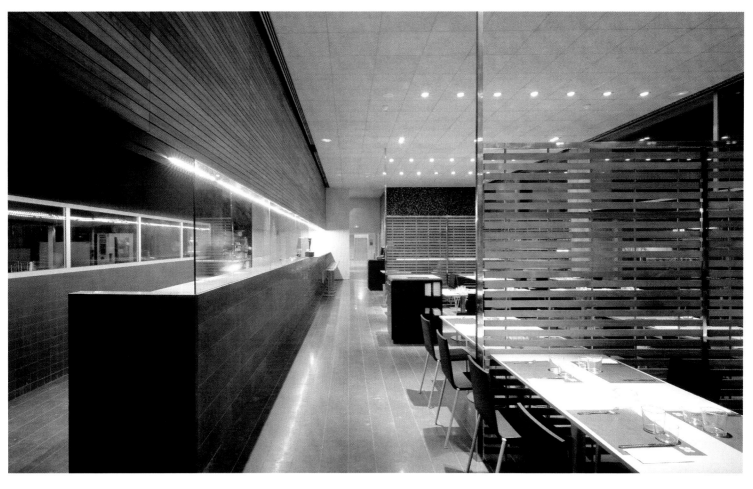

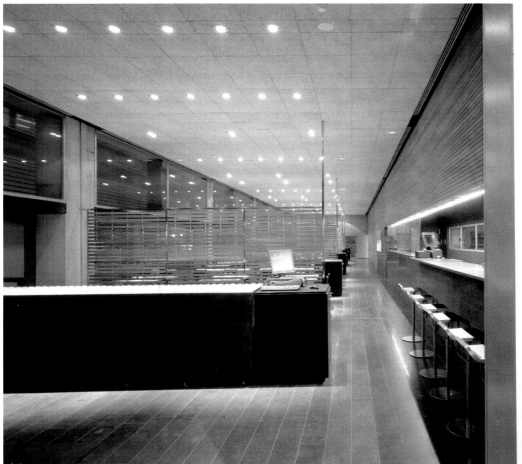

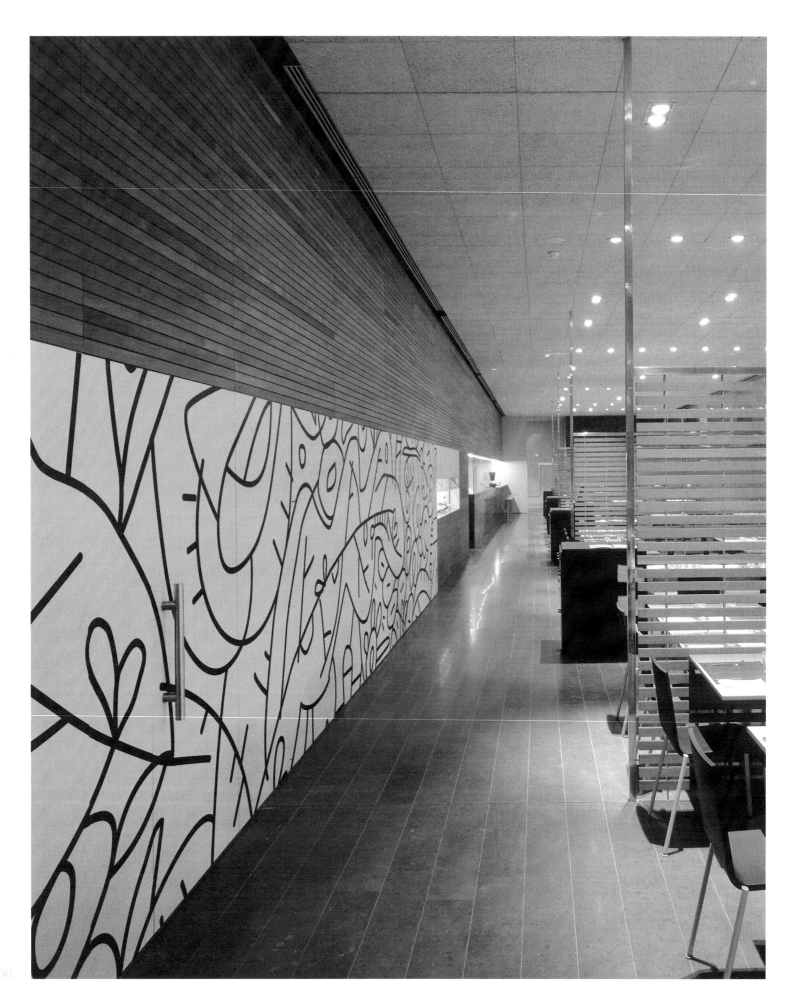

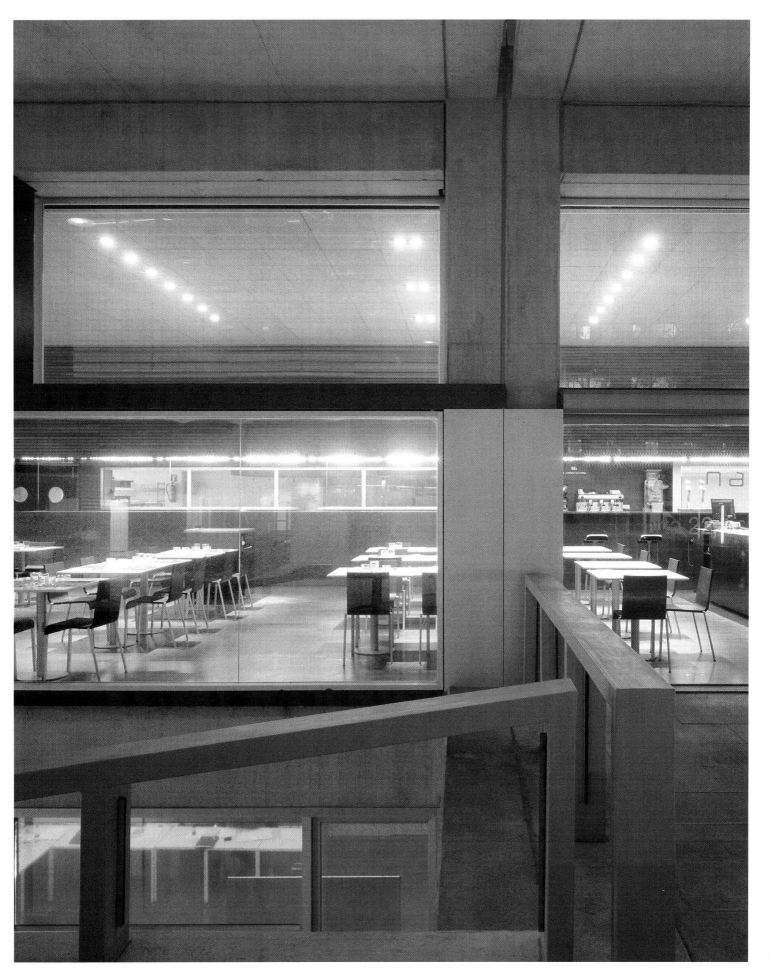

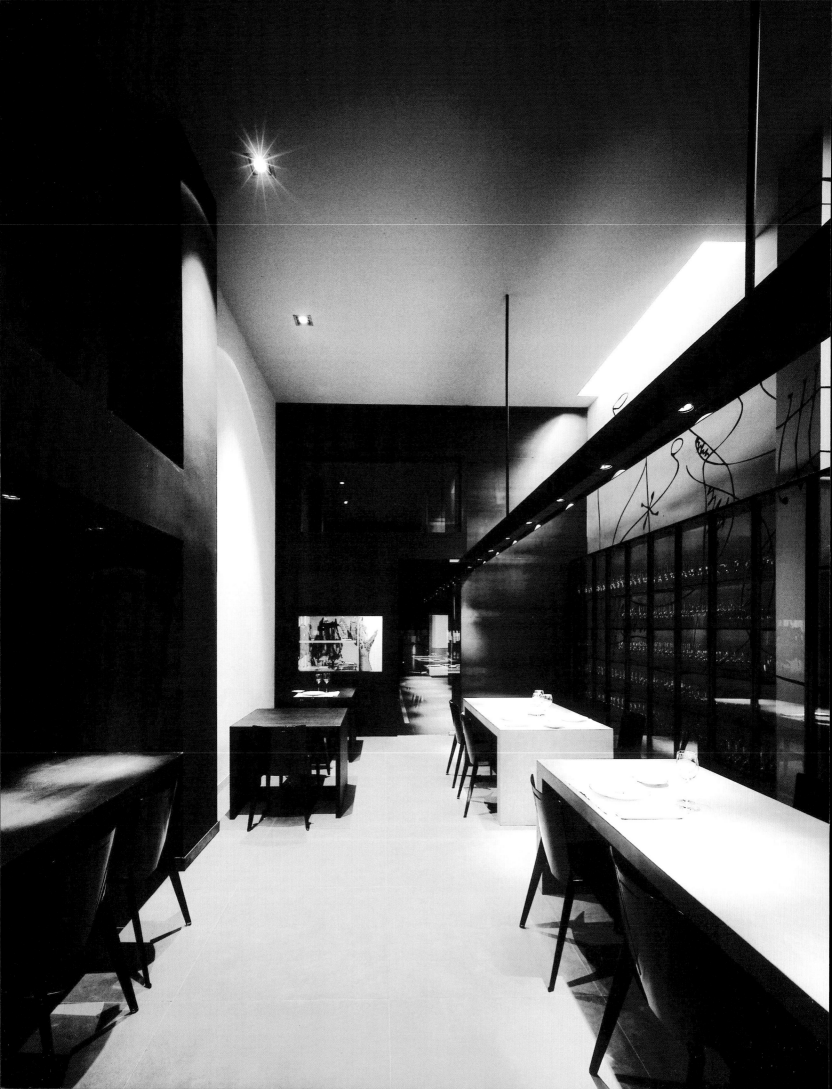

Can Fabes · Sant Celoni, Barcelona · Spain

At Can Fabes, the old rubble-work building of stone and wood has been widened, and to this nucleus another cubical structure has been added. This new part has been faced in limestone and steel mesh to enable a subtle use of transparency, the real protagonist of the project, and to open up the interior of the edifice. Thus, the basis for refurbishing the Can Fabes restaurant was to substitute three key materials of the old building—the stone rubble, the old wood, and the copper (a typical Catalan element)—with blocks of limestone, reused oak, and sheet iron, respectively. Finally, cauldron-colored laminated glass was used as a physical representation of fire, a key kitchen element that serves as a connecting thread throughout the other spaces. The new dining room is structured around a central stairway that leads to the wine cellar. Finished in orange plate glass, this structural element becomes one of the most important decorative pieces of the whole renovation. With a capacity of 8,000 bottles, the cellar is projected via a system of shelves delimited by a window that makes it possible to observe the bottles from outside. The spotlights illuminating the cellar are installed in the floor so as not to damage the content of the bottles.

Shades of black, gray, and white unite in this proposal to create an unassuming color scheme inside a set of rectangular spaces, generating austerity and luxury at the same time.

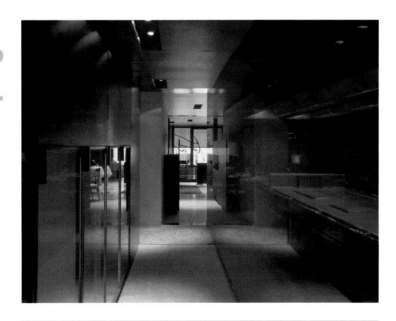

Designer **FRANCESC RIFÉ**
Photographer **EUGENI PONS**
Location **SANT CELONI, BARCELONA. SPAIN**
Opening date **NOVEMBER 2003**

The orange glass in the stairway is the only note of color in a space that features a striking juxtaposition of black, gray, and brown tones.

The plain limestone is distinguished as a low-key decorative device by the inclusion of abstract drawings on the wall.

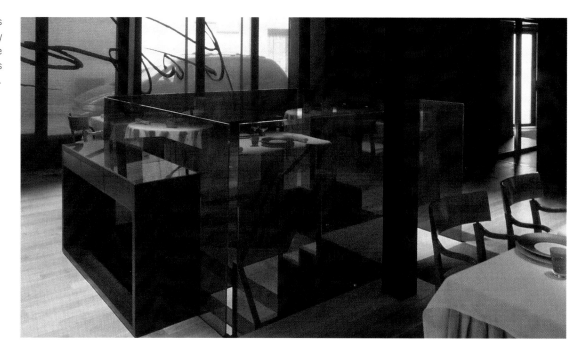

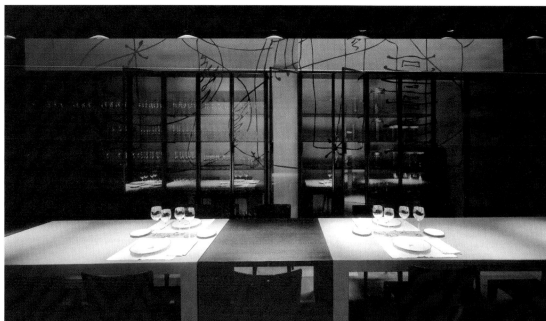

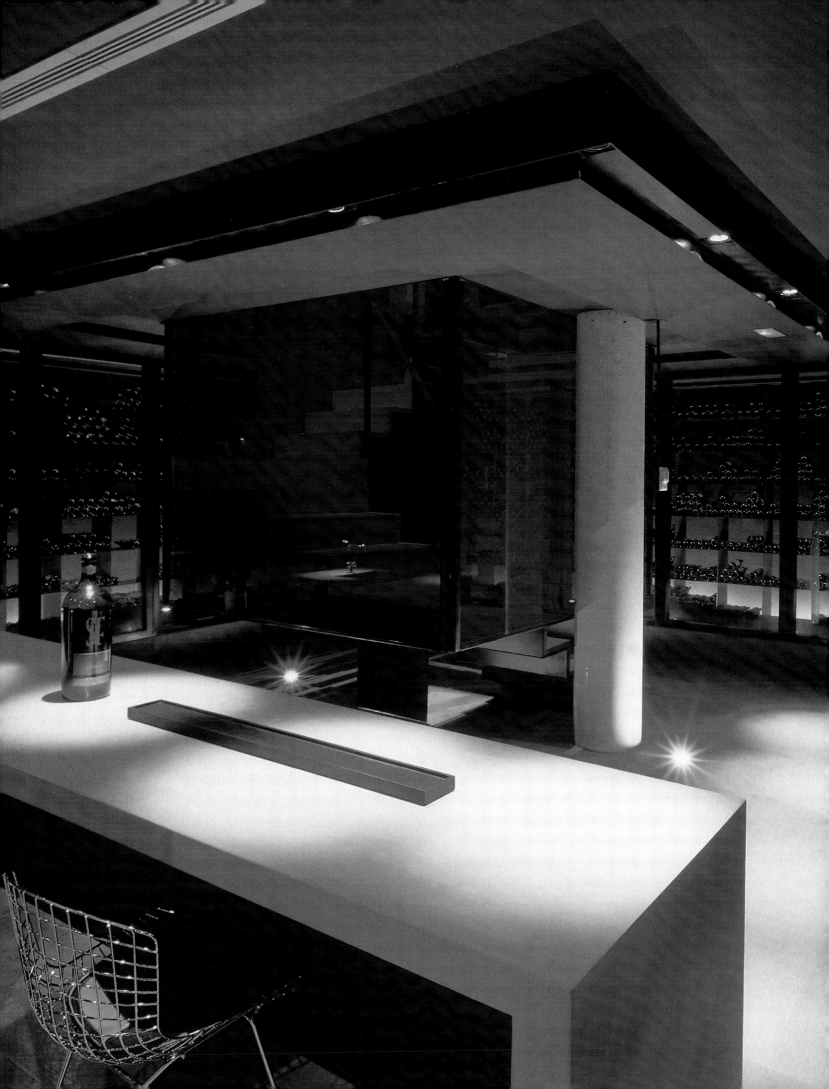

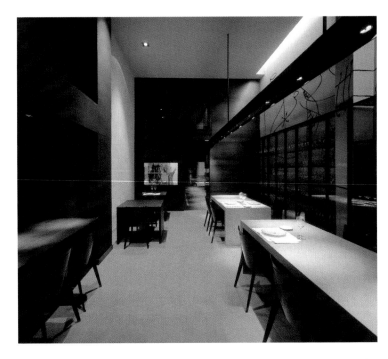

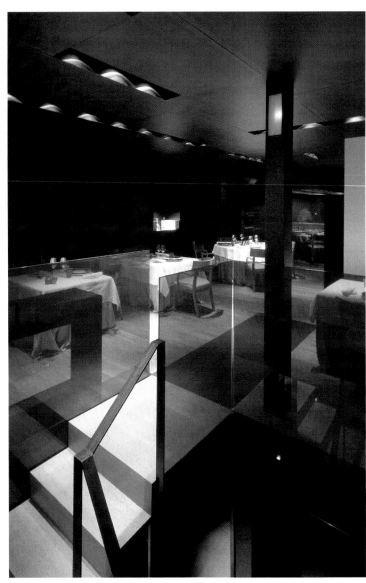

The stairway connects the central dining room to the wine cellar, where the arrangement of the bottles creates a set of motifs reminiscent of an abstract painting.

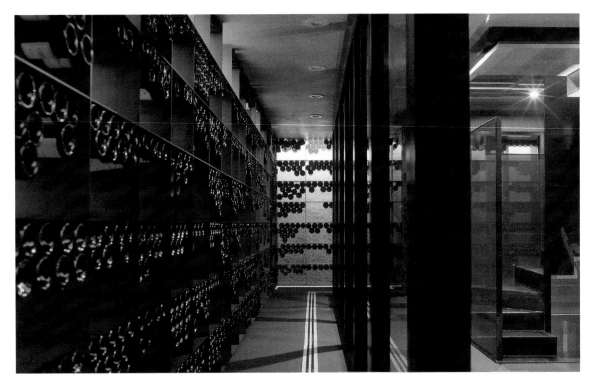

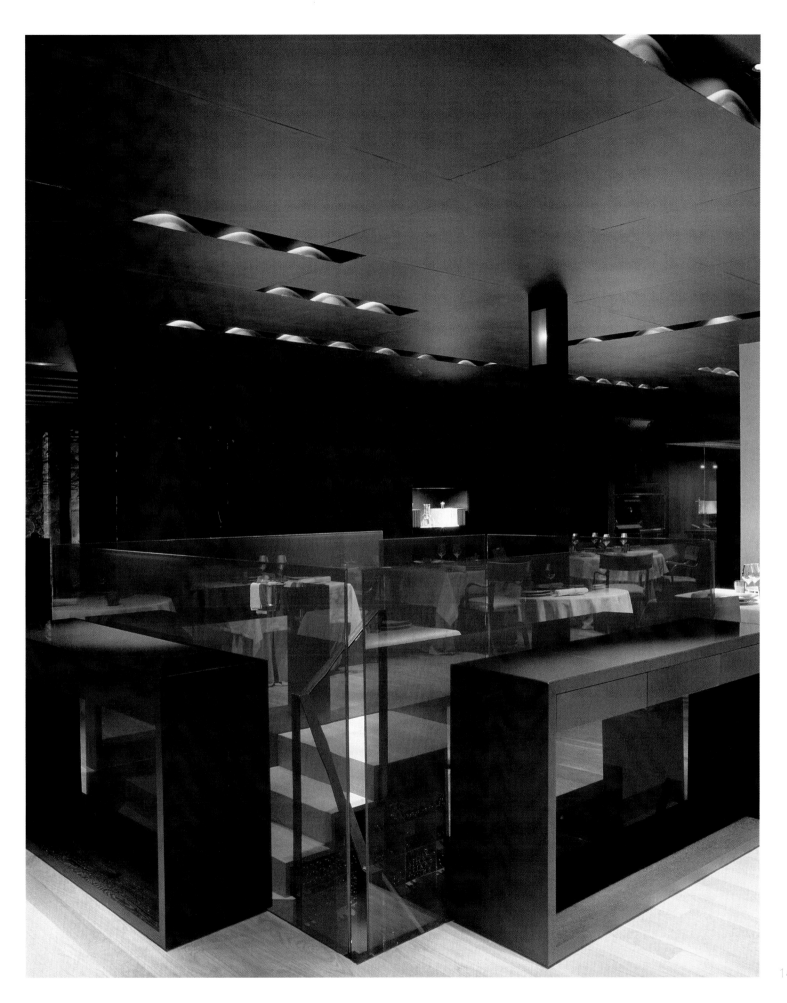

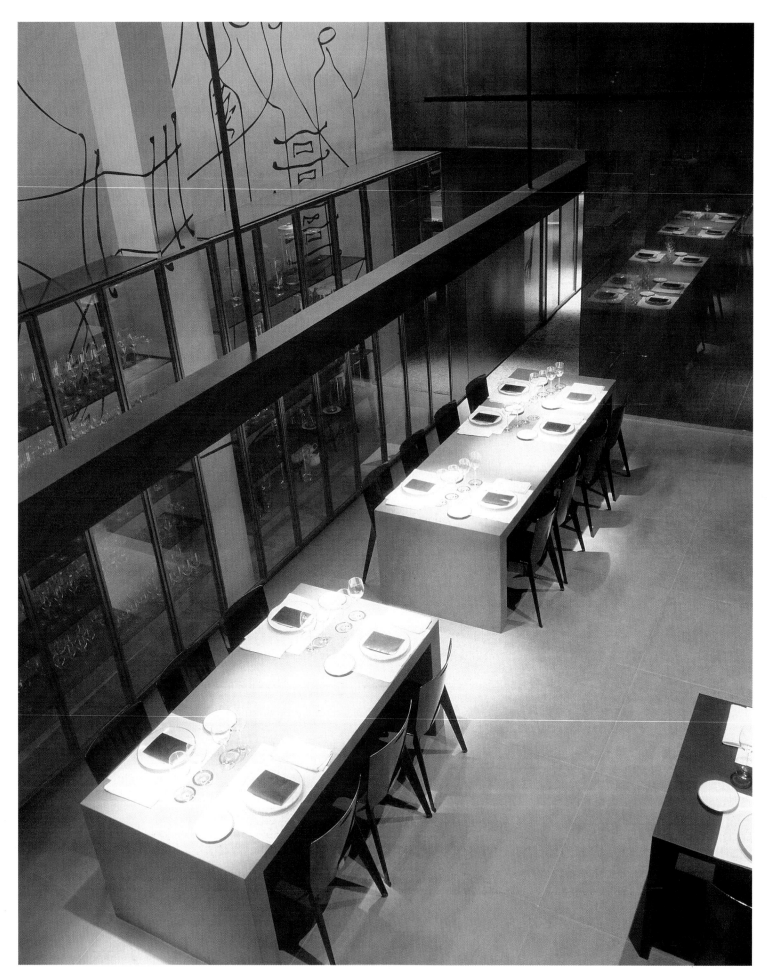

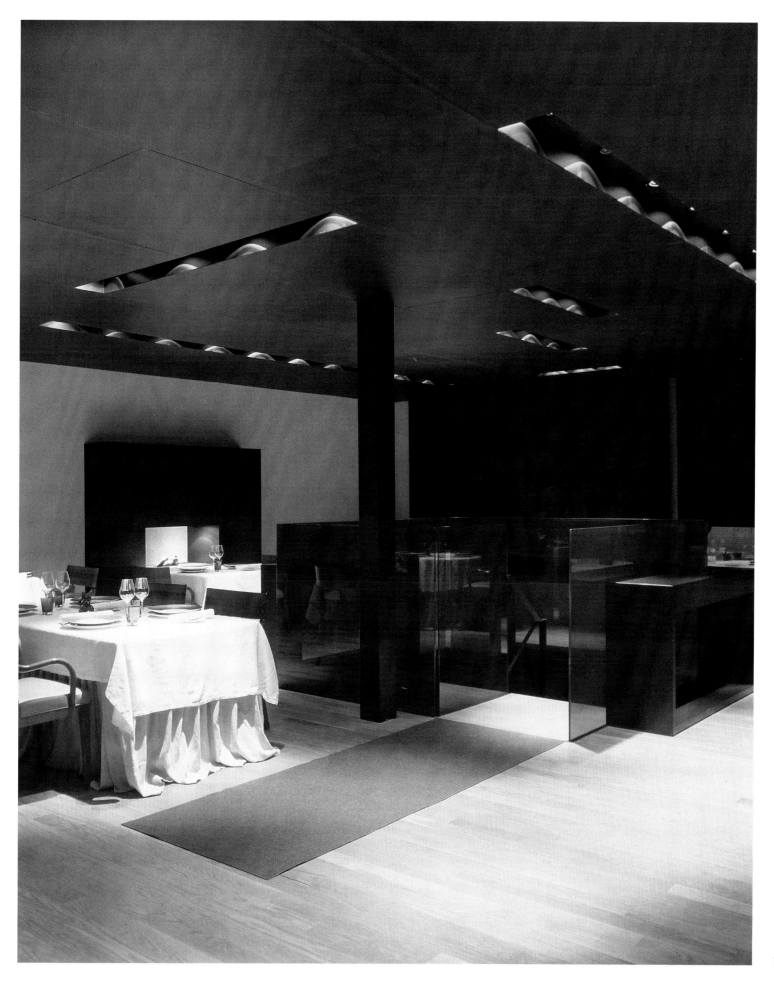

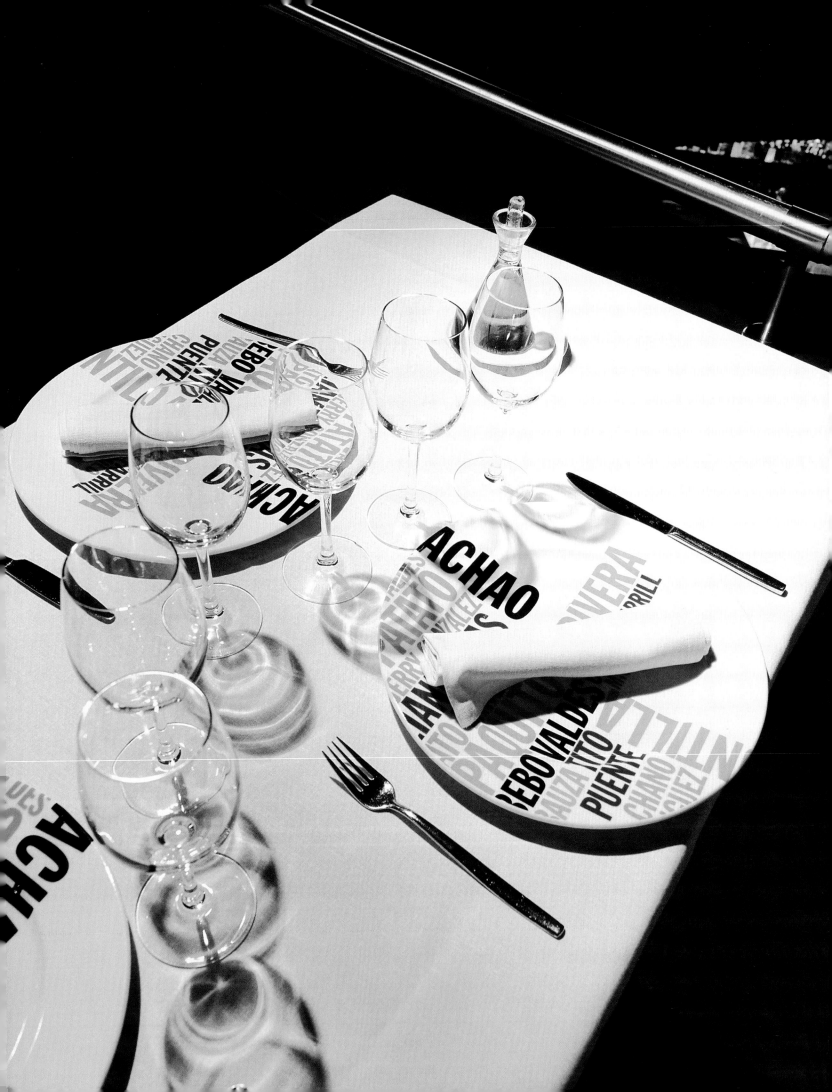

Calle 54 · Madrid · Spain

The streets of Havana and the Latino neighborhoods of New York and Miami are theatrical landscapes—staged yet somehow dramatic—and this aspect pours into what Javier Mariscal and Fernando Salas have projected in Calle 54. Its interior comes from the same spirit that inspires Latin jazz, using that iconography and echoing the same mania for myth that it conjures up.

The furnishings and settings of the restaurant respond to this character, which can also strike an informal note. Ron Arad's Plastic Elastic chair—a lilac, red, and yellow piece—functions as a spot of color enlivening the space. Downstairs, the bar is that much more striking thanks to the special series of caricatures of musicians, done by Mariscal himself and digitally reproduced on a backlit surface behind the bar. It pays homage to the great mythical figures of the jazz world who, like a lamp, shine out in a range of warm colors in the graphic tradition Latin jazz has generated since its earliest days. But doubtless the most relevant element in this project is a typographic mural that serves as a conducting thread through the bar's three floors. The mural features the names of jazz geniuses printed in relief—with three different line widths—on a black background. As with the stars' names displayed at Hollywood's Chinese Theater, these names give the

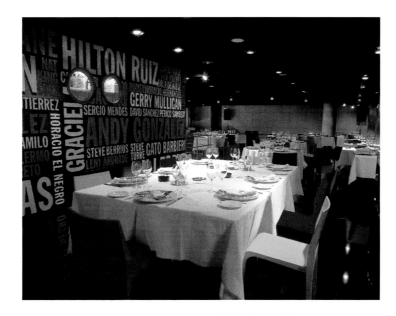

Designer **BIARQUITECTOS, ESTUDIO MARISCAL**
Photographer **JUAN CARLOS TORRES**
Location **MADRID. SPAIN**
Opening date **APRIL 2003**

Calle 54 is located inside a black box, an image inspired by jazz. Screaming colors evoke icons such as bumper cars, nightclub neon, American bars, and jazz caves.

Graphics are present in all of the settings of this locale, from the mural to the dinner service, and they coordinate with the colors of the chairs.

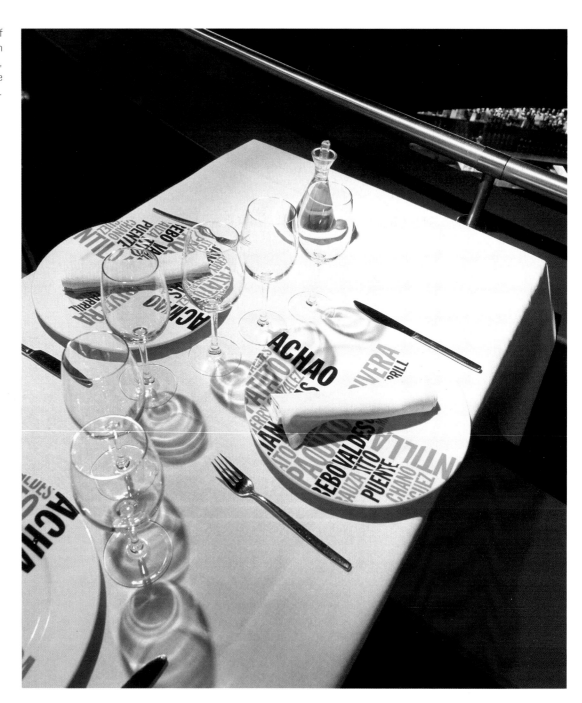

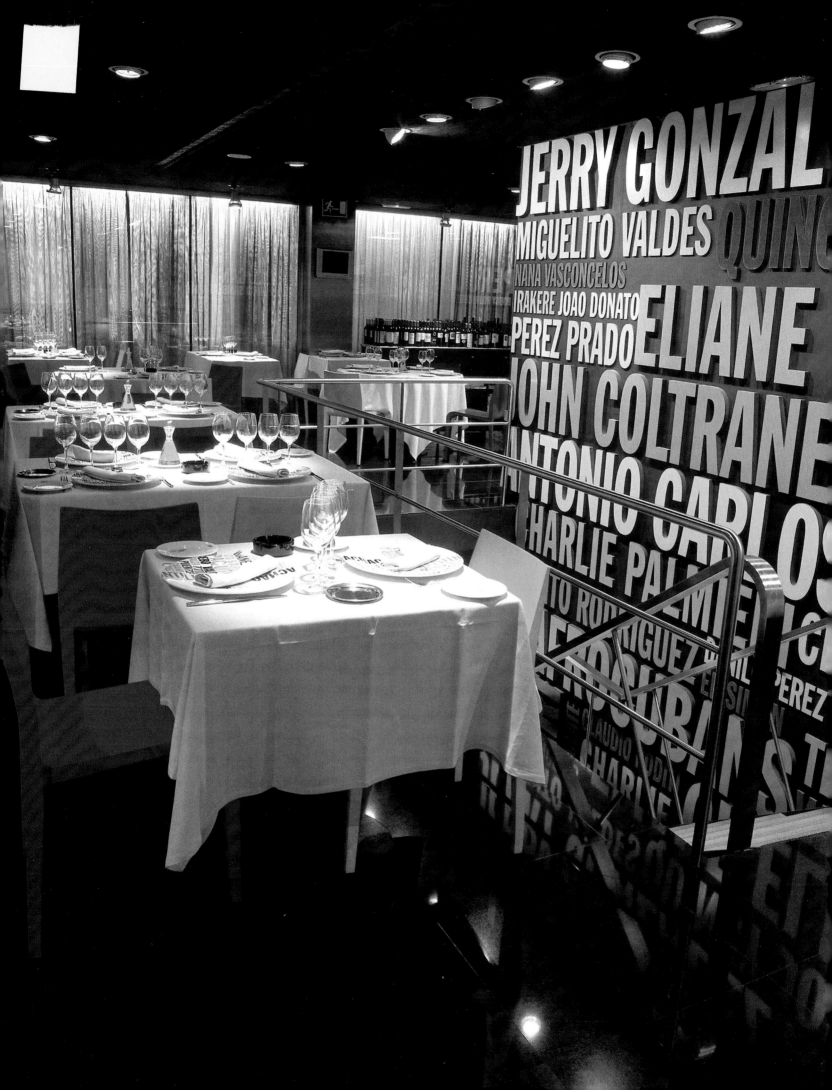

At one point, a stage inspired by
the Fender guitar pick rises up.
The back of the stage includes
two backlit screens with a
rhomboid pattern, an image
that serves as an icon for the
carnival stands and Cuban
supermarkets of the 1950s.

First-floor plan

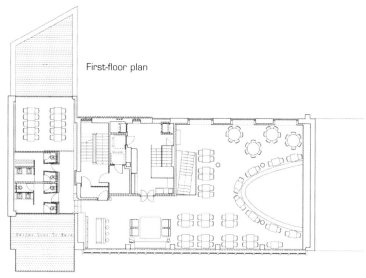

Basement plan

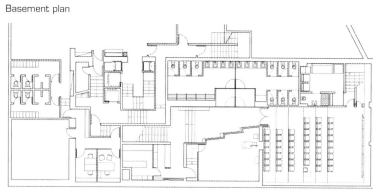

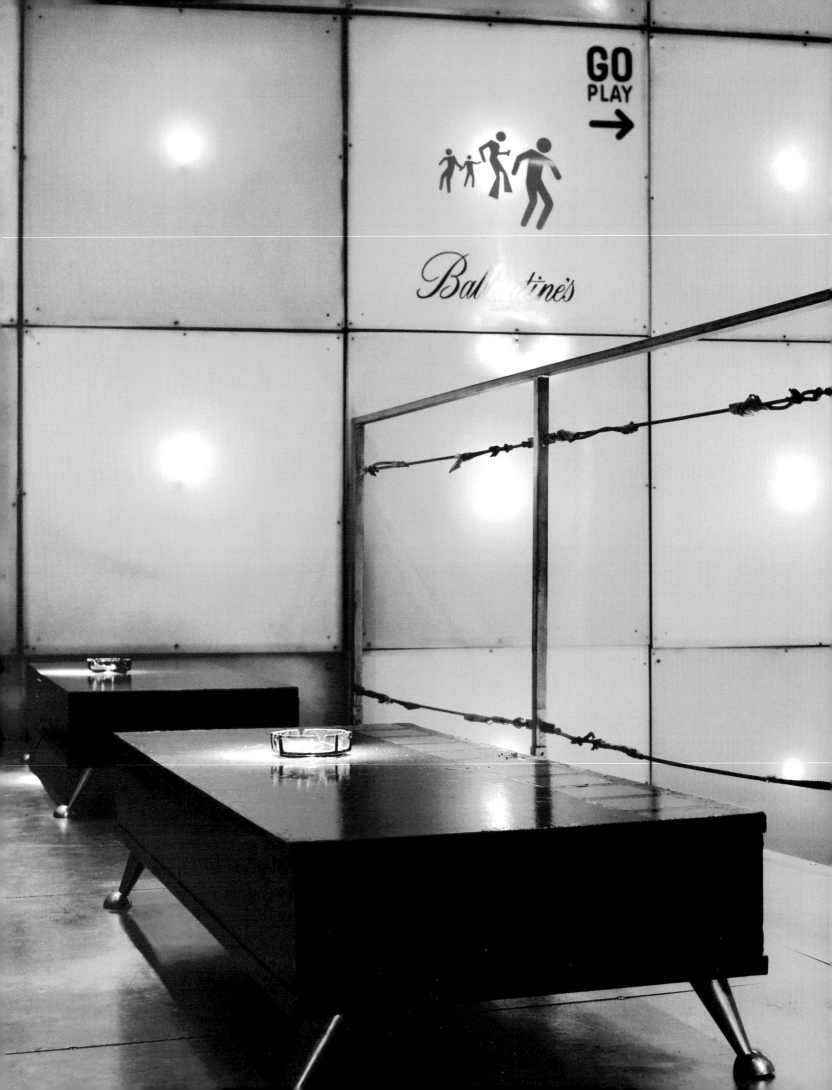

tab.00 · Seville · Spain

Modern, daring, geometric, and, above all, young, tab.00 is the expression of a new space that offers live performances, DJ sessions, and house music. A simple room with tiny apertures that look onto the street has been made over into a unique room, subdivided by the clarity of its own geometry. Clear-cut lines, intense lights, poufs, and sofas fill a pop aesthetic that turns the combination of reds, yellows, and pinks into its raison d'être.

The bar counter, with a stainless steel front, changes color under a series of recessed lights, Plexiglas bands, and concealed fluorescent lights. The dancing area, totally free of columns and partitions, is below the anxious eye of a mirror ball that might have come out of *Saturday Night Fever* with John Travolta. The same can be said for the icons drawn on the wall panels around the floor.

The walls are the veritable protagonists of a locale that knows how to benefit from the absence of objects in the center and exploit its peripheries. Faced in polyethylene panels that each reflect in a different tone, the whole is a rich interplay of geometrical shapes and colors that fit the structure of the space. Multifunctional almost to a fault, the same panels frame a series of images that would be at home in a manga comic.

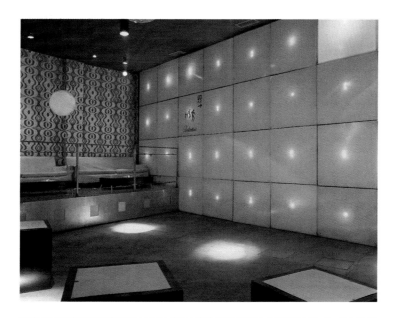

Designer **GEMA RUEDA MELÉNDEZ, PLR ARQUITECTOS**
Photographer **JORDI MIRALLES**
Location **SEVILLE. SPAIN**
Opening date **FEBRUARY 2003**

The pink of the walls and of the illumination blends with the white of the furnishings and the logo to create an image of freshness and modernity that runs through the whole tab.00 project.

Next to the DJ hut, a photo series makes reference to Pop Art.

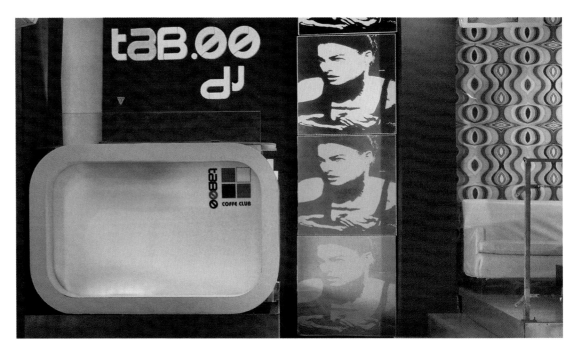

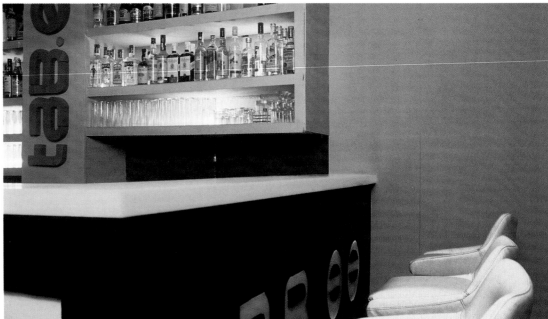

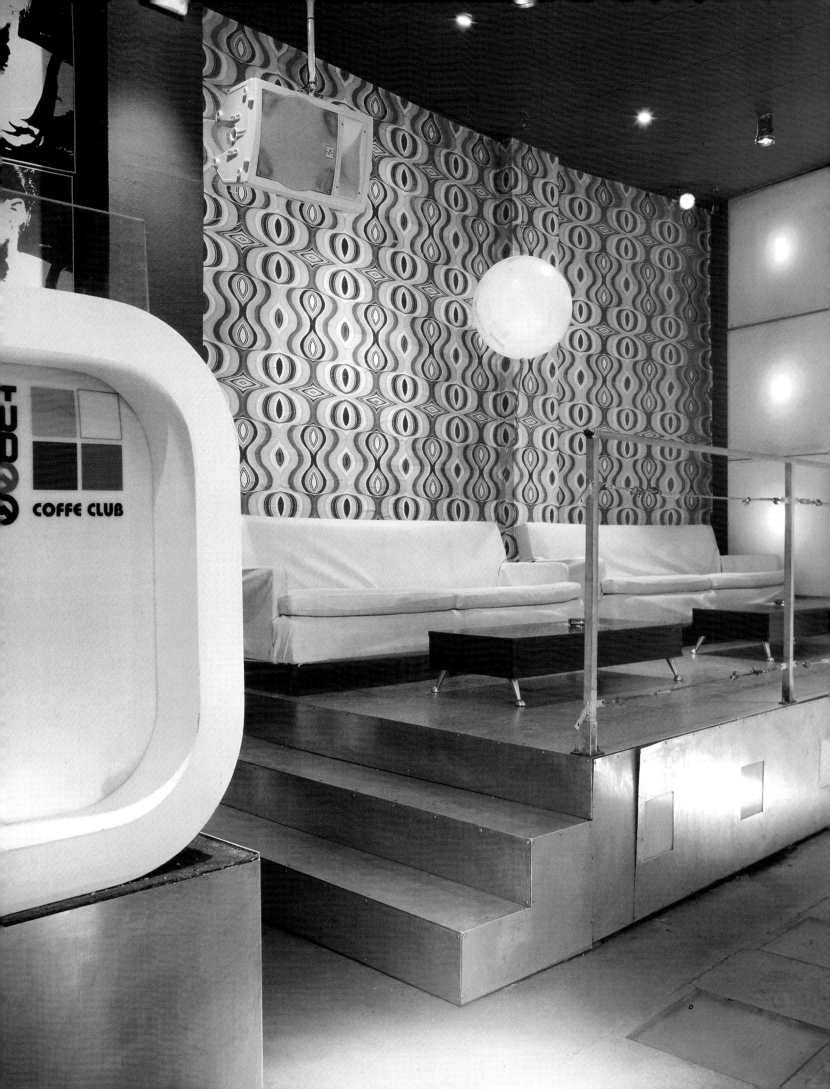

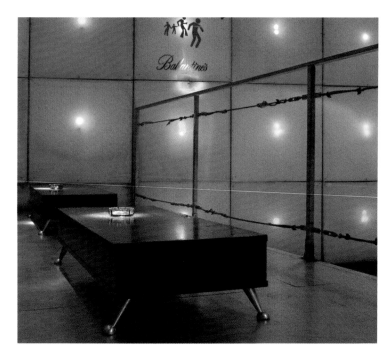

The chill-out space, on a higher level from the floor and accessed by a set of steps, features symbols of predominantly cool colors and clean forms on a psychedelic backdrop.

Floor plan

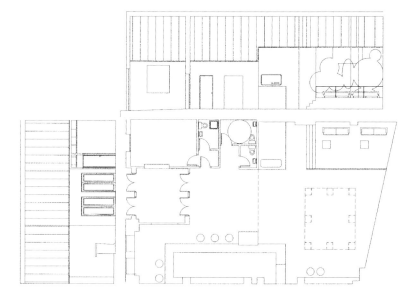

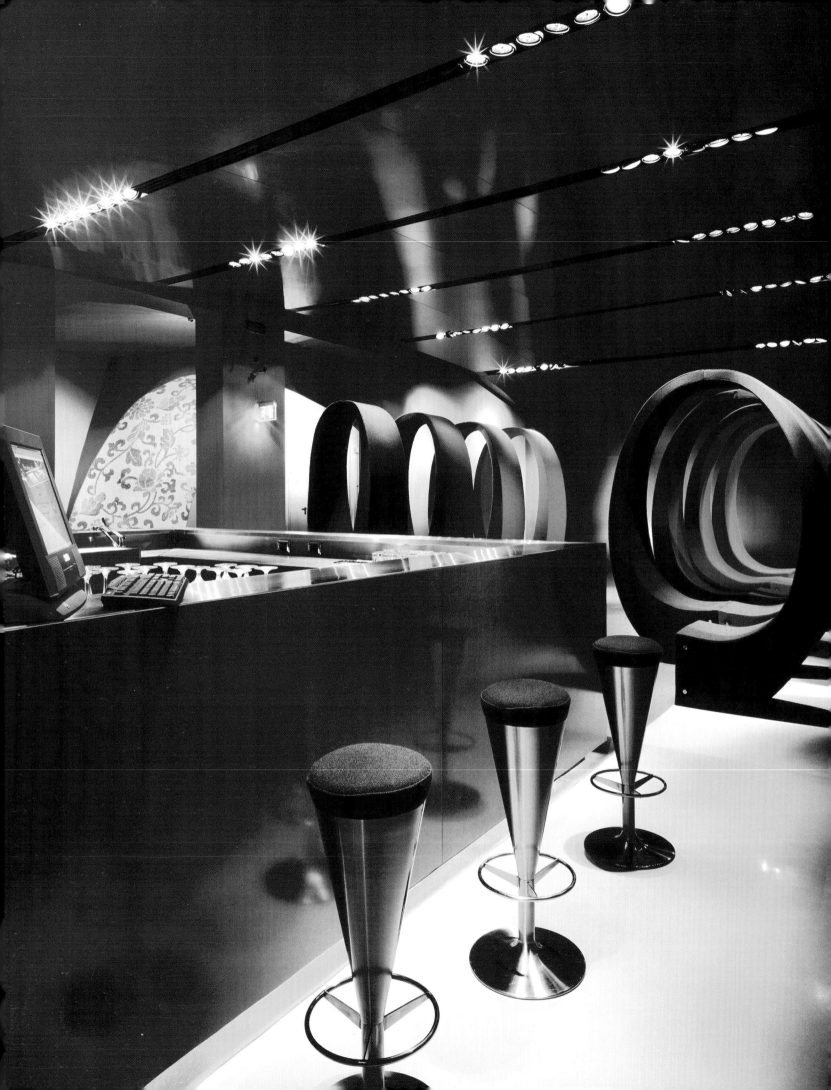

Fabio Novembre, the eclectic Italian master of architecture and design, has once again used his particular and eccentric vision of the world in this restaurant in the Una Hotel Vittoria, in Florence. Based on the conversion of an old industrial building, the restaurant, in line with the philosophy of the hotel, presents a true theater of life. The architect's themes embrace subjects like the movement of the planets, presence in absence, and intellectual nomadism.

The restaurant's interior is shaped along a main artery, a single large scraggly S-shaped wooden table, designed by Dutch artist and architect Joep van Lieshout to help bring about interaction among visitors. The molded ceiling follows the outline of the table, lighted by a stained-glass piece with an abstract design. In the same space, independent but connected to the previous one, are two ellipses that serve as decoration and as seats. At its origin, a set of original tables were added whose legs form the sculpted letters of the word "love."

The decoration of this project is not based so much on the objects as on the original combination of forms and materials. The looping finish of upward sweeping strips that decorate the walls seems to flow into a reticulated square of mosaics that shape the bank of computers, in an original contrast of opposites. Similarly, the subtle features of the table look right at the fantasy of colors in the ceiling, which gives the space its main hint of color.

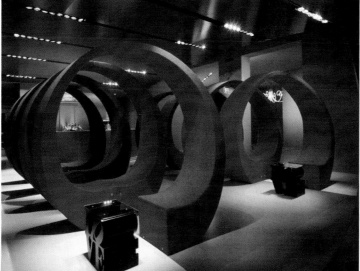

Designer **FABIO NOVEMBRE**
Photographer **ALBERTO FERRERO**
Location **FLORENCE. ITALY**
Opening date **JUNE 2003**

A continuous flow of emotions extends through the restaurant, uniting—in a happy marriage—Florentine artistic tradition and the most innovative design in a captivating harmony of forms and colors.

Along the wall, finished in wavy vertical strips, a curved bar counter serves as the support for a bank of computers with Internet connections for guests.

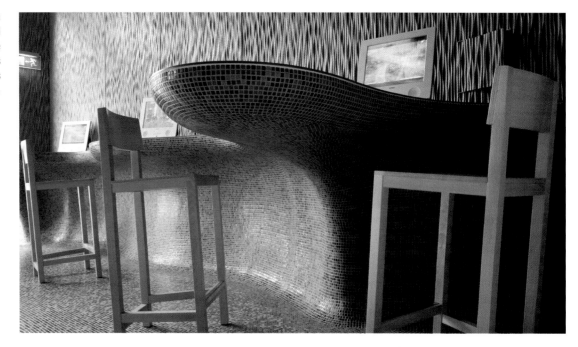

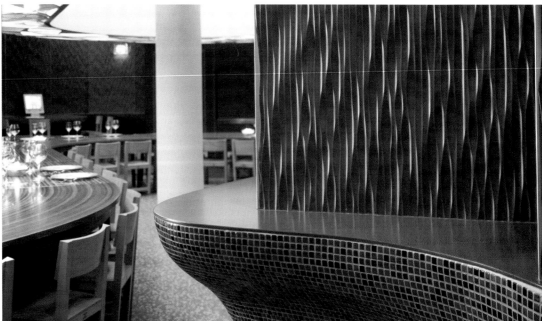

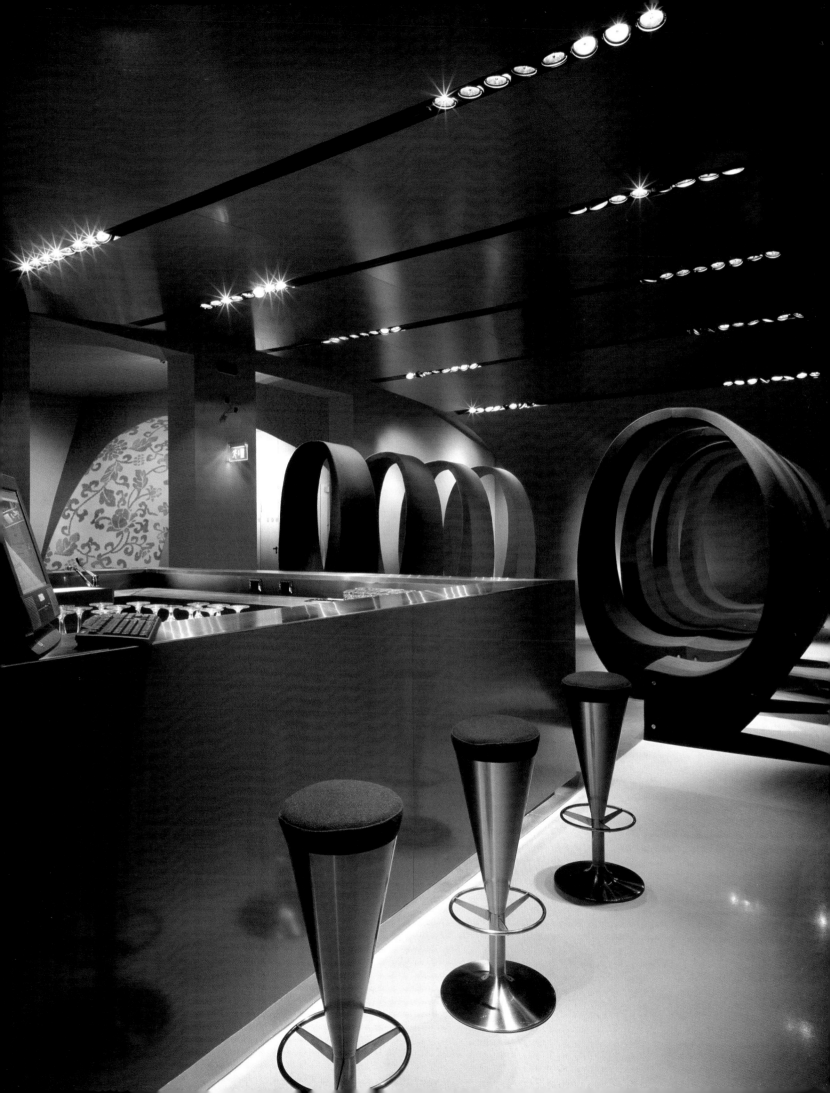

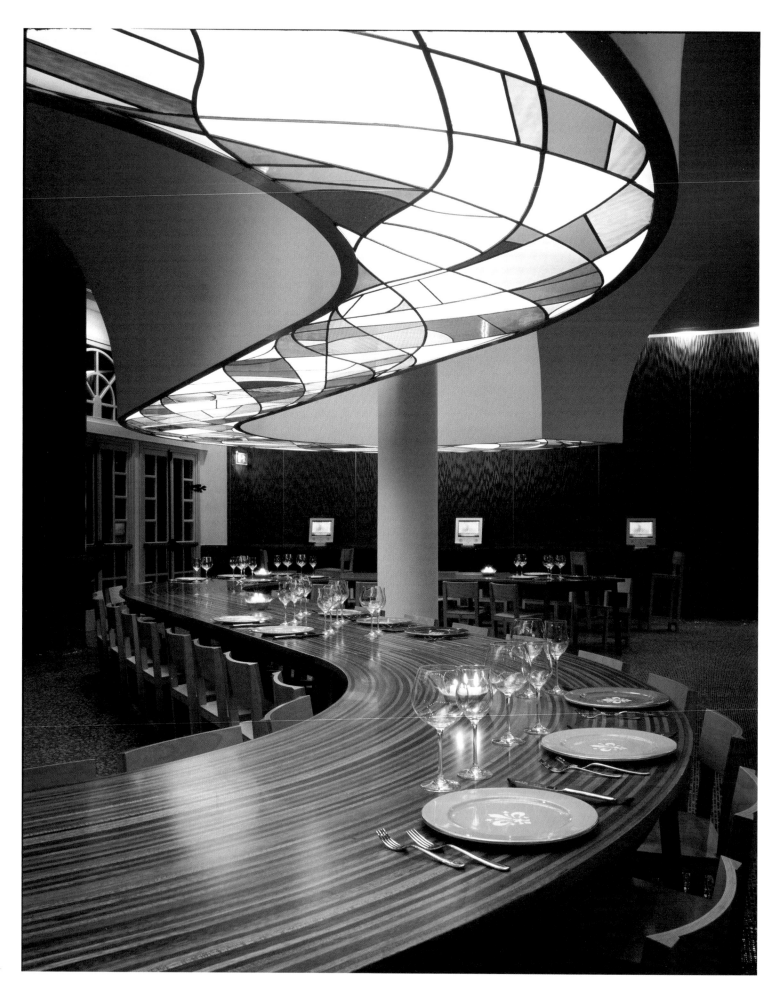

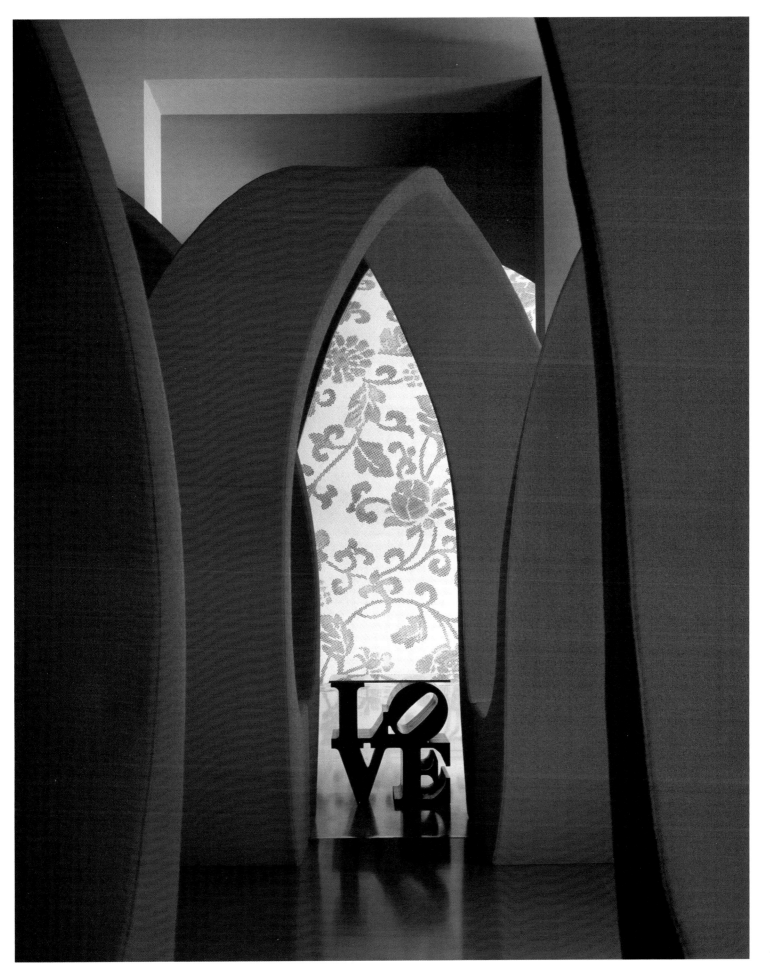

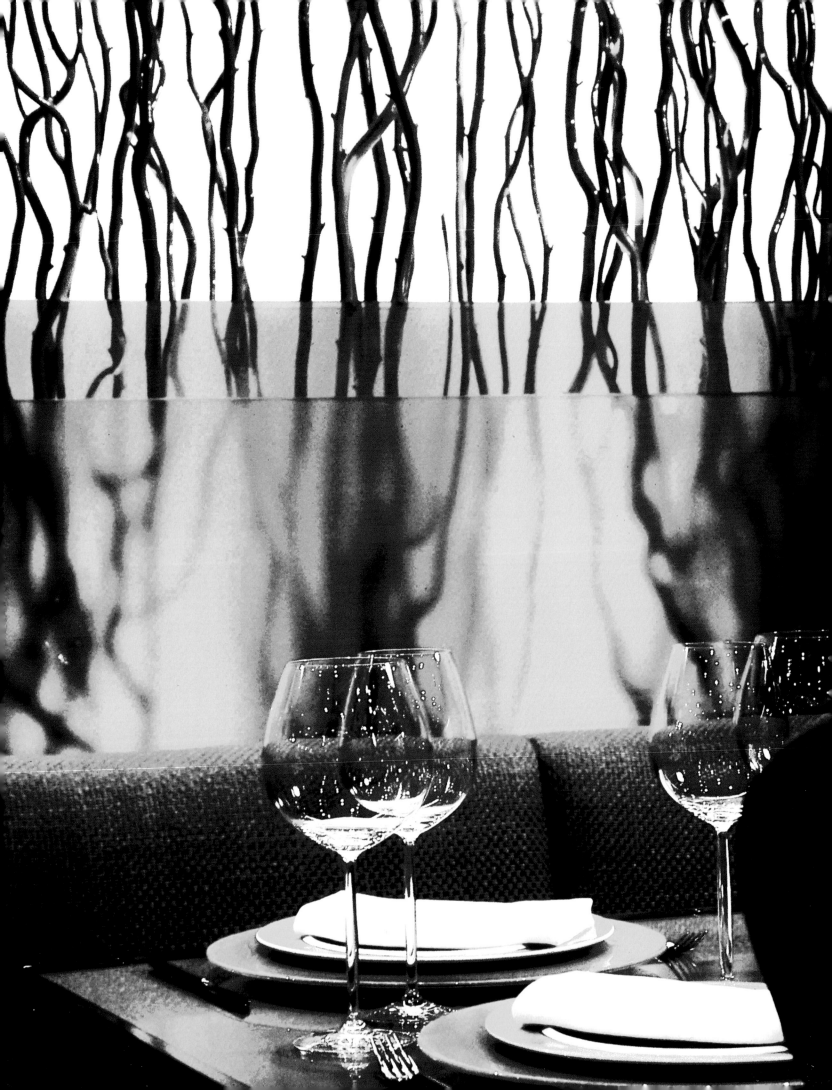

Aleph · Rome · Italy

Aleph is, in all probability, the most stylistically innovative hotel to have opened its doors in the Italian capital in recent years. Conceived by a genius of hotel design, Adam Tihany, the new project bears the stamp of Tihany's boundless imagination. Conceived entirely as an ingenious and provocative interpretation of heaven and hell, the latter concept's representation holds a special place in the restaurant, where it is staged as a provocative, sexual, and opulent theme that maintains an exquisite fineness and elegance. As hell, it is hardly the opposite of heaven in terms of attraction. Red, not surprisingly, is the king of this space. Thus, a glossy red, saturated and irre-

sistible, covers and imbues everything, with its subjects being the white and the black. Presence and absence, respectively—in keeping with the dichotomy of opposites reigning throughout the project—offer themselves to the visitor in small doses, avoiding any semblance of monotony.

Lighting based on a large number of tiny spotlights, creates suggestive shadows and brings out the reflections in the furniture simultaneously with those of the table service. These elusive images can be seen as victims that have fallen into the hell of a shining space of infinite scintil- lations that seem to invite the natural outcome of the passions.

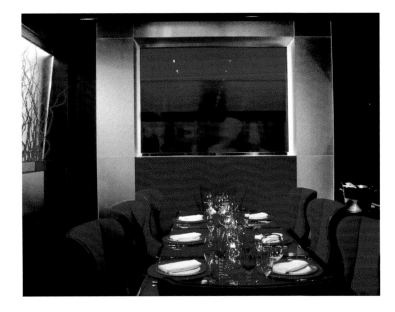

Designer **ADAM TIHANY**
Photographer **JANOS GRAPOW**
Location **ROME. ITALY**
Opening date **MARCH 2003**

The omnipresence of red comes out not only in the leather and velvet chairs, but also in the stained-glass objects. The menu offered in the Aleph is also totally red. On the white walls, red, curvy branches grow out of pots, in a clear evocation of the eternal, infernal flames.

The eternal dichotomy of the good and the bad goes on in Aleph, whose design is an interpretation of heaven and hell.

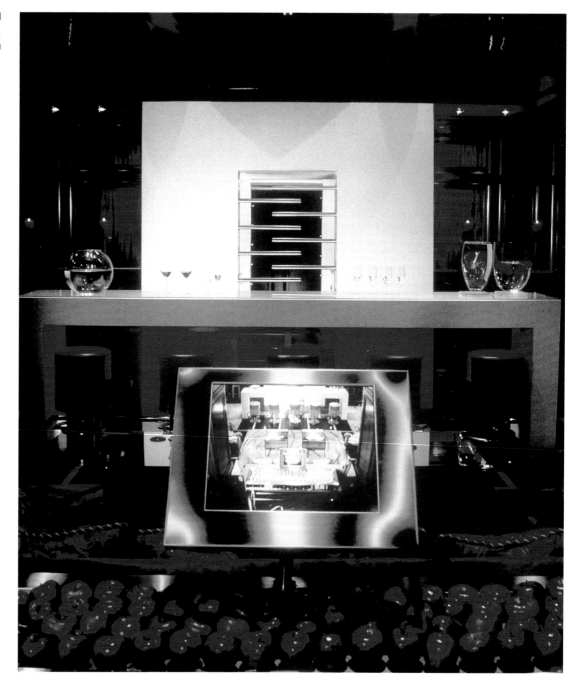

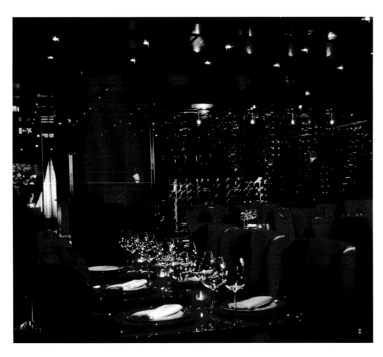

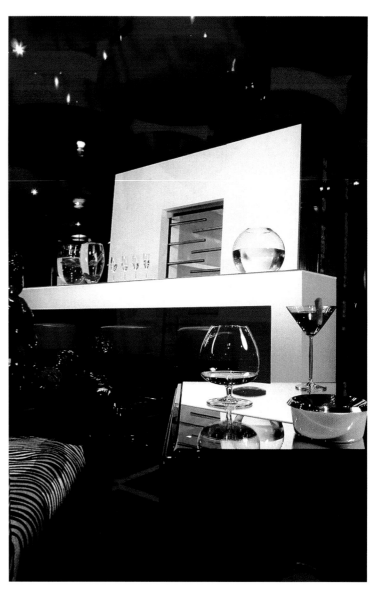

Down to the last detail, the decoration is designed to evoke the image of hell and submerge the visitor into what Tihany himself has called a state of mind.

Ground-floor plan

Elevation

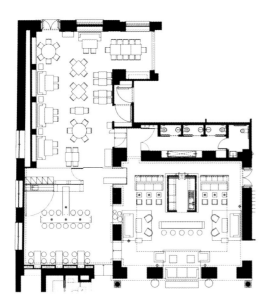

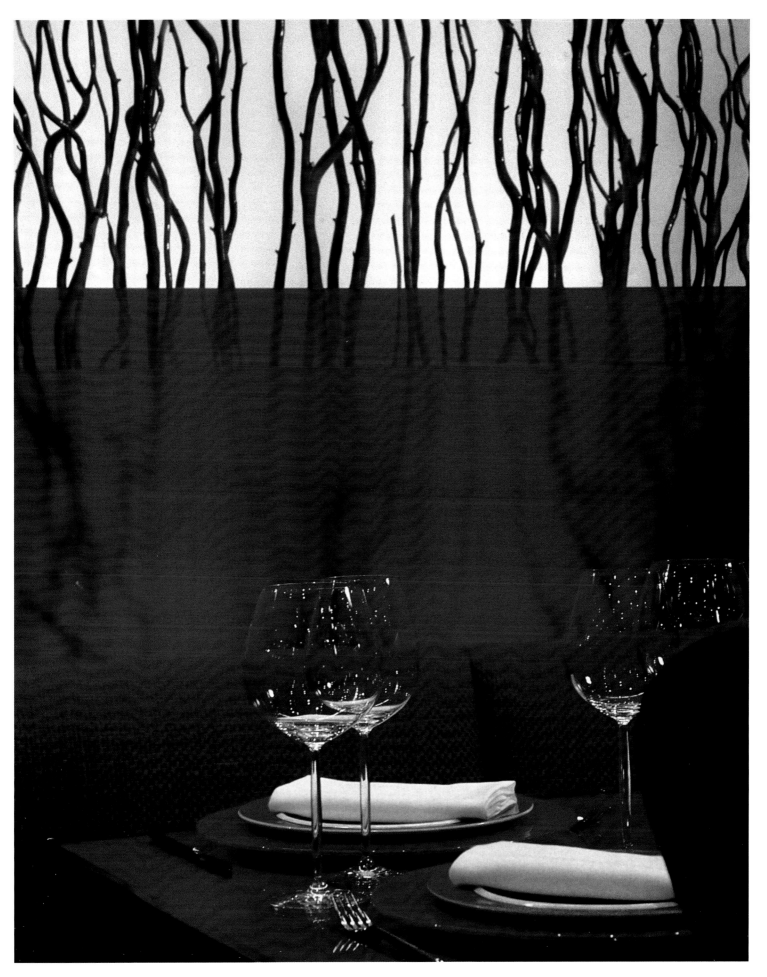

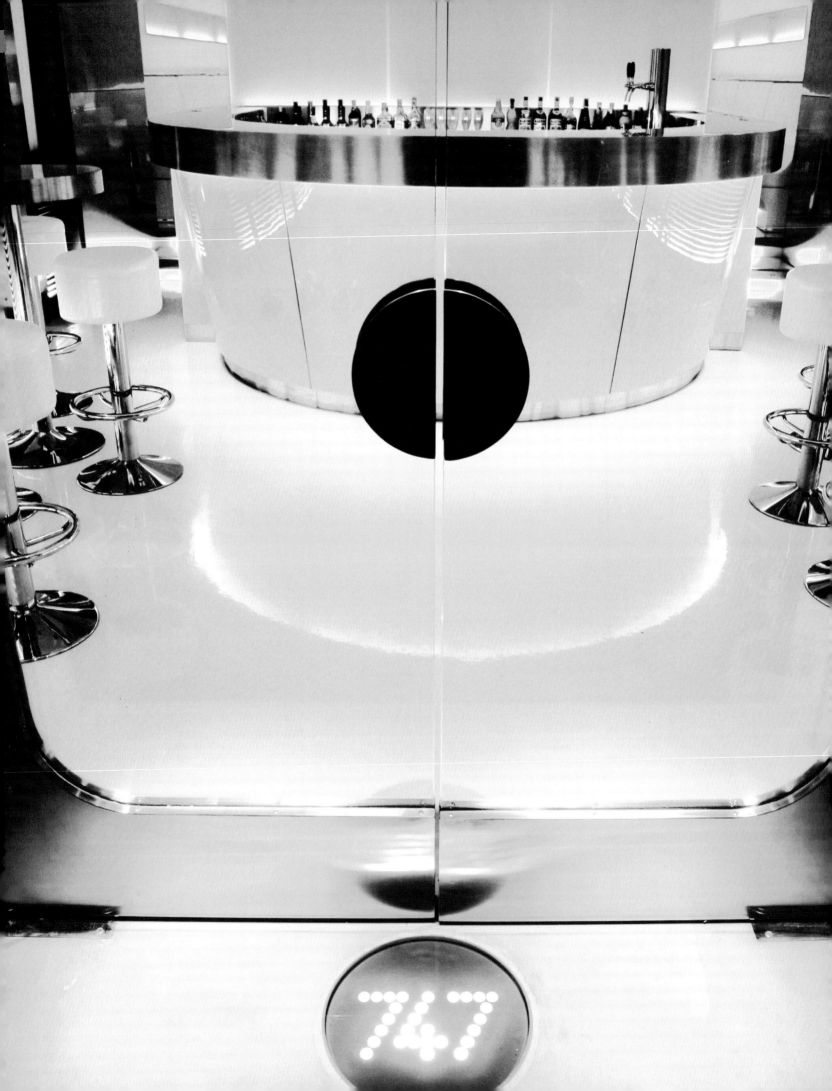

747 Bar · Syracuse · Italy

Inspired by the interior of a Boeing 747, Leonardo Annecca transformed a tunnel-shaped space into an attractive bar-restaurant in Syracuse, Italy. The idea of re-creating the cabin of an airplane was motivated by a desire to generate a new dialogue between past and present via a sensation of sunny freshness amid Sicily's elegant historical baroque buildings, whose interiors are generally dark and somber. The contrast between the dark interiors of these older buildings and the lightness of the interior of the 747 Bar, visible through its glazed entranceway, is thus marked and shocking.

One of the aims Annecca wanted to achieve was that of a "happy minimalism" where the availability of a limited budget would not limit the creation of a chic, sensual, and elegant ambience. To bring this about, a simple but effective system of lighting was used: to distinguish between the bar at the entry and the restaurant, a gigantic translucent Plexiglas screen was installed in three panels. Each of the panels contains three fluorescent tubes—one yellow, one pink, and the third blue—with sophisticated dimmers to choose the color that will come from the screen.

The authorities opposed a project outside the established traditional line of the area's interiors; and the discovery of archaeological remains during the excavations made the project a long one in terms of construction, which lasted for three years.

Designer L.A. DESIGN & ARCHITECTURE STUDIO PARIS,
 LEONARDO ANNECCA ARCHITECT
Photographer HAPPYLIVING.dK
Location SYRACUSE. ITALY
Opening date SEPTEMBER 2003

Evocation of a plane journey suggests a break in routine and the anticipation of adventure. The 747 Bar is the sensual re-creation of an airplane cabin, with futurist connotations and high-tech accents that submerge customers in a world of science fiction somewhere far from the city.

Pastel colors in the lighting—based on pinks, blues, yellows, and greens—invade the space to create a warm ambience amenable to the modern, young set.

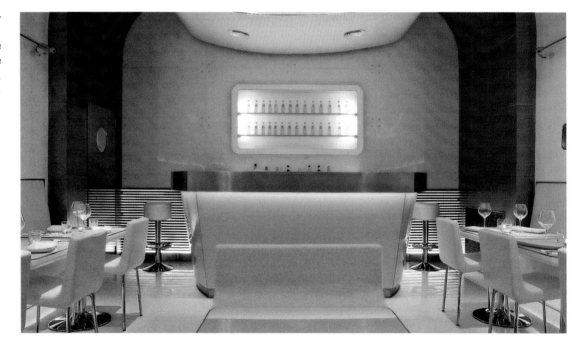

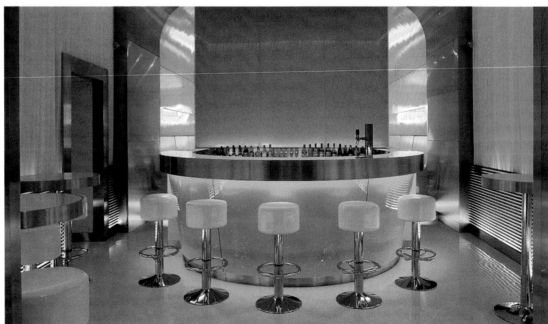

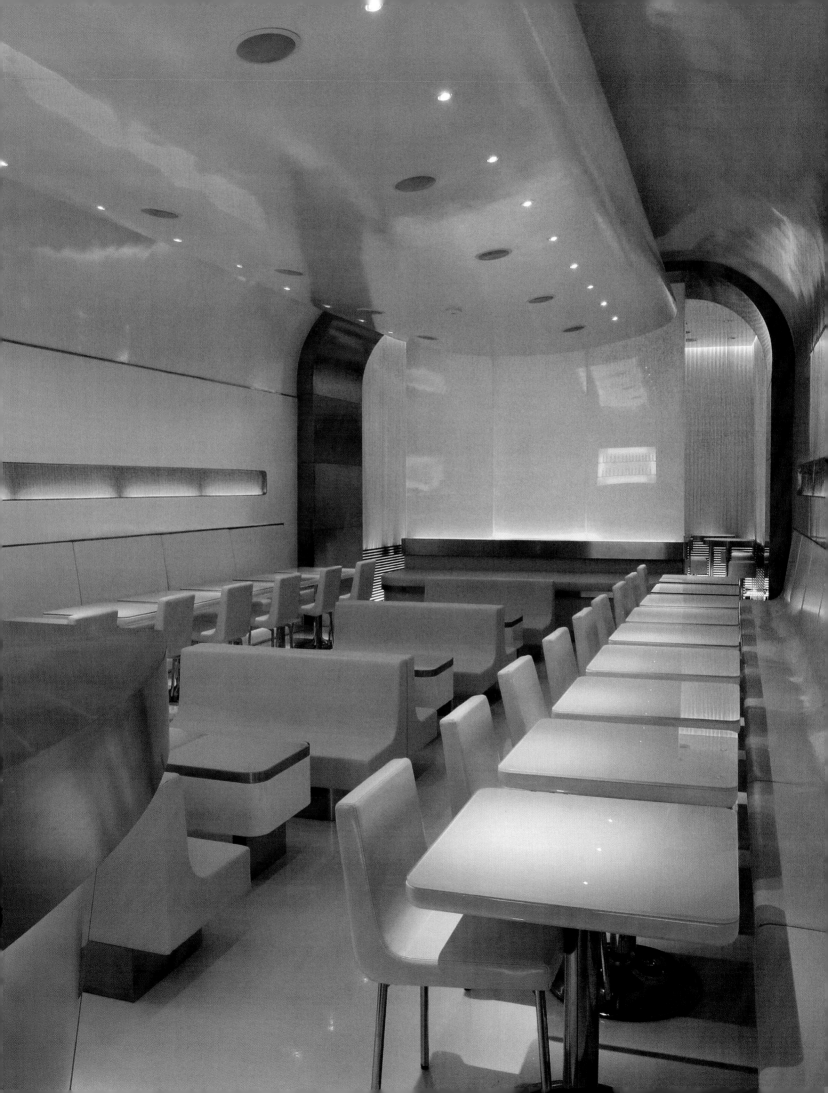

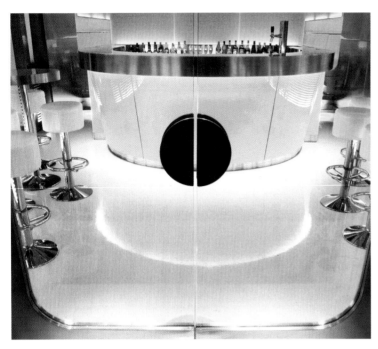

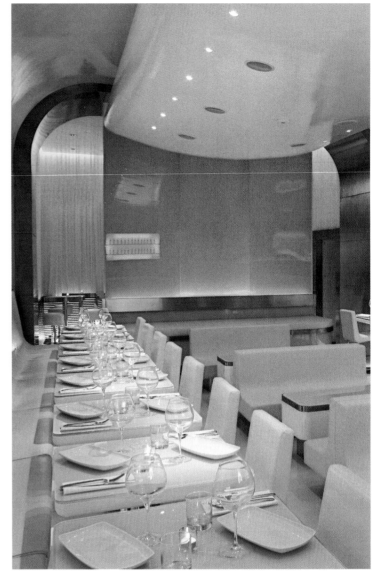

In the restaurant, a series of fluorescent tubes wrapped in orange gelatin runs the length of the walls at head and ankle height, with clear suggestions of the emergency lighting running along the aisle of a commercial airliner.

Elevation

Floor plan

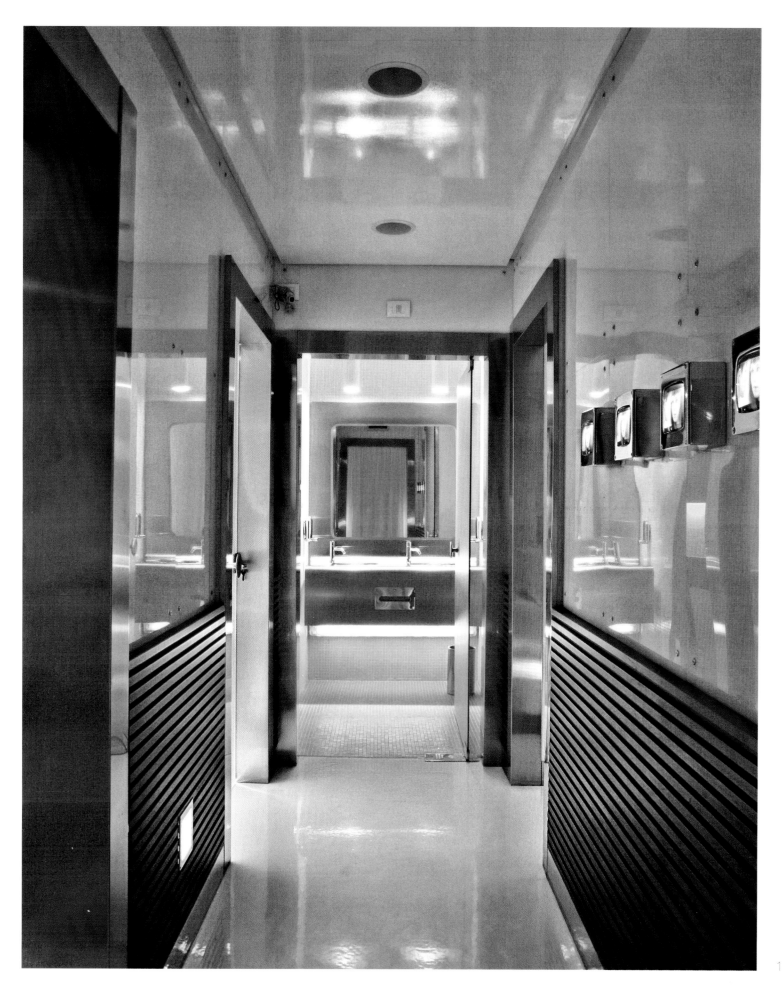

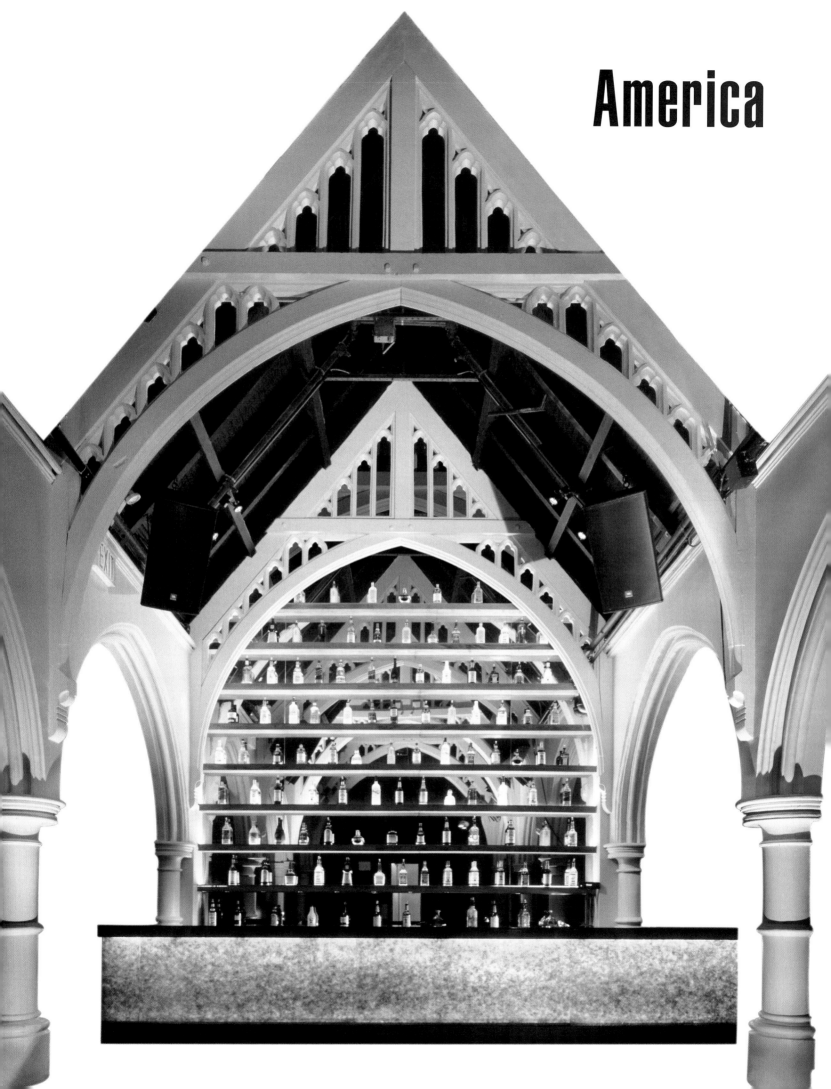

America

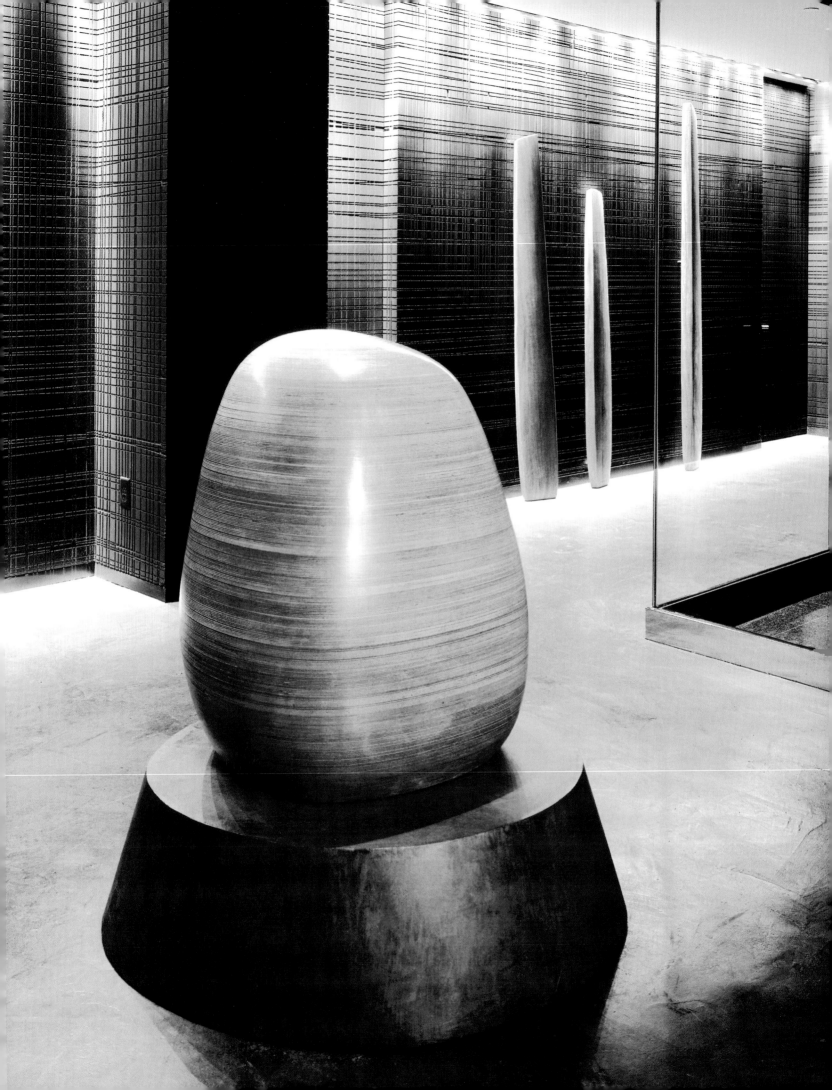

The TD Tower of Toronto, conceived by Ludwig Mies van der Rohe, is home to a new establishment designed by architects George Yabu and Glenn Pushelberg. The Bymark's restaurant contains two private spaces and a central dining room, divided in half by a long table, in an example of perfect symmetry. In the entrance, an original piece of modern art, the work of Canadian Scott Eunson, dominates the space. A second artist, David Lin, also Canadian, completed the design with pieces that are scattered throughout the restaurant and bar. Without being characterized by an overloaded design, the Bymark can certainly boast a meticulous inclusion of details, rendering homage to modern art and to the work of Mies van der Rohe.

The Bymark's pièce de résistance is the bar, located on the second floor and literally inserted into a glass structure with views of the square. The project's philosophy is aptly expressed in its design: the bar counter is made up of a smooth surface on which the light creates multiple reflections; behind this, a background of lighted horizontal strips, which are also present in the ceiling over the bar, fulfills a decorative function. The chairs, with low backs and in leather, are a reference to the dominant aesthetic in financial districts. Indigenous materials are combined with the omnipresence of wood, used both in the furniture and in the ornamentation, in a new homage to Mies van der Rohe, an enthusiastic user of this material in his interiors.

Designer **YABU PUSHELBERG**
Photographer **EVAN DION**
Location **TORONTO. CANADA**
Opening date **NOVEMBER 2003**

Two different aesthetics, clearly differentiated by the illumination, define the interior of this project. The sensuality of the indirect lighting, combined with the use of wood on the second floor, contrasts with the harder lighting of the fluorescent tubes on the ground floor.

The predominance of the straight line over the curve is present not only in the silhouettes of the furniture but also in the frequent use of a squared and linear latticework to decorate the walls and ceilings.

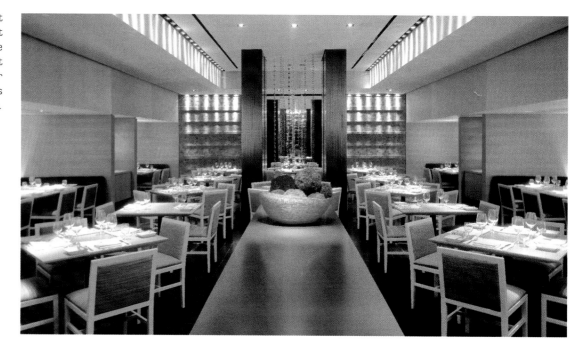

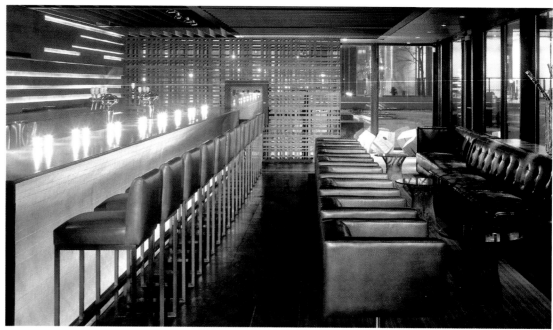

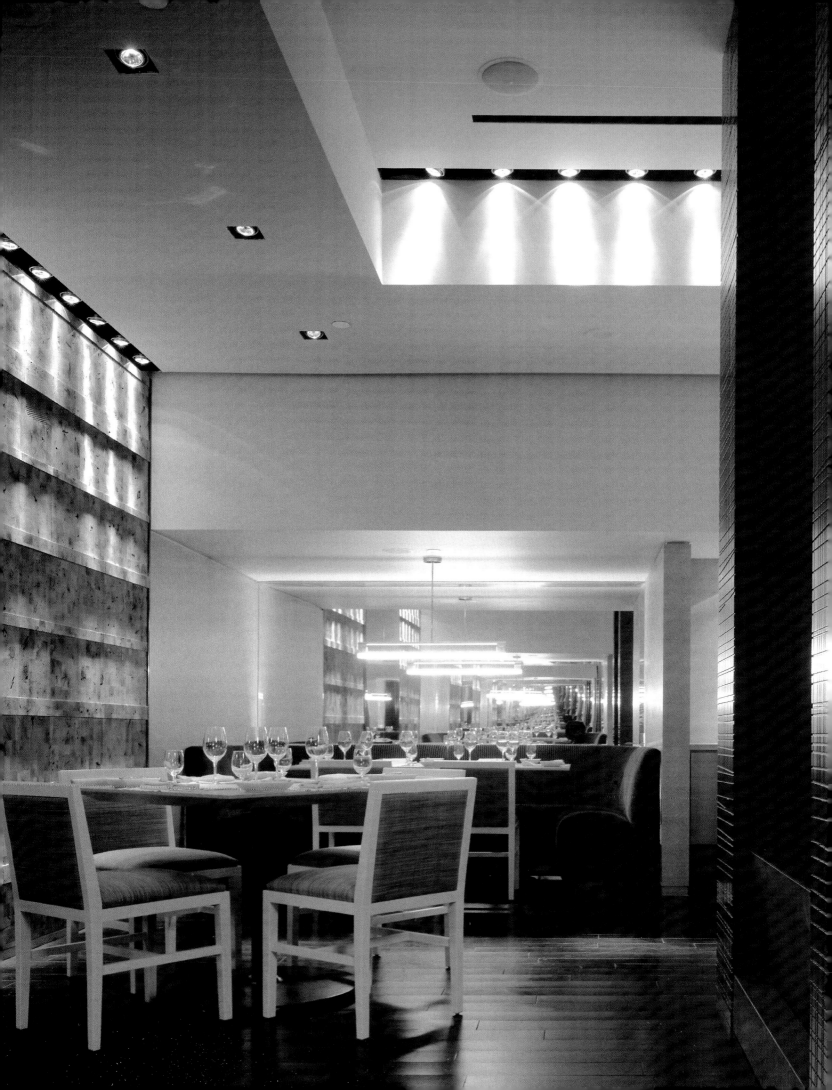

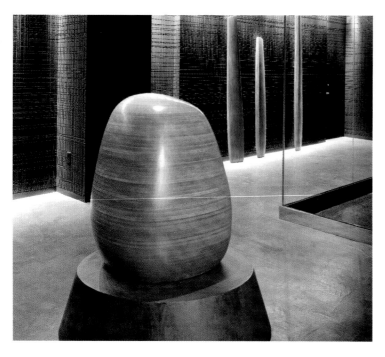

In the central dining room, the use of more contemporary materials creates a cold, modern aesthetic that contrasts with the sensuality of the warm colors in the remaining zones.

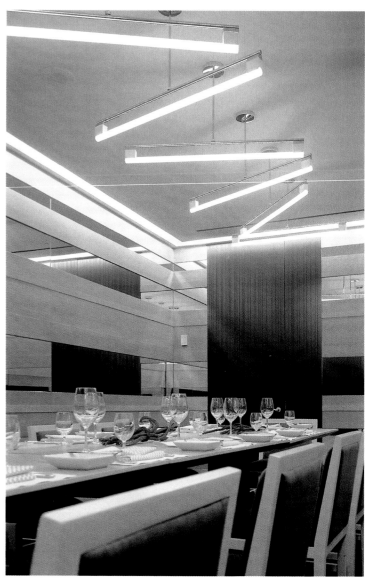

Floor plan: bar

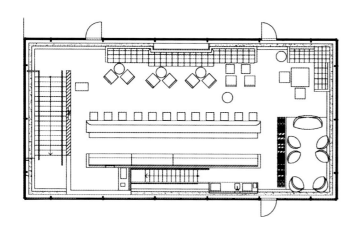

Floor plan: restaurant

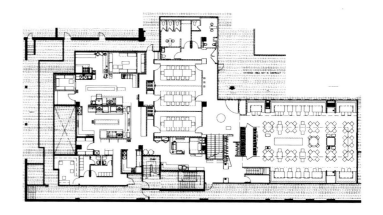

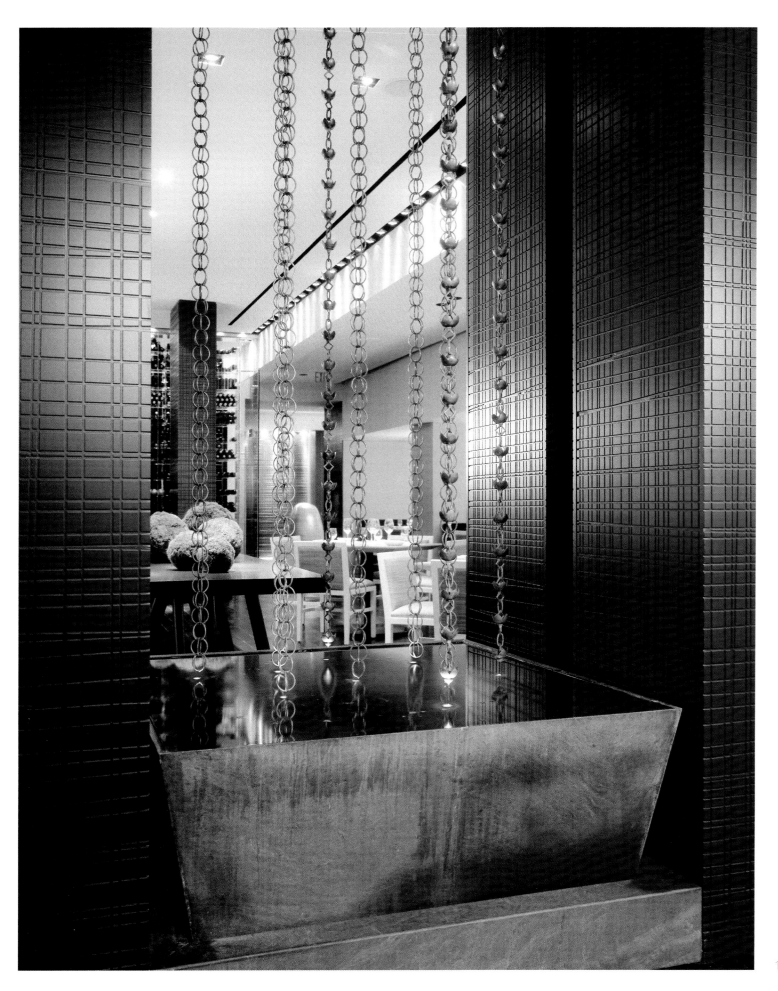

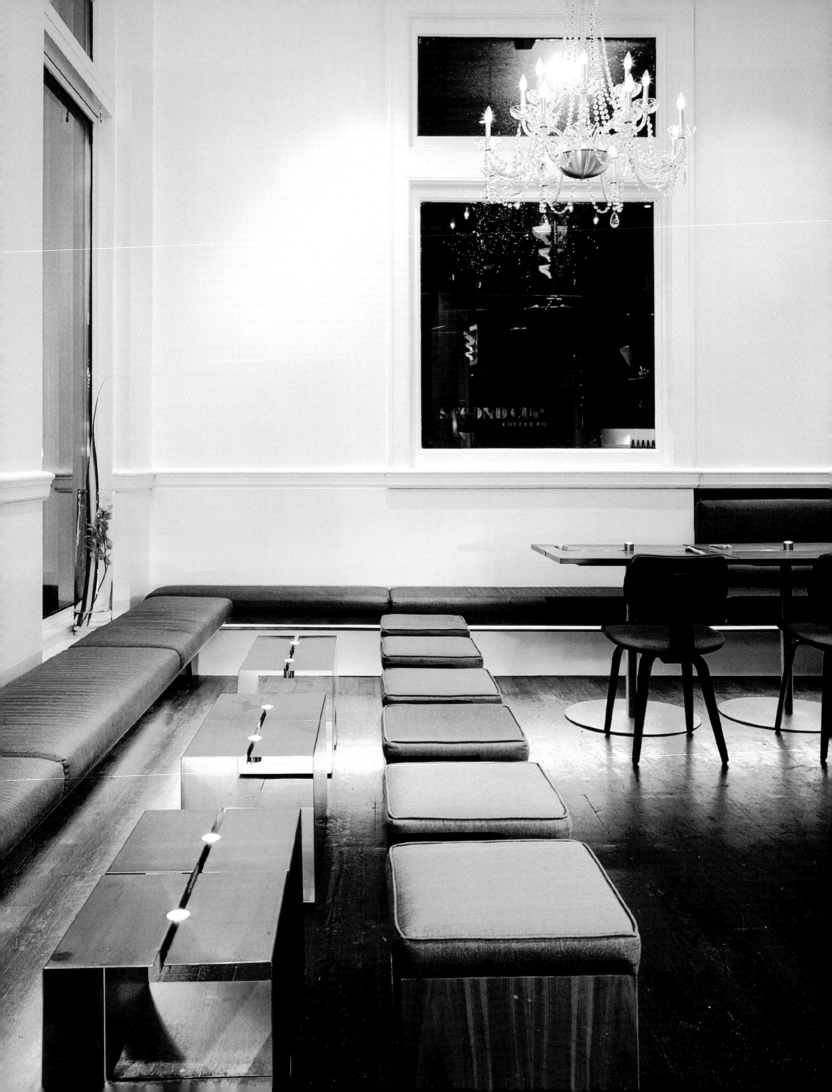

Blowfish Restaurant · Toronto · Canada

The classic façade of the historic building that was formerly the home of the Bank of Toronto now opens onto the clarity and light of the Blowfish Restaurant, designed by Johnson Chou. This project is based on a dialectical synthesis of contrasts that fuses American with European architecture, bringing together their respective shapes, materials, textures, and iconography.

The lounge area is arranged around a long bar that runs the length of the space. Separation between the bar and the dining room is provided by an immense curtain of steel mesh that both catches and enhances the changes in the light, alternating between moments of transparency and opaqueness as day turns into night.

The chandeliers hanging from the ceiling form a modern interpretation of classic French chandeliers. Though chosen to reflect their classic predecessors, the Blowfish's chandeliers provide a subdued touch that makes them subversive at the same time. More elongated than their French counterparts, the lights in this project are both simple and exuberant—with a classicism seasoned with contemporary nuances—but never ostentatious. These two elements sum up the philosophy of Johnson Chou, which forms the space on the basis of a subtle contrast between classicism and modernism in which both are protagonists.

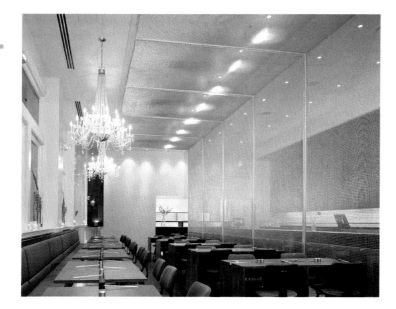

Designer **JOHNSON CHOU**
Photographer **VOLKER SEDING**
Location **TORONTO. CANADA**
Opening date **MARCH 2003**

The meeting of apparently contradictory elements within the same aesthetic achieves fine results in this interior—which is both modern and classic, elegant and austere—in a historic building whose classic façade has been conserved.

Inspired by Japanese shoji screens, the stainless steel mesh screen defines the limits of the bar area and encloses the dining room, forming two areas that are clearly separated despite their proximity.

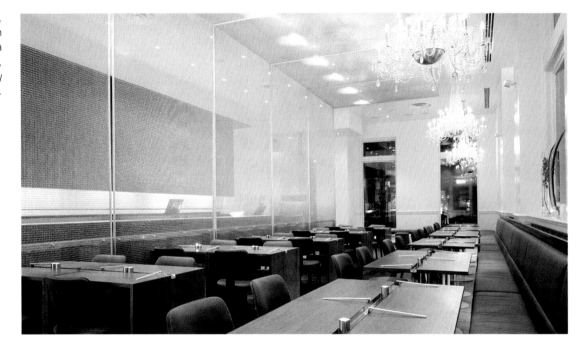

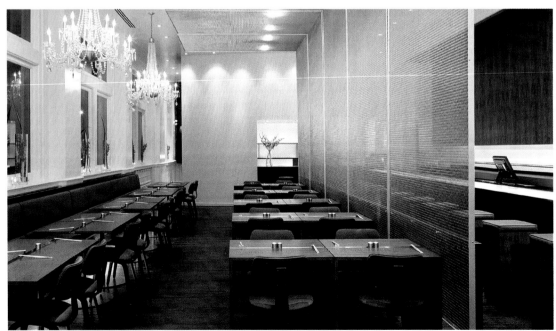

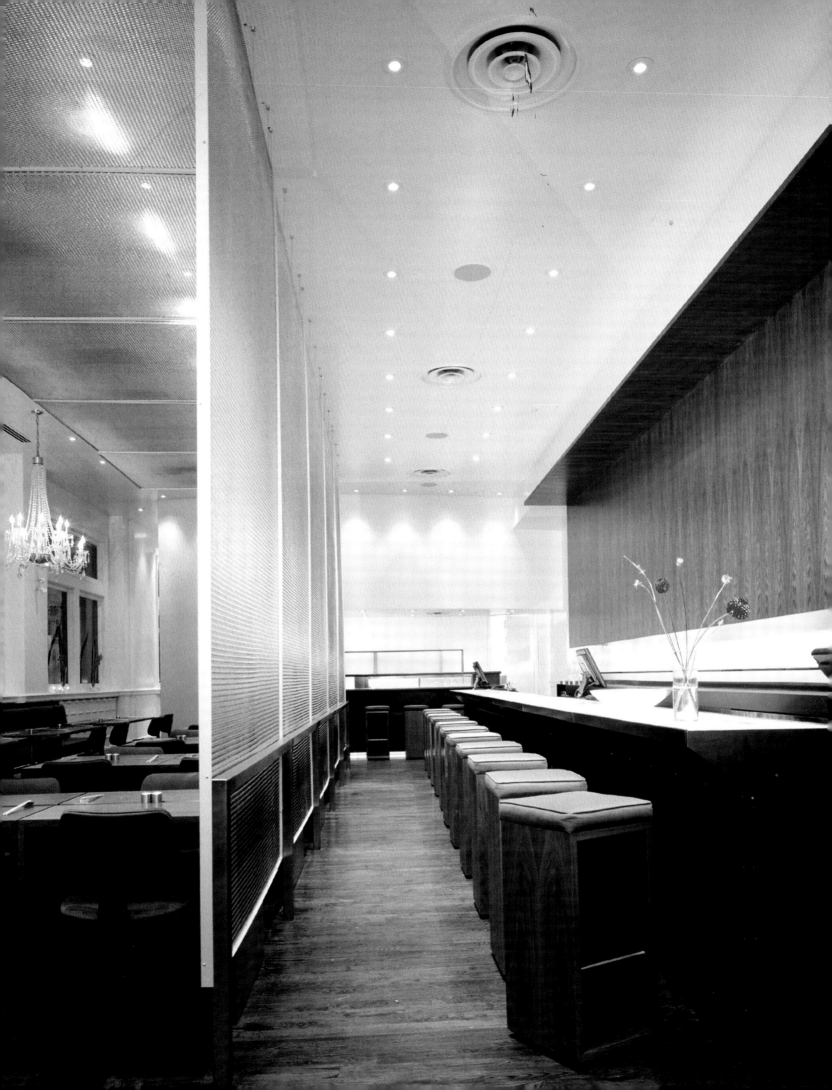

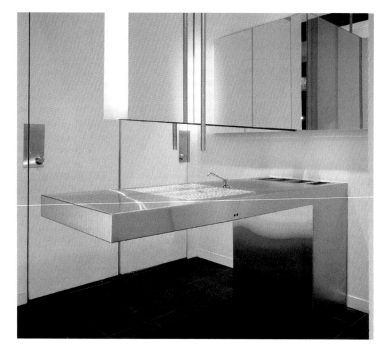

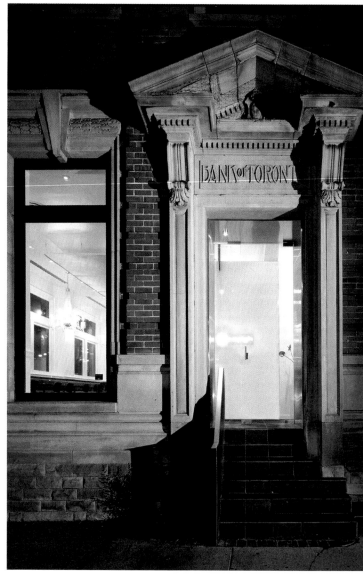

Behind the curved wall of the central lounge, the unisex bathrooms provide a new interpretation of the hybrid aesthetic.

Floor plan

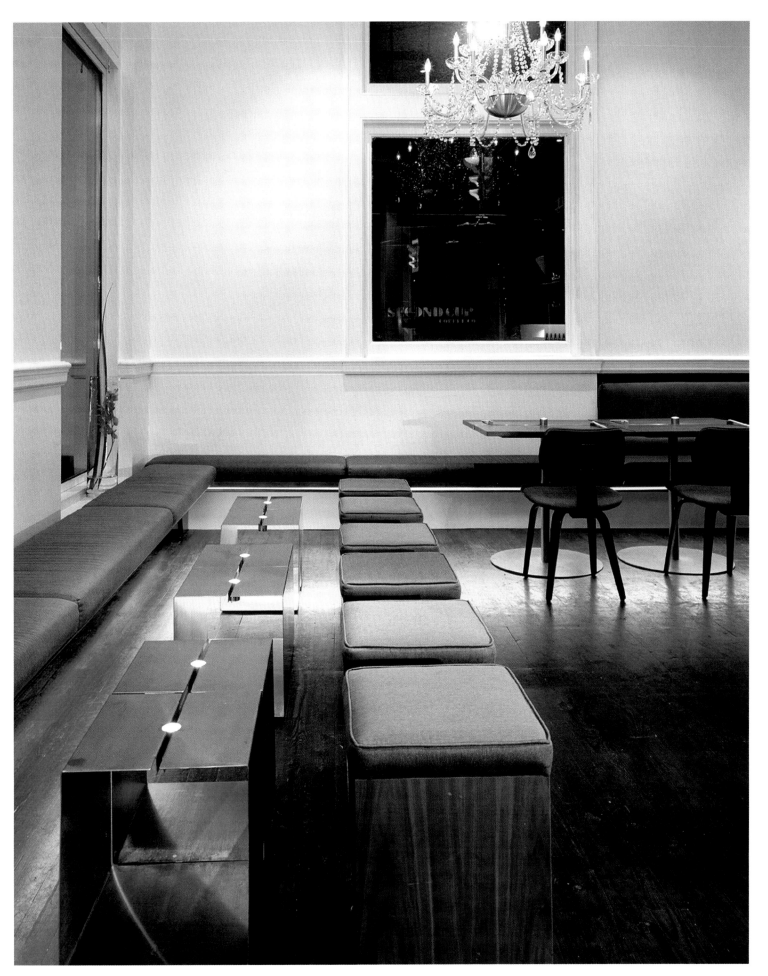

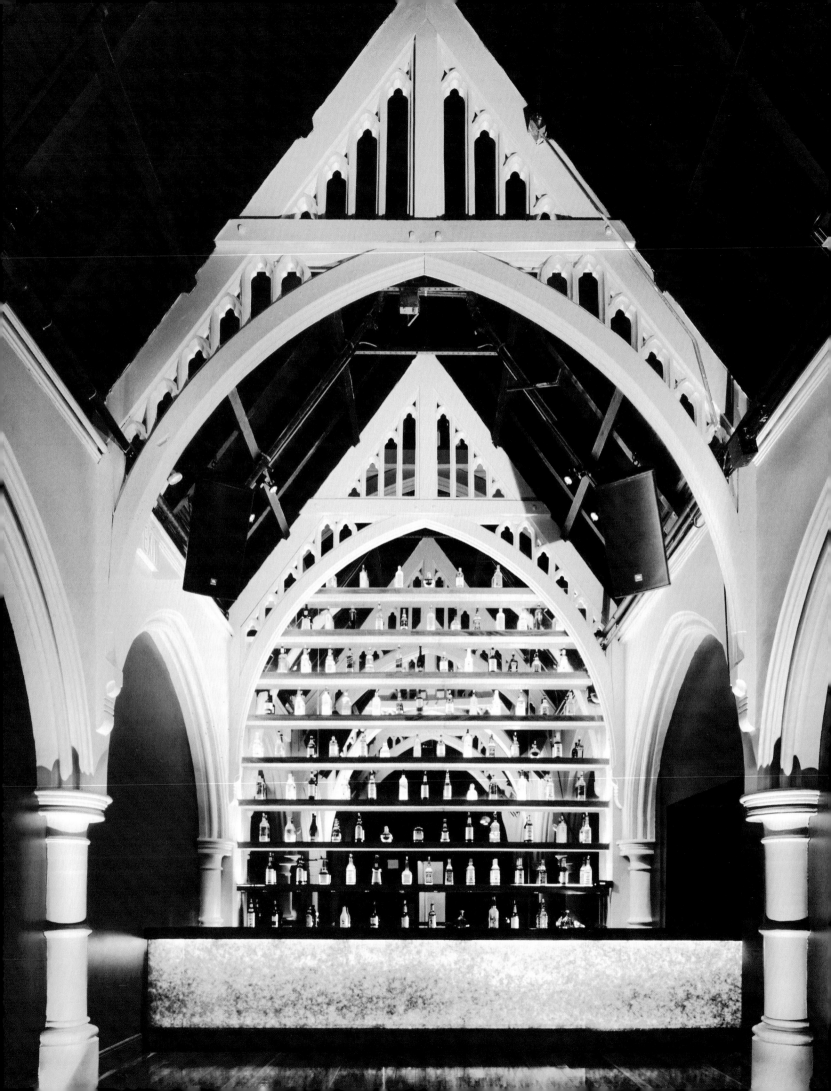

Avalon · New York · United States

What major shock can convert the interior of an old Gothic church into a discothèque? The challenge confronting the Desgrippes Gobé Group lay in creating a clear distinction between the original architecture and the new elements of the interior, while at the same time respecting the stone-and-glass structure that characterizes the church's architecture.

The church's long, rectangular plan imposes its own circulation and is distributed in an alternation of reduced and extensive dimensions that establish moments of intimacy and drama, respectively. Vestibules of giddy proportions and spiral staircases constitute architectural elements of transition between the different spaces. The three floors into which the building is divided occupy the large space that was previously the sanctuary of the church. The Avalon's ground floor houses the entranceway, the dance floor, and the main bar; the second floor has the DJ hut, a chill-out room, a second bar, and the bathrooms. On the third and final floor, a VIP room connects to a small dance floor, where a series of glass cubes makes it possible to view the floor below. Visitors enter through an external passageway that is illuminated from a lower angle, highlighting the impressive dimensions of the Gothic architecture and throwing the windows into relief, thus creating a setting that is both glamourous and austere.

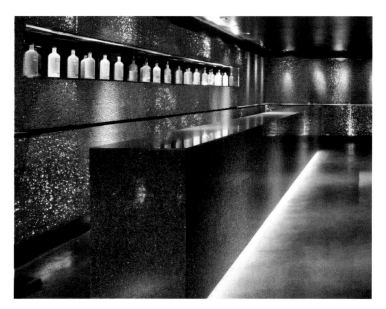

Designer **DESGRIPPES GOBÉ GROUP**
Photographer **JOHN HORNER**
Location **NEW YORK. UNITED STATES**
Opening date **SEPTEMBER 2003**

The wavy, synthetic surfaces in daring colors—elements that generate a light, modern interior—contrast with the heaviness of the stone blocks in the original walls. This interior transmits a sophisticated and cosmopolitan sensitivity that, while respectful of history, creates stylistic diversity and adds trendy shock.

The locale has two bars that meet in a modern aesthetic of saturated colors, accentuating the contrast with the original architecture's elements.

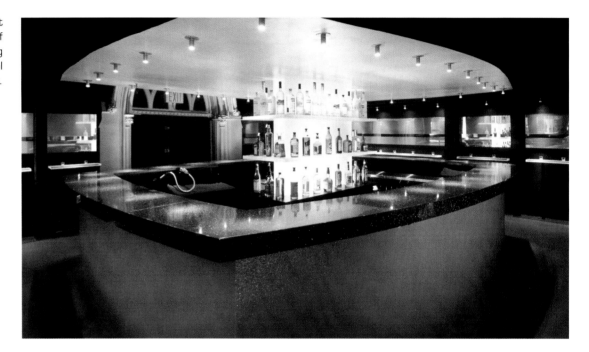

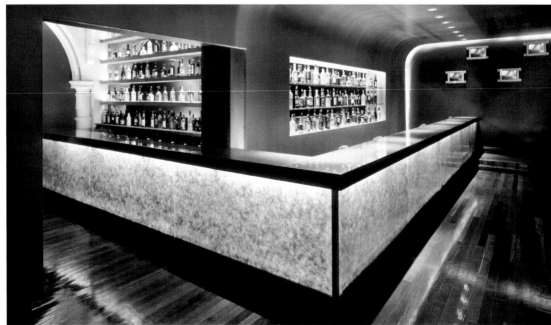

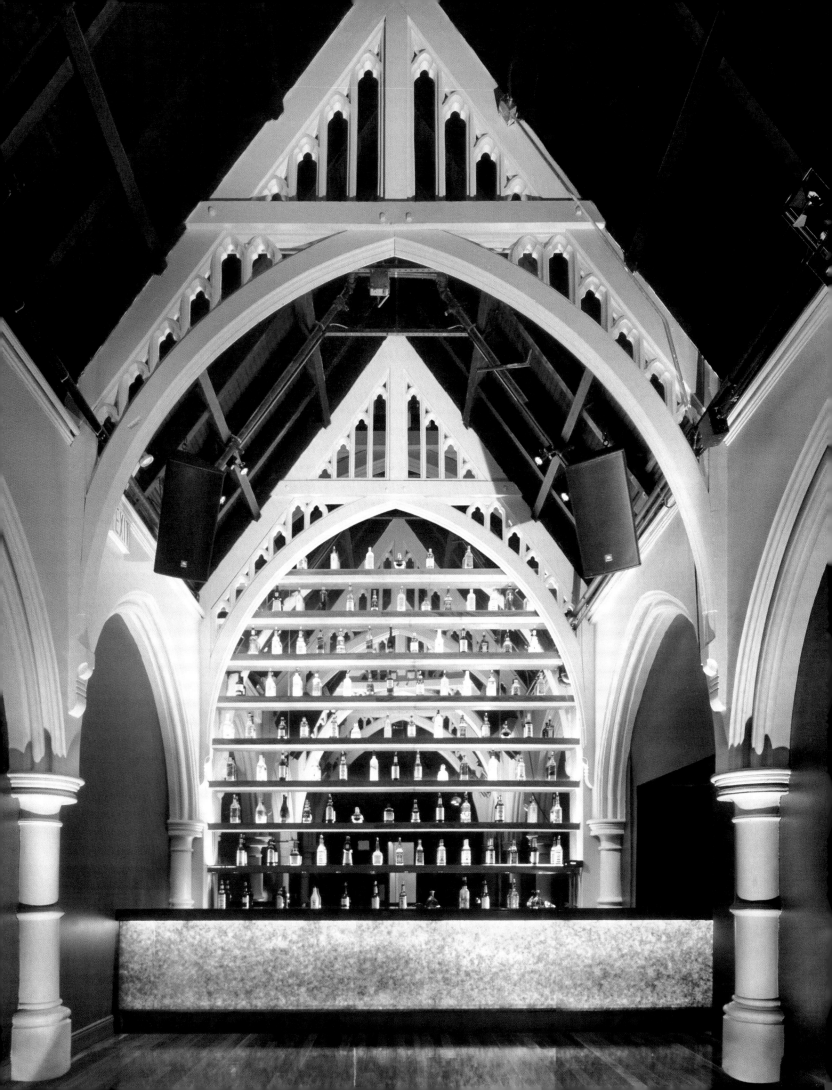

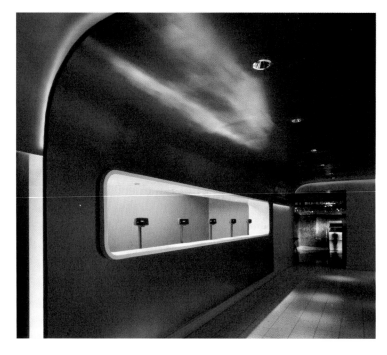

The old and the new, the Gothic and the modern, fuse to create a world of fantasy that is dramatic, dark, and unknown. The Avalon's interior includes an impressive bottle shelf between the Gothic arches that flank the dance floor.

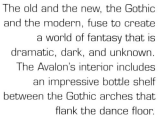

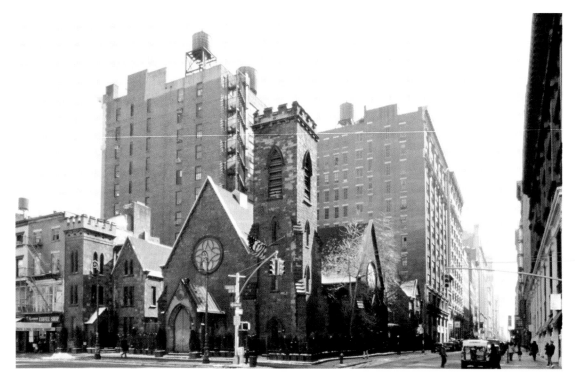

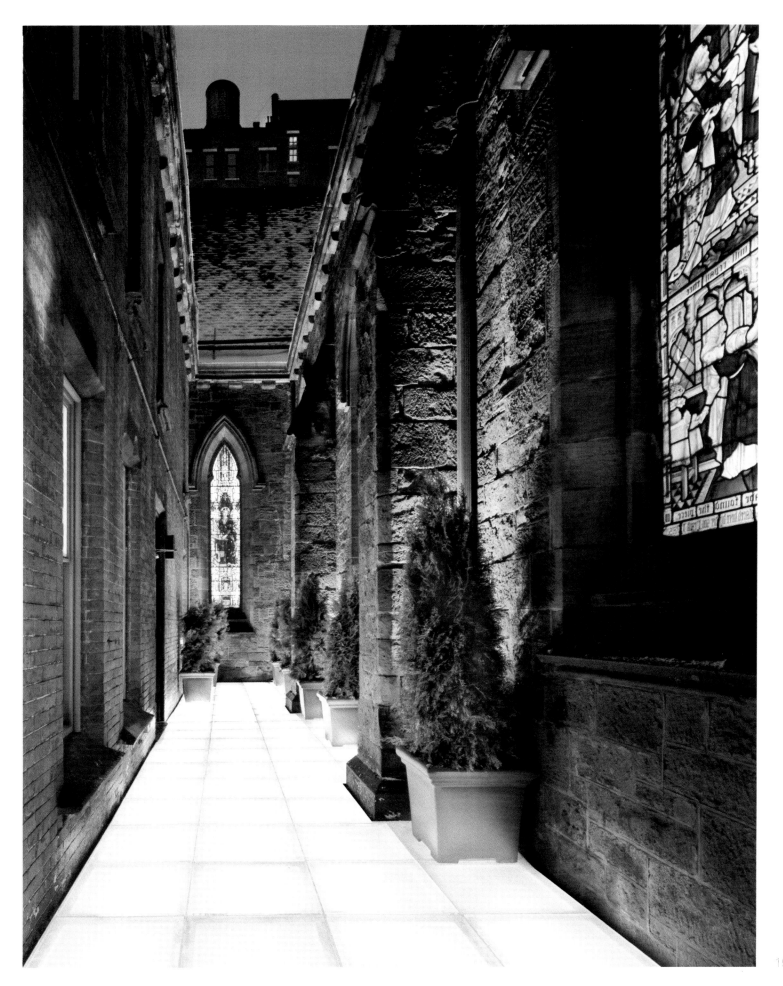

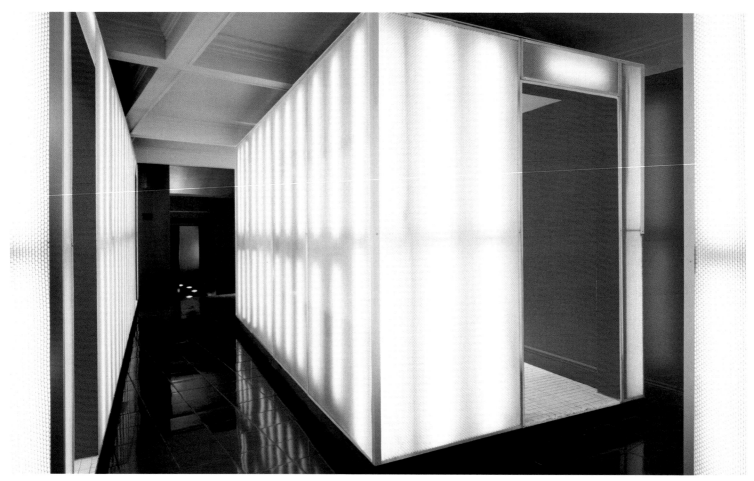

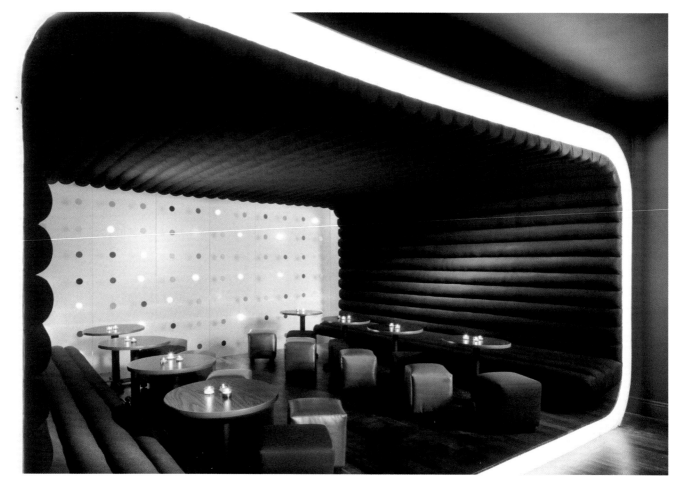

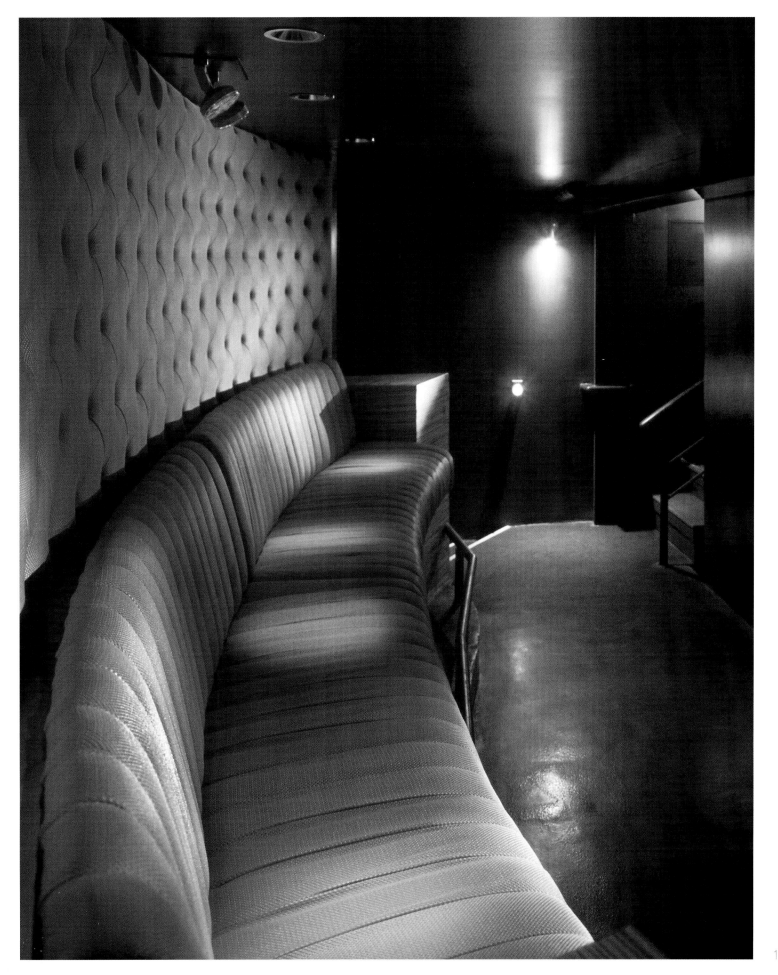

Sonotheque · Chicago · United States

Sonotheque, as the name implies, aims at being an ode to sound, a reminder of the humble initial proposal of a nightclub: music. Therefore, the designer used textured finishes on the walls that respond to different acoustical frequencies and also project from the planes of the walls like sculptures—a pragmatic approach combining functionality and art.

The phenomenas of absorption, reflection, and refraction, inherent in all sound, are represented here via the different finishes of the walls and ceilings. Absorption thus takes place within a series of round panels immediately above the sofas, which are manufactured in a kind of felt that absorbs the middle frequencies and disperses them in space. The choice of materials such as plastic and wood, as well as the use of vinyl for the floor, facilitates sound reflection, while the series of aluminum panels on the ceiling functions efficiently as a refractor. This aesthetic continues in the external façade, which is also clad in an aluminum gray skin, with a projecting vertical column of square panels in a slightly lighter shade of gray.

The visual aspect of these materials corresponds to a rather cold aesthetic: it is metalized, gray, modern, and geometric. Instead of distracting listeners, the space focuses their attention on the raison d'être of this project: the tracks the DJs are playing.

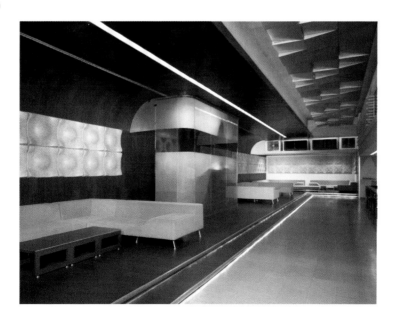

Designer SUHAIL DESIGN STUDIO
Photographer DOUGLAS FOGELSON
Location CHICAGO. UNITED STATES
Opening date JANUARY 2003

Sonotheque rises up like a temple of sound. The 3,500 square feet of what was once a liquor store are dedicated to creating a balanced acoustical space. This is the premise that underlies the whole design of the project. The artist thus employs a menu of options where the materials used in the furnishings fulfill the function of empowering sound itself.

The decoration is based on materials that project from the planes in such a way that not only functions stylistically but also creates an array of different acoustical experiences.

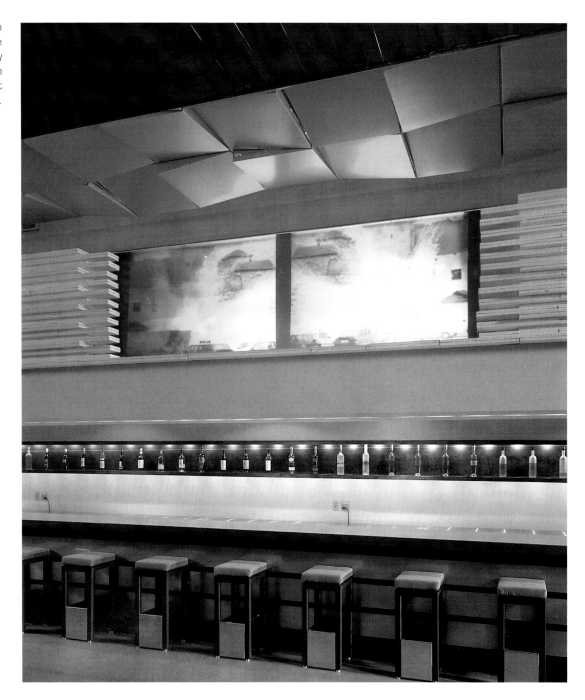

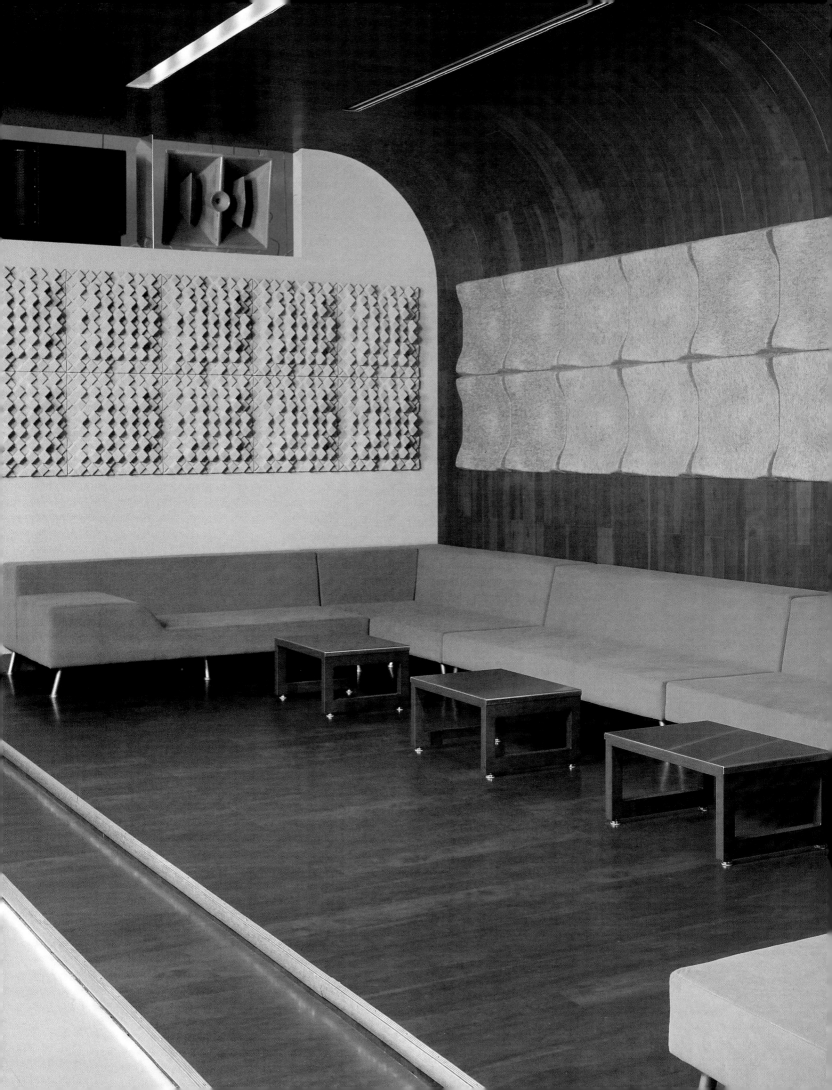

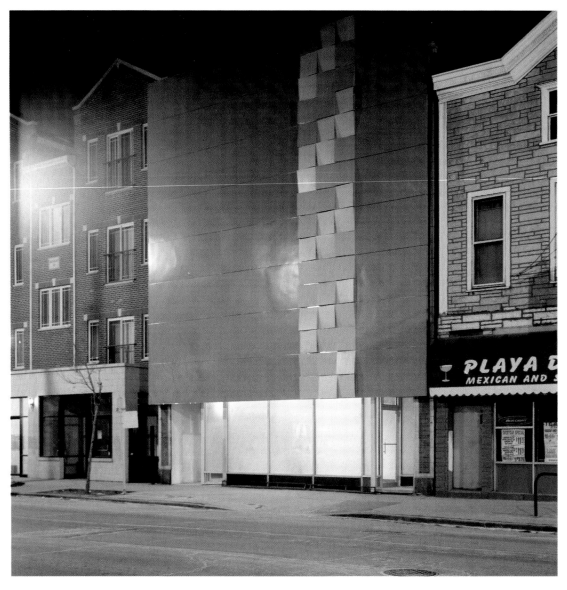

Acoustics—the main theme of the
project, both inside and outside
the façade—includes the interplay
of sets of different materials.

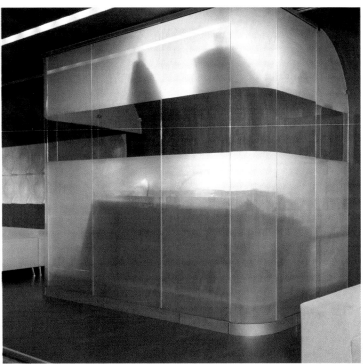

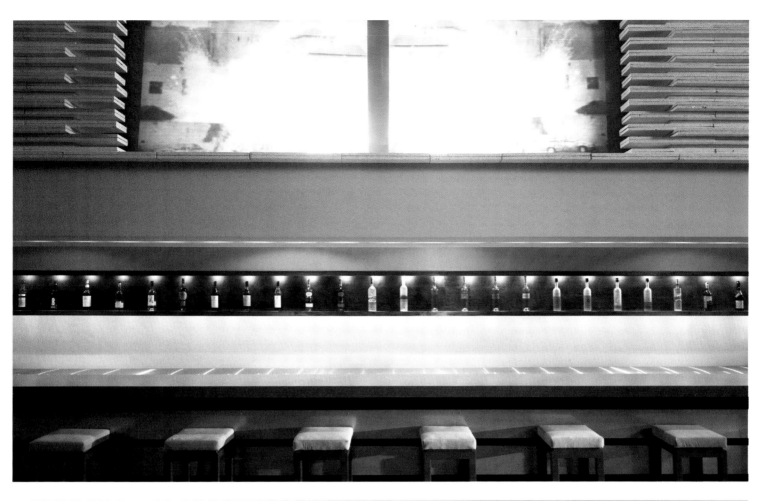

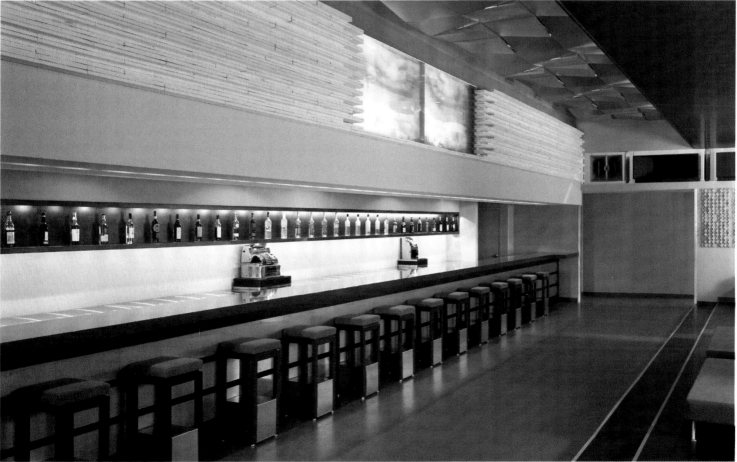

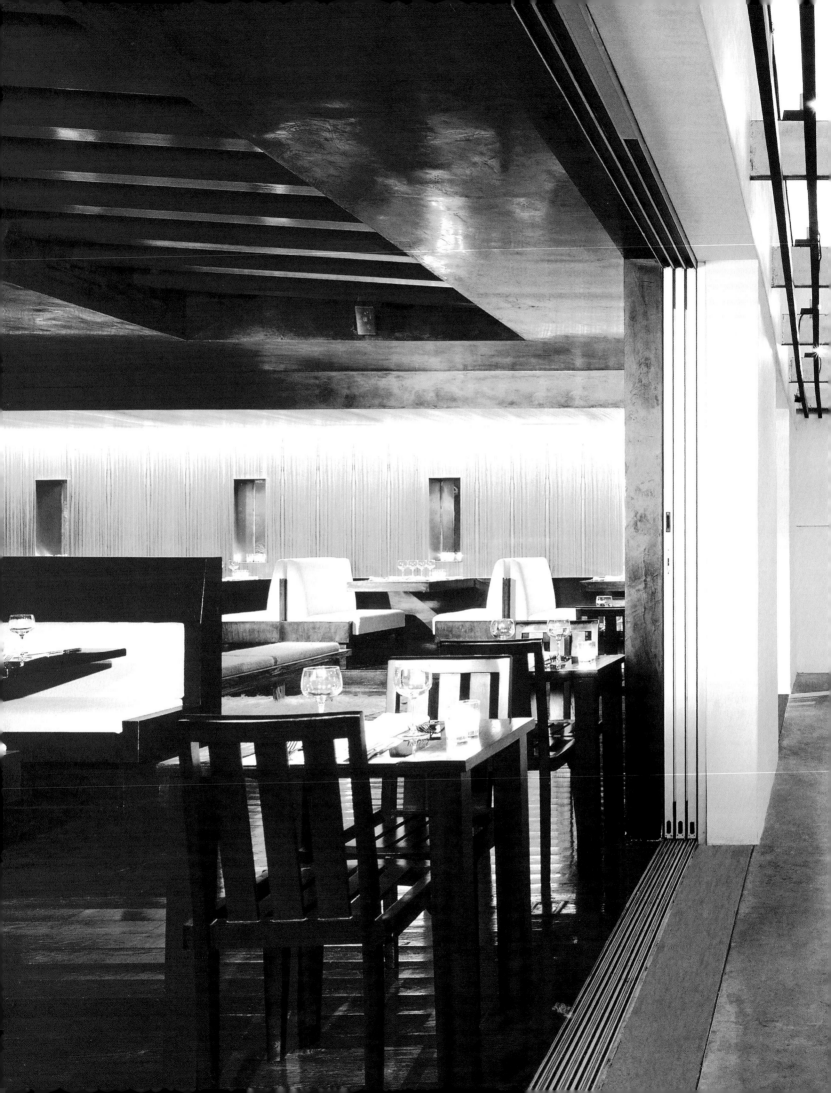

Falcon · Hollywood · United States

Amid the colorful display of posters along Sunset Boulevard, a hermetic building rises up plainly, like a tranquil, elegant oasis, in contrast with the hubbub of this popular Hollywood avenue. As in a split-screen film sequence, the project is fragmented into four spaces—entranceway, lounge, restaurant, and interior patio—each representing a different stage where independent actions are carried out.

From the entranceway, patrons can glimpse the bar, the nerve center around which the remaining rooms revolve. Through openings in the walls, one gets fragmented views of different parts of the restaurant, as well as of the patio. The sensation of fluidity generated by this distribution is the result of the archi-

tects' desire to go beyond the traditional concept of a restaurant to design an integral space that would make customers feel as if they were in their own homes when they catch sight of a living room, a dining room, and a terrace. The walls flanking the entrance are covered in mirrors that reflect the lounge and the patio, a strategy that reinforces the idea of flowing space and offers a sensation of amplitude. The spatial compactness of the interior widens out in the patio, separated from the restaurant by a tier of steps that facilitate the viewing of images projected on a large screen at the opposite end. The steps create an ambiguous relationship in which the viewers are also actors in a theater, arranged on a stage and continually observed by the diners below them.

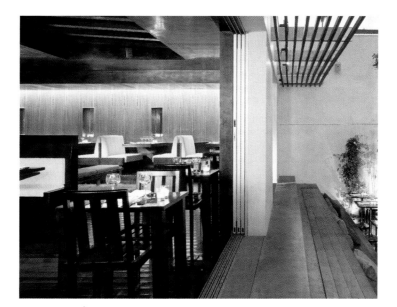

Designer **JOHN FRIEDMANN ALICE KIMM ARCHITECTS**
Photographer **BENNY CHAN/FOTOWORKS**
Location **HOLLYWOOD. UNITED STATES**
Opening date **AUGUST 2002**

The patio exploits an aesthetic completely opposed to that of the interior. As in Mediterranean settings, the whiteness of its stucco walls, with their purity and lightness, contrasts with the darkness of the restaurant. The restaurant's dark walls are in balanced counterpoint with the white upholstery of the sofas and, outside, the black tables balance the ample spatial clarity.

The self-contained look of the exterior, the preamble to the aesthetic of the interior, exercises a calming effect on the visitor.

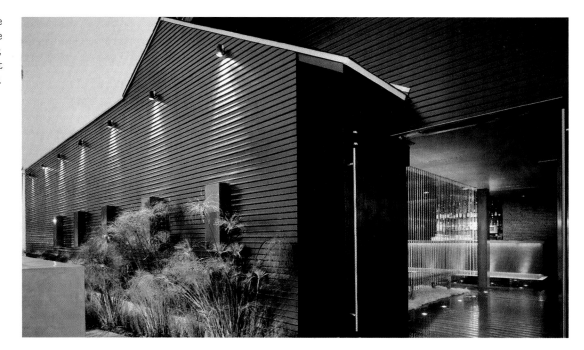

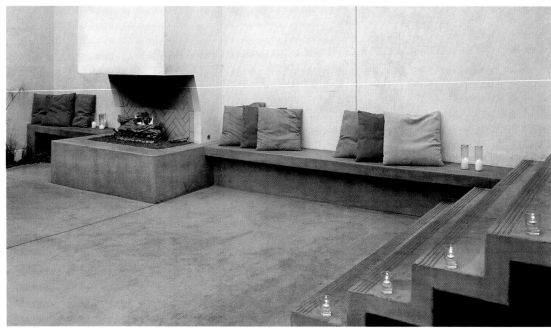

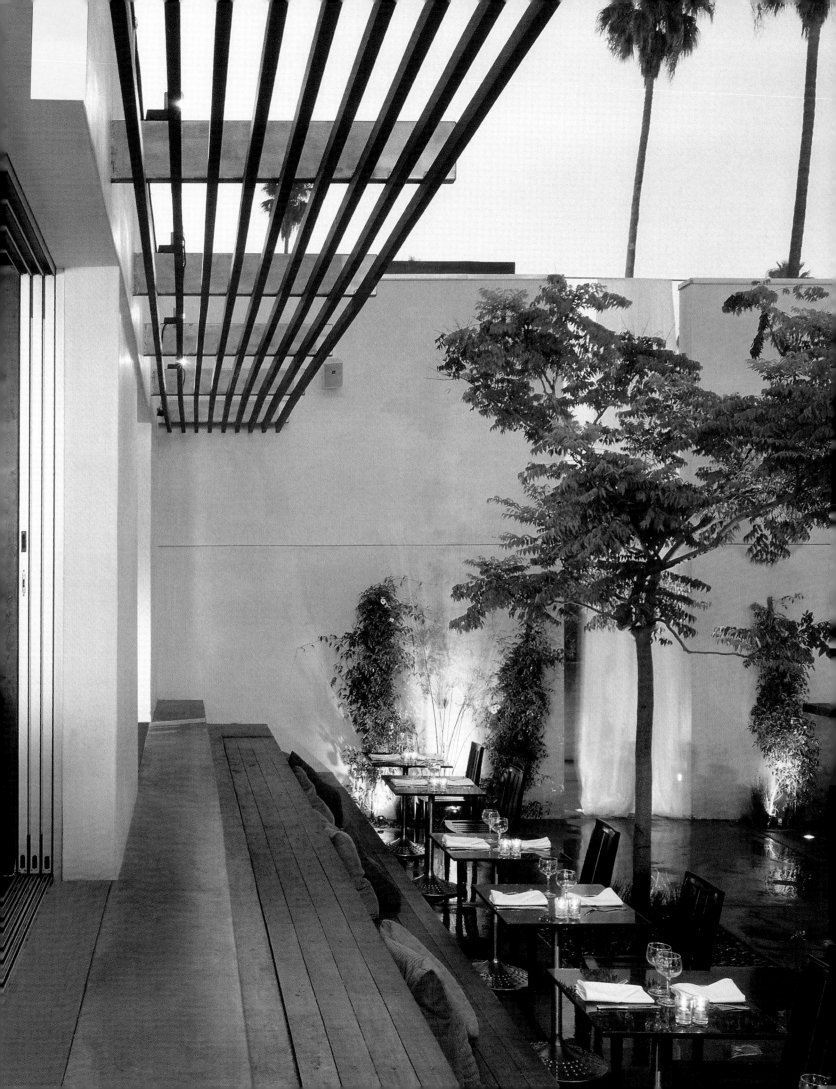

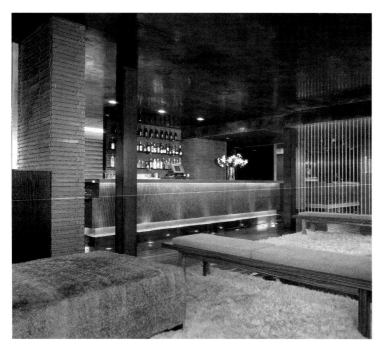

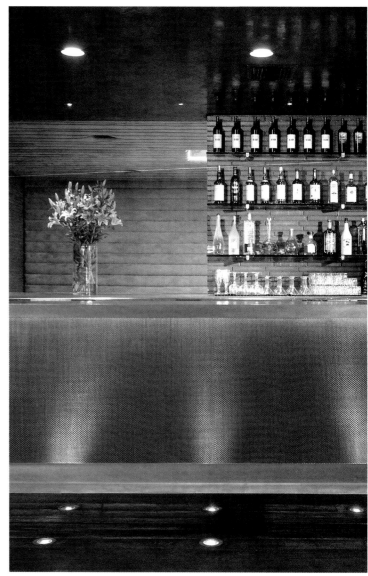

The restaurant area is L-shaped around the bar counter, whose lighting becomes the heart of the whole space.

Ground-floor plan

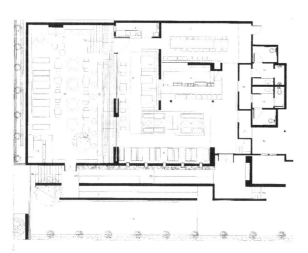

Sections

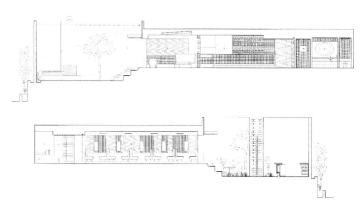

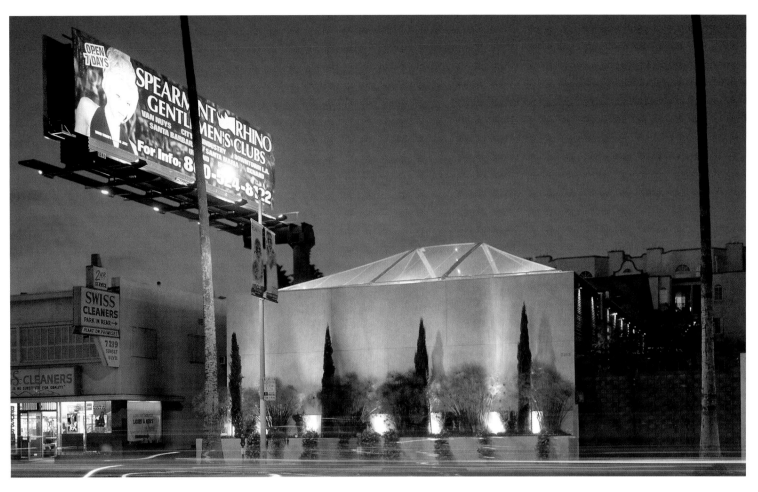

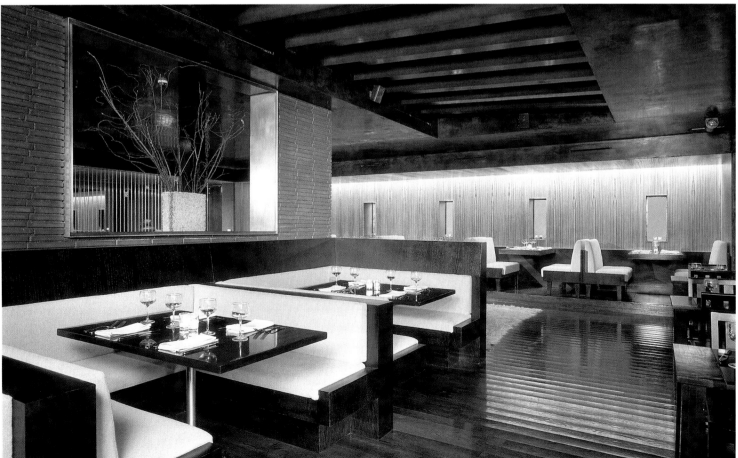

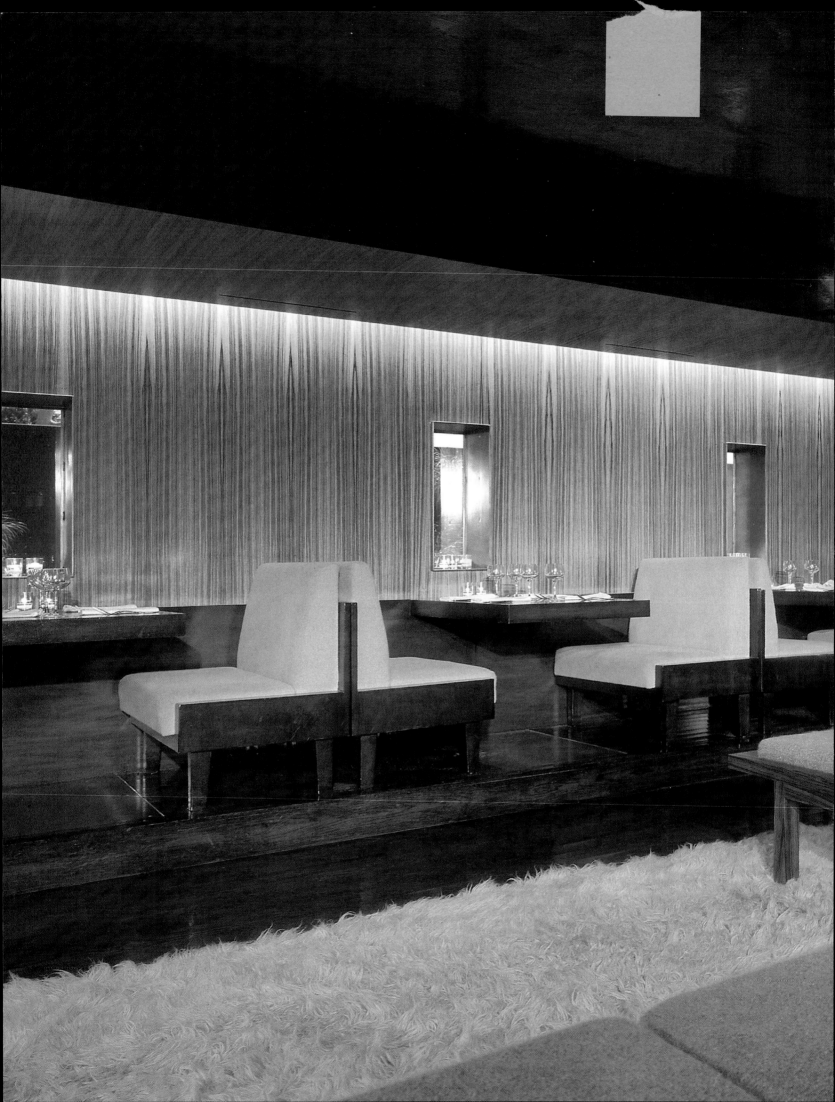

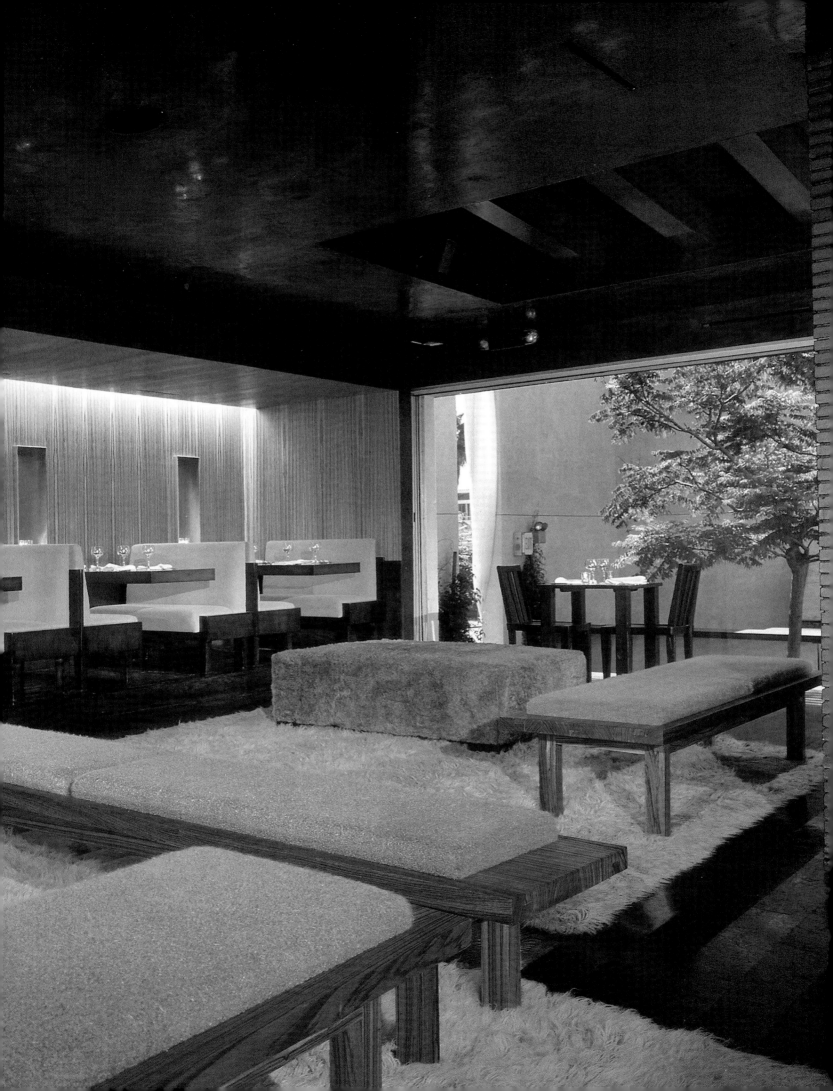

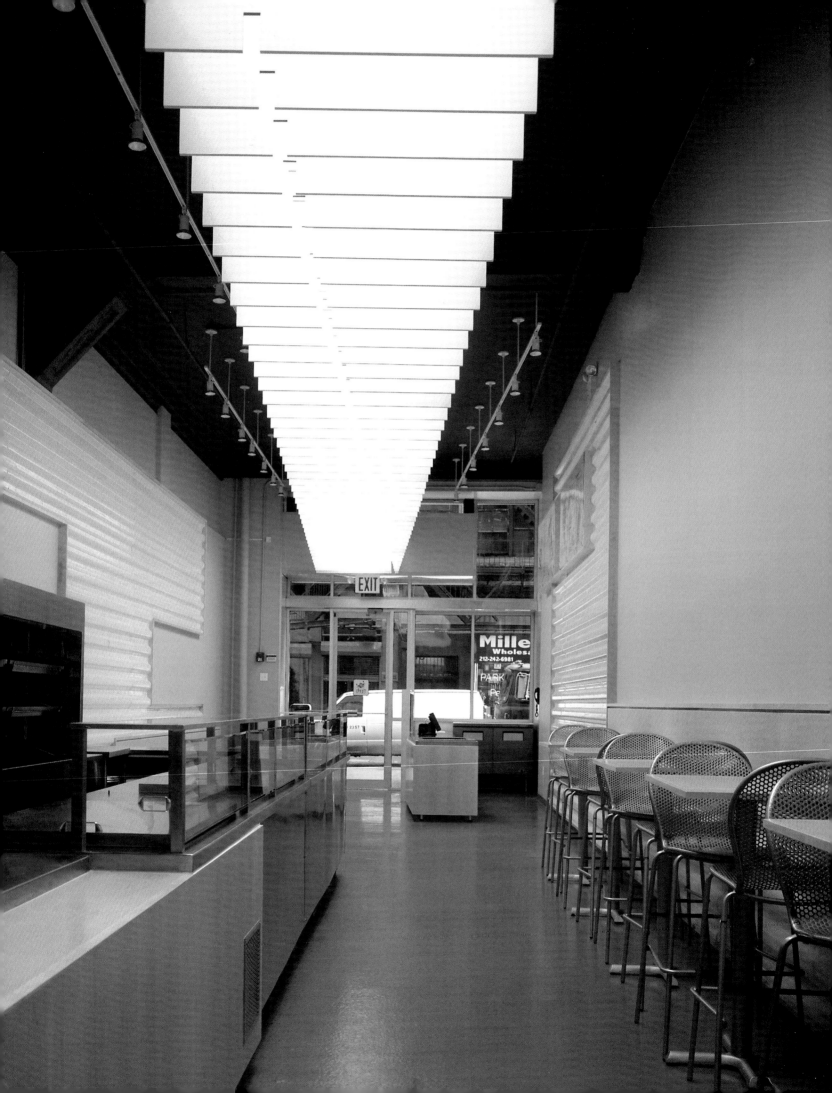

"Modernism is not in conflict with natural-ness" seems to be the idea behind Chop't, an eatery devoted strictly to doing salads. The interior of this project by Leroy Street Studio is as green as the menu it offers. The walls, painted an acid green, echo the restaurant's philosophy and take a leading role in the interior. This color, an image of naturalness as well as modernism, collides head-on with the equally intense orange of the floor in a contrast of colors that, far from clashing, creates a happy alliance of freshness and joy.

Located west of Union Square in Manhattan, the 19,375-square-foot space, in the form of a tunnel, is designed to exhibit what is going on in the kitchen, which is glassed in so that it can be seen from the outside. In designing the space, the architects opted for economical and prefabricated materials. The walls are covered with corrugated panels—generally used on roofs—of translucent fiberglass, and they extend completely around the restaurant. In their circum-navigation, though, they leave rectangular spaces, and this is where the green comes in, framed by the panels. Hard, direct lighting fills the space with a stream of light that saturates the colors and provides a sense of clarity. The furniture, surprisingly subdued, contrasts with the strong colors of the walls and the floor, giving center stage to this explosion of color that symbolizes modern style.

Designer LEROY STREET STUDIO
Photographer MICHAEL KLEINBERG
Location NEW YORK. UNITED STATES
Opening date FEBRUARY 2001

A succession of panels creates an immense light fixture that traverses the entire space, from one end to the other. Each panel has a groove in it, and the line formed by these grooves cuts diagonally across the fixture.

The geometrical, rectangular shapes that dominate this interior are broken only by chairs with curved lines.

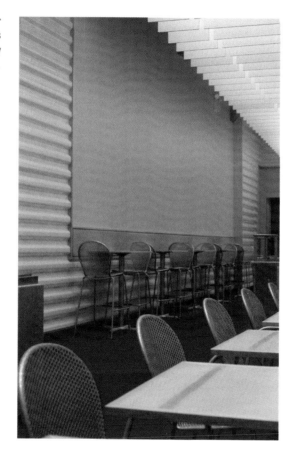
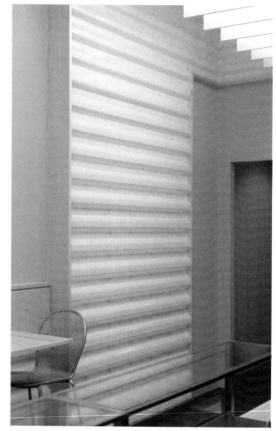

Floor plan

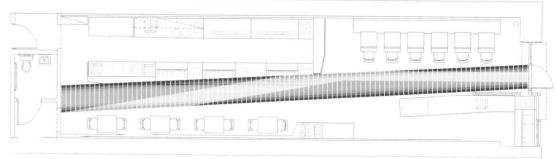

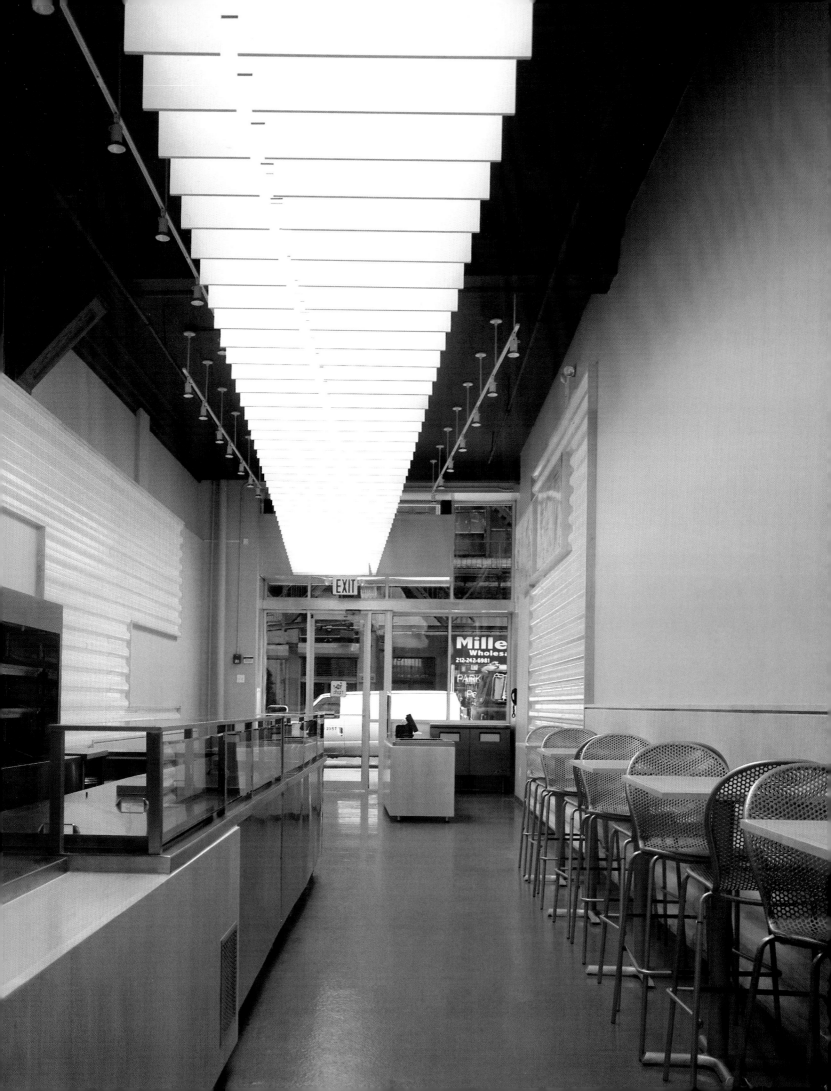

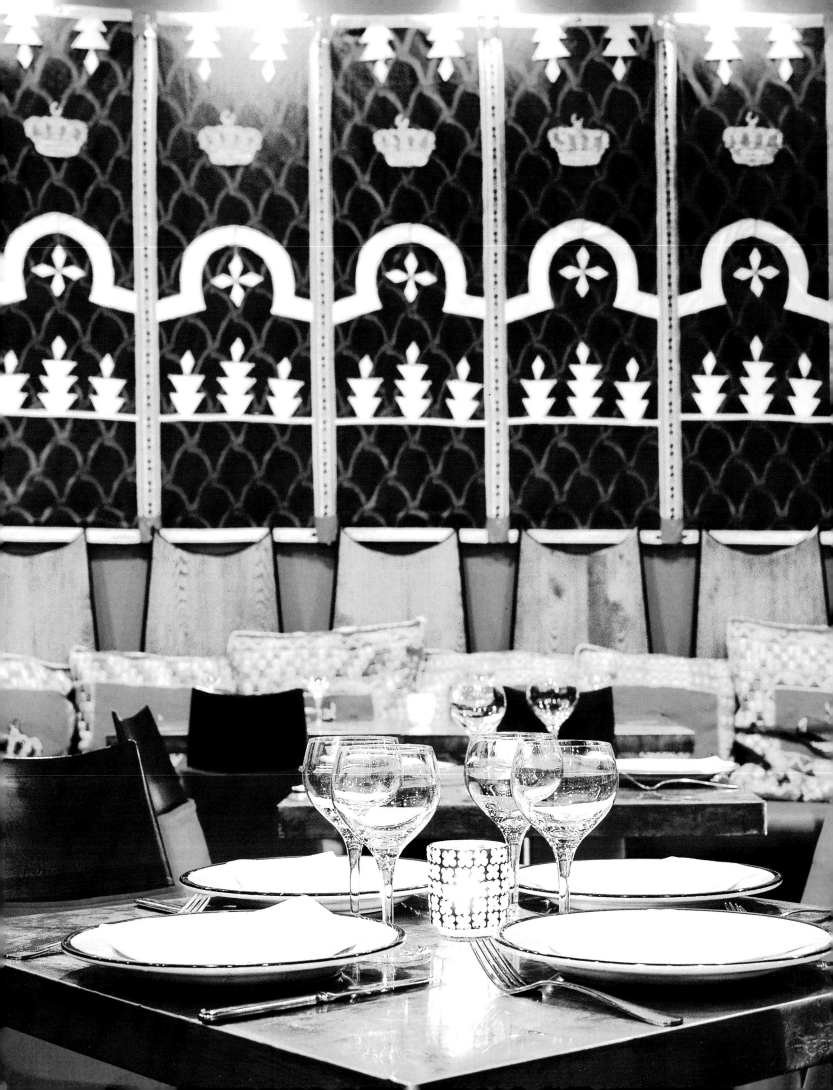

Tizi Melloul · Chicago · United States

Named in honor of a mountain in Morocco, Tizi Melloul is a personal interpretation of the culture of that country. In the vestibule, five silver containers replete with spices fill the room with the essential fragrances of Morocco. The number is hardly casual, since five is also the number of rooms in the restaurant, the number of circular windows with symbols of Islam and Morocco, and the number of small minarets on the café's perimeter, all in homage to the five-pointed star in the Moroccan flag. Tizi Melloul's large salon, with its fusion of the East and the Mediterranean, immediately brings Casablanca to mind. This is the heart of the space and acts as an interface between the two zones designated as dining areas. The first is a common space to initiate interaction among the 25 diners who fit into it. Modeled on the plan and image of a Bedouin tent, the elaborate tapestries decorated with the moon— another symbol of Morocco— adorn the walls. The main room, which seats 65 diners, reveals the main desire of the designer in its incorporation of furniture made up of both traditional and contemporary elements. The walls are an intense red, set off by attractive blue pennants with yellow borders. These match the poufs and cushions that, during banquets, are ranged around the curved perimeter wall. Together, these objects make up a series of waning quarter moons that are crowned by more than 20 silver and glass lamps in different shapes and colors, submerging the space in an ethereal brightness.

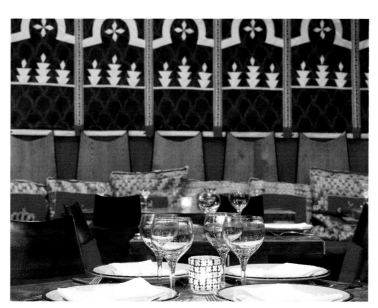

Designer **SUHAIL DESIGN STUDIO**
Photographer **DOUGLAS FOGELSON**
Location **CHICAGO. UNITED STATES**
Opening date **JUNE 1999**

The interior of this restaurant is a curvilinear and sinuous space that evokes the flourishes of Arabic calligraphy and incorporates native fabrics, colors, furnishings, and textures to re-create the setting of North Africa.

In the bar, a blend of modern and traditional furniture fills a space that features textured white walls illuminated by a multitude of lamps shaped like the peak of a nomad tent.

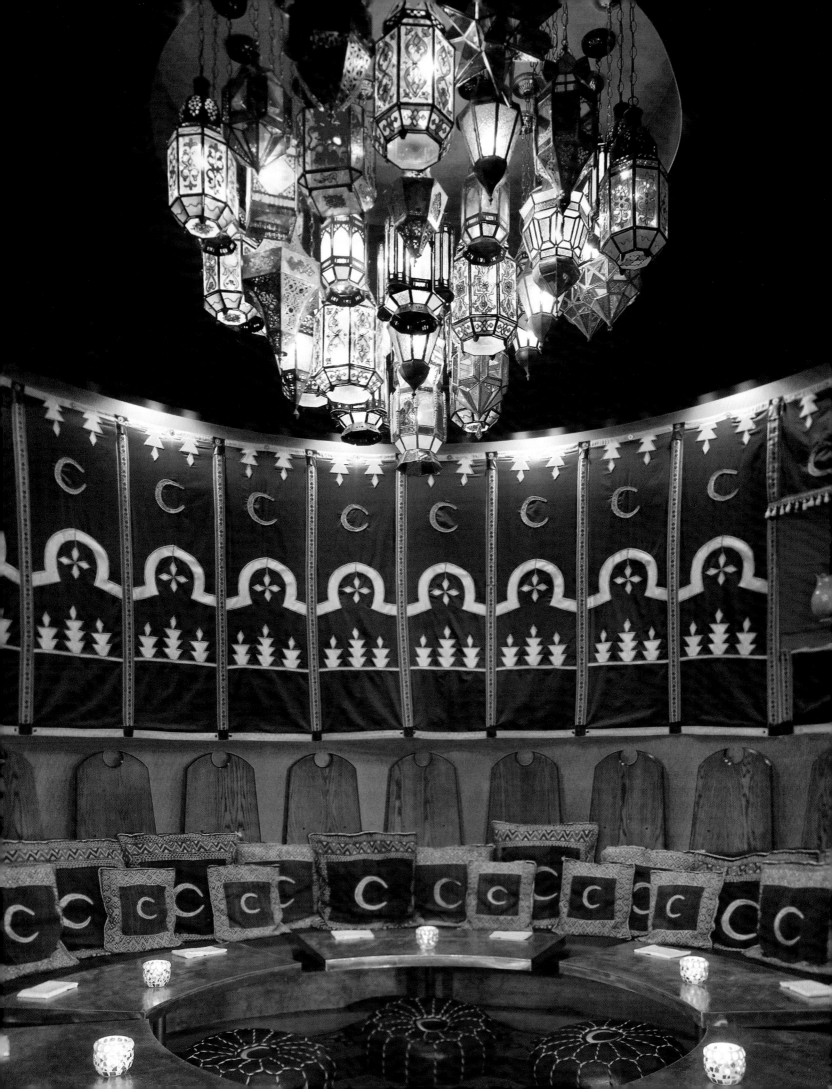

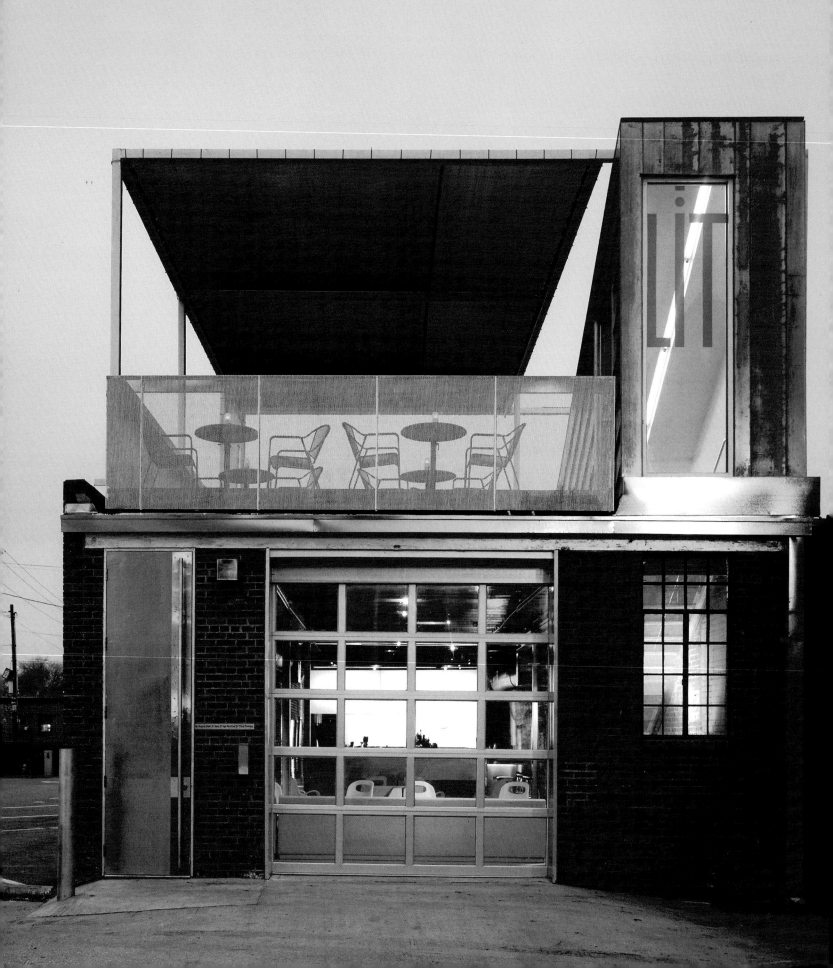

LIT might be seen as an art gallery inside a bar. Or a bar inside a gallery. It might be both of these at once, since both concepts are indissolubly united in this Elliot + Associates project that gives equal time to art and interior design, to art object and space. Rude and refined at the same time, the design of LIT starts from a very limited budget. The original brick-and-concrete structure was respected, and even the imperfections in the walls were retained as witnesses to the building's history. This history also serves as art, materialized in a series of paintings illuminated in bright colors on the wall like shining jewels in a modest attempt to palliate the nudity.

The industrial look of the furniture contrasts with the explosion of imagination that takes place on the walls, surfaces that concentrate all of the space's decoration. Brick on one side, concrete on the other, the coldness of the walls highlights to an even greater extent the paintings and sculptures they display. Thus, from a metal door, we find plastic tubes with wine bottles inside them creating a set of singular protuberances that project horizontally from the wall. The paintings concentrate all of the color on their edges, in an attempt to claim some distinction for a space that, by its very structure, has already rendered it.

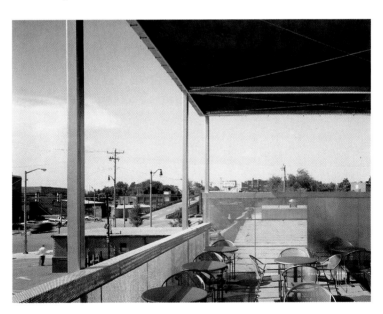

Designer **ELLIOT + ASSOCIATES ARCHITECTS**
Photographer **ROBERT SHIMER, HEDRICH BLESSING**
Location **OKLAHOMA CITY. UNITED STATES**
Opening date **JULY 2002**

The temperament of this space is defined by contrasts where the reflections of the galvanized metal play off of the translucent and opaque materials. The artwork on display provides an ever changing decoration for this project.

A large wall of backlit translucent panels illuminates an interior marked by the predominance of gray.

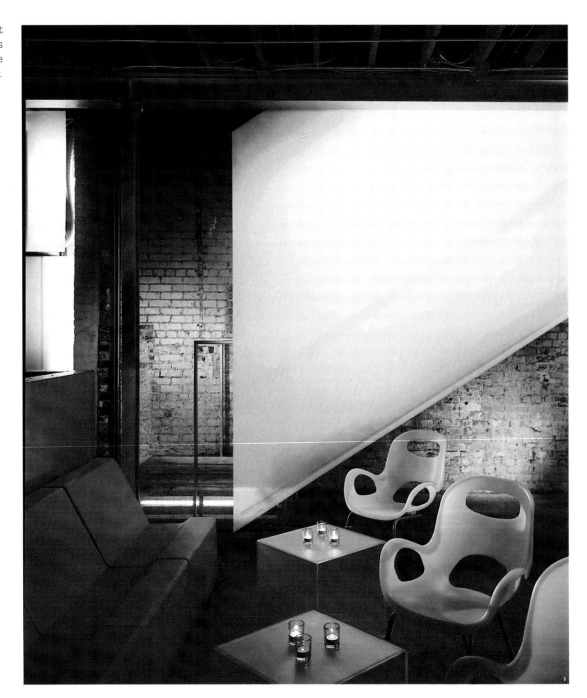

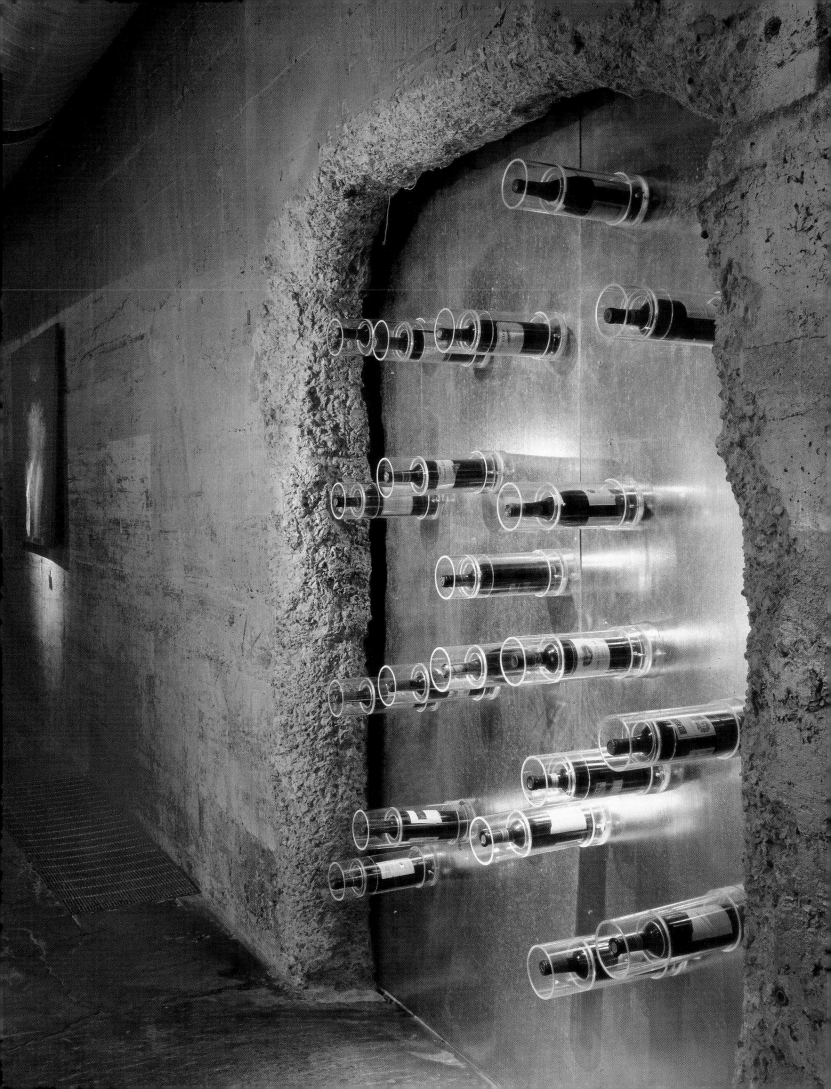

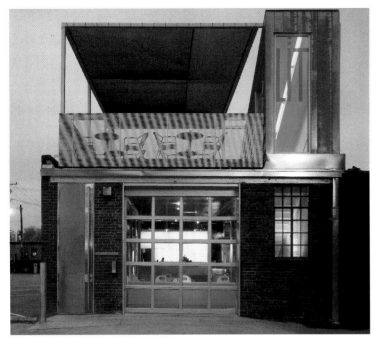

Absence and presence, brightness and opacity, mark this project of contrasts. In this interior of industrial aesthetic, the single note of color resides in the paintings on the walls and the candles on the tables.

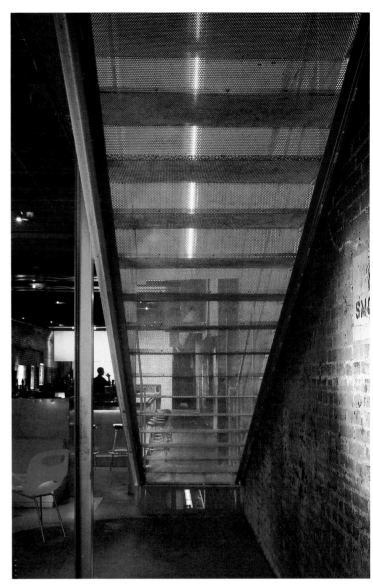

Section

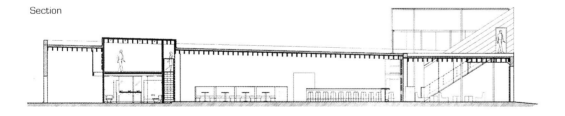

Ground-floor plan

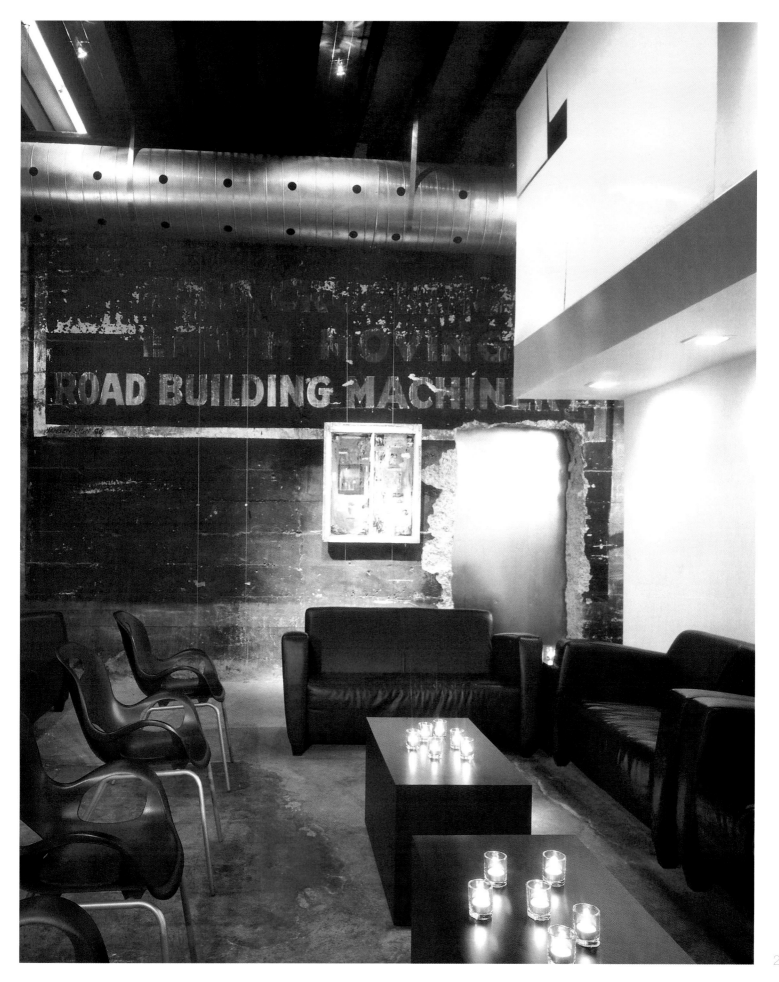

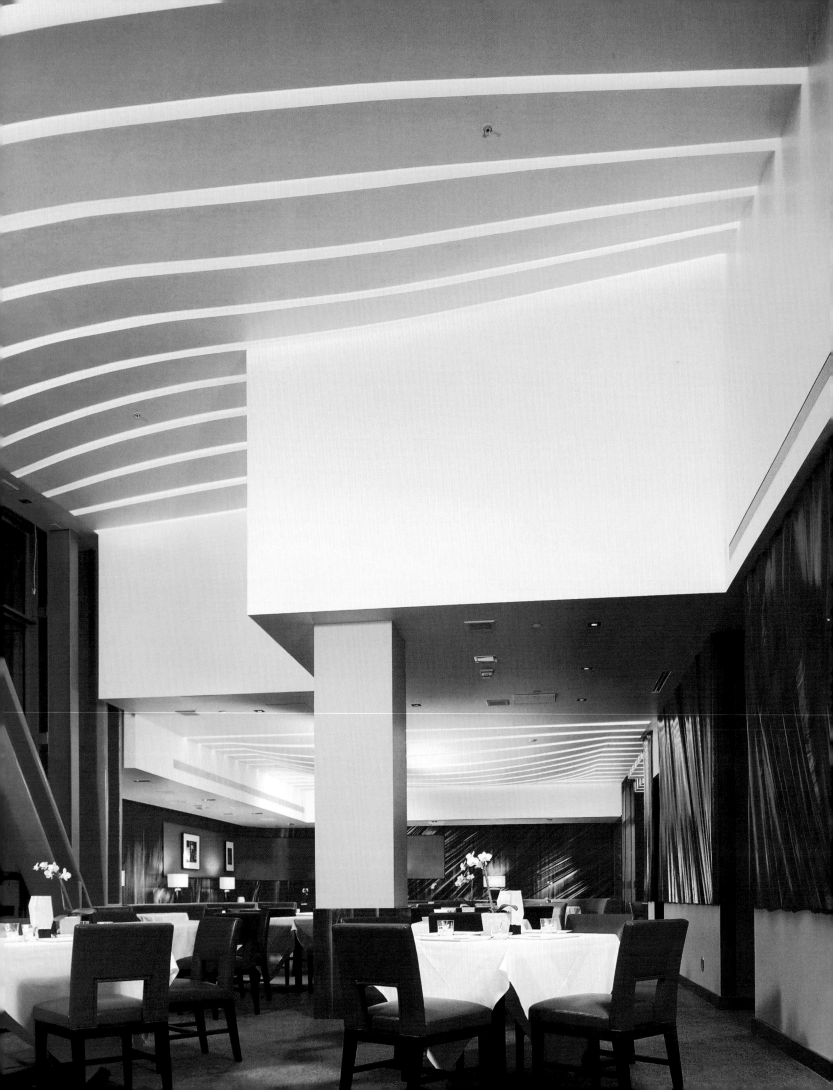

From the outside, Patina is a structure of rectangular forms and glazed panels that contrast with the composition of curved surfaces in the Walt Disney Concert Hall, the building that houses this restaurant. Belzberg Architects wanted to create a flexible project that, while following the concert hall's general aesthetic, could boast its own personality. The interior of this establishment is the result of joining these two opposing forces: curved and straight lines fuse, just as architecture and decoration intermix and cease to be separate elements that are given a different treatment.

The ceiling, of a striking phosphorescent yellow, is covered by long white panels with integrated illumination. Arranged in parallel with minimal separation between them, these panels filter the excess light. As a result, the narrow strips in the ceiling expose the yellow sea behind the panels in a curious form of decoration. The walls are ornamented with carved walnut panels that form an undulated surface, like curtains expanding through the space.

The impulse of movement and dynamism that seems to flow through the compact orthogonal materials in this interior equalizes the balance of such an oblong space, and at the same time, pays homage to the architecture of the Walt Disney Concert Hall.

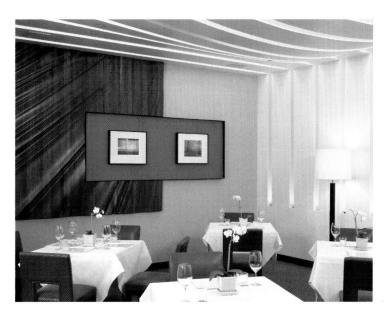

Designer **BELZBERG ARCHITECTS**
Photographer **TOM BONNER**
Location **LOS ANGELES. UNITED STATES**
Opening date **OCTOBER 2003**

Borrowing from textiles a movement and dynamism not generally associated with architecture, the fixed, hard surfaces have been given a flow characteristic of more flexible and light-transmitting materials.

In a trichromatic scheme of whites, browns, and yellows, the latter is present both in the striations visible between the ceiling beams and in the illuminated wine display.

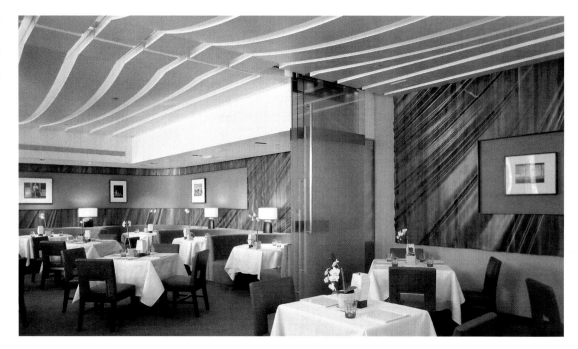

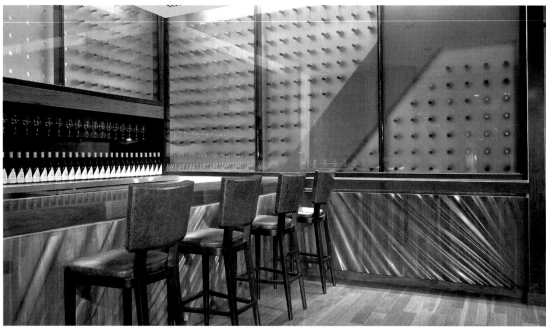

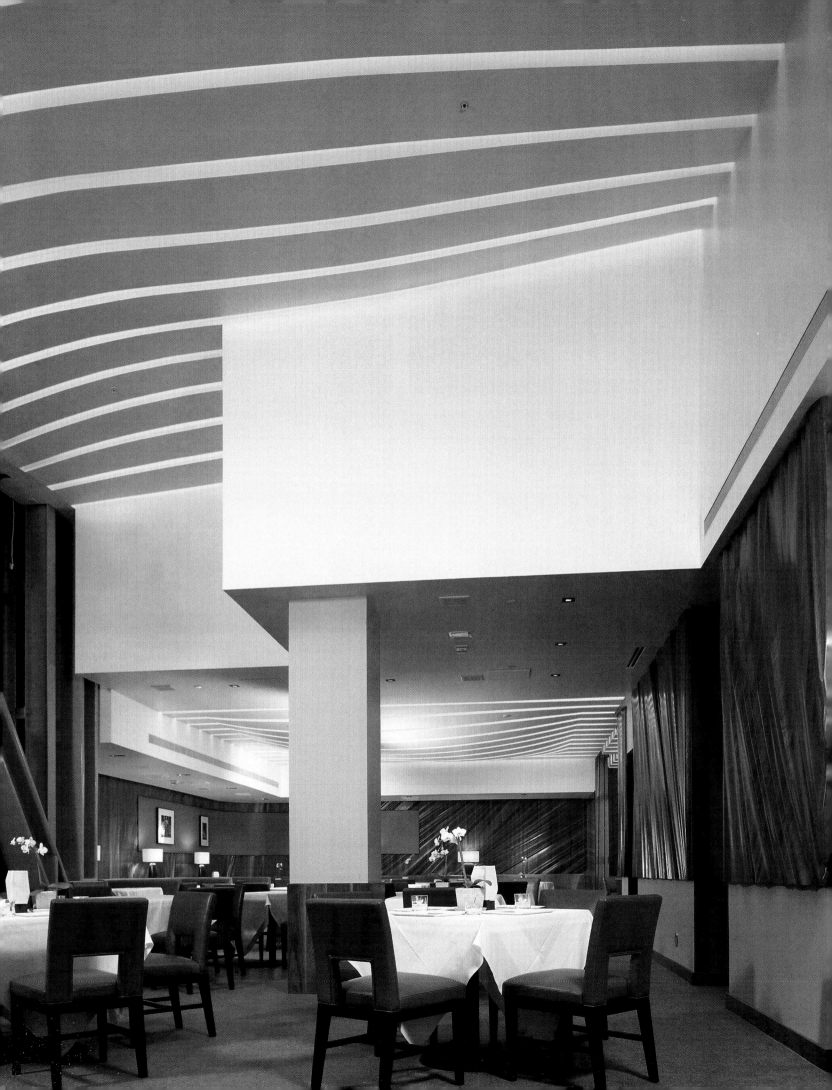

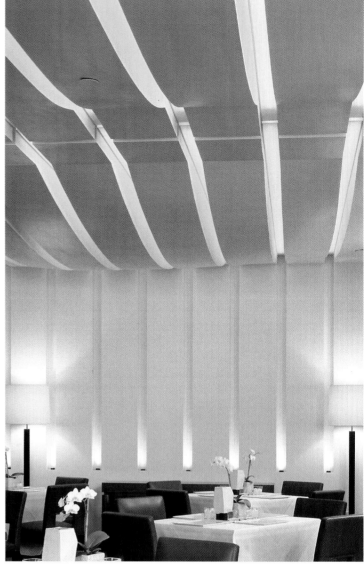

The rippled forms of the panels have a textile-like quality that brings to mind the image of a nomad tent with a ceiling covered with cloth.

Floor plan

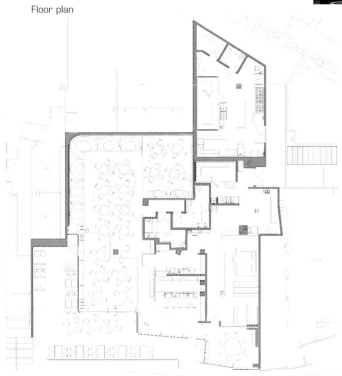

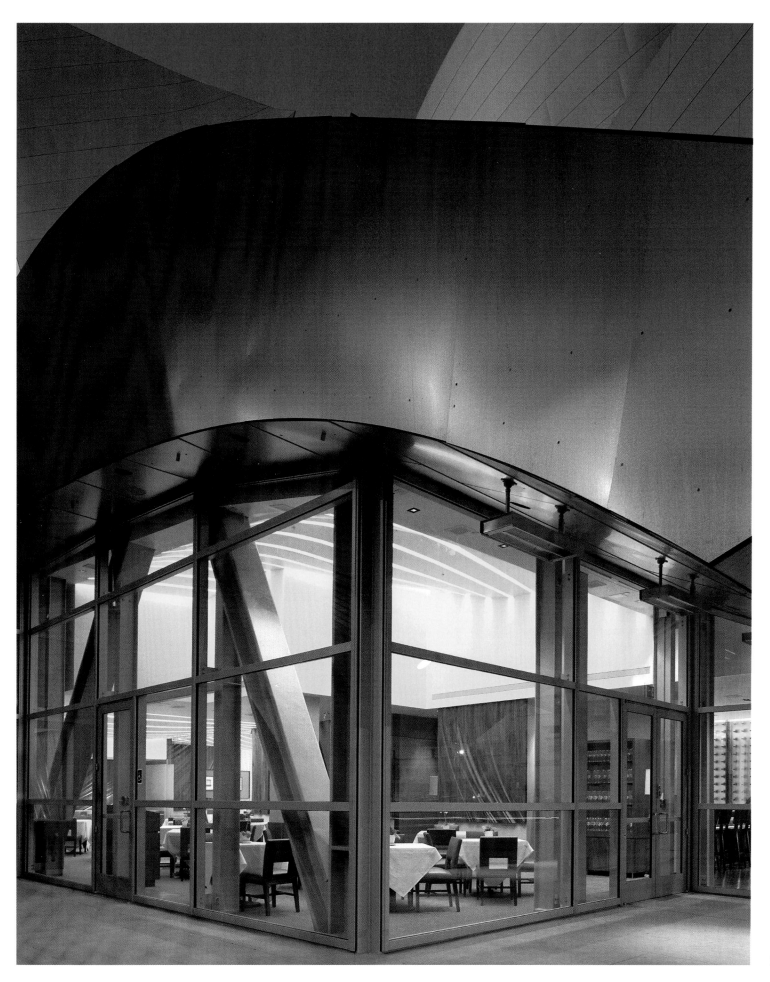

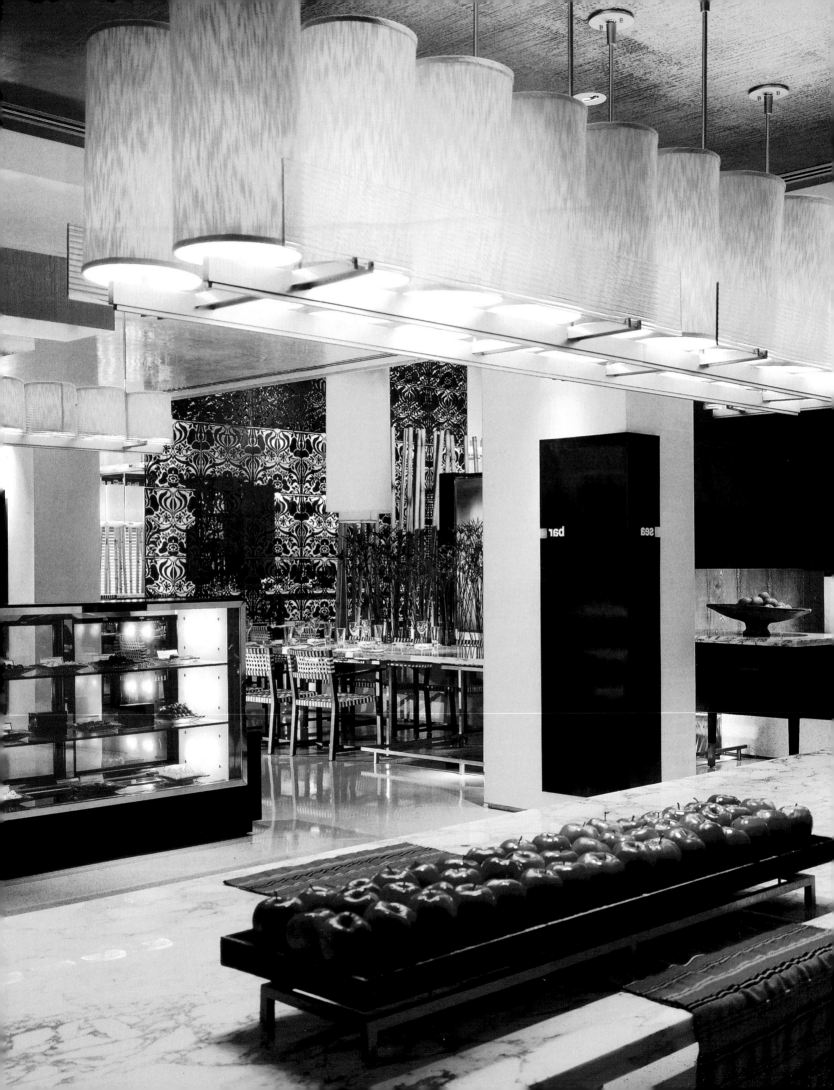

Café Sambal and Azul · Miami · United States

Contained in an architectural structure faced in copper, Café Sambal and Azul, bar-café and restaurant, respectively, are located in Miami's Mandarin Oriental Hotel. The interior of the Sambal reflects the sunny and soothing Florida setting, with plaster walls and a floor tinted in a sand color that includes seashells. A venetian blind with walnut wood slats projects a grid that surrounds the whole space and accentuates the ordered design of the geometric masses. In the center of the space, a two-floor atrium houses a stairway that links the two floors. The relaxing sound of water from a decorative swimming pool in the main room is evocative of the marine landscape of Biscayne Bay.

The water is also used in Azul, where a cascade in the entry adds to the calm, sensual interior space. Both areas use to advantage the magnificent views of the bay through the inclusion of balconies and oversize windows.

Groups of aligned cylinders in pale yellow create a cool lighting that wraps the space in a flair of elegance and exoticism. Noble components such as wood and marble are combined with other materials of more industrial appearance— stainless steel, for example, and glass. The eclecticism reigning in these interiors unites East and West in two spaces of enormous theatricality that create a setting of sensuality and serenity.

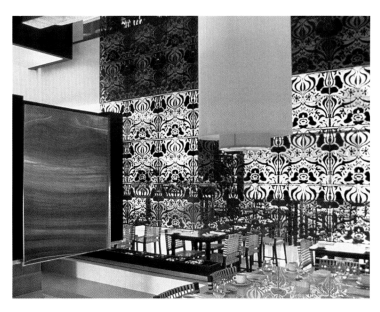

Designer **TONY CHI AND ASSOCIATES**
Photographer **DOUG SNOWER**
Location **MIAMI. UNITED STATES**
Opening date **MARCH 2001**

Tony Chi conceived the design of Café Sambal and Azul as a mestizo aesthetic that subtly fuses Oriental elements with Western components, using a savoir faire that imbues the spaces with sophistication.

Installations made up of groups of cream-colored cylindrical lamps hang from the ceiling and diffuse an air of intimacy throughout the space.

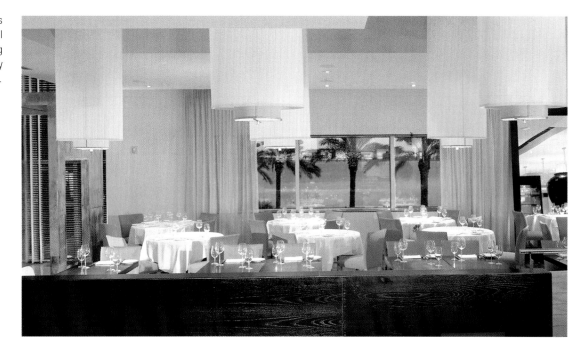

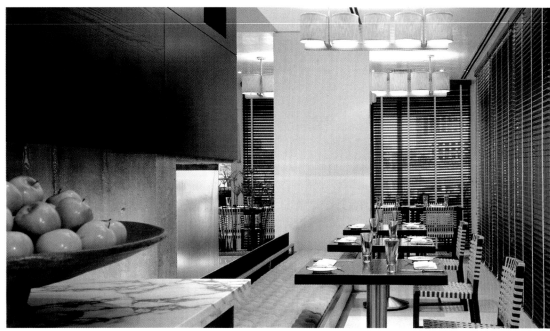

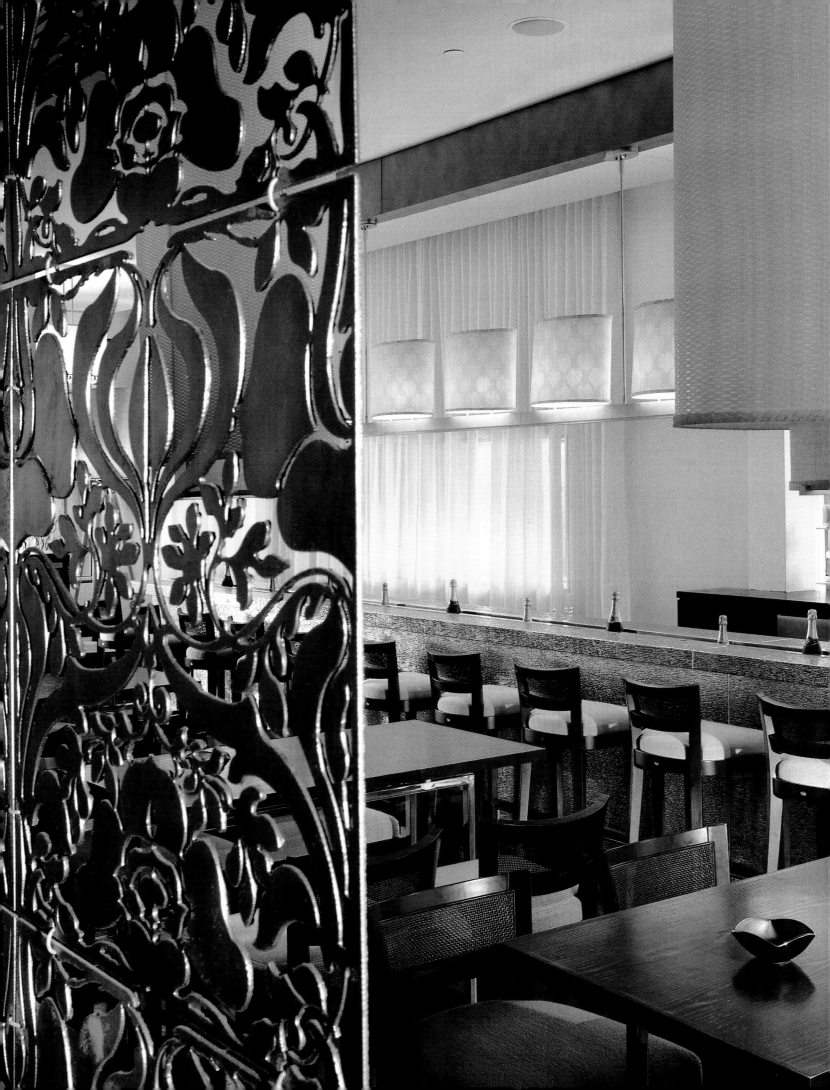

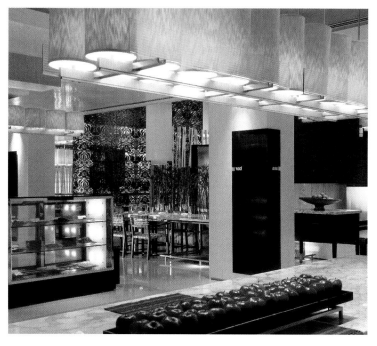

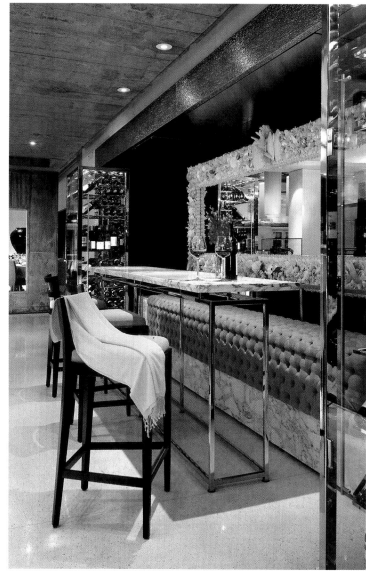

Eclecticism defines this project, which combines the coolness of marble, the warmth of wood, and the industrial character of metal.

Floor plan: one

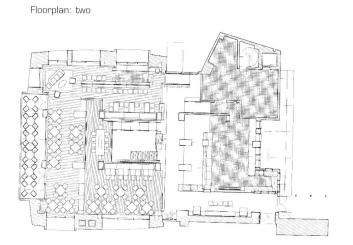

Floorplan: two

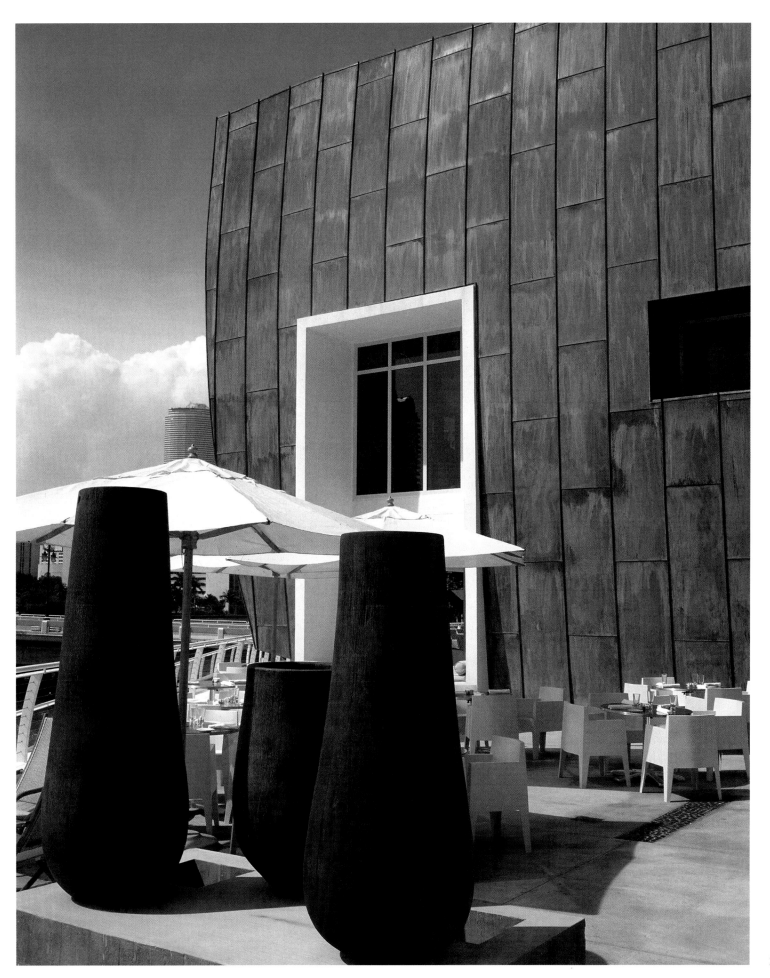

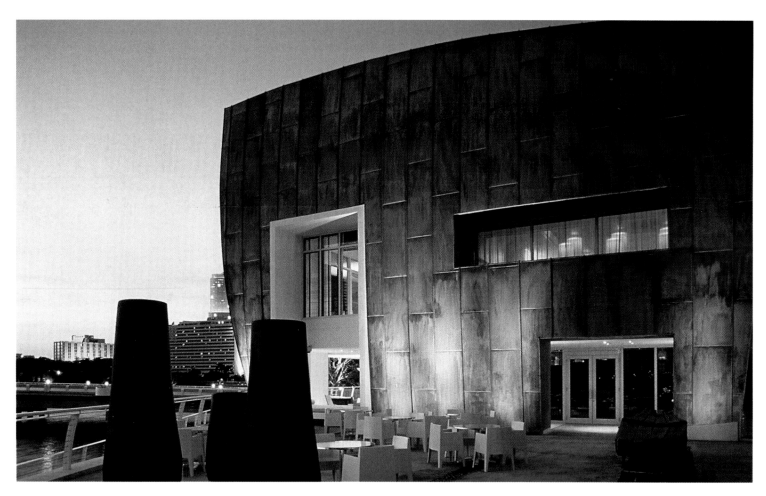

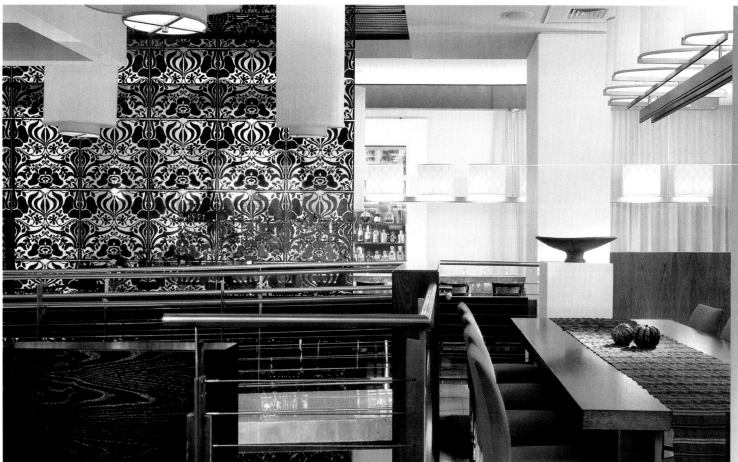

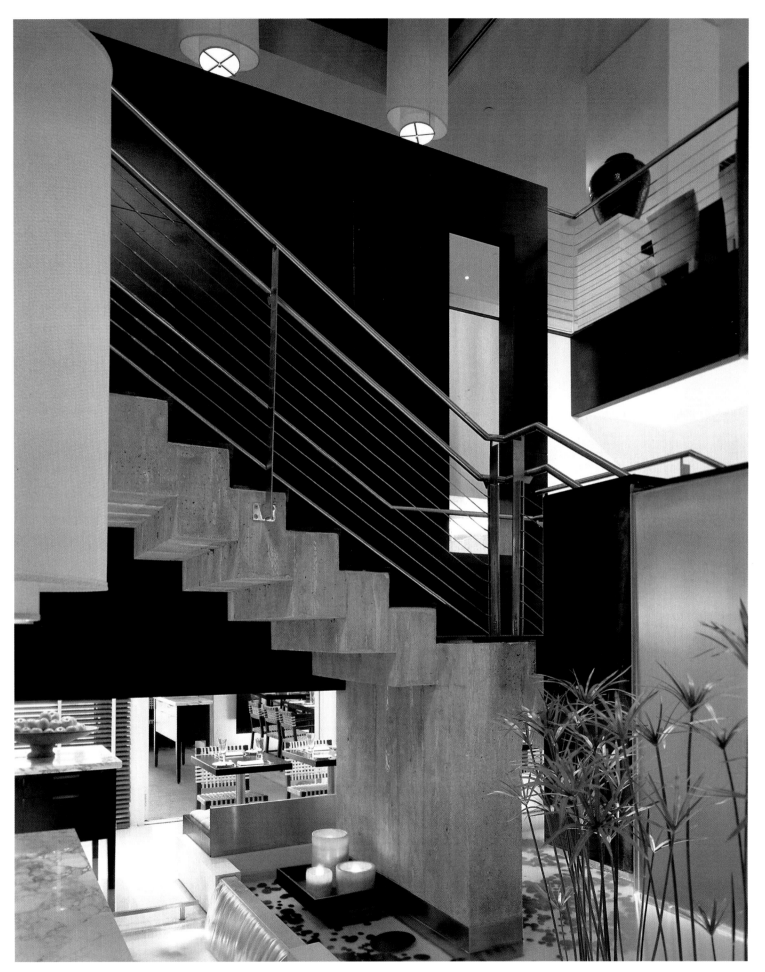

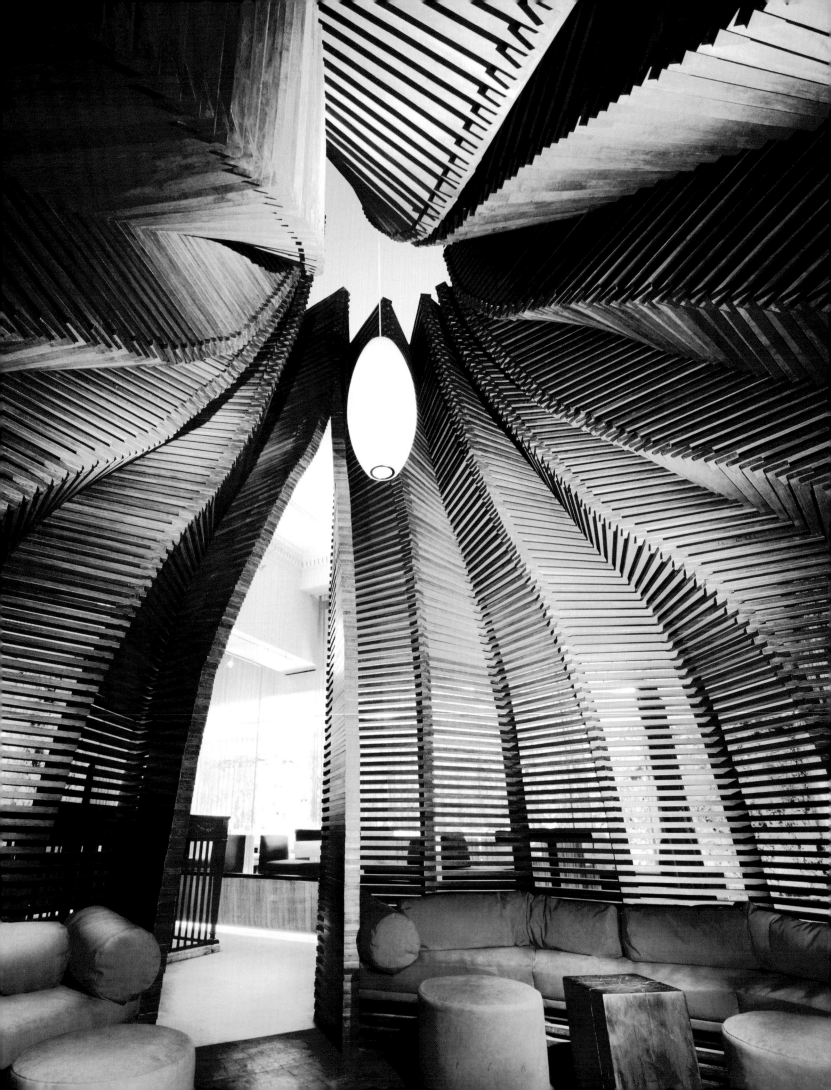

Mantra · Boston · United States

Mantra, a term of Sanskrit origin, designates the systematic repetition of a word, prayer, sacred sound, or vibration as a spiritual practice for the purification of the mind. It is, at the same time, a mental mechanism and an instrument to perfect thinking, a concept re-created in the interior design of this restaurant by the architectural studio Office dA. Indian silks, marbles, and poufs, among other Oriental elements, aid in the thematic transformation of what was once a building occupied by a bank, and harmonize with a menu based on a mixture of French and Indian cuisine.

Two elements stand out in this project: on the one hand, translucent panels are utilized in the finishing coat given some walls and as an element used to separate spaces. On the other hand, a monumental wooden structure is fitted into the restaurant like a refuge of calm, intimacy, and mental peace. This species of nomad tent is entirely constructed with strips of plywood that create a simple enclosure system, free of any kind of structural reinforcement, thus forming a vaulted frame of wood sheeting that converges on the ceiling. Decorated with red velvet poufs and low sofas that follow the perimeter of the walls, the interior of this small room generates a nucleus separated from the restaurant that, nevertheless, reproduces the general aesthetic of the whole space.

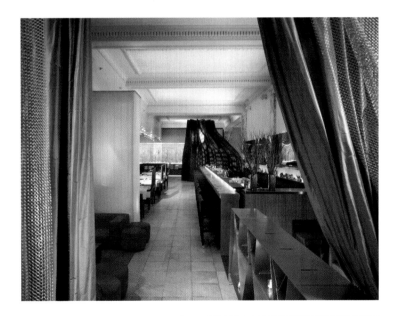

Designer **OFFICE dA**
Photographer **JOHN HORNER**
Location **BOSTON. UNITED STATES**
Opening date **JANUARY 2002**

The earth colors of the wood and the silk curtains contrast with the pink marble and with a series of backlit translucent panels in blues and pale greens.

Long curtains of Indian silk, with colors matching those of the chairs and the marble, separate the anteroom from the dining room.

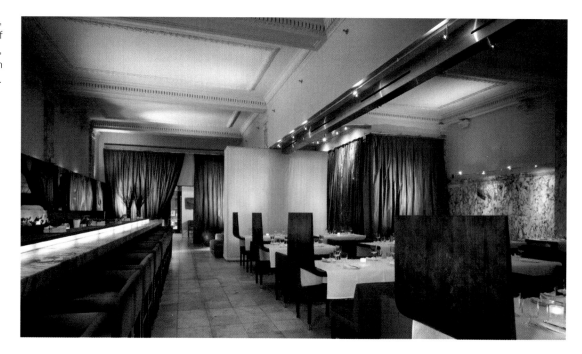

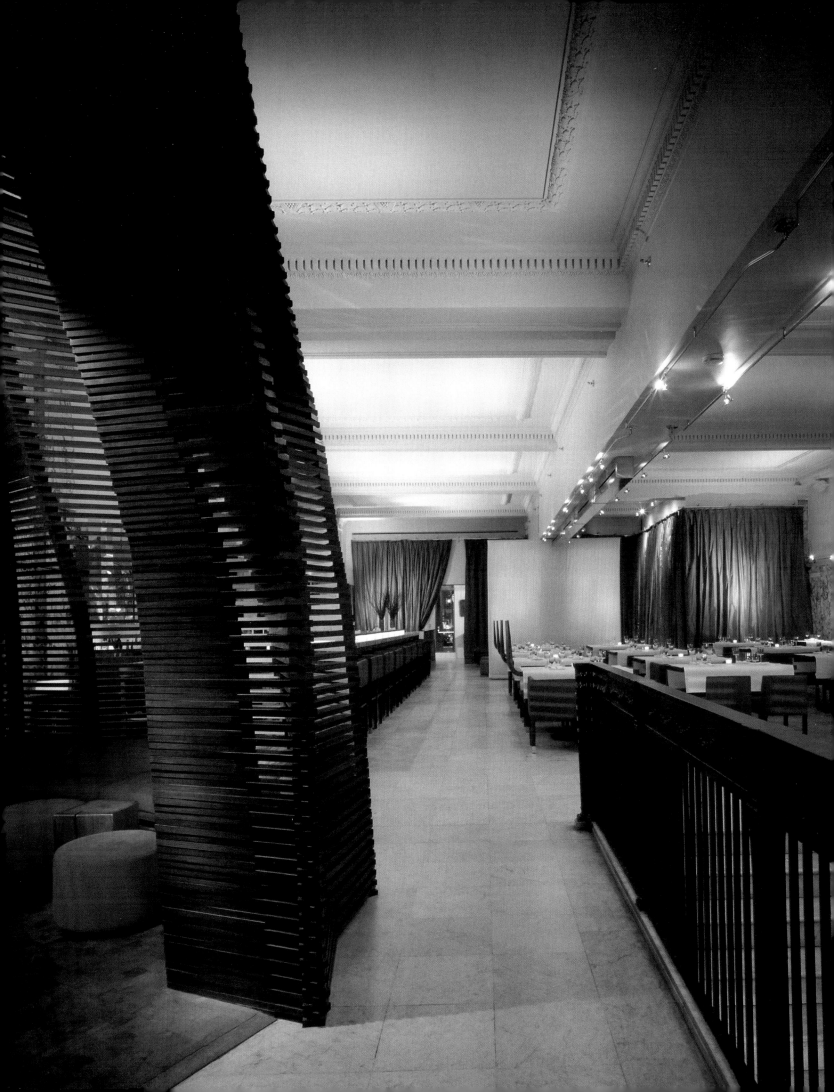

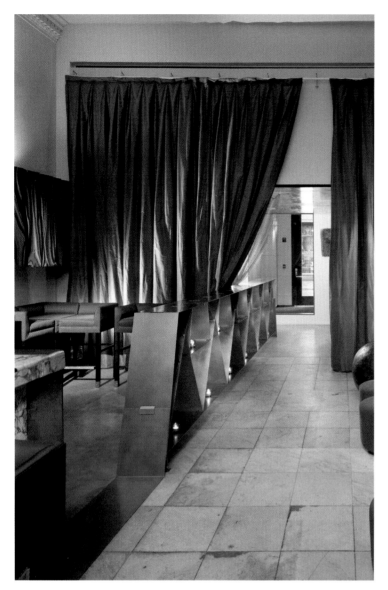
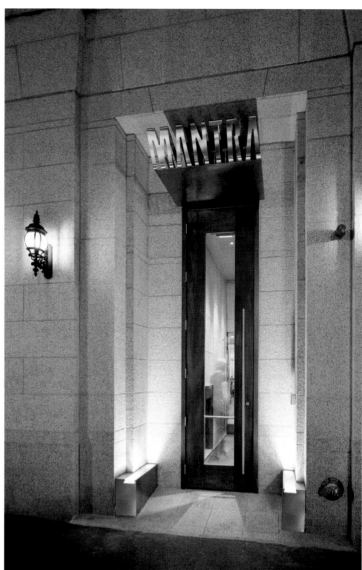

The opacity of the wood and the marble is combined with translucent materials in a project that features Indian reminiscences.

Floor plan

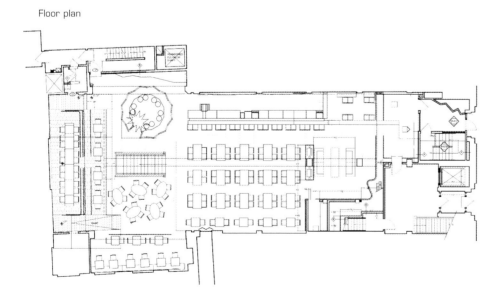

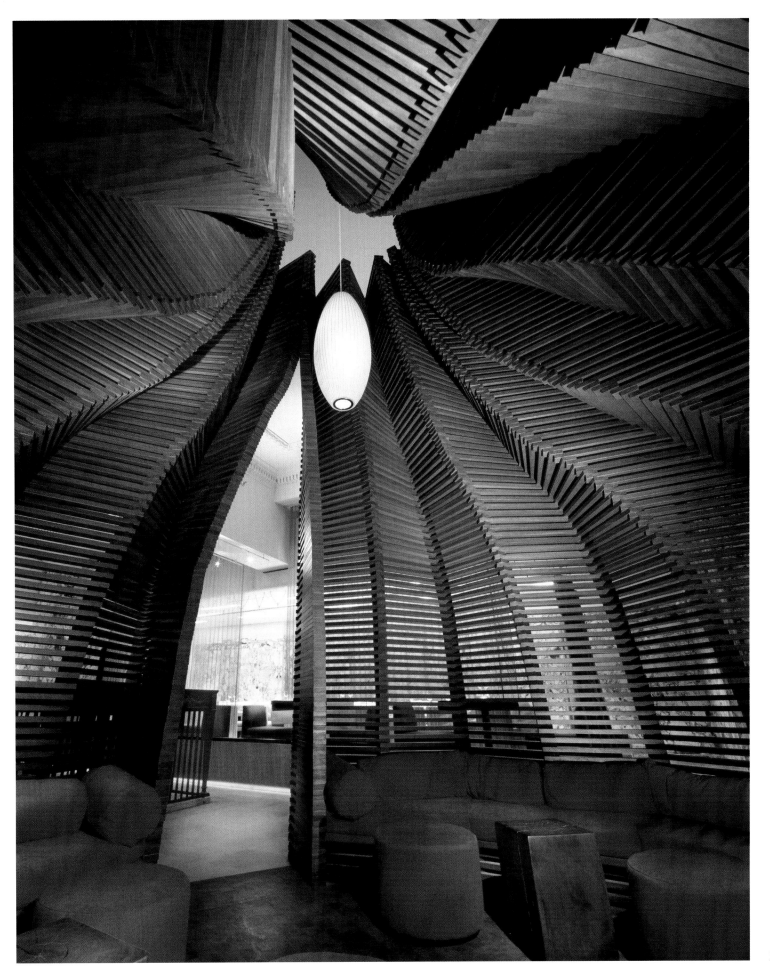

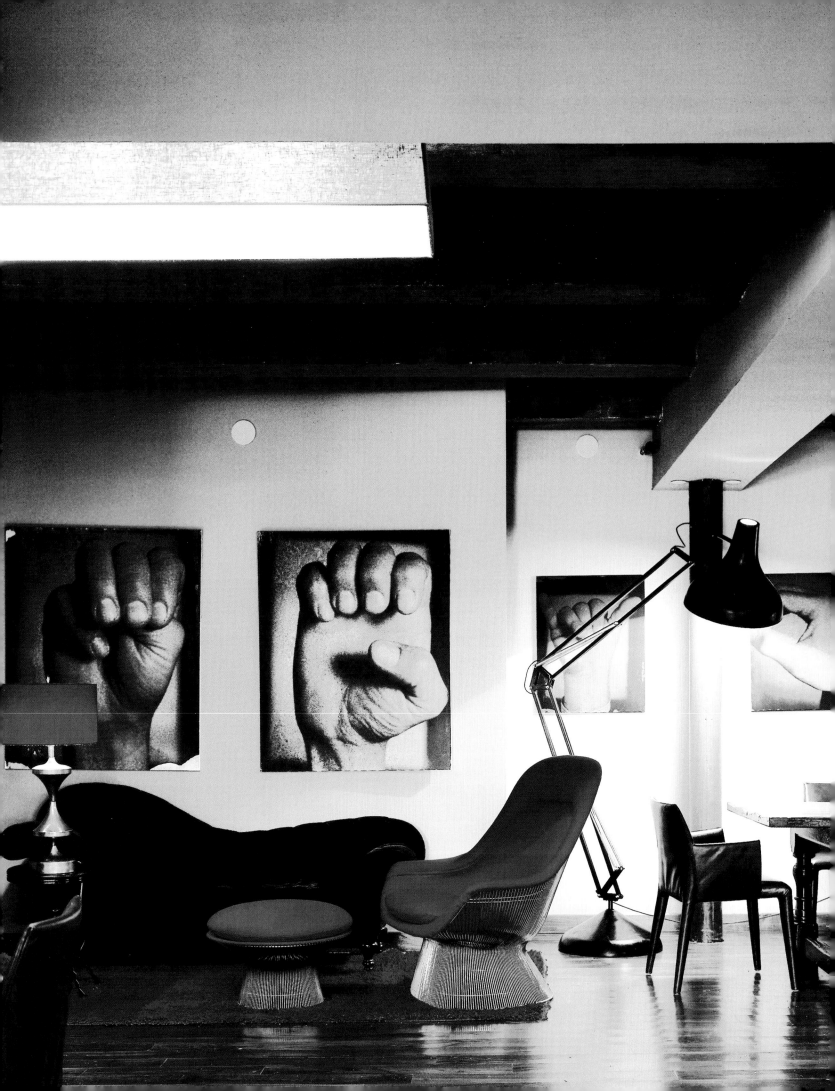

Soho House · New York · United States

Soho House crosses the pond from London to New York to open a new six-story locale in the well-known Meatpacking District of the Big Apple. Soho House—which has four dining rooms—is an exclusive hotel and club designed by Studioillse.

The restaurant seats 80 diners, and also includes private rooms with a maximum occupancy of 12 people. Although the views of downtown Manhattan are very impressive, the most spectacular decorative elements are the chandeliers by Swarovski that hang from the ceilings. The adjacent bar, with its U-shaped counter, is flanked by small tables that stamp an intimate character on the space, aided in their task by a chesterfield sofa more than three yards long. The space called the Drawing Room links the bar concept with the traditional notion of a place to relax, read, or work. A succession of sofas and chairs, as well as the inclusion of a fireplace, generates a space much like a comfortable salon where both current publications and food are served. The fifth floor houses the library, characterized by an eclectic style that brings in wooden rafters, Oriental carpets, period furniture, and contemporary art objects. The space is comfortable and warm, in keeping with the luxury of the other rooms. A bar and two long tables that seat 40 invite the visitor to an intimate meal. Here, the low lighting of candles predominates. The walls are decorated with photographs of hands, a contemporary touch in a project that stands out in its eminently classic design.

Designer **STUDIOILSE**
Photographer **MARTYN THOMPSON**
Location **NEW YORK. UNITED STATES**
Opening date **MAY 2003**

Light has been used to divide spaces that, although in the same room, perform different functions. In the library, the low lighting around the two long tables contrasts with the numerous table lamps flanking the sofas and providing direct lighting for reading.

The murals on the library walls show representations of books on shelves in honor of the room's function.

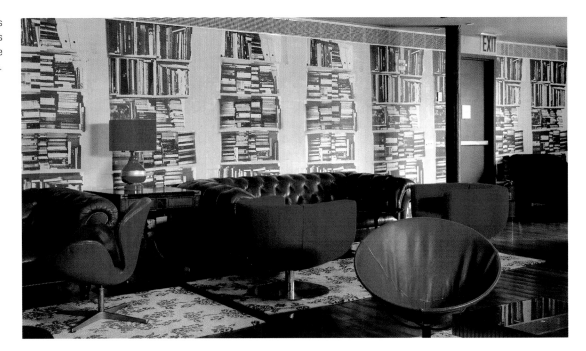

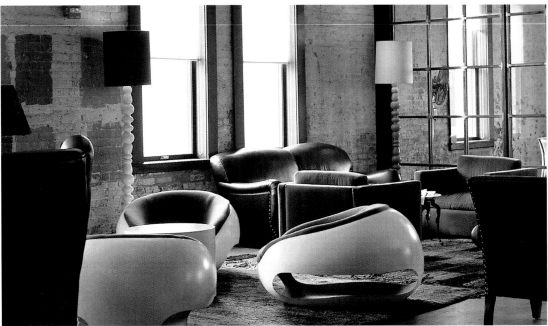

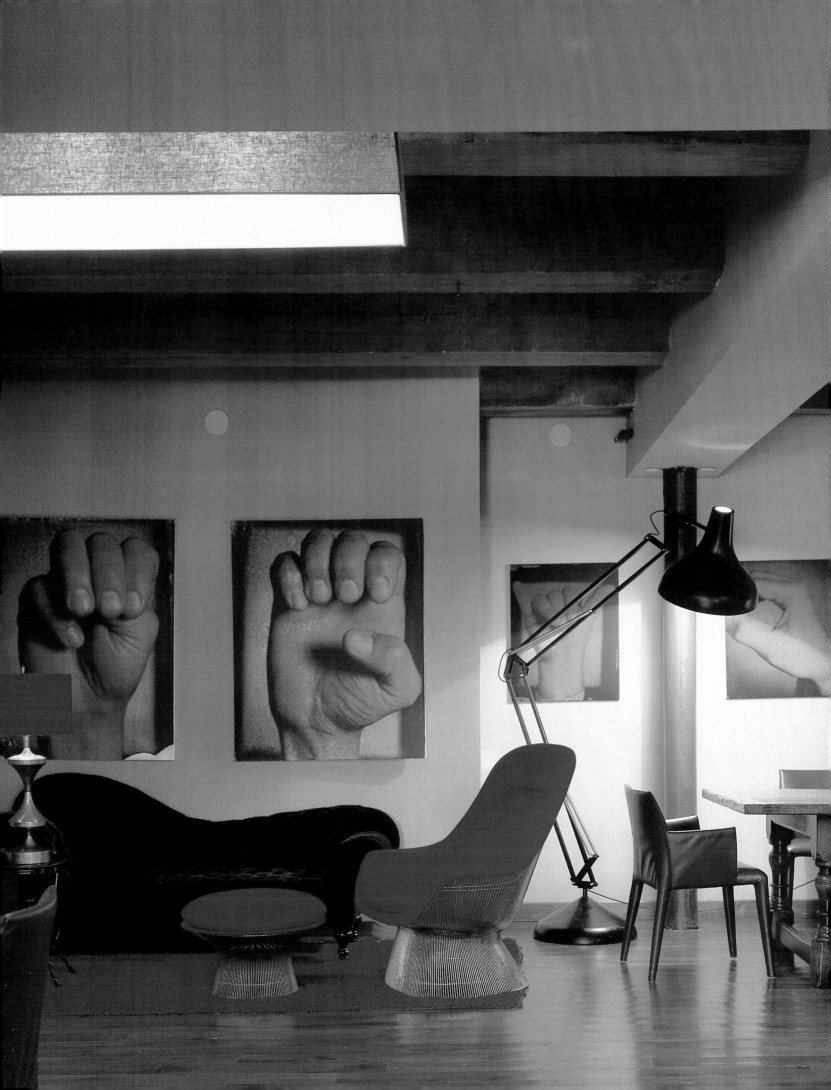

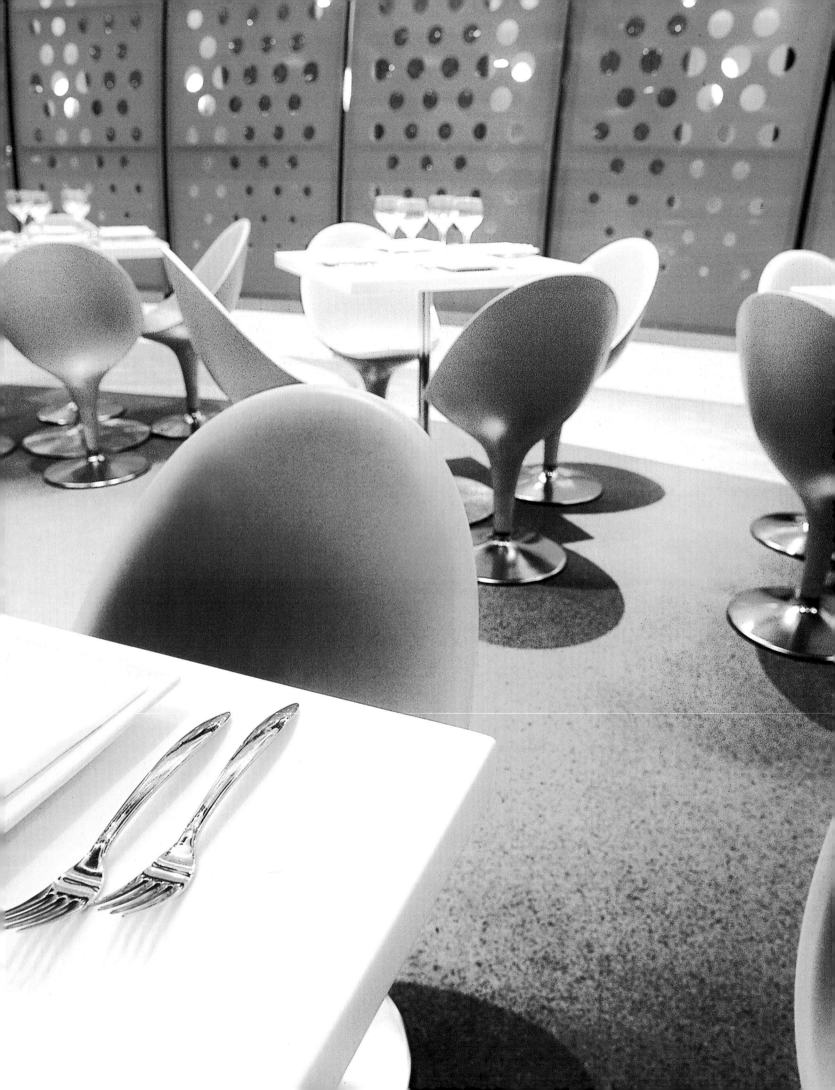

Mod · Chicago · United States

The modern, urban, and plastic aesthetic of this interior was conceived in direct opposition to the type of cuisine Mod offers. If the menu proposes country fresh products, London-born designer Suhail opts for a design grounded in recycled materials. And if the chef's theme is the natural, Suhail's is the synthetic, in a drastic contrast of philosophies gathered together in a single space.

Mod experiments with a new type of visual language that grounds itself in synthetic materials from fields that are not traditional sources of inspiration for interior design. The automobile sector and the aerospace industry have generated a true revelation, the fruit of which is the use of materials such as acrylic panels, industrial confetti foams, and compact fluorescent bulbs. One result is that anything lacking in at least one of these contemporary and deeply urban substances was immediately vetoed by the designer. Enter a mix of cork, plastics, and acrylics opposed in form and screaming in colors.

At the entrance, there is a long, electric orange passageway that runs parallel to the restaurant and presents planes entirely finished in acrylic squares, some of which are fitted with a circle motif of a lighter shade. It is a motif that will be repeated throughout the whole space–in both walls and furnishings–in a constant reference to the restaurant's logo.

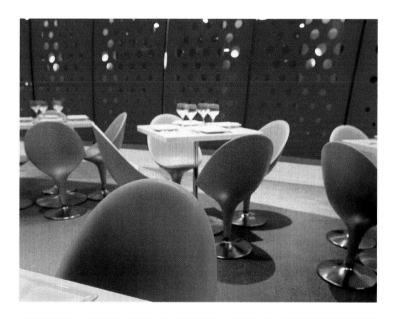

Designer SUHAIL DESIGN STUDIO
Photographer DOUGLAS FOGELSON
Location CHICAGO. UNITED STATES
Opening date JUNE 2001

Mod opens new paths in the understanding of modernity: a marriage of materials that integrates new technologies while maintaining a classic level of comfort. With this urban design and a dash of naïveté, the project proves that modernity is not necessarily tied to minimalism.

Mod is a fusion of recycled materials: it is a chain reaction of tire treads, plastic caps, and bottles. The design explodes in creativity and an appetite for innovation that can be felt as soon as you step through the door.

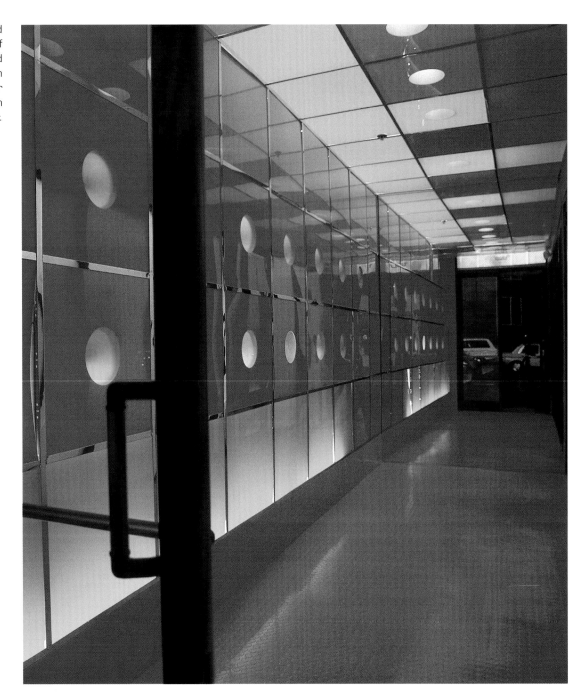

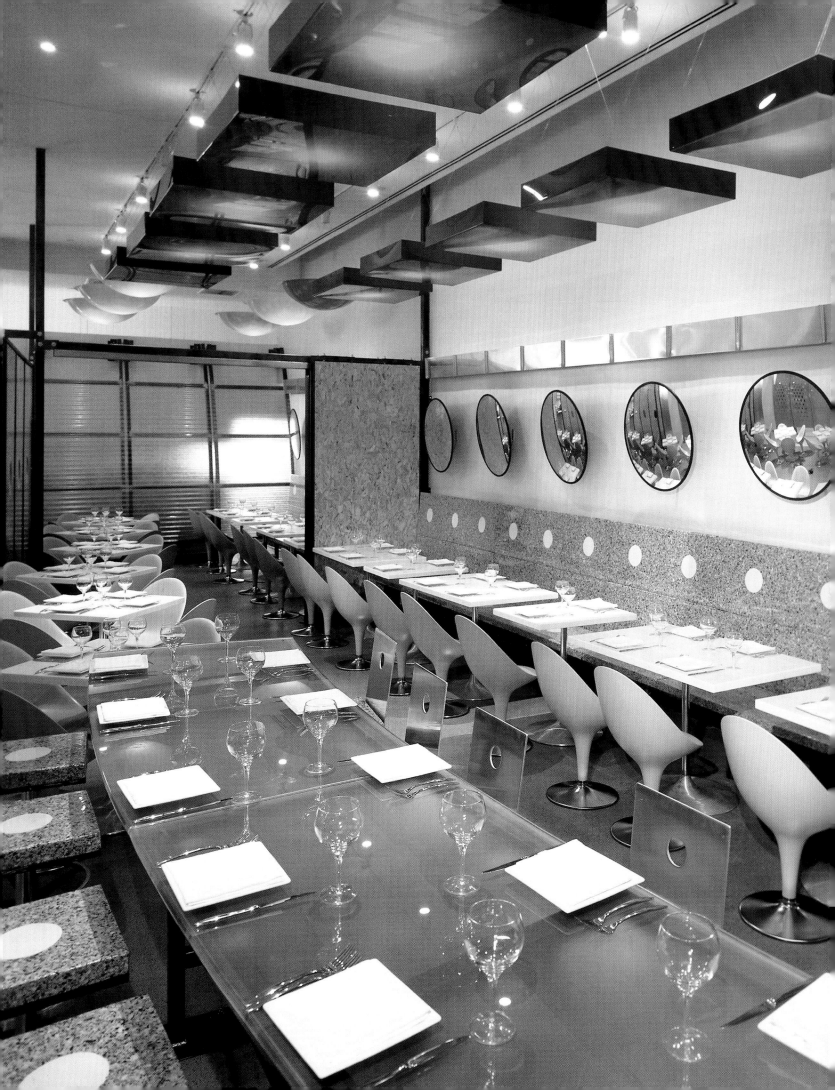

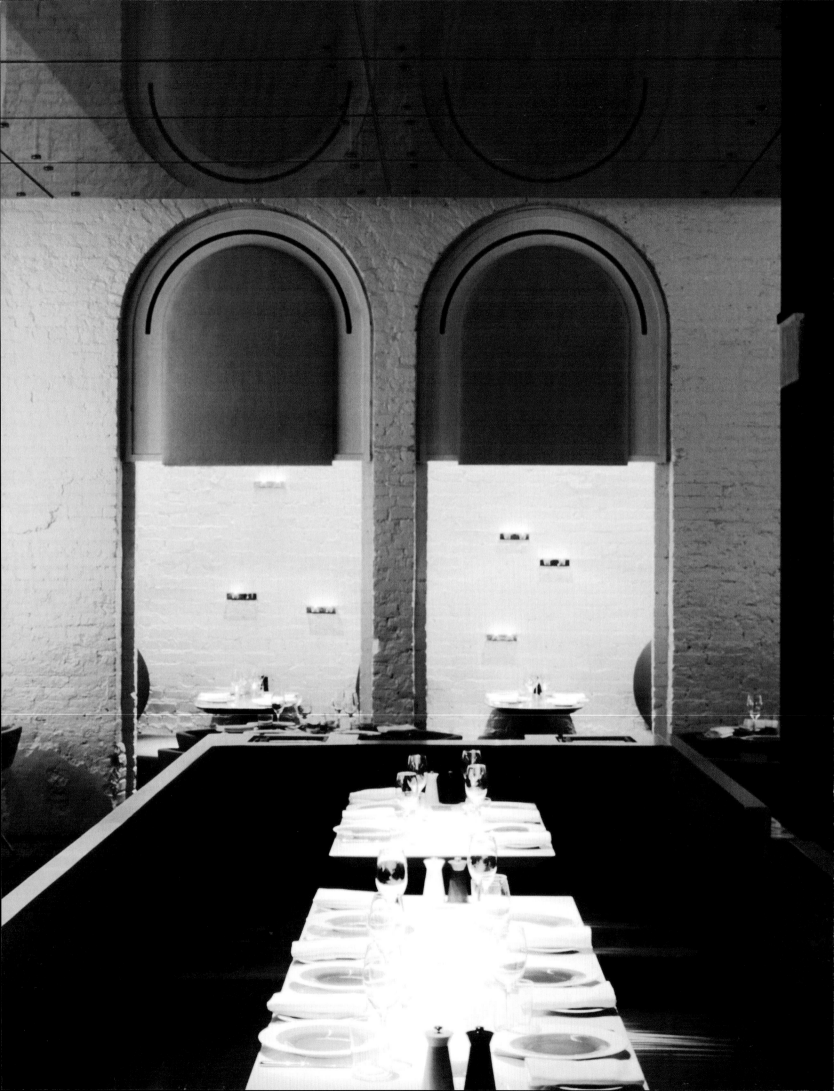

Mix in New York · New York · United States

Reminiscent of a newly excavated temple, this project by French designer Patrick Jouin makes its appearance in the dusty streets of New York. A halo of mystery seems to enclose Mix New York's walls—preserved in their original state—the result of the simultaneous conservation and transformation of the space's initial architectural characteristics. Its essence lies in its simple but radical intervention, which consists of a box of rose-colored glass that recovers the walls and leaves the brick wall revealed, like a protective plate before a work of art in a museum. From the entry, a monitor projects images and sounds from the kitchen, a device that turns customers into voyeurs and invites them to enter the tunnel that leads to the bar. The twisting interior is finished in (among other things) hand embroidery on dark faux leather that highlights a back-lit glass bar, whose colors slowly vary as the night proceeds. Flanking both sides of the tunnel, a long seating module, *le bâteau*, runs from the entrance to the central dining room, linking the spaces.

In addition to designing this whole project, Jouin also created the furniture. Among his creations, the chairs stand out as subtle reminders of 1950s Americana. The design in Mix evokes images of the old and the new, the past and the present, mixing together—as the name itself indicates—to create a suggestive ambience.

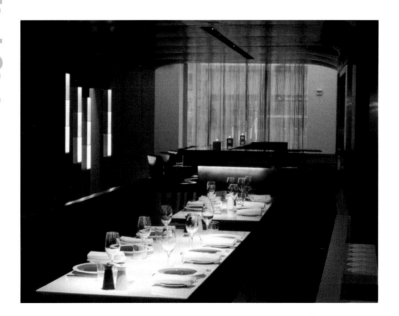

Designer PATRICK JOUIN
Photographer MIA MALLEY, THOMAS DUVAL, ERIC LAIGNEL
Location NEW YORK. UNITED STATES
Opening date SEPTEMBER 2003

In the dining room, enormous panels of pink-tinted glass are suspended along the length of the brick walls and bolted to the ceiling. The light radiates from behind the glass—bright, warm, sensual, and, above all, mysterious in its combination of past and present on a theater-like stage.

In Mix, Jouin's eighth collaboration with the well-known chef Alain Ducasse, he contrasts the modernity of a glass structure with the walls of brick, preserved in their original state.

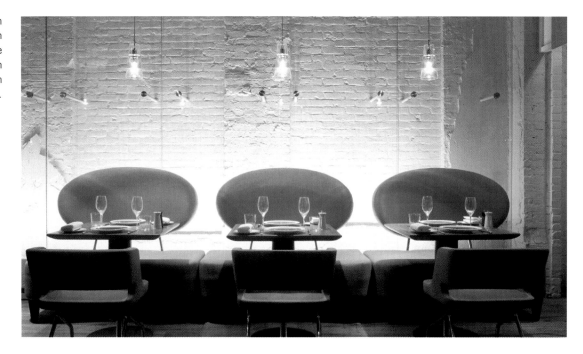

Elevations

Floor plan

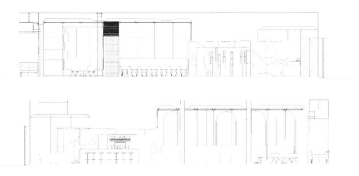

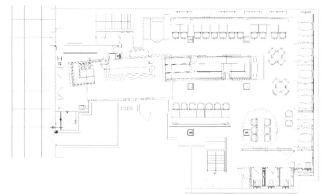

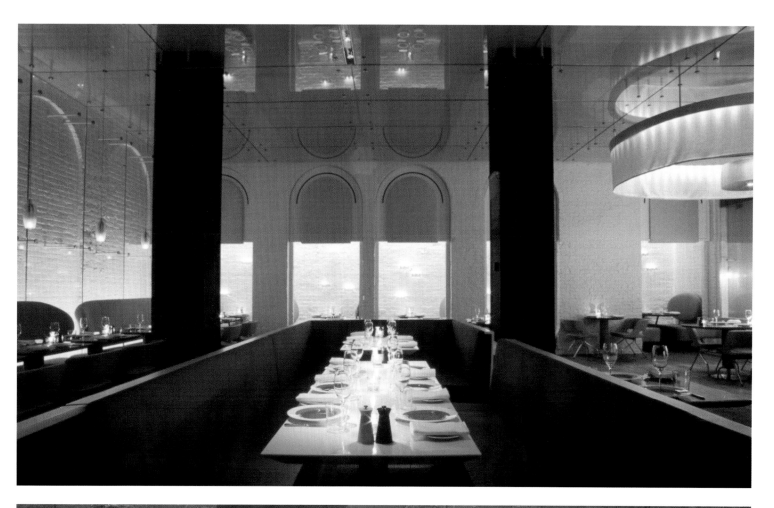

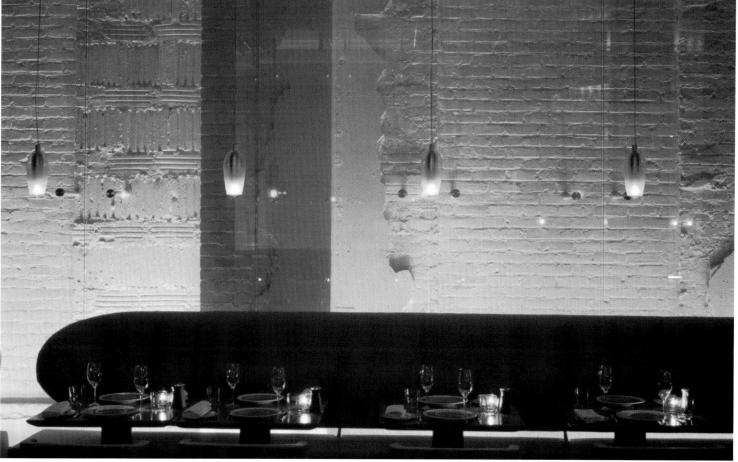

SushiSambaRio · Chicago · United States

Sushi and samba, Rio de Janeiro and Japan, carnival and calm, all evoke images that are, on the whole, contraries. However, they combine flawlessly in this new Rockwell Group project. SushiSambaRio is, as its name announces, a communion of references to Rio de Janeiro's festivities and to Japanese culture that translate into an explosion of colors, forms, and materials typical of these two locations.

Amid the brick façades characteristic of the river north of Chicago, the exterior of this project is a prelude to the Rio de Janeiro-style festivities going on full tilt inside. Likewise, the entry is delineated by stained-glass doors whose sculptured knobs pay homage to the sensual forms of the medusa jelly fish of Southeast Asia. In the actual interior, the gaze converges on an oval-shaped sushi bar done in bamboo. The curtain of beads is a direct allusion to the Brazilian carnival—a reference that is repeated in the central room, where the sushi bar is located and the tables of Brazilian wood match chairs covered in green and orange. Along the south wall, a series of platforms form small sunken areas that seat 10 diners. On the second floor, a luxurious outdoor garden with exuberant flora and fauna serves as a dining area in a double tribute to the exoticism of Brazil and the serenity of Japanese style.

Designer ROCKWELL GROUP
Photographer MARK BALLOGG
Location CHICAGO. UNITED STATES
Opening date JULY 2003

Lamps hang from the ceiling, distributing yellow light that draws different wavy designs in a serene and playful complicity with the blues in the curtains and the carmines in the tapestries.

A curtain of silver beads provides privacy for a sunken circular dining area. The red walls infuse a sensual aesthetic that contrasts with the central dining space.

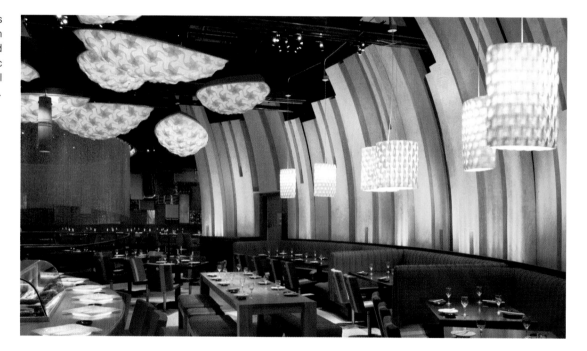

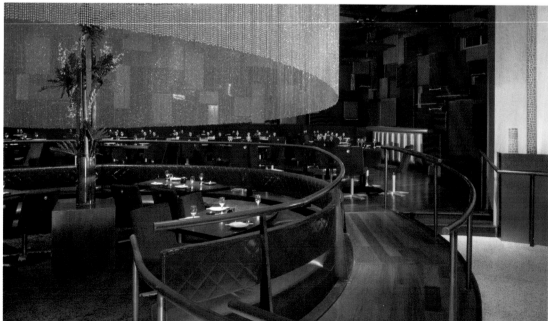

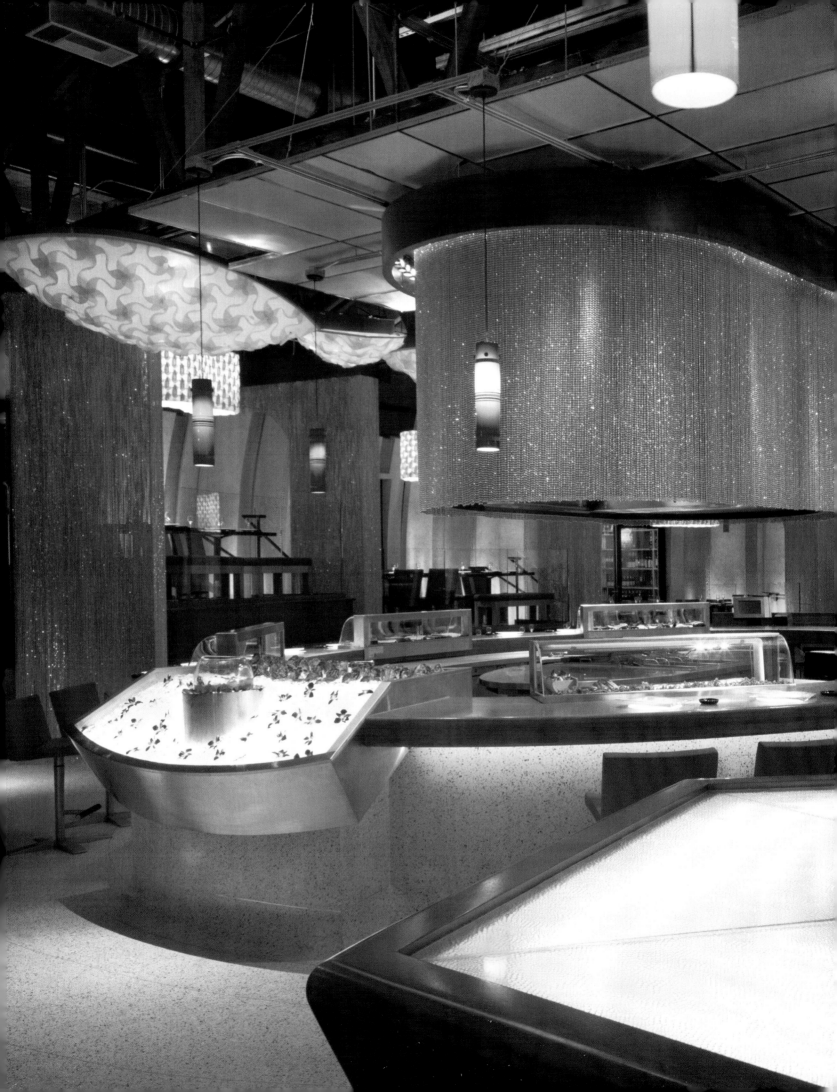

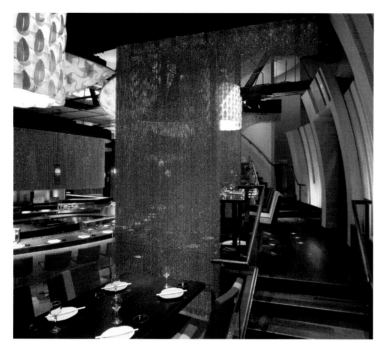

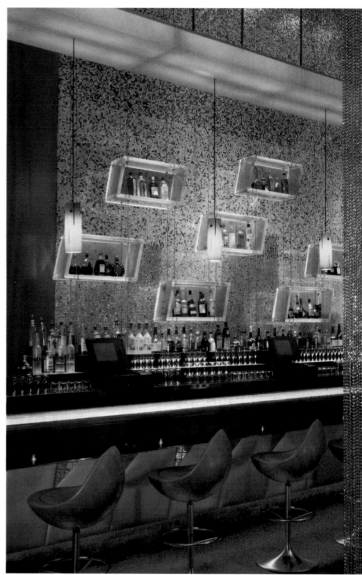

The 9,000 square feet of the SushisambaRio are distributed over two floors with a capacity for 319 people—a stage that re-creates Brazilian and Japanese culture through the use of colors, textures, forms, and materials.

Floor plan

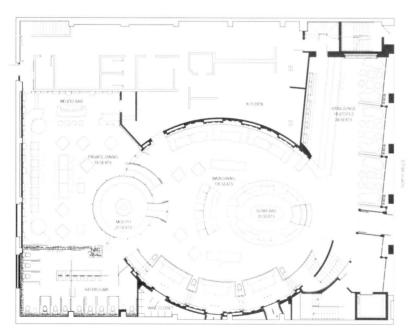

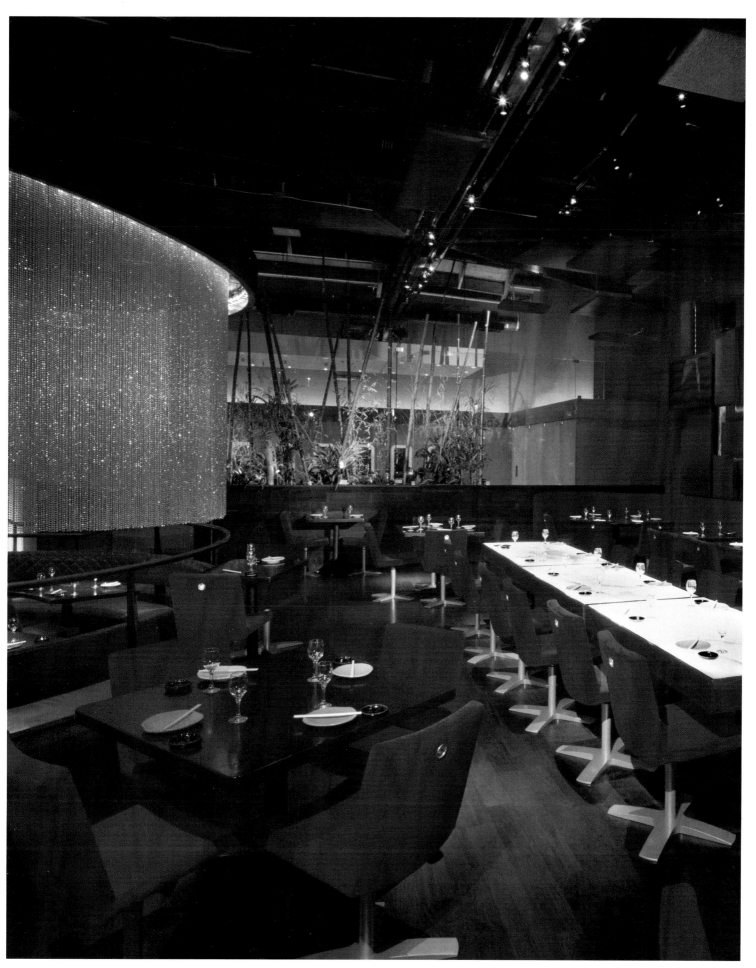

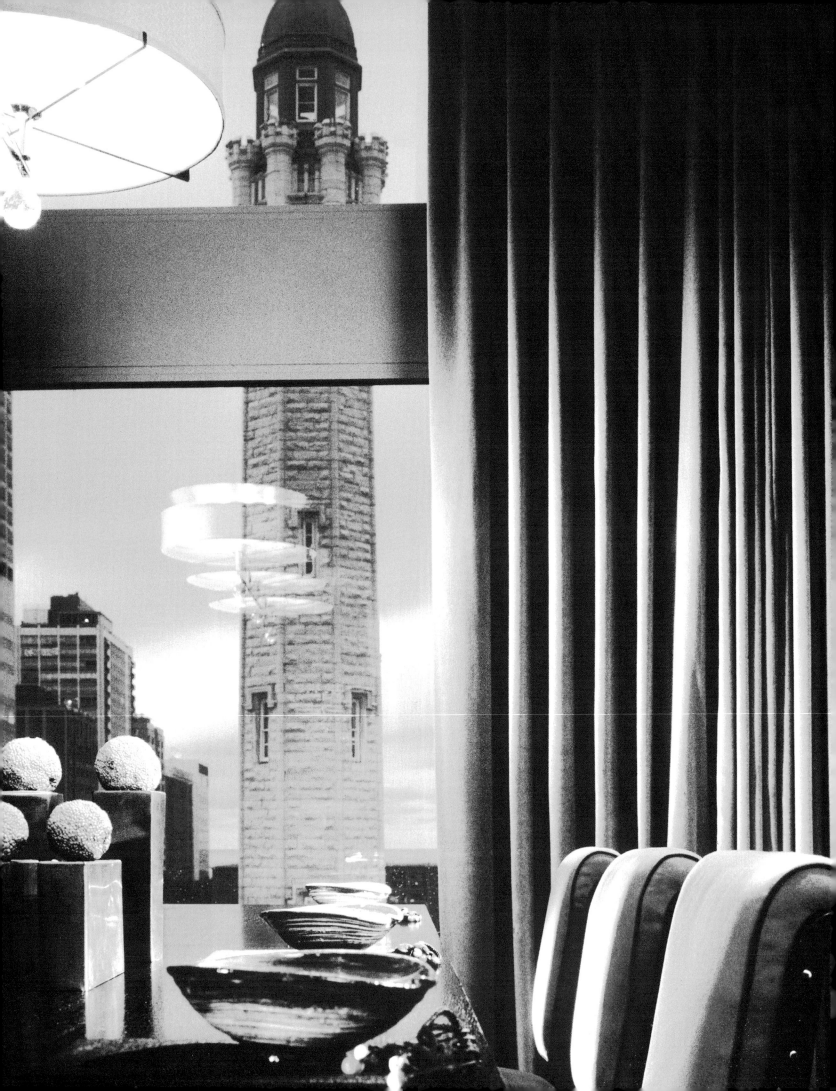

NoMI · Chicago · United States

To go through the different rooms of NoMI is to experience settings that re-create each of the seasons of the year in an homage to nature and its subtle tonal variations. Conceived by designer Tony Chi, the restaurant is laid out sequentially as a series of rooms with their own characters and identities, without losing the harmony that makes them a part of the project's philosophy. This division stems from a pre-defined structure that, while framing the space that flanks a dividing wall, makes entry into each room one of expectation, like the successive acts of a stage play.

A sushi bar is at the entry to the main dining area, where the open kitchen is visible through a row of columns. The sushi bar is a theatrical display, drawing the gaze on and underlining its importance within the space. Equipped both to show itself off and to blend the working environment with design, the kitchen is the result of a desire to minimize the separation between this area and the dining room. The kitchen thus holds a preeminent position within the space. It boasts an original plaster sculpture that extends from the ceiling of the dining room, creating organic forms that guide the eye toward the gallery through the abstract bottle columns. A wine metaphor clearly alludes to the celebration of the seasons and of nature itself. This, in the opinion of the designer, will become an important source of inspiration in the design of contemporary restaurants.

Designer **TONY CHI AND ASSOCIATES**
Photographer **DOUG SNOWER**
Location **CHICAGO. UNITED STATES**
Opening date **JUNE 2000**

The color scheme in NoMI combines browns and whites with touches of yellows and reds, a relaxing palette that emphasizes the neutral tones as a celebration of nature in all of the restaurant's rooms.

The seasons of the year, a recurrent image in this project, materialize in a trajectory that includes a garden, an ode to spring; a living room, an homage to summer; and a room dedicated to fall and winter, dominated by a fireplace and a mural that casts snowy branches on the ceiling.

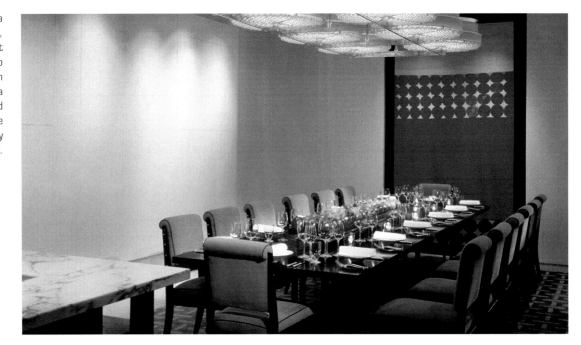

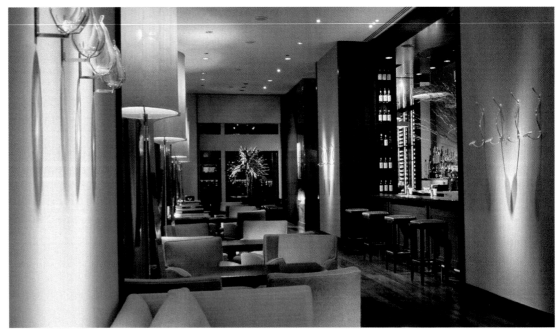

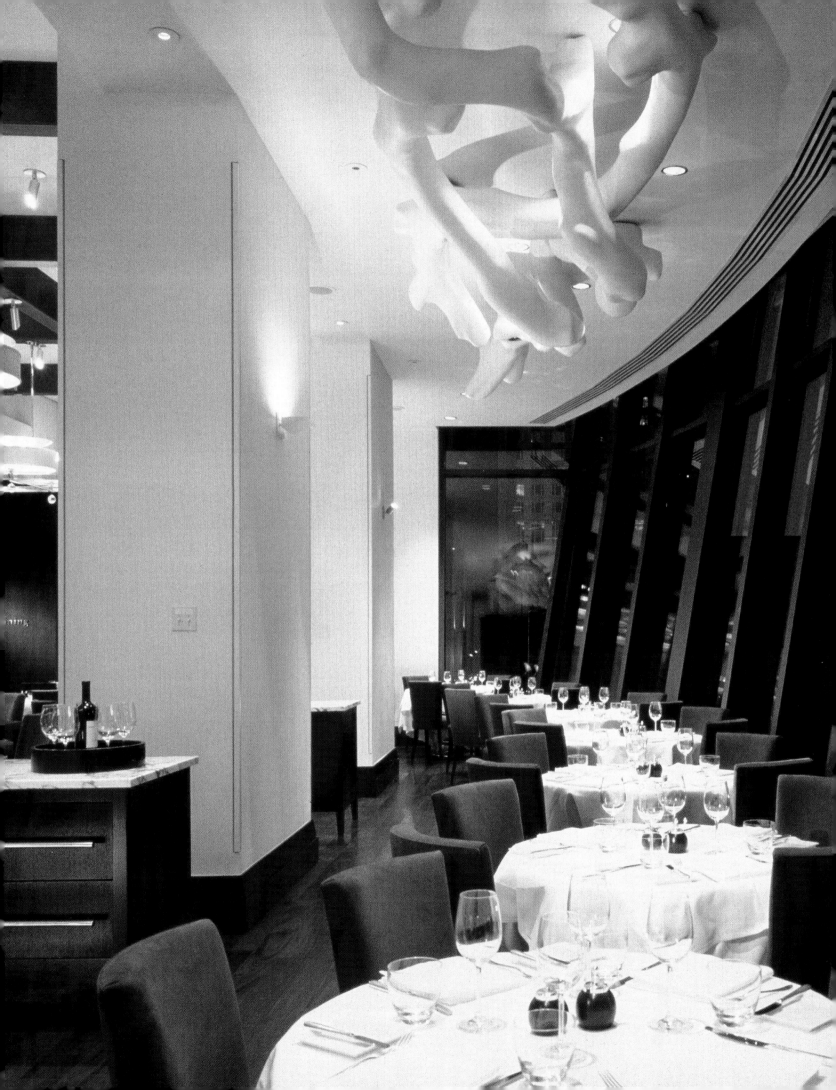

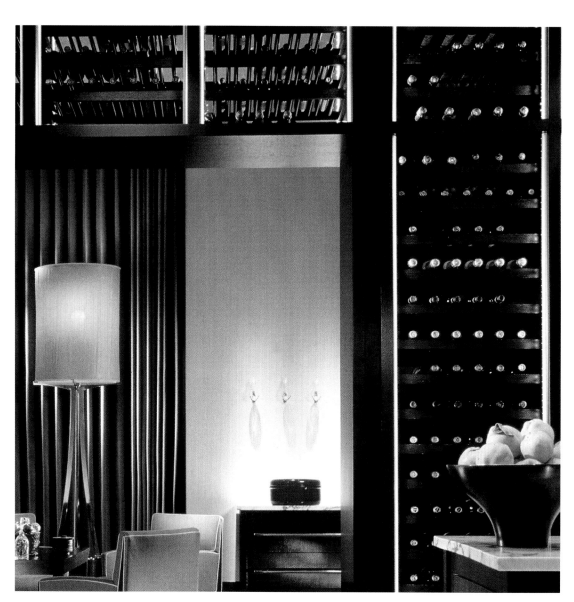

At the entry is a wine cellar used as a tasting and storage room. From here, mosaics of floral motifs and a white iridescent marble floor direct guests toward the living room.

Floor plan

The space is divided into a series of rooms by a wall that structures the ground floor, a solution that creates a metaphor for nature as a temporal sequence of tonal variations.

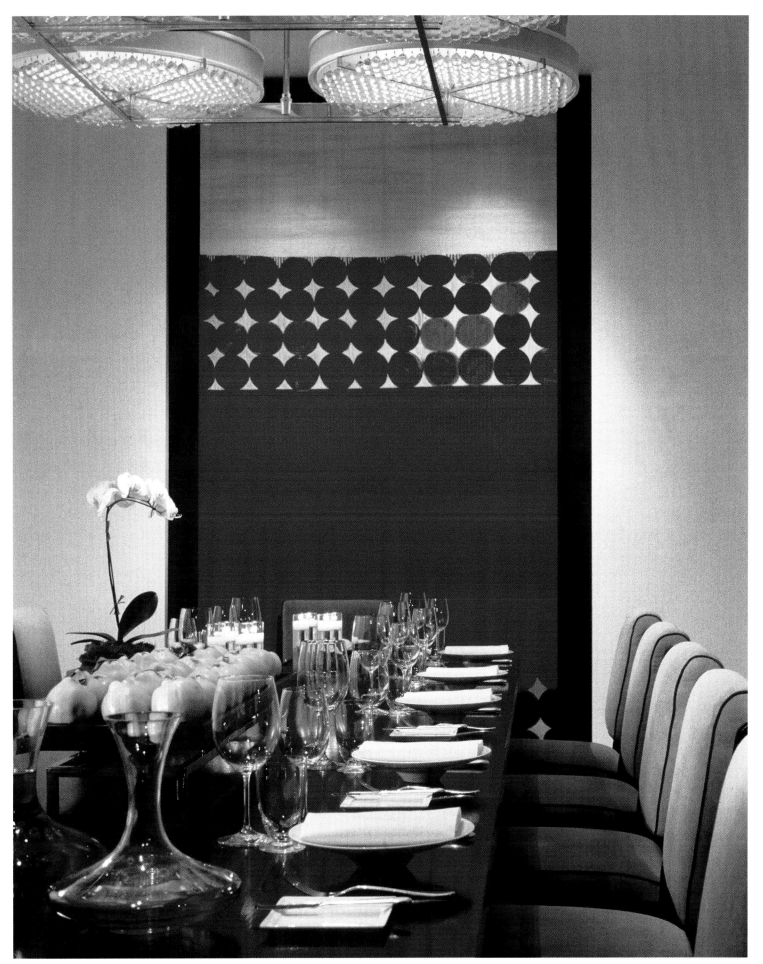

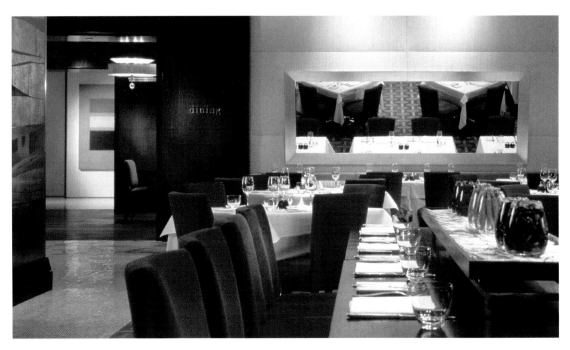

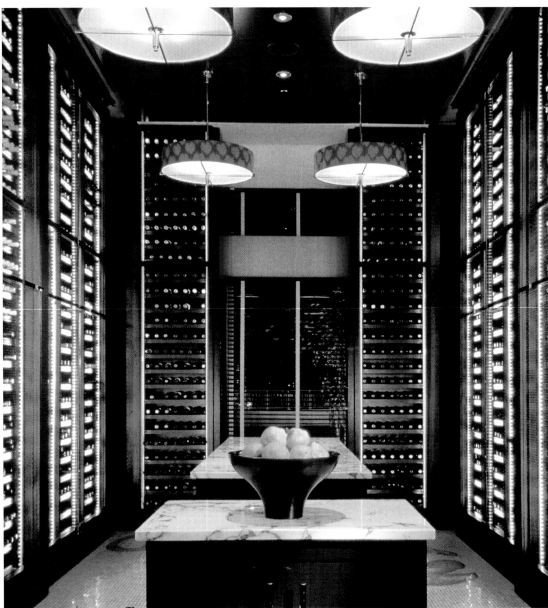

Le Cirque · Mexico City · Mexico

The latest creation by Adam Tihany bears the mark of his highly personal vision of luxury. Le Cirque, the new social mecca for Mexico City's élite, is a free-plan pavilion, roofed in wood and flanked by walls of lighted glass. The restaurant extends on both sides of a wavy metal wall that acts as leitmotif to guide visitors from the entranceway to a glassed-in garden with an attractive waterfall, one of the high points in this space that offers a complete sensorial experience. The wall separates the surface into a bar, wine room, and six private rooms. In this project, Tihany exploits an extraordinary love of detail: flowers, stoneware jars, wine bottles, and trays of fruit are arrayed as a series of decorative elements that, without quite saturating the space, still manage to be present on every available surface. The most original element is provided by pieces of silver-plated abstract sculptures that appear to stand sentinel over the visitors to Le Cirque. Tihany's project opts for brown in the leather, such as the upholstery of the chairs, in combination with similar tones in the wood of the furniture and the finishes of the walls in the private rooms. Le Cirque is an experience based on equilibriums, compensations, and oppositions in which each element functions within a specific place.

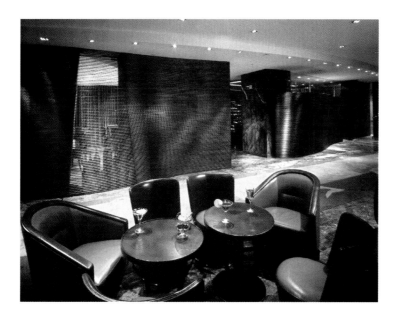

Designer ADAM TIHANY
Photographer SEBASTIAN SALDIVAR
Location MEXICO CITY. MEXICO
Opening date DECEMBER 2002

In contrast to the plainness of the furnishings and in a delicate balance of tones, sprays of exotic flowers, trays of fruit, and lamps form an explosion where each color is represented in its exact measure.

The main room is framed by an open kitchen on one side and a garden on the other.

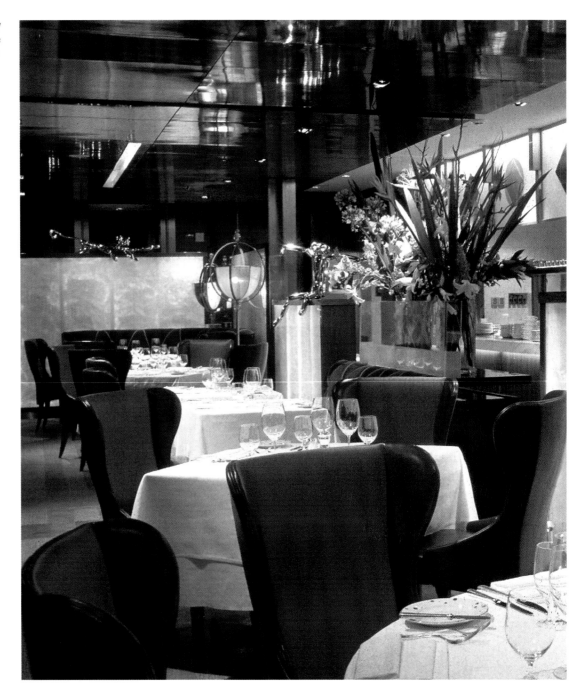

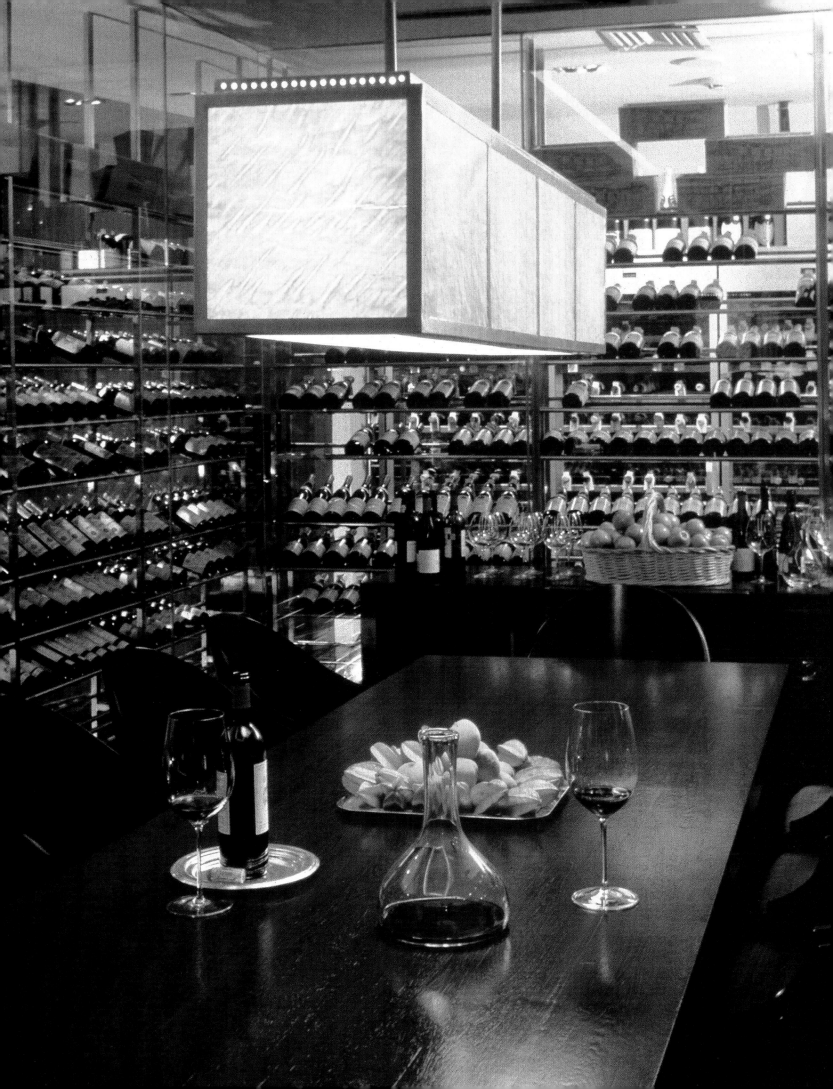

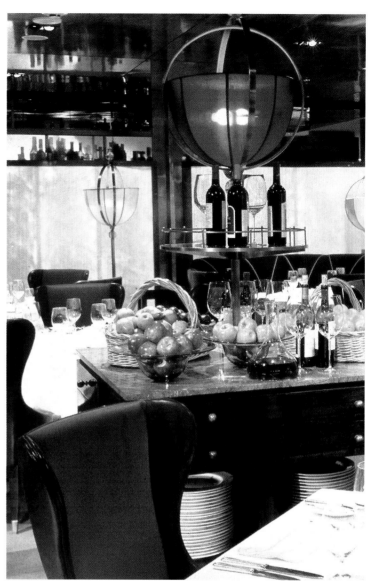

Luxury, softness, and comfort are the sensations associated with this project, enhanced by the art, color, and cheerful look of the decorative elements.

Floor plan

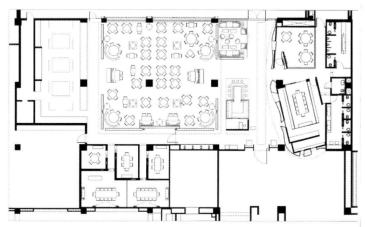

Le Cirque

Bar Tubo · Lima · Peru

Literally inserted inside a tube, this combined bar and art gallery is located in an old neoclassical palace dating back to 1820. It was originally constructed to house an orphanage and at present incorporates the cultural heritage of the city of Lima. The interior design was conceived in complete opposition to the preexisting architecture. Hence, while it didn't alter the building's basic structure, the result was a transgression that decontextualized some of the building's original design components. The project occupies two classrooms on the second floor of one pavilion of the palace, which were joined together for the occasion. A pavilion was introduced, curved at the edges and separated from the floor, the ceiling, and the walls of the building, like a living cell that floats inside a larger organism. One of the walls, as well as the ceiling of this tube, is perforated and small circular apertures permit the entrance of a blue violet light that invades the interior.

The space is arranged around a longitudinal, luminescent bar counter. This is clearly the center of the locale, connecting with a continuous table where guests dine elbow to elbow. The remaining space includes sculptures and other art objects by contemporary Peruvian artists. The decoration is spare but original. Above all, it is highly contemporary: the same perforations that serve a practical function are also part of a minimalist design and contribute to the sensation of floating inside a violet magma.

Designer **FELIPE ASSADI**
Photographer **JOSÉ LUIS RISETTI**
Location **LIMA. PERU**
Opening date **SEPTEMBER 2003**

Felipe Assadi utilized the empty spaces as a means of focusing attention on the art objects displayed around the perimeter of the bar counter and the whole length of the tube.

The steel, the Vulcanite, and the glossy white epoxy paint generate an abstract, vanguardist space much in keeping with the work exhibited.

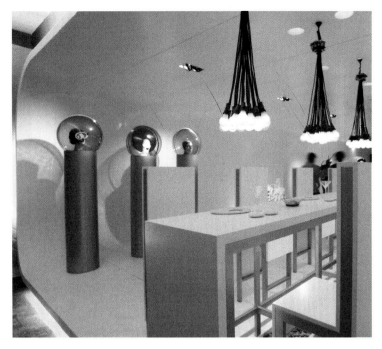

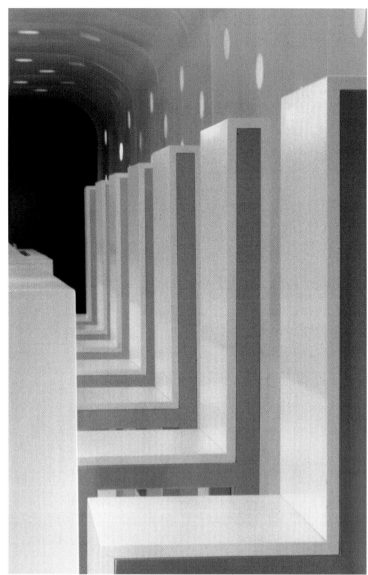

Over the central table
hang branches of bulbs,
gathered in at the base,
illuminating the high-backed
chairs. The flooring includes a
strip of stones equal to the
width and length of the table.

Floor plan

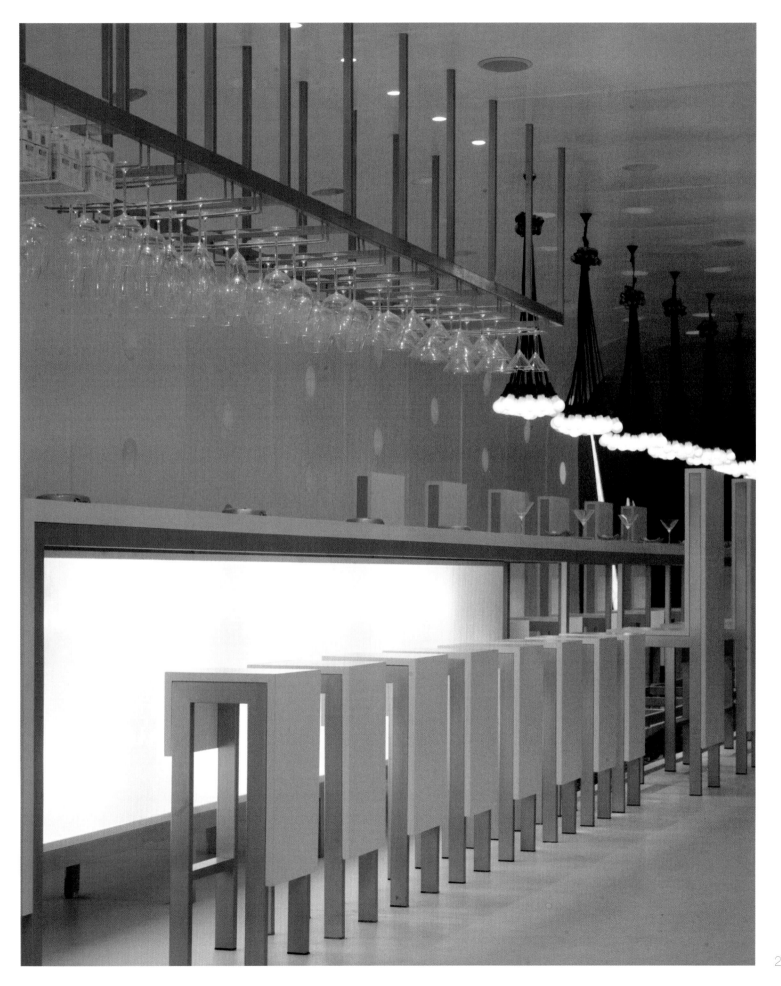

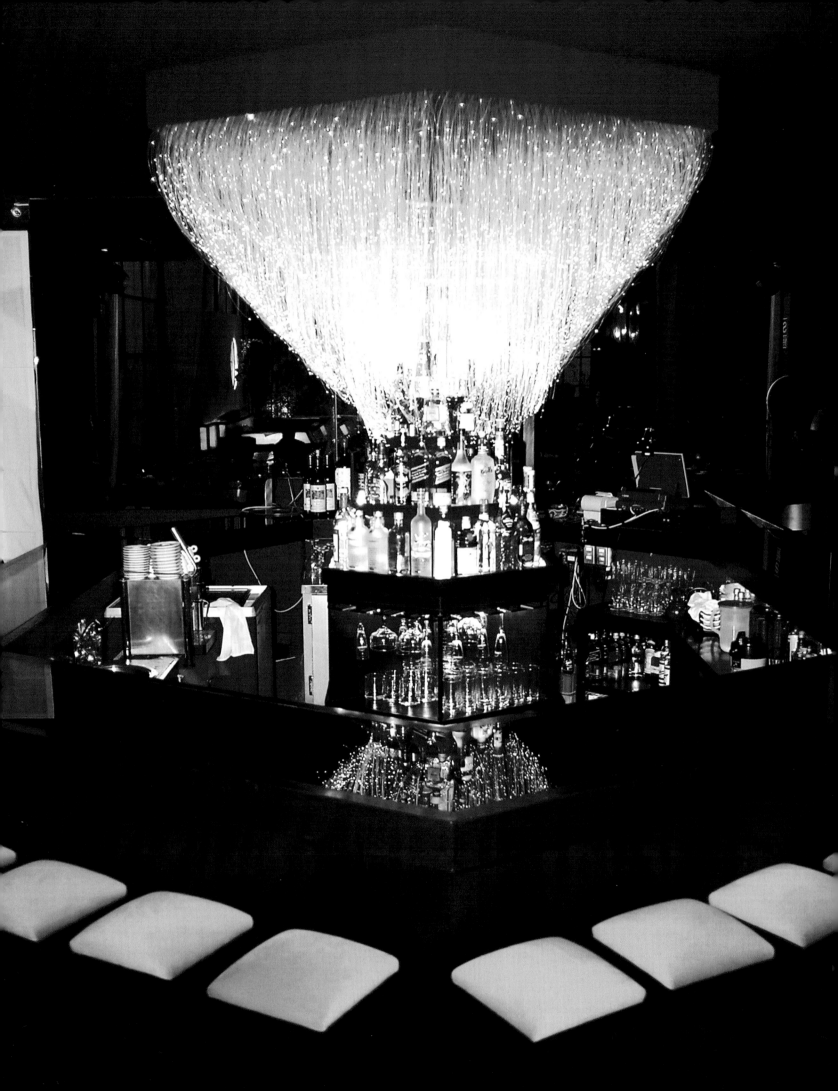

Asia de Cuba was designed in response to two distinct ideas that, visually, imply clearly differentiated aesthetics. The restaurant's inclusion of ornamentation representative of Oriental cultures within a space of eminently Occidental forms and materials breaks with the traditional aesthetic of a space. Without the least reference to the local culture, a space of this kind is capable of submerging its guests in an entirely different cultural world. Asia de Cuba uses these two techniques as a crescendo of Western and Eastern iconographies.

The ground floor, accessed through a small bamboo forest, introduces a world of Buddhist plainness whose reference points are to be found not so much in the furnishings as in a given set of decorative solutions. Among these, the light curtains stand out in their substitution for doors and their softening effect on the walls. The effects bring to mind the relaxation of body and spirit conjured up by the meditative sculpture installed near the entry. Low, indirect lighting enhances this play of sweetness and softness, filled out by a color palette of yellows, oranges, and reds. A spectacular stairway connects the containment of the lower level with the explosion of colors and textures of the VIP room. All of the elements—including the fabrics covering the ceiling, the cushions and the upholstery used in the furniture, and the decoration of the walls—submerge this second floor in an Indian-Thai arabesque fantasy, of which the restaurant is no more than an introduction.

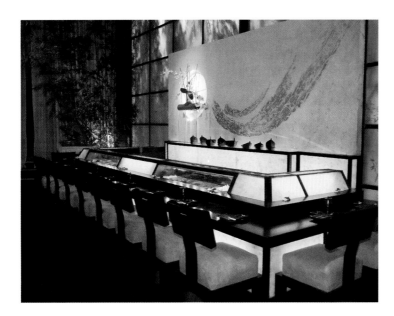

Designer **MELISSA CASTAÑEDA DE LEON DE PERALTA**
Photographer **JOSÉ GAMBOA**
Location **LIMA. PERU**
Opening date **MAY 2003**

Plainness and fantasy, tranquility and happiness, make up the two sides of a single coin—Oriental culture. Asia de Cuba's interior represents this culture through two spaces: the bar-restaurant and the VIP room or *shisha* (water pipe) room.

On the backlit surface of the bar counter, a series of small wooden boats appears to float in a sea of lava illuminated by the sunset drawn on the wall.

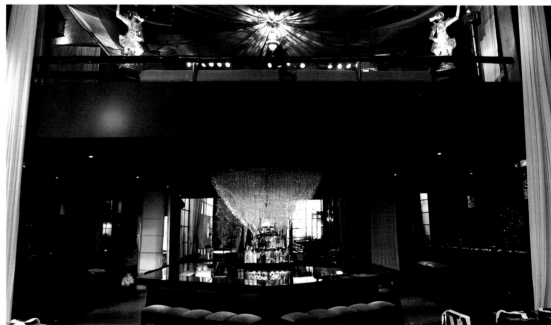

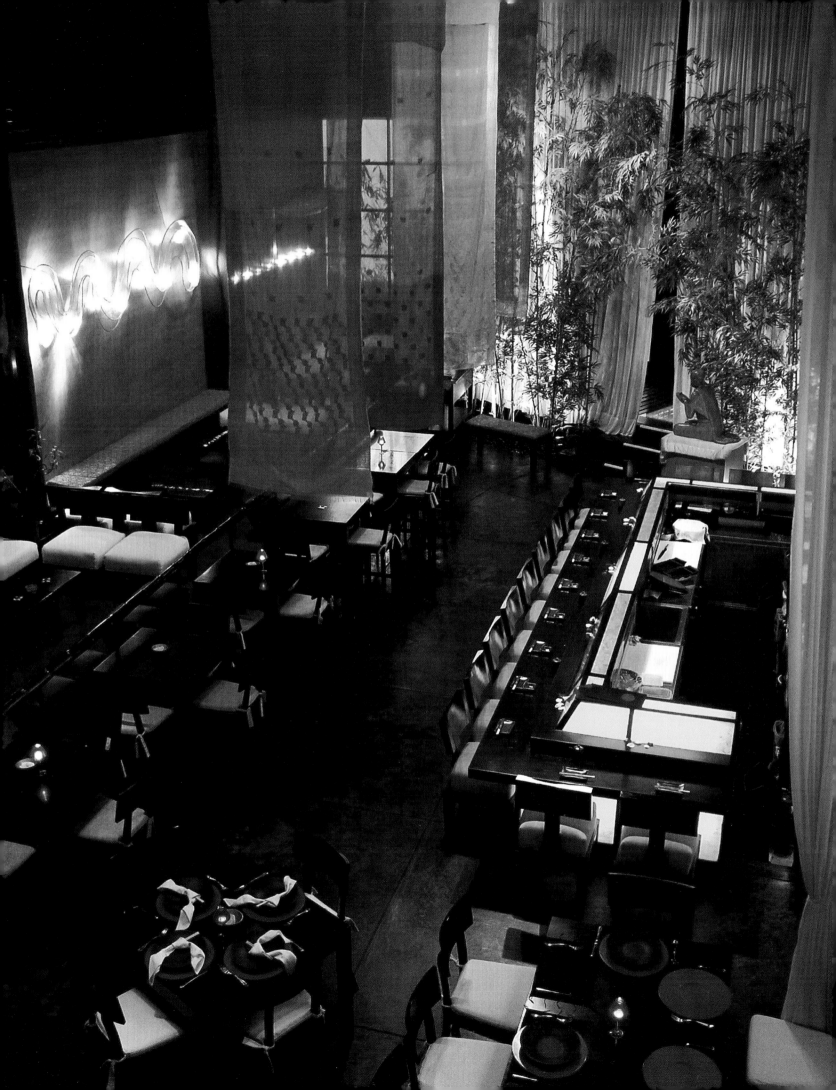

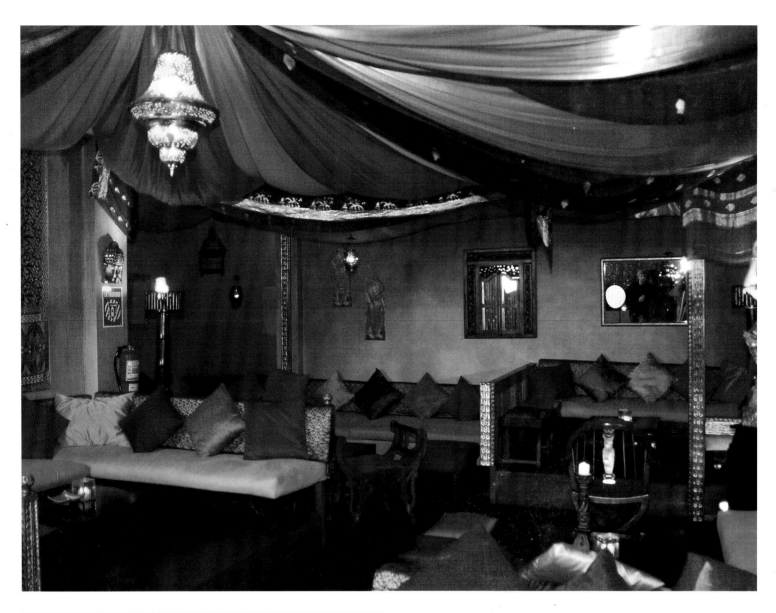

The main bar counter forms a
hexagonal island whose
lacquered surface reflects the
enormous fiber-optic lamp
hanging from the ceiling.

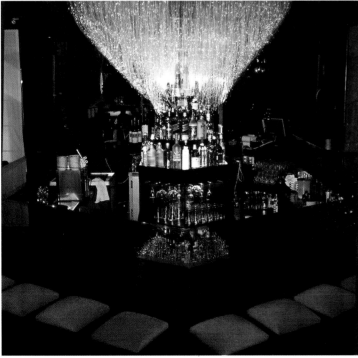

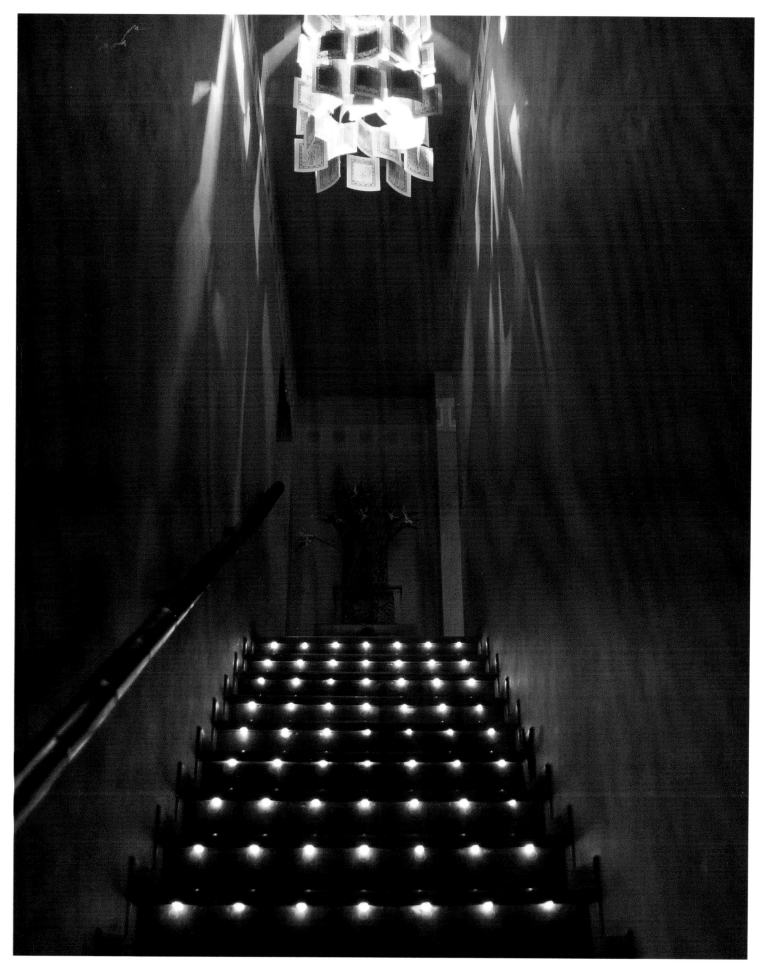

Australia Tokyo China Thailand Hong Kong

Tokyo Hong Kong China Bangkok Sydney Japan

Australia Tokyo China Thailand Hong Kong Sydney China

Tokyo Hong Kong China Bangkok Sydney Japan

Australia Tokyo China Thailand Hong Kong Sydney China

Tokyo Hong Kong China Bangkok Sydney Japan

Australia Tokyo China Thailand Hong Kong Sydney China

Tokyo Hong Kong China Bangkok Sydney Japan

Australia Tokyo China Thailand Hong Kong Sydney China

Asia

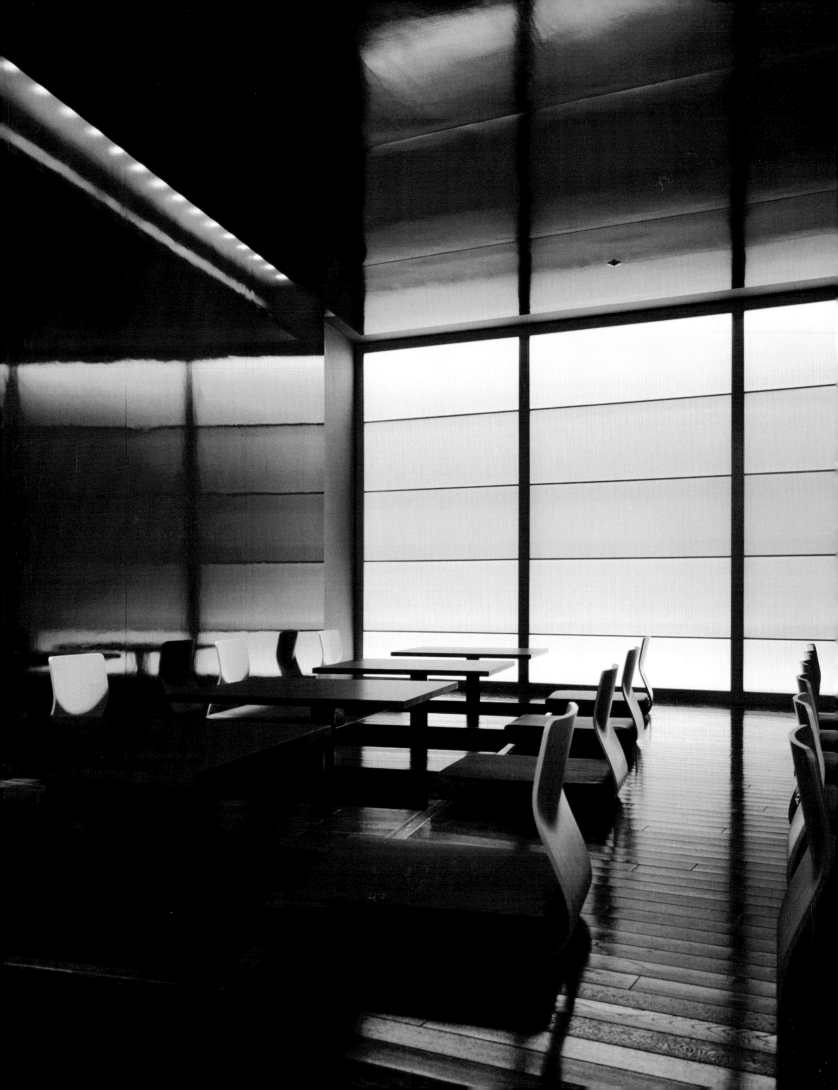

Roppongi Hills Club · Tokyo · Japan

Prosperous, vast, overpopulated, lively, a crucible where Eastern and Western civilizations merge—Tokyo is not just a city of skyscrapers and multinationals. It is also a city that is rich in history, with an ancient culture that is still alive today. And all of this is reflected in this latest project by Conran & Partners. Located on the 51st floor of an office building, Roppongi Hills Club is a private, members-only establishment that offers a series of restaurants that attempt to reflect these contrasting forces in their design, from ancient Japanese traditions to the most innovative technology. However, this design is based on one premise: luxury, which is understood as a subtle elegance rich in points of reference. One feature is common to all of the different spaces: spectacular views of almost the entire city. Tokyo Bay, Odaiba, and the Tokyo Tower lie at the feet of those privileged few who, surrounded by the vast windows that run the full 360 degrees around the building, enjoy spaces with a design that fluctuates between the traditional and the contemporary. Restaurants like the Fifty One Club represent modern Tokyo in their design, while others are laid out under a ceiling filled with stars, and still others have arranged their tables around a wall of flowers. At the other extreme is Onjaku, a traditional Japanese tearoom that, stripped of nonessentials, forms a space that is at the same time both modest and full of splendor.

Designer **CONRAN & PARTNERS**
Photographer **KOJI OKAMURA**
Location **TOKYO. JAPAN**
Opening date **APRIL 2003**

The stark contrasts that come together in Tokyo are a direct source of inspiration for this project that mixes the East and the West, local and foreign, in a fusion of tradition and modernism that provides a platform for a Japanese global sensibility.

Elegance is the key concept in a project that brings together different styles, from the Western aesthetic of the Fifty One Club to the Japanese iconography of the Sake Bar.

J-Pop Café Odaiba · Tokyo · Japan

Entering the J–Pop Café Odaiba means nothing less than diving into 1970s Pop culture. Everything in the space—colors, forms, design—evokes the concept of living, with interconnected cells moving you from one space to another. The 5,920 square feet of the café are divided into two main spaces. In the restaurant, with impressive views of Tokyo Bay, a rectangle fitted with irregular curves houses the Bio Forest Zone. Here, small round tables are replete with DVD screens inserted into what might be protuberant shoots of a tree that appears to grow vertically from the wall. A cave-like space, where music is sold, connects the restaurant with the animation zone via a curvilinear tunnel leading to the central zone of the café itself. In the Bio Cave Zone, the energy is concentrated into a wavy–lined bar counter that runs wavelike through the room, emulating the image of a tree trunk from which the rest of the organism extends. Arranged in an orderly fashion along the bar counter, a wavy succession of white chairs, designed by Vitra, plays at being a row of pearly teeth. The remaining space combines tables designed by Suzuki, Oh chairs by Karim Rashid, and Soft Egg seats by Philippe Starck—selected of course for their organic shell form. The organic feel is alive and well in every corner of the J-Pop Café Odaiba, arising out of the will to re-create a setting Suzuki himself defines as Bio-Future. It is a future in which biotech will facilitate the use of organic materials as construction material.

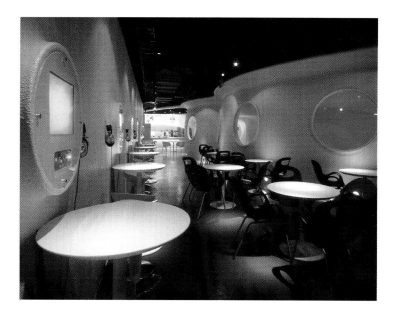

Designer **FANTASTIC DESIGN WORKS**
Photographer **NACÀSA & PARTNERS INC.**
Location **TOKYO. JAPAN**
Opening date **JULY 2002**

The softness of the colors and materials is the base employed to create the organic feel of J–Pop Café Odaiba—where the central space is a mother cell, with a life of its own, that progressively extends toward the sides, creating niches and subspaces.

Curved walls in a spongy texture, made of plaster of paris and reinforced with fiberglass, create the soft, sink-into effect that reigns throughout the whole café.

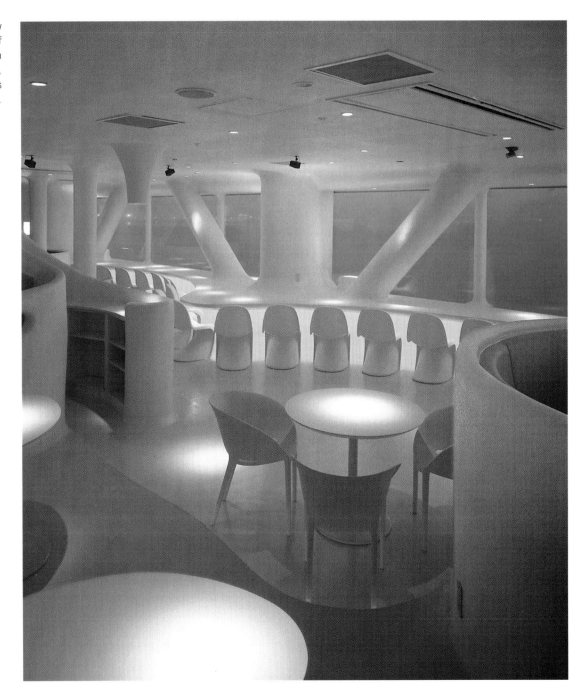

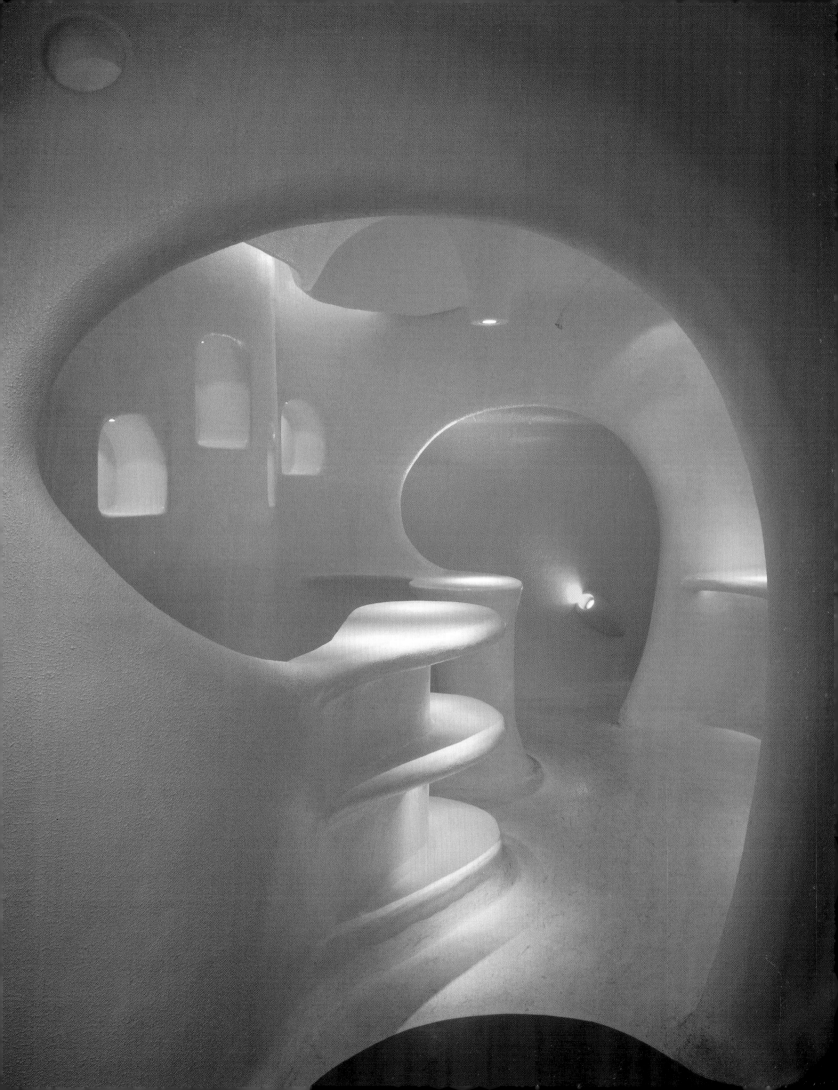

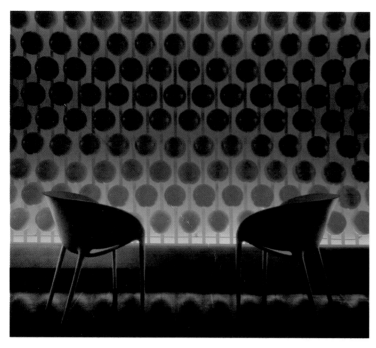

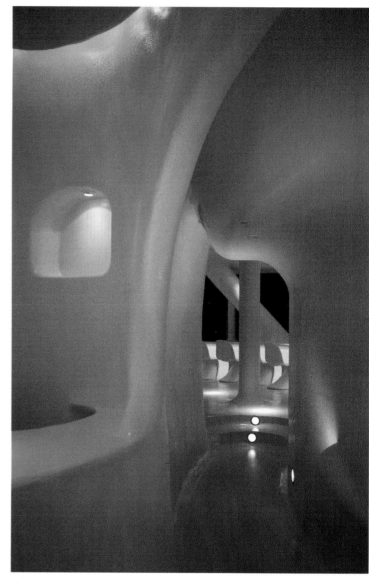

At night, the whiteness reigning throughout the café blends with splashes of violet, red, and green. The lighting creates asymmetric spirals of changing colors that strengthen the organic feel of a living cell.

Elevations

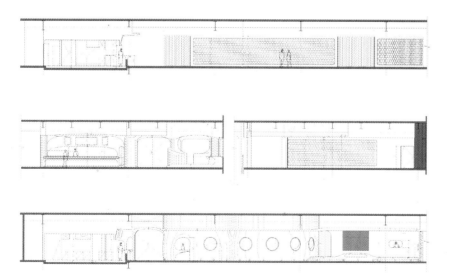

Guests go through round holes into independent niches, like those on tree branches—a touch meant to guarantee maximum privacy.

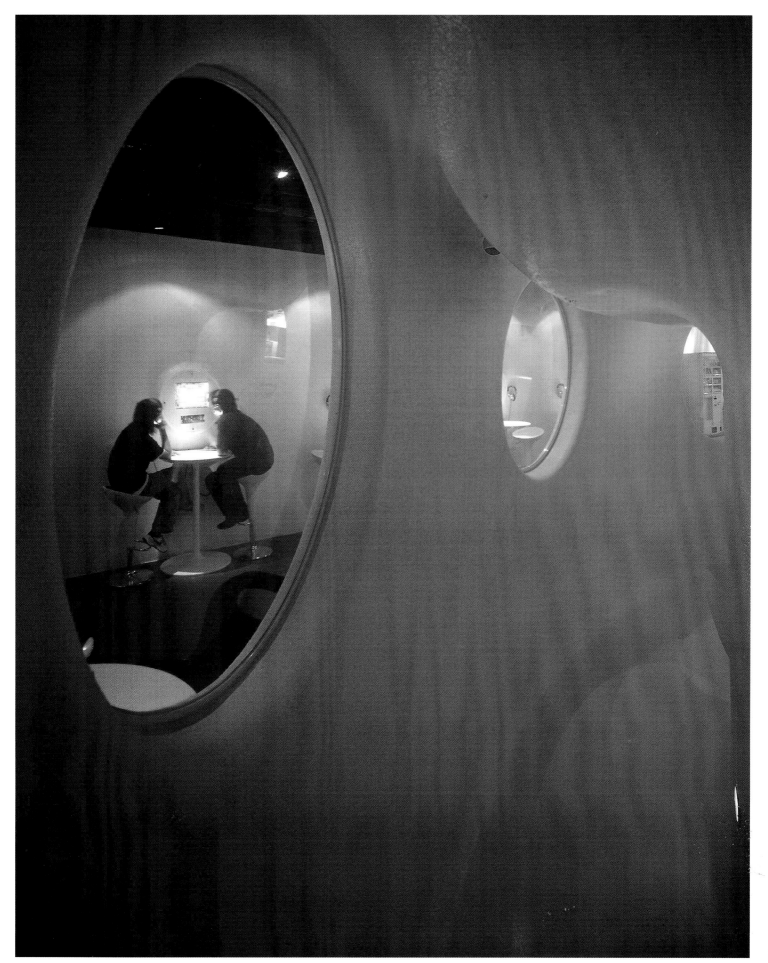

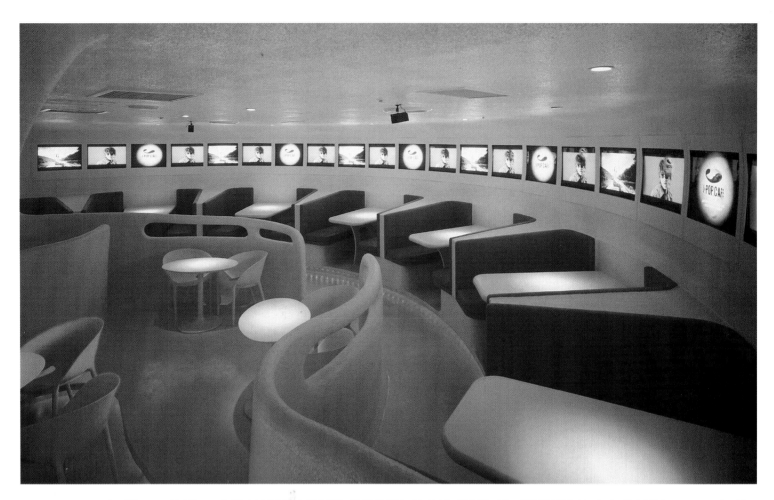

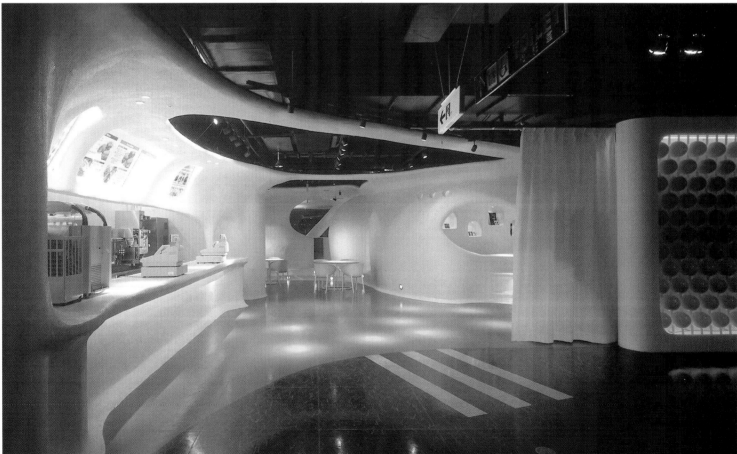

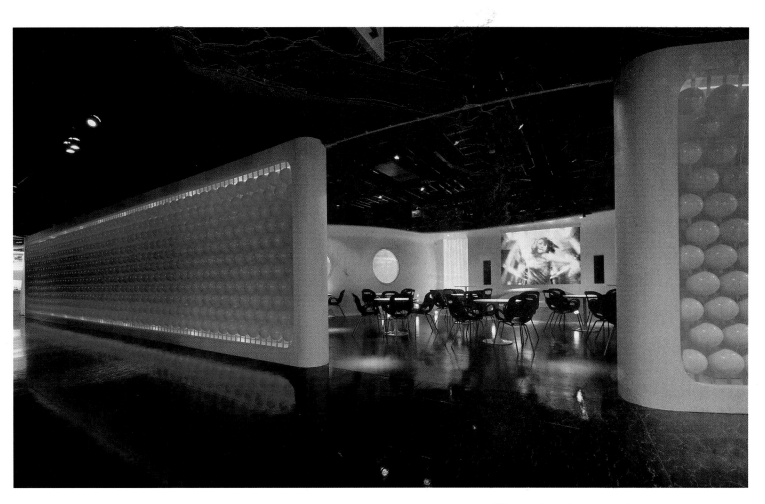

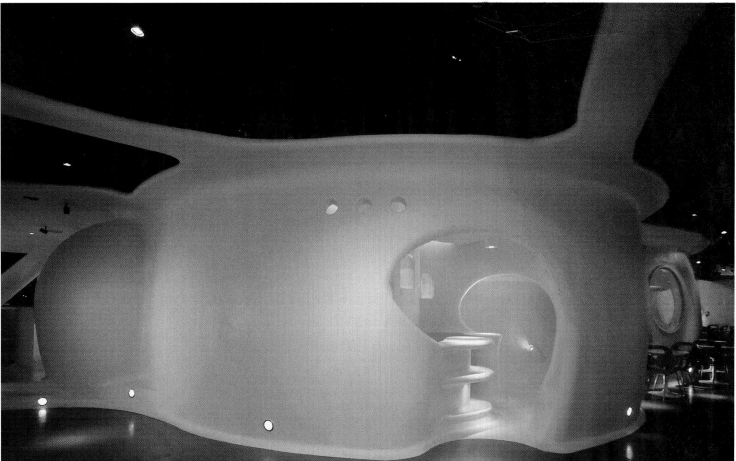

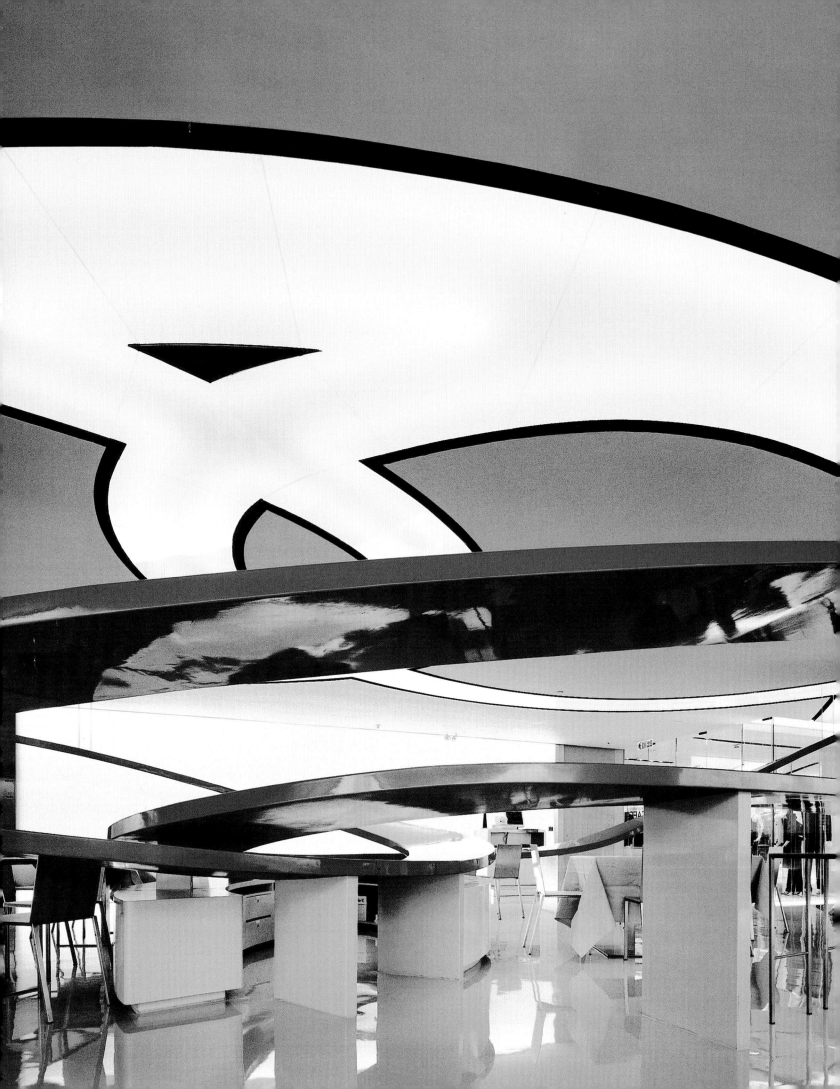

Emporio Armani Caffé · Hong Kong · China

We live in a time of constant changes, encouraged by a series of fashions and styles that catches consumers in a cycle of fluid obsolescence. Massimiliano and Doriana Fuksas reflect this permanent stylistic fluidity with this proposal of a space that shuns any kind of architectural formalism. The main emphasis falls on the empty spaces: absence in the face of presence, the nonexistent in the face of the permanent, and, above all, flowing elements as substitutes in the decoration. The Emporio Armani Caffè was developed around the concept of the fluid as the essential characteristic of our society, mirroring the paths of the visitors and their movements. The furniture is "helped" by a 344-foot-long red ribbon of fiberglass, around which the space is laid out. The ribbon is a live element in the permanent movement that emerges from the floor and is converted into the bar. Rising up and letting itself fall to create the dining room space, it doubles over itself to house the DJ hut and finally flips over into a spiraling tunnel that defines the main entrance.

The floor, made of a shiny blue resin, generates a glazed surface with many reflections that evoke the image of water—the perfect fluid. Supports have been placed on this apparently liquid surface to prop up the omnipresent red glass ribbon, the element that guides the visitors' steps through the space and sums up the decoration of the restaurant.

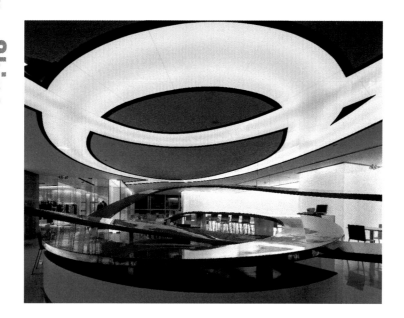

Designer **MASSIMILIANO & DORIANA FUKSAS**
Photographer **RAMON PRAT**
Location **HONG KONG. CHINA**
Opening date **OCTOBER 2002**

The space's lack of structure and ornamentation, along with the invisibility of any illumination device, catapults the viewer into the center stage. The translucent walls of the restaurant vary in color and intensity, creating different ambiences throughout the day.

The absence of any reference to classical geometry is the main feature of this project, whose focus is the concept of mobility and the possible variations of space.

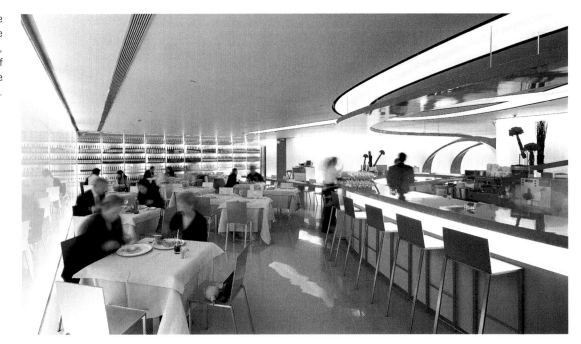

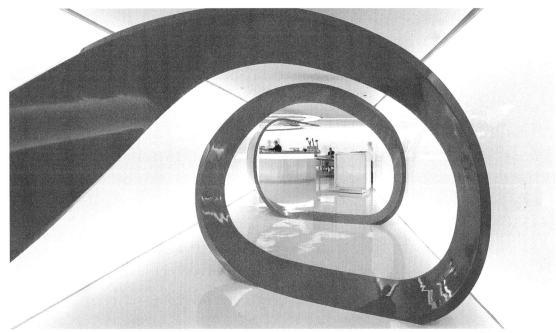

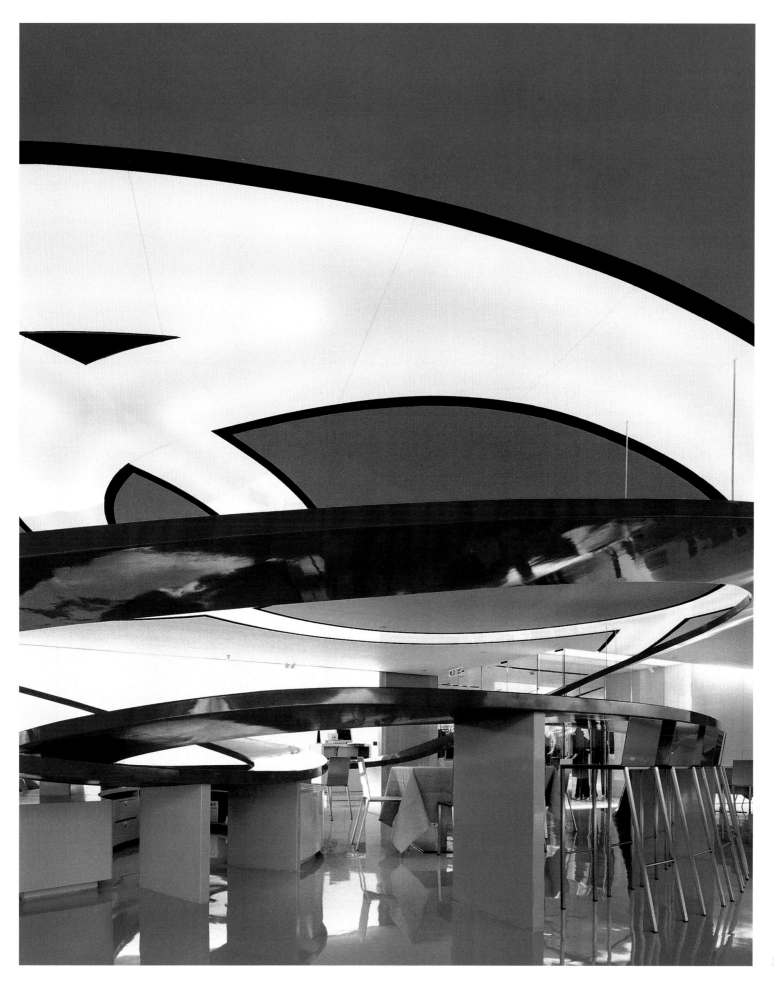

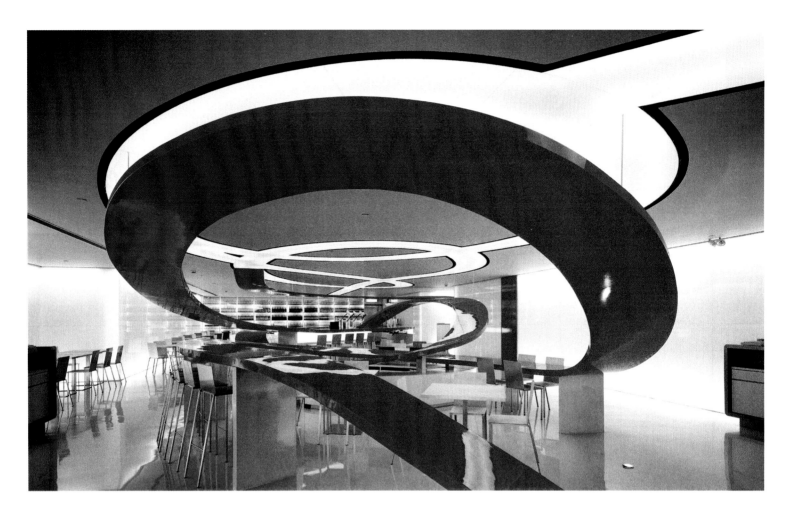

Without quite touching the ceiling, except at its initial point, the red ribbon is complemented by a yellow-and-black counterpart of corresponding shape that runs in a similar trajectory on the ceiling.

Floor plan

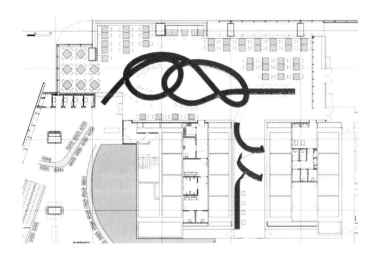

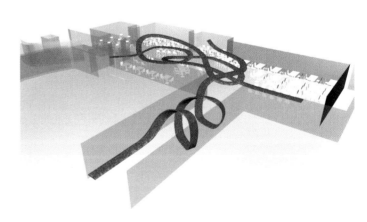

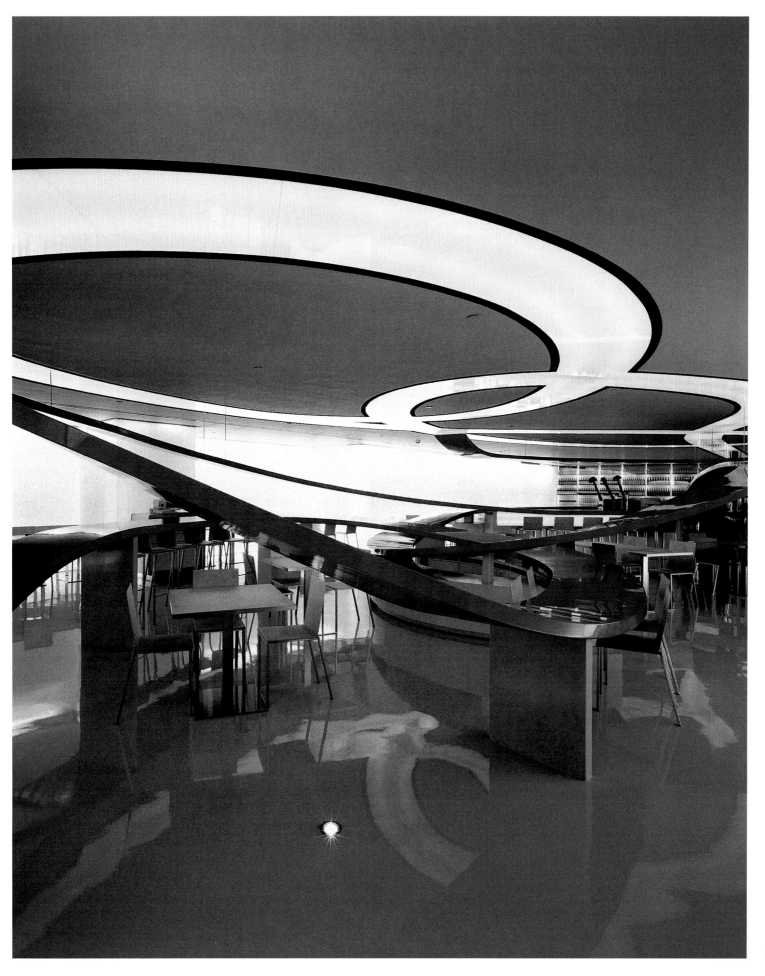

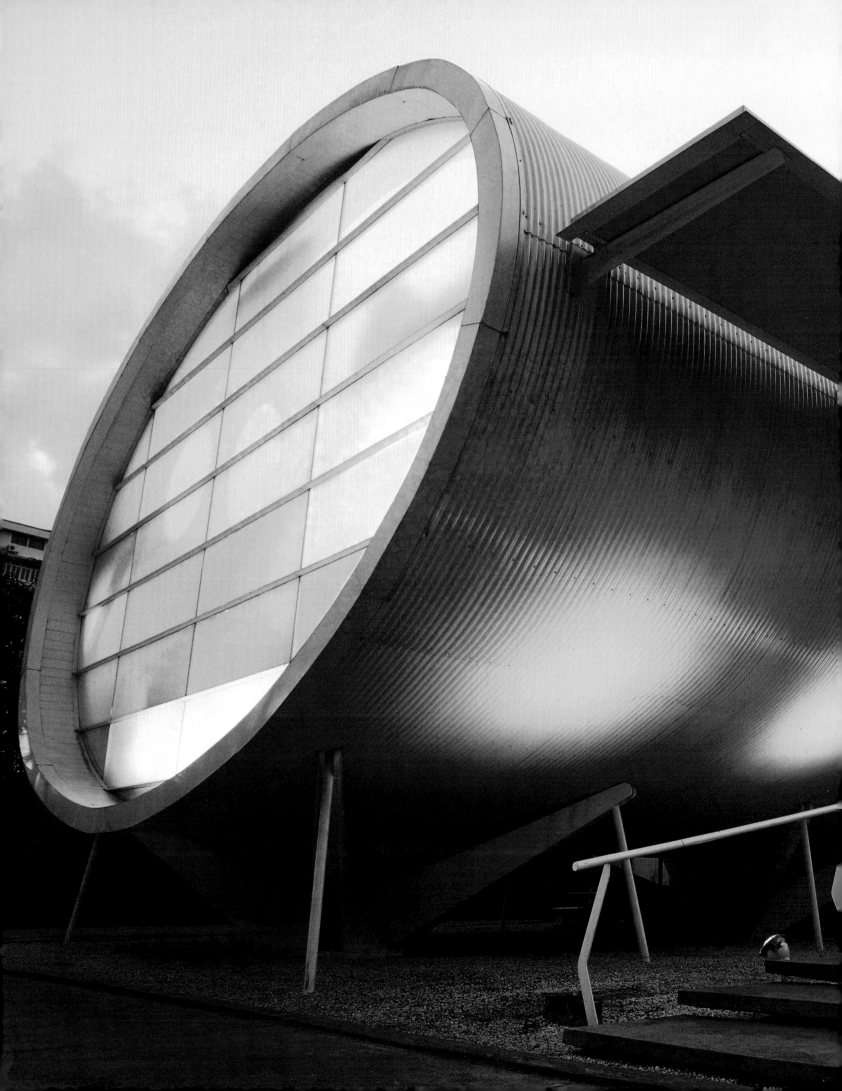

Bed Supperclub · Bangkok · Thailand

Tucked away in the dusty streets of Bangkok is a white oval-shaped tube bathed in a spray of light. Different tones are re-created in the glass front in a continuously changing play of light and shadow. On the opposite side, a red aperture atop a ramp shapes the entrance. Bed Supperclub, a restaurant and bar, was designed by Orbit Design Studio for the purpose of creating a new concept in social spots that combines the idea of a chill-out space with that of a restaurant.

The characteristic soft form of the exterior continues right into an interior of pure, precise lines that act as an anecdote to the chaos reigning all around. White—the symbol of purity, but also of modernity—fills the entire space. It passes from the ceilings, walls, and floors to the staircases and furniture, and continues on to the beds—the distinguishing emblem of this supper club. An outsize bed with heavy cushions and low panel stands—elements halfway between trays and tables—circumnavigates the wall perimeter both on the ground floor and one floor up, inviting the guest to dine in style and comfort. Both of these levels surround the bar, positioned as the center of attention under a screen that projects images. The central space is occupied by a set of tables and chairs, should the visitor be in the mood for a more conventional meal, whose wavy resin finish re-creates an organic sensation that blends with the outer shell.

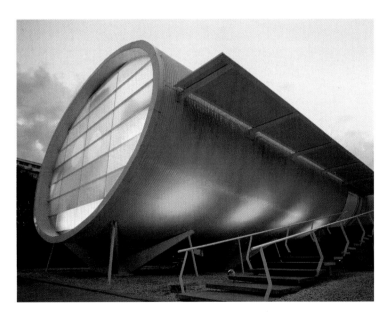

Designer **ORBIT DESIGN STUDIO**
Photographer **MARCUS GORTZ**
Location **BANGKOK. THAILAND**
Opening date **AUGUST 2002**

Versatile, computer-controlled lighting mixes with a series of spotlights in the ceiling to focus strikingly on the tables and create varied motifs and reflections on the floor.

The open structure of this space provides an uninterrupted view that takes in the whole locale, from bar to DJ hut.

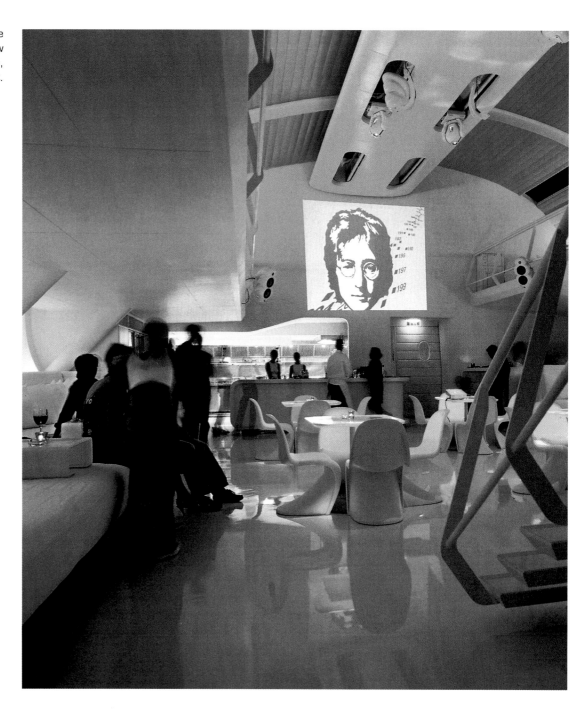

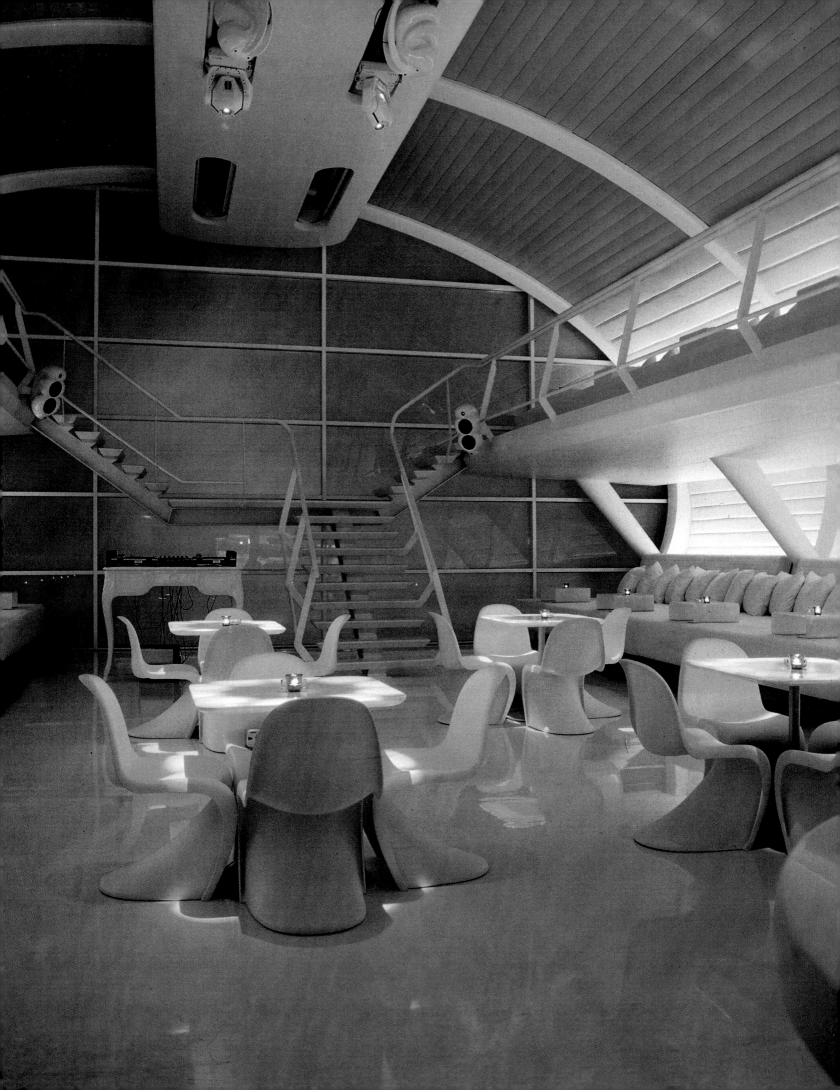

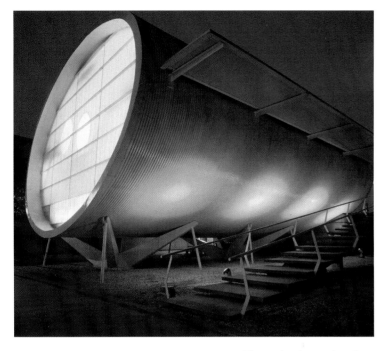

The project's exterior, done completely in steel corresponds to an interior based on materials such as concrete and treated resin.

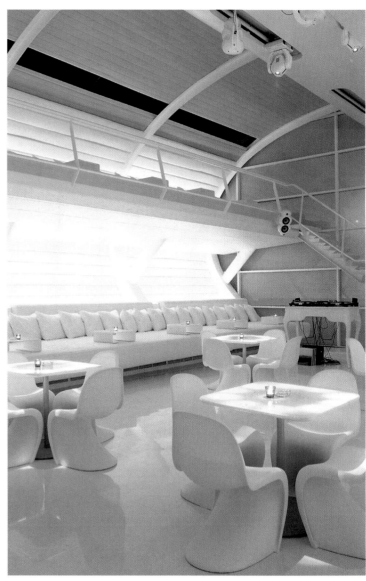

Entry

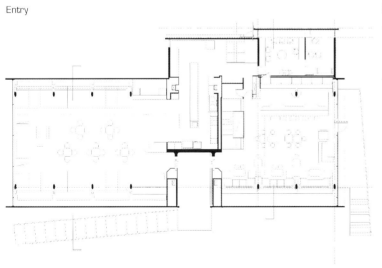

Section

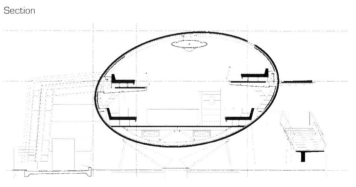

Gray white is the predominant shade throughout. It extends through a wide range of colors produced by computer-controlled lighting in continuous variation.

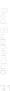

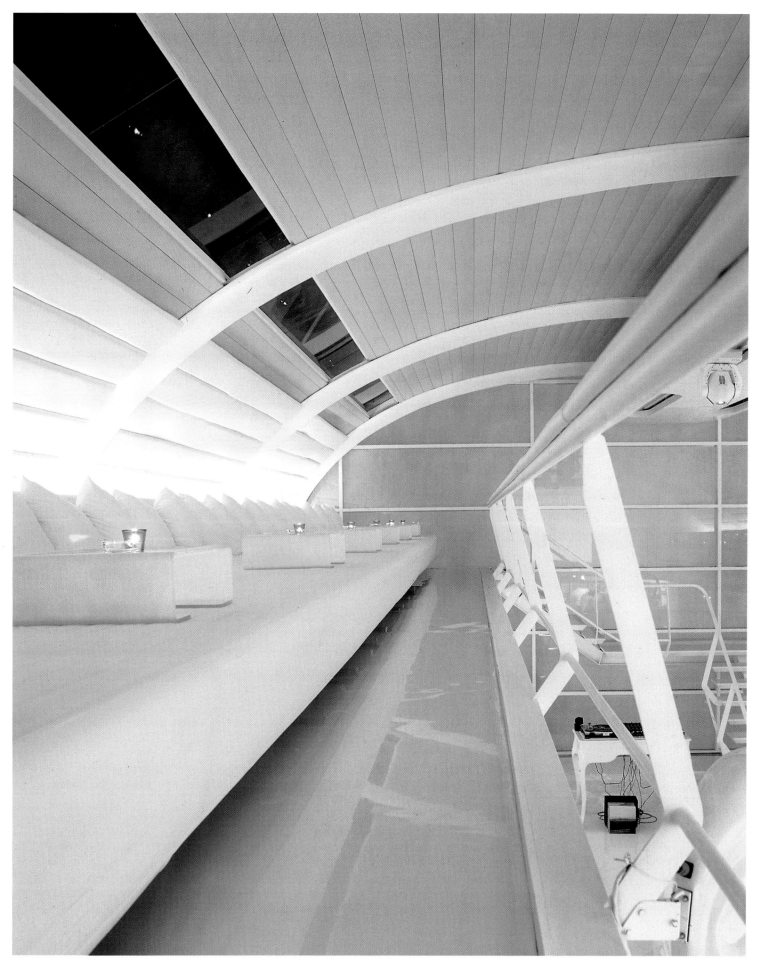

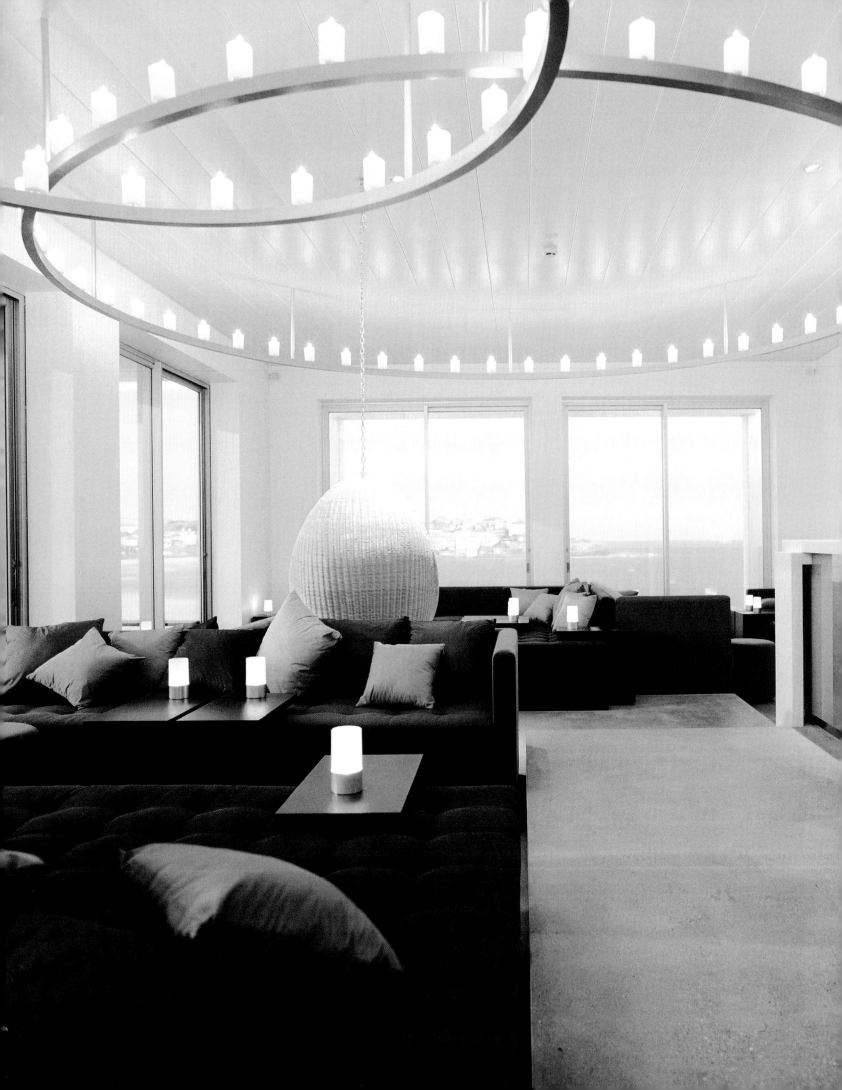

Icebergs · Sydney · Australia

When a corridor approximately 164 feet long and 16.4 feet wide has to be transformed into a restaurant, there is always a risk of creating a succession of tables and chairs that get stacked up in a closed and claustrophobic space. The challenge confronting Lazzarini Pickering Architetti in the design of Icebergs was that of being able to create a diaphanous space, serene and open despite the restrictions placed on its structure. To this purpose, large windows are present at different points in the restaurant, connecting it with the terrace, furnishing light, and concentrating attention on the marine landscape that extends in front of it. The inclusion of mirrors and semicircular structures, contributes to the openness and asymmetry of the space.

The design of Icebergs is a response to the desire to create a restaurant that would be integrated into the landscape surrounding it. The floor forms a collection of colors and textures not unlike the sand; at the same time, the colors of the fabrics emulate those of the swimming pool and the sea, from the turquoises and aquamarines of the water on sunny days to the dark greens and lilacs of a cloudy afternoon. One element characteristic of the restaurant's natural intergration is present in the chairs that hang from the ceiling and swing freely. An evocation of deck chairs, they are, along with the sofas throughout the whole bar area, an irresistible invitation to relax and enjoy the landscape.

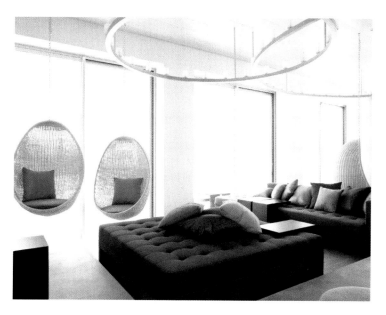

Designer **LAZZARINI PICKERING ARCHITETTI**
Photographer **MATTEO PIAZZA**
Location **SYDNEY. AUSTRALIA**
Opening date **DECEMBER 2002**

The original idea of illuminating the whole space with candles in large candelabra was replaced for security reasons by an equally innovative and original procedure: a system of little lamps that look like candles and give off light of a similar intensity, moving every 20 seconds thanks to electromagnetic pulsations.

Sofas and reclining armchairs are some of the decorative elements used to create an ambience that directly conjures up the beach.

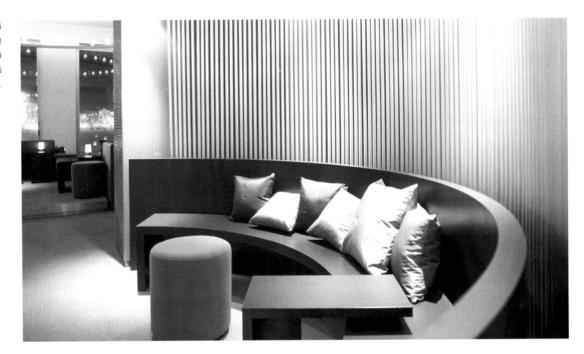

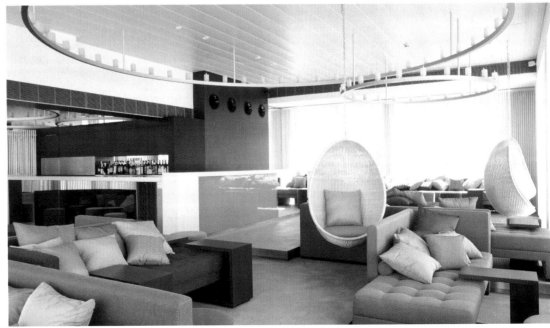

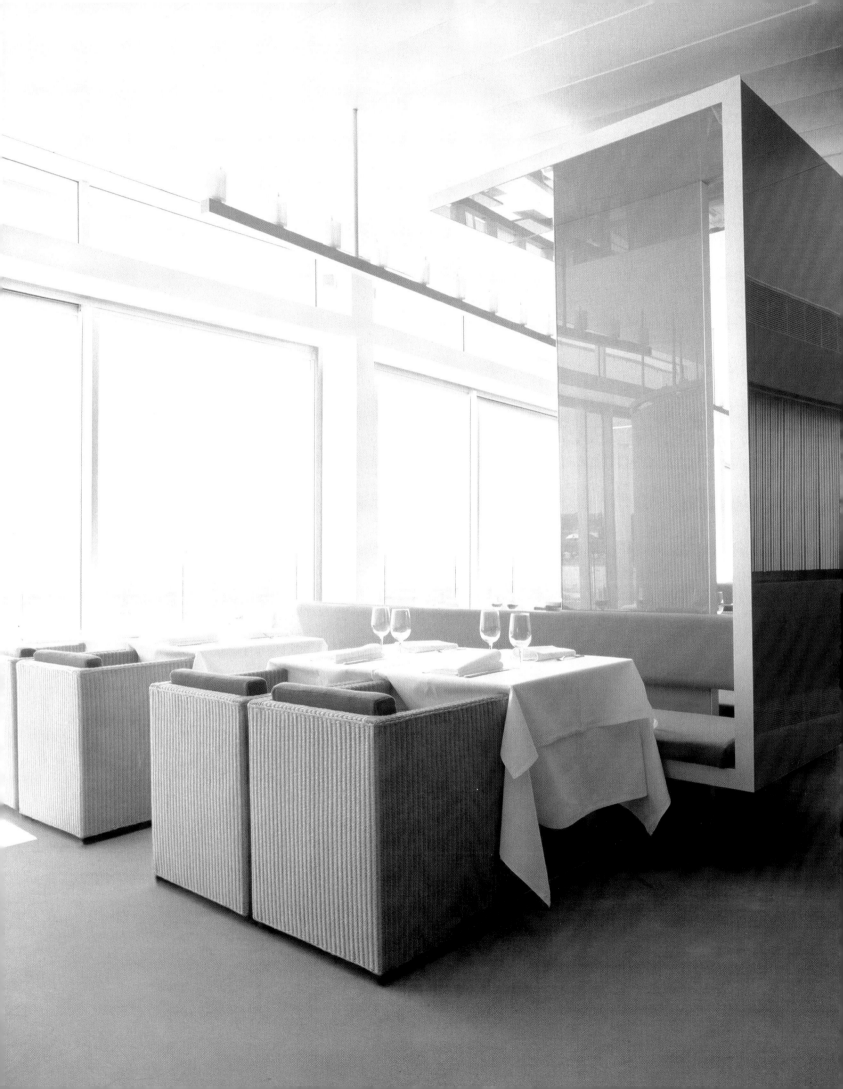

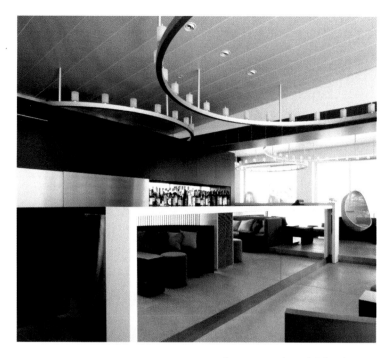

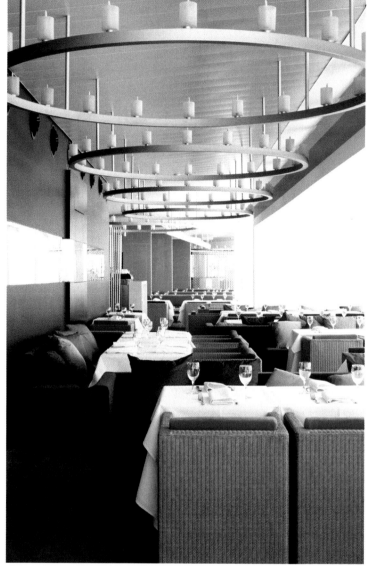

Large round candelabra hang a few inches from the ceiling, backing up the lamps that imitate candlelight both aesthetically and as light sources.

Section

SECTION G-G

Floor plan

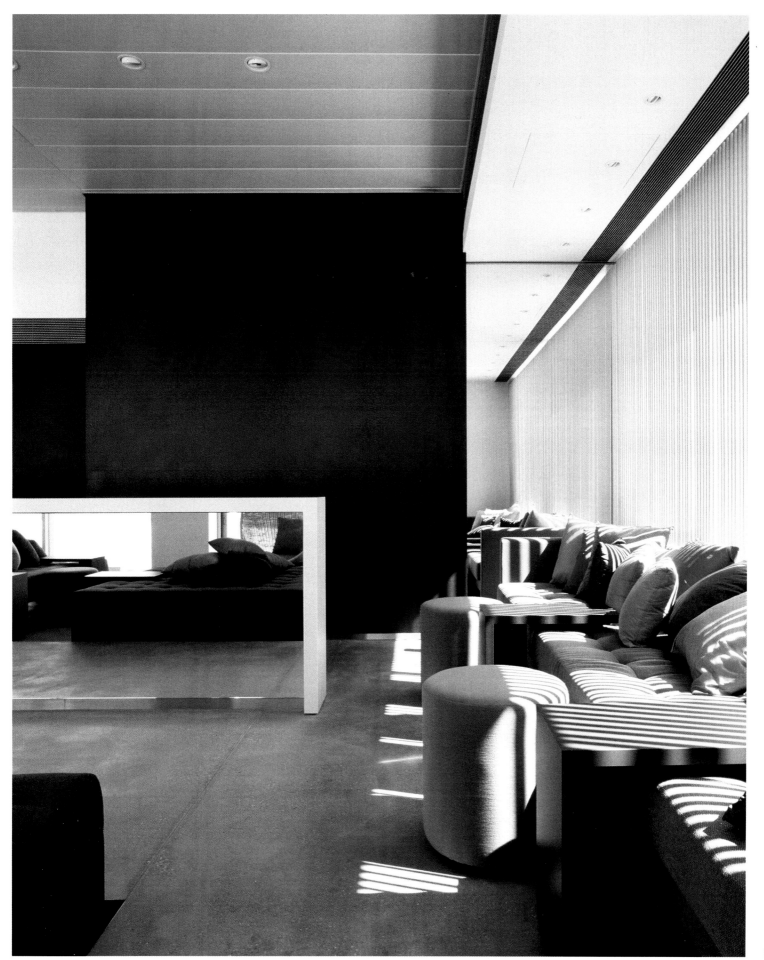

The design selected for the interior continues right on out onto the terrace, which offers views of the coast and thus comprises an added value.

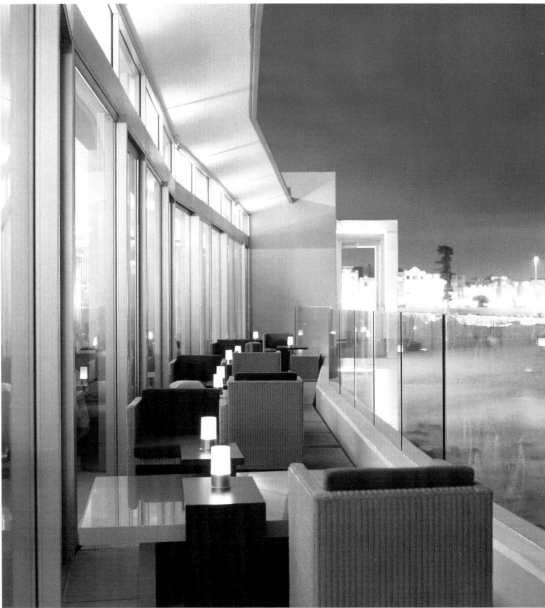

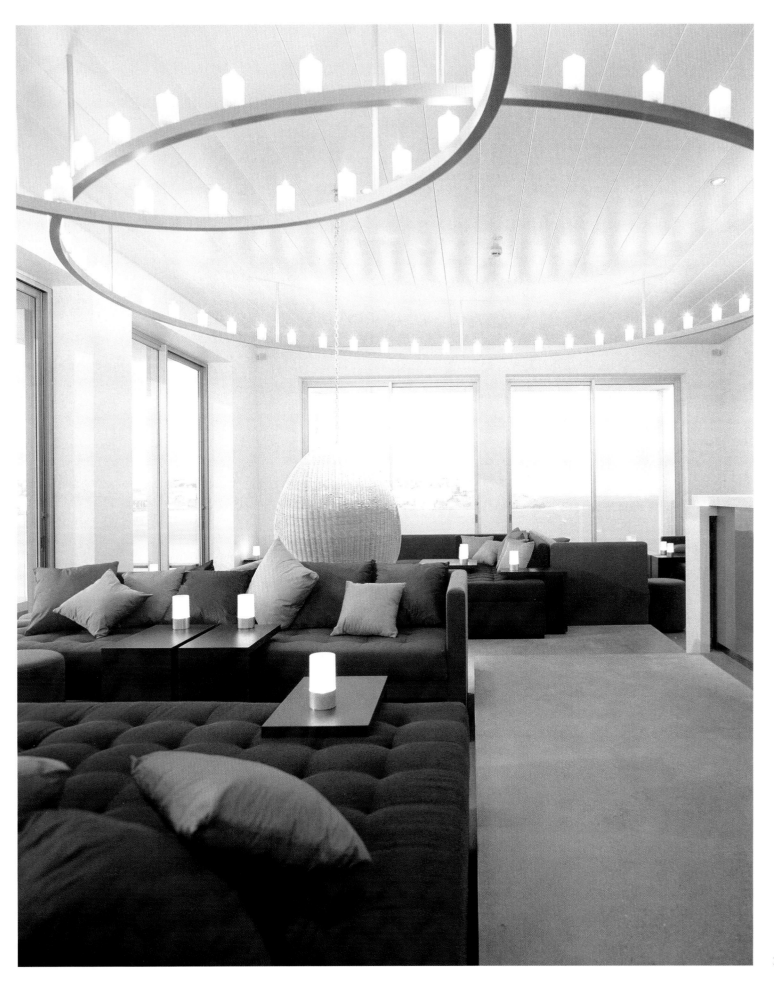

Bar & Restaurant

Directory

Belzberg Architects
1655 Stanford St.
Santa Monica, CA 90404
United States
Tel. 001 310 453 9611
Fax. 001 310 453 9166
studio@belzbergarchitects.com
www.belzbergarchitects.com

Biarquitectos
Avenida de Cristobal Colón, nº 7, 4º B
28850 Torrejón de Ardoz, Madrid
Spain
Tel. 0034 91 512 09 22
Fax 0034 91 711 68 83
biarquitectos@ctv.es

Bruno Caron
7, rue Bertin Poirée
75001 Paris
France
Tel. 0033 1 42 33 41 43
Fax 0033 1 42 33 42 43
caronbr@club-internet.fr

Concrete Architectural Associates
Rozengracht 133 III
1016 LV Amsterdam
Netherlands
Tel. 0031 20 52 00 200
Fax 0031 20 52 00 201
info@concrete.archined.nl
www.concrete.archined.nl

Conran & Partners
22 Shad Thames
London, SE1 2YU
United Kingdom
Tel. 0044 20 7403 8899
Fax 0044 20 7407 5502
cp@conranandpartners.com
www.conranandpartners.com

Damià Ribas
Hort de la Vila, 45, Baixos
08017 Barcelona
Spain
Tel. 0034 93 203 26 00
uluck@coac.net

Desgrippes Gobé Group
411 Lafayette St.
New York City, NY 10014
United States
Tel. 001 212 979 8900
info@dga.com
www.dga.com

Elliot + Associates Architects
35 Harrison Ave.
Oklahoma City, OK 73104
United States
Tel. 001 405 232 9554
Fax 001 405 232 9997
design@e-a-a.com
www.e-a-a.com

Enrique Kahle and Ana González
Goroabe, 23, Bajos
31005 Pamplona
Spain
Tel. 0034 94 823 39 40
Fax 0034 94 823 39 40
ekahle@arquired.es

Estudi Francesc Pons
Bonavista, 6, Bajos 3ª
08012 Barcelona
Spain
Tel. 0034 93 217 03 97
Fax 0034 93 237 40 62
info@estudifrancescpons.com
www.estudifrancescpons.com

Estudio Fernando Salas
Pellaires, 30-38
08019 Barcelona
Spain
Tel. 0034 93 303 33 18
Fax 0034 93 307 18 33
fernando@salasstudio.com

Fabio Novembre
Via Mecenate, 76, Milan
Italy
Tel. 0039 2 504 104
info@novembre.it
www.novembre.it

Fantastic Design Works Inc.
201, Maizonminamiaoyama
5-18-4, Minato-ku
Tokyo 107-0062
Japan
Tel. 0081 3 5778 0178
Fax 0081 3 5778 0179
tokyo@f-fantastic.com

Felipe Assadi
Málaga, 940
Las Condas, Santiago de Chile
Chile
Tel. 56 2 263 57 38
info@assadi.cl
www.felipeassadi.com

Francesc Rifé
Escoles Pies, 25, Baixos
08017 Barcelona
Spain
Tel. 0034 93 414 12 88
Fax 0034 93 241 28 14
f@rife-design.com

GCA Arquitectes Associats
València, 289
08009 Barcelona
Spain
Tel. 0034 93 476 18 00
Fax 0034 93 476 18 06
info@gcaarq.com
www.gcaarq.com

Grego & Smolenicky
Architektur
Rennweg 20
8001 Zürich
Switzerland
Tel. 0041 1 221 1323
Fax 0041 1 221 1343
architektur@grego-smolenicky.ch
www.grego-smolenicky.ch

Hassan Hajjaj
95 Parkway, Camden
NW1 7PP London
United Kingdom
Tel. 0044 428 0263
hassan@hajjaj.fslife.co.uk

Javier Mariscal
Pellaires, 30-38
08019 Barcelona
Spain
Tel. 0034 93 303 69 40
Fax 0034 93 266 22 44
estudio@mariscal.com
www.mariscal.com

John Friedman Alice Kimm
Architects, Inc.
701 E. 3rd St., Suite 300
Los Angeles, CA 90013-1843
United States
Tel. 001 213 253 4740
Fax 001 213 253 4760
jfak@jfak.net
www.jfak.net

Johnson Chou Inc.
902-110 Spadina Ave.
M5V2K4 Toronto
Canada
Tel. 416 703 6777
Fax 416 703 7009
mail@johnsonchou.com
www.johnsonchou.com

Juli Pérez-Català
Sant Cristofol, 12, Baixos Esq.
08017 Barcelona
Spain
Tel. 0034 93 418 13 48
Fax 0034 93 418 13 98
jp-c@coac.net

Kristin Jarmund Arkitekter
Drammensveien 44
N-0271 Oslo
Norway
Tel. 0047 22 43 85 96
Fax 0047 22 44 08 57
firmapost@kjark.no
www.kjark.no

L.A., Design & Architecture
Studio Paris
53, rue Montreuil
75011 Paris
France
Tel. 0033 1 444 99006
leonardo@l-a-design.com

Lazzarini Pickering Architetti
Via Cola di Rienzo, 28
00192 Rome
Italy
Tel. 0039 6 3210305
Fax 0039 6 3216755
info@lazzarinipickering.com

Leroy Street Studio
113 Hester St.
New York City, NY 10002
United States
Tel. 001 212 431 6780
Fax 001 212 431 6781
info@leroystreetstudio.com
www.leroystreetstudio.com

M41LH2
Kalliolanrinne 4 A 8
FIN-00510 Helsinki
Finland
Tel. 0035 841 522 0434
Fax 0035 896 94 0847
www.M41LH2.com

Massimiliano and Doriana Fuksas
Piazza del Monte di Pieta, 30
I-00186-Rome
Italy
Tel: 0039 6 6880 7871
office@fuksas.it
www.fuksas.it

Matali Crasset
26, rue du Buisson Saint Louis
75010 Paris
France
Tel. 0033 1 42 40 99 89
Fax 0033 1 42 40 99 98
matali.crasset@wanadoo.fr
www.matalicrasset.com

Melissa Castañeda de León de
Peralta
Av. Conquistadores 256 Of. 802A
Lima 27
Peru
Tel. 0011 5114 429206
Fax 0011 5114 224347
melissa@asiadecubaperu.com

Mourad Mazouz
9, Conduit St. Mayfair
London W1
United Kingdom
Tel. 0044 870 777 44 88
Fax 0044 207 629 1684
www.sketch.uk.com

Mueller Kneer Associates
18-20 Scrutton St.
London EC2A 4EN
United Kingdom
Tel. 0044 20 7247 0993
Fax 0044 20 7247 9935
info@muellerkneer.com
www.muellerkneer.com

Office dA
57 E. Concord St., Suite 6
Boston, MA 02118
United States
Tel. 001 617 267 7369
Fax 001 617 859 4948
da@officeda.com

Orbit Design Studio
2A, 2nd Floor M. Thai Tower
All Seasons Place, 87 Wireless Road
Lumpini, Patumwan
Bangkok 10330
Thailand
Tel. 0066 2 654 3667
Fax 0066 2 654 3666
info@orbitdesignstudio.com
www.orbitdesignstudio.com

Patrick Jouin
8, passage de la Bonne Graine
75011 Paris
France
Tel. 0033 1 55 28 89 20
Fax 0033 1 59 30 60 70
agence@patrickjouin.com
www.patrickjouin.com

Phillippe Starck
18-20, rue du Faubourg du Temple
75011 Paris
France
Tel. 0033 1 48 07 54 54
Fax 0033 1 48 07 54 64
starck@starckdesign.com
www.philippe-starck.com

PLR Arquitectos
Plaza de los Tercero, 8
41003 Seville
Spain
Tel. 0034 95 422 56 29
plrarquitecturas@telefonica.net

Rockwell Group
5 Union Square W. 8th Floor
New York City, NY 10003
United States
Tel. 001 212 463 0334
Fax 001 212 463 0335
www.rockwellgroup.com

Studioilse
13 Great James St.
London WC1N 3DP
United Kingdom
Tel. 0044 20 7242 4739
Fax 0044 20 7405 4131
ilse@studioilse.com

Suhail Design Studio
W. Carroll C-231
Chicago, IL 60612
United States
Tel. 001 312 733 9411
Fax 001 312 733 9412
suhail1@aol.com
www.suhaildesign.com

Tibbats Design
1, St. Paul's Square
Birmingham B31QU
United Kingdom
Tel. 0044 121 233 2871
Fax 0044 121 236 8705
info@tibbats.co.uk
www.tibbats.co.uk

Tihany Design
135 W. 27th St., 9th Floor
New York City, NY 10001
United States
Tel. 001 212 366 5544
Fax 001 212 366 4302
mail@tihanydesign.com
www.tihanydesign.com

Tonychi and Associates
20 W. 36th St., 9th floor
New York City, NY 10018
United States
Tel. 001 212 868 8686
Fax 001 212 465 1098
t.Chou@tonychi.com
www.tonychi.com

Yabu Pushelberg
55 Booth Ave.
M4M2M3 Toronto
Canada
Tel. 001 416 778 9779
Fax 001 416 778 9747
design@yabupushelberg.com

Zeynep Fadillioglu Design
Ahmet Adnan Saygun Cad. No: 72/5
80630 Ulus–Istanbul
Turkey
Tel. 0090 212 287 09 36
Fax 0090 212 287 09 94
design@zfdesign.com

Directory Bars

ALEPH
Via San Basilio, 15
00187 Rome
Italy

ANDY WAHLOO
69, rue des Gravilliers
75003 Paris
France

ASIA DE CUBA
Av. Conquistadores, 780
San Isidro, Lima
Peru

AVALON
662 6th Ave.
10011 New York City, NY
United States

BAR TUBO
Av. Del Ejército, 750
Magdalena del Mar, Lima
Peru

BED SUPPERCLUB
26 Soi 11, Sukhumvit Rd.
Klongtoey-nua
10110 Bangkok
Thailand

BLOWFISH RESTAURANT
666 King St. W.
Toronto
Canada

BON 2
2, rue du Quatre Septembre
75002 Paris
France

BYMARK
TD Tower
66 Wellington St. W.,
Suite 22 D
Toronto
Canada

CAFÉ SAMBAL AND AZUL
Mandarin Oriental Hotel
500 Brickell Ave.
Miami, FL 33131
United States

CALLE 54
Paseo de la Habana, 3
28036 Madrid
Spain

CAN FABES
Sant Joan, 6
08470 Sant Celoni
Barcelona
Spain

CHINTAMANI
122 Jermyn St.
London SW1Y
United Kingdom

CHOP'T
24 E. 17th St.
New York City, NY 10003
United States

CINNAMON CLUB
The Old Westminster
Library,
Great Smith St.
London SW1
United Kingdom

DODOCLUB
San Roque, 17, Bajos
31011 Pamplona
Spain

EL NOTI
Roger de Llúria, 35-37
08009 Barcelona
Spain

ELYSIUM
68 Regent St.
London W1B5EL
United Kingdom

EMPORIO ARMANI CAFFÈ
Chater Rd.
Hong Kong
China

FALCON
7213 Sunset Blvd.
Los Angeles, CA 90046
United States

HAPPY BAR
Hi Hotel 3
Avenue des Fleurs
06000 Nice
France

HELSINKI CLUB
Yliopistokatu 8
00100 Helsinki
Finland

HOTEL AC PAMPLONA
Irurrana, 21
31007 Pamplona
Spain

ICEBERGS
1 Notts Ave., Bondi
Sydney, NSW 2026
Australia

J-POP CAFÉ ODAIBA
5F Decks Tokyo Beach
1-6-1 Daiba, Minato-ku
Tokyo
Japan

KONG
5th and 6th floor Kenzo
Building
1 rue du Pont Neuf
75001 Paris
France

LE CHLÖSTERLI
3783 Grund bei Gstaad
Switzerland

LE CIRQUE
Camino Real Mexico
Mariano Escobedo 700
Col Anzures
11590 Mexico, D.F.
Mexico

LIT
208 E. Sheridan
Oklahoma City, OK 73104
United States

MANTRA
52 Temple Place
Boston, MA 02111
United States

MEMPHIS VAAKUNA
Asema-aukio 2
00100 Helsinki
Finland

MIX IN NEW YORK
68 W. 58th St.
New York City, NY 10019
United States

MOD
1520 N. Damen Ave.
Chicago, IL 60622
United States

NATURALMENT.e
Llacuna, 162-164
08018 Barcelona
Spain

NERI
Sant Sever, 5,
08002 Barcelona
Spain

**NEW CAFÉ IN THE
NATIONAL GALLERY**
Nasjonalgalleriet
Universitetsgaten 13
0164 Oslo
Norway

NoMI
Park Hyatt Chicago
800 N. Michigan Ave.
Chicago, IL 60611
United States

PATINA
111 S. Grand Ave.
Los Angeles, CA 90012
United States

PLATEAU
Canada Place, Canary Wharf
London E14 5ER
United Kingdom

ROPPONGI HILLS CLUB
51st Floor, Roppongi Hills
Mori Tower
6-10-1 Roppongi
Minato-ku, Tokyo,
106-6151
Japan

747 BAR
Via Roma, 112
96100 Syracuse
Italy

SILKA
6-8 Southwark St.
Borough Market
London SE I
United Kingdom

SKETCH
9 Conduit St. Mayfair
London W1
United Kingdom

SOHO HOUSE
29-35 9th Ave.
New York City, NY 10014
United States

SONOTHEQUE
1444 W. Chicago Ave.
Chicago, IL 60622
United States

STROZZI'S PIU
Paradeplatz
8001 Zürich
Switzerland

SUPPERCLUBCRUISE
Amsterdam
Netherlands

SUSHISAMBARIO
504 N. Wells St.
Chicago, IL 60610
United States

tab.00
Trastamara, 29
41001 Seville
Spain

TIZI MELLOUL
531 N. Wells Ave.
Chicago, IL 60610
United States

UNA HOTEL VITTORIA
Via Pisana, 59
50143 Florence
Italy